Photoshop CS6 and Lightroom 4
A Photographer's Handbook

Stephen Laskevitch

Photoshop CS6
and Lightroom 4
A Photographer's Handbook

rockynook

Stephen Laskevitch (www.luminousworks.com)

Editor: Joan Dixon
Copyeditor: Cynthia Anderson
Layout and Type: Stephen Laskevitch
Cover Design: Helmut Kraus, www.exclam.de
Printer: Lifetouch, Inc. through Four Colour Print Group, Louisville, Kentucky
Printed in the USA

ISBN 978-1-937538-03-3

1st Edition 2012
© 2012 by Stephen Laskevitch

Rocky Nook Inc.
802 East Cota St., 3rd Floor
Santa Barbara, CA 93103

www.rockynook.com

Library of Congress Cataloging-in-Publication Data

Laskevitch, Stephen.
 Photoshop CS6 and Lightroom 4 : a photographer's handbook / Stephen Laskevitch. -- 1st
ed.
 p. cm.
 ISBN 978-1-937538-03-3 (pbk.)
 1. Adobe Photoshop. 2. Adobe Photoshop lightroom. 3. Photography--Digital techniques. I.
Title.
 TR267.5.A3L3723 2012
 006.6'96--dc23
 2012015815

Distributed by O'Reilly Media
1005 Gravenstein Highway North
Sebastopol, CA 95472

Acknowledgements

Many thanks go to my students. There have been many of you who've shaped not only my teaching, but also my humanity. You make it obvious that I found the right career. I wrote this book to be a complement to the time you spend in my classroom. I hope you and the educators who use this book find it a means to great creative ends.

To Colin Fleming, my heartfelt thanks for so often creating an atmosphere that sparks creative and geeky sharing.

To my wife, Carla Fraga, for sharing me with software *and* for pulling me back to the real world to spend time with her. You're the best thing in a world of wonders.

Thank you, too, reader, for choosing this book.

Steve Laskevitch
July 2012
www.luminousworks.com

Table of Contents

Introduction

In some ways, digital technology has fundamentally changed photography and printing. Photographers have almost unlimited options to achieve the precise image that they intend. Printing has become infinitely more flexible and pushed closer to the control of the image creator—you. The level of control at our disposal now exceeds even some of the most powerful darkroom techniques used in the past. This power and flexibility is dazzling, even confusing, to many.

The Adobe Photoshop products are some of the most complex programs many of us will ever use. There is a reason "Photoshop" has become a verb! Despite that, my goal is to present them in a reasonably accessible way. Although we are provided with thousands of complex techniques for editing images, most users (and most images) don't need all of that complexity. In fact, only a few steps are needed to get the vast majority of images to shine. In this book, I'll introduce you to the processes that I and my students have found most valuable: from organizing a large image library, through editing density, contrast, and color, to more detailed processing like converting images from color to black-and-white, sharpening, and basic retouching. The workflow discussed is complete, but I will not discuss the more bizarre techniques common to the Photoshop marketplace.

In this book's two main sections, you'll find both the foundational concepts and vocabulary you'll need to use the software discussed, and the pieces you'll need to build your full photographic workflow from capture through print or online output. Let's get working!

About the Photographer's Handbook

Who Should Use This Book

This book is for those who want to learn the basic tools and image editing steps within Photoshop and Lightroom to create professional looking images. This, of course, includes photographers and graphic designers, but also a wide range of technicians and office workers who simply want to do more effective image editing. This book provides insight into the creation of good images, but doesn't showcase wow-factor Photoshop techniques. I also don't pull any punches. I include all the key techniques necessary for good image editing: using layers and layer blending, color correction, printer profiles, and more.

Most readers should have a good grasp of working with computers so they will have no problem navigating the computer menus, dialog boxes, or dragging a mouse. I do not demand that the reader have any experience with Photoshop, although many readers who have a good, basic understanding of Photoshop will find that this book deepens their understanding.

Steps for Using This Book

This book has two key sections. *Section 1: The Setup* includes three chapters: *Important Terms & Concepts*, *System Configuration*, and *The Interface: A Hands-on Tour*. The first chapter familiarizes the reader with the key concepts behind color and digital images, as well as some thoughts on how cameras convert light to data. The brief second chapter will help you decide how to configure your hardware and software settings, including certain application preference settings you'll want to configure correctly early on for the kinds of images you work with. The third chapter, the most likely to earn dog-ears or bookmarks on its pages, covers the layout and general use of the software applications we'll be using.

Section 2: The Workflow focuses on the key steps in a complete photographic workflow. Each chapter highlights those steps: *Capture & Import*; *Organizing & Archiving Images*; *Global Adjustments*; *Local Adjustments*; *Cleaning & Retouching*; *Creative Edits & Alternates*; and *Output*.

This book is of greatest benefit when read from beginning to end. However, those looking for a reference on Photoshop can search through the pages to find the specific topics of interest.

Conventions

Some helpful conventions are used throughout the book. Important terms are in bold type, making it easier to skim through for specific information.

Conventional notation for choosing items from a menu is used throughout: e.g., File>Browse to select the Browse command from the File menu.

The icons and vocabulary used in the application are used in this book for identifying different types of information. Application logos will appear on pages which feature discussion of that software. Processes that are specific to Photoshop, Bridge, ACR (Adobe Camera Raw), or Lightroom will begin with headers colored like each application's logo.

Note: The red "Note" text identifies text in a chapter that summarizes or emphasizes a key point.

Photoshop Versions

At the heart of modern photographic workflows are the Adobe® Photoshop® family of products. It's a large family, spanning from the online and mobile apps Color Lava, Eazel, Nav, Revel, and Photoshop Touch, to the capable but still entry-level Photoshop Elements, to the fully capable Photoshop and Photoshop Extended. Extended includes tools for scientific analysis, 3-D, and video. There is also the photography workflow tool, Adobe Photoshop Lightroom. In this book, I'll outline my workflow steps in Photoshop CS6 Extended (released May 7, 2012) and its companions Bridge and Adobe Camera Raw 7, as well as Lightroom 4, so you can decide which is most appropriate to the work you do.

For the most part, the workflows and techniques described in this book still work well with the previous versions of these products.

Mac vs. Microsoft Windows Operating Systems

Although most of the screen shots in the book are taken from a computer running Mac OS 10.6.8, Photoshop is completely platform indifferent. The interface is almost identical on both Windows and Mac. In fact, Photoshop happens to be one of the best cross-platform programs ever developed. The few differences that exist are identified in the text.

Keys

Two differences throughout are keyboard modifiers and mouse clicks. The two keyboards have essentially the same function keys, but with different names. The Mac Command key ⌘ functions the same as the Windows Ctrl key. In this book, this keyboard modifier is identified as ⌘+[other key(s)] / Ctrl+[other key(s)]. ⌘+N / Ctrl+N, for example, means you would hold down the modifier key then press the N key. As you can see, we'll be using pale red for Windows and light blue for Mac or as part of a Mac-specific shortcut.

Similarly, the Mac option key, identified in application menus by the cryptic symbol "⌥", functions the same as the Windows Alt key. This keyboard modifier is identified as option+[other key(s)] / Alt+[other key(s)].

Look for text and icons like these:

Photoshop

For processes that involve Photoshop or Photoshop Extended.

Bridge/ACR

For information regarding organizing images in Adobe Bridge and/or "developing" images in Adobe Camera Raw.

Lightroom

For Lightroom's methods of achieving the processes discussed.

Bridge/ACR Lightroom

You will see this heading when the text describes processes that are very nearly identical in both Adobe Camera Raw and Lightroom.

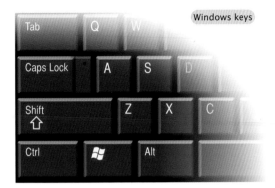

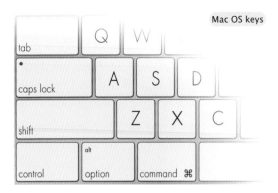

Keys that are not platform-specific (space , shift , enter , etc.) will be noted in gray.

The Windows mouse includes a second mouse button for additional functionality—often a Context menu. Mac users can achieve this same functionality on a single-button mouse by holding down the control key when clicking the mouse. This mouse modifier is identified by control+click / Right-click .

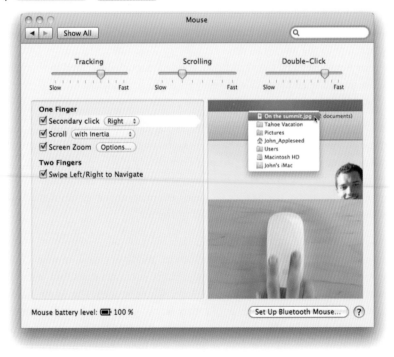

Mac mice *can easily* have two-button functionality within their single shells. I recommend enabling that "Secondary Click" functionality in your Mac mouse's **System Preference**. Mac users really should update older mice and turn on the right click functionality. Ironically, a Microsoft mouse works great when plugged into a Mac.

System Requirements

It is best to see the following for full requirements:

http://www.adobe.com/products/photoshop/tech-specs.html

http://www.adobe.com/products/photoshopextended/tech-specs.html

However, as of this writing, Photoshop CS6 requires the following:

▶ 1024x768 display (1280x800 recommended) with 256MB (512MB recommended) of VRAM

▶ OpenGL 2.0–capable system

▶ Requires activation. Broadband Internet connection and registration are required for software activation, validation of subscriptions, and access to online services. Phone activation is not available.

Windows

▶ Intel® Pentium® 4 or AMD Athlon® 64 processor

▶ Microsoft® Windows® XP* with Service Pack 3 or Windows 7 with Service Pack 1. That's right: not Vista.

Mac

▶ Multicore Intel processor with 64-bit support

▶ Mac OS X v10.6.8 or v10.7

▶ Cannot install on a volume that uses a case-sensitive file system or on removable flash storage devices

Section 1
The Setup

Trajan's Column

Important Terms & Concepts

1

There's an old joke in computer graphics circles. The biggest geek in the room utters a long sentence referencing PDF, EPS, PSD, GIF, RAM, HDR, DNG, ACR, RGB, L*a*b, "and other TLAs".

"What's a 'TLA?'" someone asks.

"Three Letter Acronym", replies the geek, to groans from those still listening.

A challenger pipes up, "What about CMYK?"

"Oh, that's an ETLA—Extended Three Letter Acronym."

Despite the fact that this is intended as a joke, the language of computer graphics, even when restricted to digital photography, is still specialized. Of course, photographers have used special words, or common words in novel ways, for almost two centuries.

"Sharp" to a medical technician is a biohazard, but to an imagemaker, it's something to embrace. "Flat" may describe an easy path to walk, but it could also be the descriptive characteristic of a boring photo. In this chapter, I hope to decipher many of the terms one encounters perfecting images.

I also intend to answer some of the most common questions about digital imaging: Is shooting digitally more like slide or negative film? What is "bit depth" and why should one care? What's a color profile? Hopefully, by the end of this chapter, you'll feel ready to take on the software.

Some Background

This section covers many technical details of how computers and software deal with digital images. Many people just want to skip the technical details about the geeky inner workings of the computer. But it is useful to have a basic understanding of how Photoshop "sees" your digital image.

I'll break down these details into a fairly straightforward glossary of terms: Digital Images, Pixels, Resolution, Bits, etc. As much as software engineers try to hide the technical details of image editing, these terms still pop up over and over again in digital photography. You may already know many of the details of computers, but review the terms as I define them here anyway. They're often used misleadingly in regard to digital imaging.

What is a Digital Image?

Computer software programs (including Photoshop) see digital images as a rectangular array of pixels. Each pixel (a shortening of "Picture Element") is merely a tiny square of color and light. This image of ornate stonework is composed of an array of 511 x 332 pixels—or 169,652 pixels. A typical digital camera image often has at least 2000 x 3000 pixels—or 6 million total. Most digital images contain millions of pixels—thus the common term "Megapixels".

Summary: Digital images are merely rectangular arrays of pixels that represent an image. Digital images typically contain millions of pixels.

Pixels

Visually, pixels are small squares of color: the most basic elements of a digital image. If you've ever seen mosaic tiling, you get the idea. In the computer, which lives in a world of math, pixels are a simple set of numbers used to describe a color. For most images, each pixel contains a Red (R), Green (G), and Blue (B) value. The computer uses these RGB values to create the color for that particular pixel. Grayscale images use only one number for each pixel to represent the density or level of black. It is useful to remember that as computers are used to manipulate an image, they're only adjusting these values.

Dots & Sensors

What about the resolution of pixels in scanners, digital cameras, monitors, and printers? Although the term "pixels" is often used in regard to these devices, it is best to think of the "sensors" in our input devices as the "dots" of ink produced by printers. Usually, scanners and digital cameras produce one pixel for each sensor, but not always. And printers print many dots for each pixel. The following examples illustrate these phenomena. Since a typical scanner might have 3000 sensors per inch, scanning a 1" x 1½" piece of film produces a digital image of 3000 x 4500 pixels. Similarly, a printer doesn't print with pixels, but rather converts pixels into ink dots that are sprayed onto the paper. There are almost always significantly more ink dots printed per digital image pixel.

Thus, a printer with a resolution of 2880 *dots* per inch (DPI) prints an image with only 300 *pixels* per inch (PPI). In practice, the term "DPI" is commonly used for the resolution of a wide number of devices. We can't change the usage of this word completely, but remember there is a difference between the computer's "pixels", the scanner's and camera's "sensors", and the printer's "dots".

Summary: Pixels are not the same as dots and sensors: even though "pixel" and "dot" are commonly used interchangeably, pixels actually exist only within the computer.

Image Size

The size of a digital image is referred to in several different ways. The most informative—and least common—method is to refer to its horizontal and vertical dimensions. A typical image might have a size of 2000 x 3000 pixels. This provides information about the shape of the image as well as its size. But the most common way to refer to image size is to refer to its overall number of pixels—multiplying the horizontal by the vertical dimensions, which in this example results in 6,000,000 pixels or 6 megapixels.

Finally, it is also common to refer to image size in terms of megabytes. Traditionally, computers used 3 bytes of information to store one pixel. By

multiplying the number of megapixels by 3, you get the size in megabytes (MB), or 18MB in this example.

Resolution

A convenient way to understand resolution is to look at the density of pixels in an image. We might express this as 300 pixels per inch or 115 pixels per centimeter.

Remember, our objective is to transform a physical scene or image into a digital image and, likely, into a physical image (i.e., take a piece of slide film, scan it into the computer to create a digital image, edit the digital image, and print it back out to paper). To generate an acceptable print, we need to send a sufficient number of pixels to the printer for each inch or centimeter of dots it will produce.

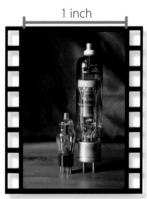

Scanned at 2400 ppi
2400 pixels x 3600 pixels

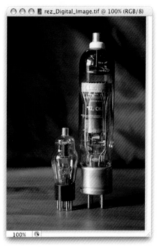

Digital image

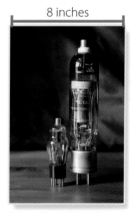

Printed at 300 ppi
or 1200 dpi

For example, our image of 2400 x 3600 pixels image "maps" to a size of 24" x 36" at 100 pixels per inch—or to a size of 8" x 12" at 300 pixels per inch. Resolution is further complicated by the difference between dots and pixels. Typically, scanners produce an image with one pixel for each scanner sensor. But, as noted previously, printers almost always print with many more dots than pixels; often 6, 8, or more dots print for each pixel in the digital image.

Here's a concrete example demonstrating the transformation of a piece of 35mm film to a larger printed image:

The 35mm film has an image area of about 1" x 1½". If your scanner scans at 2400 samples per inch (sensors per inch) and produces a file with 2400ppi (pixels per inch)—that's one pixel for each sensor.

1" x 1½" at 2400ppi produces a file of 2400 x 3600 pixels.

While this file is in Photoshop, you can edit it without much regard for the resolution—it is simply a 2400 x 3600 pixel image.

However, to output an 8" x 12" image, we would change the image resolution to approximately 300ppi, a typical printer-friendly resolution. The

image is still 2400 x 3600 pixels even though the printer might print at 1440dpi (many *dots* for each *pixel*).

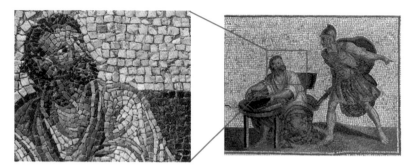

Considering an ancient mosaic floor tiling, artists would use many small tiles to construct what appeared to be an image when viewed from sufficiently far away: when standing upon it, or perhaps on a balcony above. To enhance the illusion for viewers, or to keep the illusion when viewers approach more closely, the artist had to use smaller tiles so there would be more under each foot. One might say a mosaic with a resolution of 12 tiles per human foot is not as compelling when viewed as closely as one with 24 tiles per foot.

If that artist could only afford a certain number of tiles in any size, he might choose to make either a small mosaic of high resolution (many small stones) or a large one of low resolution (fewer larger stones).

Note: An image with a set number of pixels can have any resolution if its size is changed: higher resolution (defined as pixel density) for a smaller size, lower resolution for a larger size. Digital cameras are sold advertising how many megapixels they create. Sadly, many use an initial density/resolution of only 72ppi, leaving it to us to pack them in more tightly.

Resampling/Interpolation

But, what if you want to print an image that is 4" x 6" instead of 8" x 12"? By changing the digital image size to 1200 x 1800 pixels, the image prints at 4" x 6" at 300ppi. Changing the actual number of pixels of a digital image size causes Photoshop to **resample** (or interpolate) the image. In other words, Photoshop takes the existing pixel information and estimates the appropriate pixel colors for the same image with the new image size. Interpolation is a good thing; it makes it possible to change the size of the image from various source sizes (different film sizes, scanners, or digital cameras) to various output sizes (different print sizes, printers, or the web).

Photoshop is generally very good at resampling digital images. However, each time an image is resampled, there is wear on it. It is best to keep your original archived with its original pixels intact and have copies, real or virtual, with other needed resolutions. More on that virtual part later!

Native Resolution

Often, when we discuss interpolation, many people suggest that they can avoid interpolation merely by changing the scanning resolution and/or the printing resolution. For the 2400 x 3600 pixel example—couldn't you also change the print resolution to 750ppi if you wish to print a 4" x 6" image? The math is correct, but most digital imaging devices (like scanners and printers) only operate at a single fixed resolution—their **native resolution**. For scanners, the native resolution is based on the number of actual sensors in the scanner. A typical film scanner has a 1" wide sensor with perhaps 3000 actual elements for measuring light across the sensor. The software for most scanners allows you to set the resolution to any value, but the scanner merely scans at its native resolution and then interpolates to the resolution you set. Similarly, most printers only print with a resolution of approximately 300ppi. But, if you send the printer a digital image at a different resolution, the printer software will interpolate to 300ppi. In almost all cases, Photoshop does a better job of performing this interpolation. Don't interpolate in the scanner or printer software—do it in Photoshop.

Many professional scanner or printer operators disagree and recommend scanning at the specific resolution for the desired print size or sending a file with any resolution to the printer. In the case of very expensive scanners or printers (in the $100,000 range), this is true—the issues of native resolution don't apply rigidly. But the vast majority of desktop scanning and printing devices have a single native resolution.

Color & Tone

Bits & Bytes

Computers are binary devices. At the simplest level, all numbers within a computer are made up of **bits** (Binary Digits). A bit can have a value of only 1 or 0: that is, yes or no, on or off, black or white.

Bits are grouped together into **bytes**. There are 8 bits in a typical byte, providing a range of values from 0000 0000 to 1111 1111, or 0 to 255 in the decimal notation that we commonly understand. Traditionally, the color represented by a pixel is stored in three bytes—one each for red, green, and blue. This is the reason that Photoshop often represents the values of colors with the range from 0 to 255—the range of values for one byte. We'll see this range of 0 to 255 throughout Photoshop and digital imaging. A color pixel has three such numbers (for each red, green, and blue). For example, R100, G58, B195 is a rich purple. A grayscale pixel has only one number representing the density of the pixel from black to white.

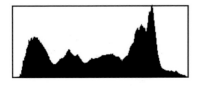

The histogram, of which I have more to say later, is simply a graph of the relative number of pixels at each byte value from 0 (on the left) to 255 (on the right).

Bit Depth

The number of bits used for each color channel (red, green, and blue) in a pixel is referred to as its "bit depth". An image that uses one byte (or 8 bits) per channel is referred to as an 8-bit image or as having a bit depth of 8 bits per channel. The vast majority of digital images have 8 bits per channel. This allows for 255 different values of each red, green, and blue, or ideally over 16 million possible colors. For the vast majority of printing or display options, this is more than sufficient for representing colors. But in the world of digital image editing, more bits are often desired.

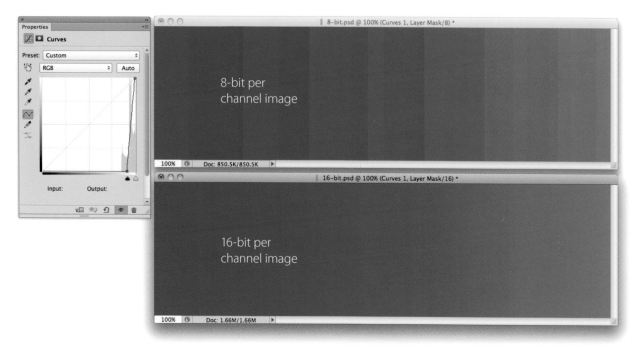

Scanners and digital cameras often create files with more than 8 bits per channel—each of these options provides the same range of values (0 to 255), but the extra 8 bits provide intermediate values for finer precision (i.e., values like 100.254 rather than 100). Color can be described much more precisely with two bytes or 16 bits. When editing images, it's possible that significant edits will result in visually revealing the limited precision in 8-bit images.

In the illustration, a field of pale blue to gray has been adjusted to increase its contrast, now from an intense blue to dark gray. The version with 8 bits per channel doesn't have sufficient precision to smoothly display this entire range of colors, resulting in an image with obvious steps of discrete value. This is called posterization.

The version with 16 bits per channel has sufficient precision to edit across the full range of colors and display a smooth gradation of colors.

When scanning images or capturing digital camera images, it's best to create images with more than 8 bits per channel. Most scanners allow for

scanning at more than 8 bits. Digital cameras that support RAW files allow for more than 8 bits, as well. JPEG files typically support only 8 bits per channel. (This is a major limitation of using JPEG files for capture in digital cameras.) JPEG files can still be used for digital capture, but cannot be edited as well as RAW image files.

When devices with 12-, 14-, or 16-bit capability save files, they always save the files with two full bytes per color channel per pixel. These are all represented as 16 bits per channel when the files are opened in Photoshop.

Since each pixel has three color channels, each with 8 bits, these images have 24 bits per pixel. Images with 16 bits per color channel have 48 bits per pixel. Remember that having only 8 bits per color/channel limits the amount of image editing you can do, while more than 8 bits (e.g., 16 bits per channel) provides for very extensive editing.

Note: When editing in Photoshop, start with images in 16 bits per channel mode. However, it rarely helps to convert an image that starts at 8 bits to 16 bits.

HDR Images

In the last several years, many photographers have discovered something called **High Dynamic Range Images**. While 16-bit per channel images allow for fine gradation and precise specification of color, HDR images use 32 bits per channel. However, the arithmetic is different here. Instead of giving still greater precision from, say, the darkest and lightest values in an image, HDR uses its 32 bits to specify values exceeding what we're accustomed to seeing in images of any sort.

Estimates of the dynamic range (the range from dark to light, from black to white) of human vision vary from 12 to 20 f-stops! As our digital cameras are challenged to provide even half that tonal range, there have been almost no photographic processes that capture the full human range. Today, our software allows us to combine multiple images, each responsible for different parts of a scene's tonal range, into a single image with the entire tonal range! Although there are many examples of poorly executed HDR images on the Internet, and many criticisms based on those examples, it is possible to achieve sublime images that are closer than ever to the range we actually see.

I will share some insights into both capturing images for HDR processing and some tips for that processing.

Channels/Color Models

In Photoshop, the red, green, and blue (RGB) parts of the color image are separated into three distinct images referred to as "channels". Typically these are displayed in Photoshop as grayscale images in the Channels panel. You can see the channels for your image by selecting Window>Channels.

Understanding RGB is understanding color photography itself. Imagine three slide projectors shining light onto a screen. The first has a red light bulb, the second a green light bulb, and the third a blue one. The three lights overlap partially (see below). Where the red and green lights overlap, they combine to form yellow. This is not like pigment! Notice the colors where any two lights overlap. You might think of these (cyan, magenta, and yellow) as the sum of two colors, or as the absence of the third.

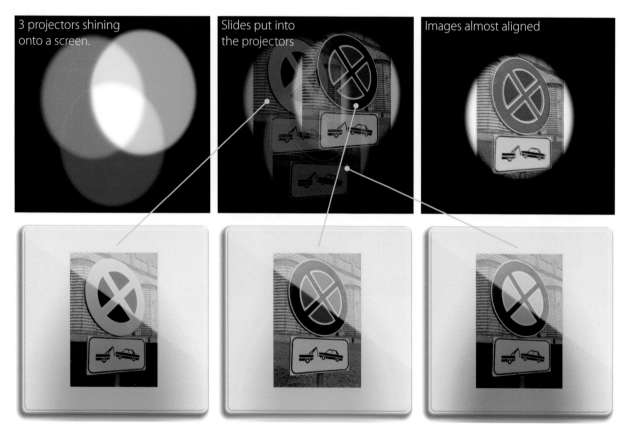

If something were to block one of the lights, for example the blue one, the shadow would either be completely dark or filled in by one or both of the other lights. If the item casting the shadow was not completely opaque, then we'd be able to control the ratios of each light.

The first color photograph worked in exactly that way. The photographer made three black and white transparencies of the same subject. The first was made with a red filter in front of the lens. The other two used green and blue. The result was three images capturing the ratios of red, green, and blue in the scene. In this illustration, we have a similar situation.

Where each slide is dark, it blocks (or masks) the projector's light. Where the image is lighter, the transparency allows more light through to the screen. If the red-lit image is very light, and the other two dark, then the light that reaches the screen will be predominantly red.

In this example, each of the three channels is shown. The red on the sign is lightest on the red channel (letting through the red light), the grass is lightest on the green channel, and the blue of the sign is lightest on the blue channel. Thus, each of these elements appear in those colors.

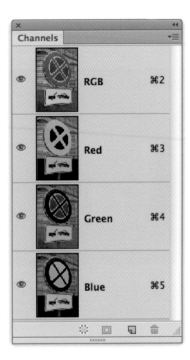

The first color photograph was made by James Clerk Maxwell this way in 1861! Since this is the way color photographs have been made for 150 years, it makes sense that Photoshop should use the same method. However, since we're dealing with software, we should keep in mind this is a metaphor, and there are other methods for making color.

Indeed, RGB is just one of several color models available in Photoshop. For photography, color digital images should (almost) always be in RGB mode. Digital cameras and scanners capture information in components of red, green, and blue: their sensors are sensitive to the amount of light, not color. So each sensor has a red, green, or blue filter in front of it, just as Maxwell's lenses did in 1861. And most desktop printers, as well as many large professional photo printers, also work in components of red, green, and blue.

But, don't commercial printers work in CMYK—Cyan, Magenta, Yellow, and blacK? Yes, generally most printers create colors by using CMYK inks. Cyan, magenta, and yellow are the complementary colors of red, green, and blue. And CMY inks need to be used to create colors when mixing ink onto paper. But converting from RGB images to CMYK images is something best left to your print professional if you send images elsewhere for printing. In the case of most desktop printers, the printer driver only accepts RGB values and performs the conversion from RGB to CMYK within that printer driver.

Note: For digital photography, there are really only two important color modes: RGB and Grayscale. RGB has three color channels: Red, Green, and Blue. Grayscale only has one channel: Gray (or Black).

Digital camera sensors use red, green, and blue filters just as the first color photos had

Color Management

To understand color management is to realize that your digital darkroom actually contains *at least* three different image versions: the virtual image inside the computer, the monitor image on the computer screen, and the printed image on paper.

The virtual image is how the computer (Photoshop) sees your image. This is the digital version of your image, the numbers that Photoshop uses, and for color management we'll assume it's the most accurate version.

When displayed on a monitor or printed, the image becomes subject to the limitations of those devices. Innate faults within monitors and printers render the image imperfectly. We can address this by preparing monitor and printer profiles. A device's profile is a document that lists the corrections necessary to render certain colors in the virtual image correctly (or as closely as possible) on that device.

Summary: Your digital darkroom contains at least three different images: the virtual (Photoshop) image, the monitor image, and the printer image. The goal of color management is to render the monitor image and the printer image as a match to the virtual image by using profiles.

Profile
- darken
- less Red

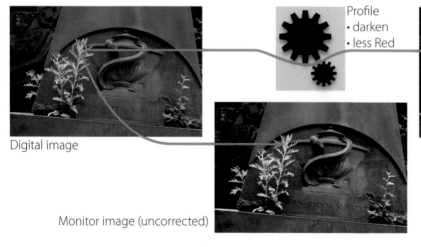

Digital image

Monitor image (via profile)

Monitor image (uncorrected)

Let's take a closer look at the monitor version of an image. The monitor image is the computer's attempt to display the virtual image on the computer screen, but unless given some help, it fails to do so exactly. For example, assume that the virtual image contains a specific shade of green, represented in Photoshop as, let's say, "165 Green". Photoshop knows exactly what color 165 Green is supposed to be, but the monitor fails to display that exact color. Perhaps it makes the image lighter and more red. A monitor profile makes these quirks of the monitor "known" to Photoshop, which then uses the profile to correct the image by darkening it and removing red *as it's displayed*. The actual color number (165 Green, in our example)

remains unchanged: it still represents the correct color, but the adjustment happens only for our specific, quirky monitor. Very clever!

Summary: A profile is a list of target colors with value corrections to allow precise color rendition by a particular device. By using a profile, we can present a particular target color and correct it so it is accurately rendered. Monitors and printers must be profiled and color corrected independently.

An Honest Window to Your Image: Monitor Profiling

There are two basic elements of monitor profiling: calibration and profiling.

Calibration

You need to configure your monitor to the best settings for brightness and color. A well-calibrated monitor does a good job of displaying colors; if it's close to "right", the monitor profile will only need to note a few small adjustments. To calibrate your monitor, you will need to use the controls on the monitor itself to adjust brightness and color. Refer to the monitor's user manual if you don't already know how to do this.

▶ Set the Target Color and Contrast: these values are referred to as the White Point and the Gamma. All monitor profiling tools require that you set these. Although the monitor can mimic the color and contrast of a variety of light sources, you should set your monitor to mimic daylight.

▶ Set the White Point to: 6500K, D65, or Daylight, which are synonyms for the same value.

▶ Set the Gamma to: 2.2, Windows, or TV Standard (even on a Mac).

Profiling

The most robust profiling requires a software utility to display colors on the monitor and provide a chance to measure and correct these colors. The best solutions also use a hardware sensor to measure the colors displayed by your monitor (to know how far off they are). The software utility creates a profile that corrects for those inaccuracies.

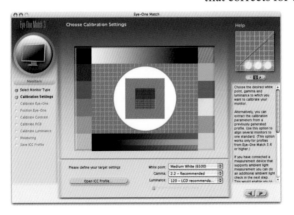

If you use one of these solutions, turn on your monitor and let it warm up for 20 minutes before profiling it. Be sure you've set it up not to go dark in that time.

Devices

It is possible to buy a hardware sensor (known by some as a "puck" or "spider" or, properly, a colorimeter) that can be attached to your monitor to measure colors displayed by companion software. The result is a very accurate monitor profile.

The software for the sensor is also fairly easy to use, requiring only one or two steps after the initial installation, so it can easily be run once a month.

Some monitor sensors:

▸ **X-Rite Colormunki Photo** *(also does printers)* or **i1Display Pro**
 (www.xrite.com)

▸ **Datacolor Spyder series**
 (www.datacolor.com)

All of these products work well. They each provide a software utility that uses a step-by-step wizard to guide you through the process of profiling your monitor. These also have an easy or automatic mode; this mode will automatically set the White Point and Gamma values for you (to 6500K and 2.2 respectively) if the monitor supports it. The more advanced models also include steps for precisely calibrating your monitor using the sensor device.

Checking the Profile

Once you have profiled your monitor, it is best to check the profile using a good visual target. A good test image contains a variety of common objects in color and gray, a color test target, and most importantly, some examples of skin tones. Open the image on your computer screen and evaluate it. **ColorWiki (http://www.colorwiki.com/wiki/Test_Images)** provides excellent test images for evaluating the color of your monitor.

Printer Profiles

Printer profiles are more complex. A good printer profile addresses a specific printer, ink set, paper type, *and* software settings. There are many good sources of printer profiles, though. Your printer driver likely includes a good set of profiles to work with the inks and papers designed for it.

Summary: Monitors and printers are profiled and color corrected independently. If we set up both the monitor and the printer to match the virtual image inside the computer, then the printer and monitor should match each other reasonably well.

But devices have another limitation. The real world has a vast array of colors: saturated and brilliant to muted and gray. No device can reproduce all of the colors our eyes can see.

Our devices produce a subset of these colors. The **gamut** of a device is the range of colors it can render. Colors outside this gamut simply cannot be rendered by that device. Were you to try, the device would render the nearest color it can display.

Because of the differences between monitor gamuts and printer gamuts, you cannot assume the monitor image will match the printer image. Colors that appear on the monitor may simply be unprintable. To resolve the mismatch in printer and monitor gamuts, periodically use Photoshop's "soft-proofing" feature. This allows you to simulate any printer (or other device) for which you have a profile on your monitor! We'll talk more about soft-proofing in Chapter 10, "Output".

Working Color Spaces

Even the virtual image in our computer has a profile to describe its gamut. The gamut, or the **color space**, is usually set by the limitations of a physical device. But our software has no physical limitations, just what we choose in its settings. The Working Color Space defines the color gamut used by Photoshop when editing images. The boundary of a working color space indicates the brightest, darkest, and most saturated colors that are possible within that space.

There are two schools of thought on how broad a gamut one should use. Many recommend a space not much larger than the color space of our output devices. Then, our images won't experience such a drastic change when output. Also, some working spaces exceed many monitor spaces, and thus we won't really know what we're dealing with. The two choices in this category are called **sRGB** and **AdobeRGB (1998)**. They are built to be similar to output devices: low-end printers and high-end printing presses, respectively.

Others suggest using a space that holds every nuance of color from our *capture* device. In this way, as output devices get better, we can take advantage of their improvements to produce more of the colors our cameras actually recorded. This perspective requires one to have the expectation that current output will always reduce the saturation and/or dynamic range of our images. The primary choice for this philosophy is **ProPhotoRGB**.

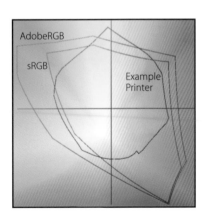

sRGB

sRGB is the standard assumed color space for the Internet and many consumer imaging devices (e.g., low- to mid-range cameras and printers). Images created supporting sRGB should look similar on any monitor across the Internet, as this is the standard presumed by web browser applications and many monitor manufacturers.

Its main limitation is that it holds the smallest gamut of these three color spaces—a sort of lowest common denominator. For professional output it is not recommended, however, for the web it's ideal. So use sRGB to create web images—it's the Internet standard. Also, use sRGB if you wish to forever forget about color spaces. It is the easiest color space to use because of its ubiquity—it is Photoshop's default—but it will rarely produce the full range of image.

AdobeRGB

AdobeRGB is the most popular color space for digital photographers, and has a larger gamut than sRGB. It includes most of the colors of a typical photo printer and is made to encompass all the colors of printing presses. In fact, it was designed to do so.

Use AdobeRGB to ensure access to a large range of colors that your printer can print. Many high-end monitors are touted as displaying "nearly all" of AdobeRGB. For matching (and just somewhat exceeding) current printing technology, this is a great choice and many have made it.

You will still use sRGB for web images and those printers that don't support AdobeRGB or custom printer profiles.

ProPhotoRGB

ProPhotoRGB has recently become a popular color space for professional photographers for at least parts of their workflow. Larger than AdobeRGB's gamut, it includes all colors available to printers for many years to come. With such a large color space, it's very easy to edit colors that are unprintable, so expectations need to be adjusted. Also, ProPhotoRGB includes colors that cannot be rendered on any current monitor. However, it is useful on the input end of an advanced workflow: it will encompass all the colors from your camera, for instance.

I recommend ProPhotoRGB as the working color space: it offers the smoothest handling of images that use 16 bits/channel. Although it offers access to many colors that *no* printer can currently print, it is the right choice for Adobe Camera Raw's Workflow Options (next chapter) and for Adobe Photoshop Lightroom, as these make great use of all of your camera's colors.

Summary: When you choose AdobeRGB or ProPhotoRGB, you will achieve all that your output devices can produce. As I feel duty-bound to help you protect your images and preserve their full integrity, I recommend the slightly more difficult ProPhotoRGB as your working color space.

Camera Profiles

Using modestly priced software and a color target like the one included with the X-Rite Passport (see page 125), you can make custom profiles that correct for even strange lighting conditions in which you may find yourself.

These profiles can be applied at the time of image import in Camera RAW or Lightroom to correct for those lighting conditions and/or your camera's quirks.

File Formats for Digital Imaging

Photoshop supports a wide variety of file formats, but almost all image editing work will be completed with the formats described below. Most of the other formats are either outdated or of little interest to photographers. With the exception of RAW formats, you can select the format for your image file by selecting File>Save As and selecting the file format from the Format list.

DNG & RAW Files

Many digital cameras can save their images as RAW files. These are unprocessed digital camera images. We can process them to a higher quality than we can with JPEG files. One of the biggest advantages of RAW files is that they have more than 8 bits per channel of information and can therefore be edited more than JPEG files.

Every camera manufacturer has its own proprietary RAW file format—one that contains all the data recorded by the sensors. These include NEF (Nikon RAW), and CR2 (Canon), as well as many other formats. Adobe Photoshop CS6 supports most RAW file formats. Unfortunately, that support does not extend to adding metadata or saving edits into these manufacturer-proprietary formats. For that, there is the Adobe Digital Negative (DNG) format. Unless you use DNG, metadata is saved in an accompanying "sidecar" file or a central database—indirect at best.

Therefore, I recommend converting manufacturer-specific RAW files into Adobe's published format, DNG. Adobe has pledged to be the steward of this format in much the same way they have for TIFF. Files you save in this format can be archived safely as they will be supported by Adobe far into the future. Some camera makers have adopted it as their format, too.

DNGs will contain all the image data of your camera's RAW file and will not require any support files as they are processed or have metadata applied. There are a few cameras that store nonstandard data in the proprietary RAW file that is lost in the conversion to DNG. This data is relevant *only* if you're one of the very few who use the camera-maker's software to process the images. I use Lightroom and Photoshop, and therefore I don't need the esoteric instructions that are "lost". So DNG it is.

Lightroom and Adobe Camera Raw integrate RAW files with Photoshop easily and provide a simple, powerful interface for making adjustments before—or perhaps instead of—opening them in Photoshop. These features make Adobe Camera Raw and Lightroom the best RAW utilities available. Adobe has done a good job of maintaining support as new cameras (and RAW formats) are released. Newer cameras may require that you occasionally check that your software is up-to-date.

Lightroom and Adobe Camera Raw (ACR) provide rich options for editing to quickly generate very good-looking images. You may use these for many of your corrections and leave others to Photoshop, which allows for more precise fine-tuning.

Photoshop (*.PSD) & Large Document Format (*.PSB)

Photoshop Document (PSD) is the standard file format for Photoshop. After completing edits in Photoshop, it's important to save your image in a format that stores all the structure and information that you have added so you can access it all when you open the file later. PSD stores all of the information for a Photoshop image, including Channels, Layers, and more. Only Photoshop (or other Adobe software) can reliably read Photoshop format. PSDs also provide powerful integration features when used with other Adobe products like InDesign.

When saving Photoshop PSD files, Photoshop will provide you with a **Maximize Compatibility** option dialog. Note the text in the dialog box below. You can change the preferences so that you always generate the preview, and never see the dialog box again. Check the Maximize Compatibility and Don't show again boxes. To change back, use Edit>Preferences>File Handling (Windows) or Photoshop>Preferences>File Handling (Mac OS).

Photoshop PSD files can support files up to 2GB in size. For the majority of images, this is sufficient. But in the real world of digital imaging, it is possible to have larger files. Photoshop supports larger files by using the Large Document Format (PSB). This format supports all of the features of PSD files, but also supports files of any size. It is also the format that is generated when editing.

TIFF (*.TIFF, *.TIF)

Tagged Image File Format (TIFF) is an industry standard image file format. TIFF format can also preserve much, if not all, that Photoshop format does. Depending on the options chosen when saving, TIFF may be accessible to someone who may not have Photoshop. In many ways, a basic TIFF is just a big array of pixels stored in a large file. It may not contain all of the sophisticated information used in Photoshop (e.g., layer information usable in InDesign). But TIFFs are a very safe way to save your image files since the image is typically saved in a lossless state, (i.e., there's no data conversion caused by image file compression).

Adobe has added a wrinkle to TIFF: saving layers. As far as I know, this extended version of TIFF is supported only by Adobe. As this may prevent

non-Adobe programs from accessing the data, check with an image's recipients to see if this is an option they can handle.

One TIFF option allows compression of files. Check with your images' recipients before using these compression settings. Lempel-Ziv-Welch (LZW) compression can save much space on storage media, and is widely supported. ZIP compression can make even smaller file sizes, but is not as well supported. Don't use this option if you're worried about compatibility with other programs and systems, but certainly use it if archiving for yourself. The other TIFF options aren't typically recommended or relevant.

JPEG (*.JPG, *.JPEG)

This is the format for *very* compressed files. Most images on the Internet are saved in Joint Photographic Experts Group (JPEG) format, since they can be compressed to such small file sizes—at least 20:1, that is, 5% of the nominal file size—with little loss in *apparent* image quality. Compressions of 100:1 are possible, but result in a significant loss of image quality.

All digital cameras have the option to save images as JPEG files, which allows you to save many more images onto your camera's data card. But since this format only supports 8 bits per channel, and achieves its amazingly small file sizes by actually deleting data, avoid using it for capture. However, if your camera only supports the JPEG format, it's still workable if you choose the highest quality JPEG and then arrest the deterioration of the image by saving it in a lossless format from then on.

JPEG files are essential for use on the Internet, where download time is a more crucial consideration than image quality. Use JPEG for images on a website or for email.

The JPEG Options dialog appears when you save your image. Set Image Quality to about 9 (High) for most files, or to 6 (Medium) for relatively pixel-heavy or unimportant files.

JPEG Format Options should be set to Baseline for most images that are to be shared via email.

PDF Files

Photoshop has excellent support for Portable Document Format (PDF) files. These files can be viewed by anyone using the free Adobe® Reader. Since Adobe Reader is almost universally available, PDF files are an excellent way to send very high quality versions of your files to someone who may not have access to Photoshop or even a modest image viewing program. You may even add a password either for opening the file or just for printing or editing.

The Lightroom Catalog

Whereas Photoshop is an image editing application, Lightroom should be thought of as a photographer-friendly database application. Instead of opening, editing, saving, and then closing your image files as we do in Photoshop, Lightroom essentially uses one file: its catalog database. As you work in Lightroom, it is continuously updating this file. Indeed, if you look under the File menu, you will not see a Save command!

When you import RAW files (including DNGs), JPEGs, TIFFs, video files, or PSDs into Lightroom, you are asked to specify where those image files are or to where they should be stored. They do not reside inside Lightroom! Lightroom's catalog database is simply aware of where they are. Thus, and this is critical, if you move the images using any method other than those within the Lightroom application, the catalog will have *no* idea where the images are! So choose wisely when deciding where the images are to be when you import, or use Lightroom to relocate them later.

Normally, all the work you do in Lightroom is stored in the catalog database *alone*. However, although there is no Save command under Lightroom's file menu, the universal keyboard shortcut for Save (⌘+S / Ctrl+S) still does *something*. It makes the Lightroom catalog write much of its data to the image files. I like to think of this "saving" as informing the image that edits have been done to it. Then other programs that understand this metadata (Bridge, for example), can display the image accurately. For many users, this is a completely new way to work, and it takes time to get used to it. So I will be sure to describe this new—and powerful—way of working as we go through the workflow section of this book.

System Configuration

2

This chapter is an overview of how you might configure some general settings in each of the applications we're discussing: Photoshop, Bridge/Adobe Camera Raw, and Lightroom. There are also some issues to consider when buying or outfitting your hardware. I strongly recommend revisiting the settings you initially chose. After a few weeks of frequent use, or a few months of more leisurely use, go through the settings I discuss to see if your way of working would benefit from other choices.

Whether we're talking about Preferences, Color Settings, Workflow Options, Workspaces, or other settings, the workflow they aid is your own, not mine. I will offer reasonable suggestions, but it's up to you to determine what's best in the end.

Computer Requirements

What is the best computer for running Photoshop? One can get by with modestly priced computers and enjoy Photoshop CS6's marvelous performance enhancements. However, if your computer has a 64-bit operating system, Photoshop may well benefit tremendously. I say "may" because the benefit this allows is Photoshop's active use of more than 2GB of RAM.

One of the goals of 64-bit architectures is the use of more RAM, or memory. Do not confuse these bits with the bit depth of images. In mainstream desktop computers where 32 bits is common, only 4GB of RAM can be accessed. [Did I just write "*only* 4GB"? Wow.] 64-bit computers can handle over 16 *million* times that. Not that any of us can afford that much RAM, but the ceiling has been raised so that we can dedicate as many resources as we can afford to improve the speed and stability of applications like Photoshop. And with high-end graphics processors designed to accelerate Photoshop CS6 (and Adobe's video applications), anyone can enjoy lightening-fast performance. Of course, this comes with a price tag.

Nonetheless, I usually use modestly configured computers to run Photoshop. The greatest aid to a smooth and responsive performance is adding additional RAM (again, the more, the merrier). In my Seattle training lab, I'm using 4GB of RAM in iMacs (running either Windows or the Mac OS) with very decent results!

Buy a good monitor. The monitor is the interface between you and the image inside the computer. Inferior monitors make it very difficult to edit images: you simply can't see the details. You don't need to buy the best monitor on the market (they can cost much more than the rest of the system!), but avoid the cheapest ones. I suggest buying the second tier of any product line. Lastly, if you want to do color correction, you need to calibrate and profile your monitor. This can be done with a hardware device made for that purpose. Calibrate your monitor as soon as is practical.

The graphics processor (GPU) has seen its role growing as well. Some features, like the new Blur functions, can be accelerated with hardware rather than depending on software. If your GPU is supported for this acceleration, it will be on automatically. To see if your graphics card is supported, go to Photoshop>Preferences>Performance.

Work Environment

Light

Work with subdued and consistent lighting. Overly bright lights make the monitor appear dim and reflect light off the monitor. Dim lights can make the monitor appear overly bright and lead to eye fatigue as you glance from the monitor to adjacent objects. Variations in room lighting will also change the appearance of images on your monitor. You can keep reflected light off

your monitor by buying or making a monitor hood. You will need a good, bright light for viewing your prints. It is worthwhile to consider daylight balanced lights for that purpose, as monitors often are aglow with that same color of light.

Colors

Use boring, gray colors for your computer desktop. You should set the colors of the computer screen to be mostly neutral (grays, black, and white); vibrant colors on the monitor surrounding your images make it difficult for you to accurately perceive colors in your images.

Finally, keep overly vibrant and distracting colors away from your direct field of view. Your walls don't need to be flat gray, but avoid hot pink. Some professionals do use medium to light gray walls in their windowless rooms, have only daylight-balanced lighting, and wear dark, neutral colors that won't reflect noticeably in their display! Who says we don't use darkrooms anymore?

Application Preferences & Settings

In the software we use, we can specify the general behavior, performance, and appearance of these applications. What follows is an overview of settings you may wish to consider. If some of the choices seem mysterious now, you may wish to trust the recommendations below, but then promise yourself that you'll return to these choices when their topics are more familiar to you.

Some of these settings benefit from being applied early in one's use of the software. So give this section a read, even if you're beginning to get tired of these preliminaries.

One begins a journey through the "prefs" by choosing Photoshop>Preferences>General (on the Mac) or Edit>Preferences>General on Windows. More efficiently, one can use a keyboard shortcut ⌘+K / Ctrl+K .

General

While learning Photoshop, some users find it useful to have the application take notes of what they do. If this seems handy, enable the **History Log**. It's up to you whether it records your actions into a standalone text file or into the document itself (accessible by using File>File Info… and choosing History). You may be tempted to choose Detailed History, but be warned that it is deeply detailed.

It is also here that Warning Dialogs can be reset. When an annoying message keeps appearing, you may notice a checkbox in its dialog that says Don't Show Again. Later, if you need that dialog, or wish to see it again to evaluate whether it's really unnecessary, use this preference to show all those messages again.

Interface

The new twist we find in Photoshop CS6 is the **Color Themes**.

From very dark to the light look of past versions, we get to choose the color theme that best suits our eyes and tastes. So far, I'm using the lightest choice. It seems to provide me with the best contrast, so it's easy to find the various small buttons and icons I need. My aging eyes also enjoy the larger **UI** (User Interface) **Font Size** choices.

I have come to appreciate the preference to **Open Documents as Tabs** in a single window. This saves much-needed screen real estate.

File Handling

Some Photoshop luminaries dismiss the **Maximize PSD** and **PSB File Compatibility** preference as a drive space waster. However, I know it allows other applications like Bridge, InDesign, and my operating system to show me what my image actually looks like. It does this by embedding a preview of the image in the document for the benefit of those applications that can't parse (read) a Photoshop Document.

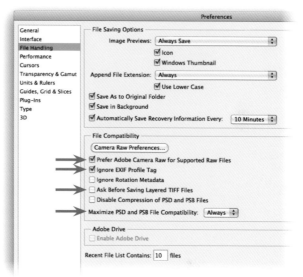

Some cameras have a tendency to put a "tag" into their images that claims the image is in sRGB, whether that's true or not. For that reason, I choose to **Ignore EXIF profile tag**.

TIFF files are close to PSDs in the data they can record. Luckily, the recipients of my TIFF files all have Photoshop and can handle that data richness, so I don't need Photoshop to warn me whenever I save a layered TIFF file.

Camera Raw Preferences

Accessible from either Bridge or Photoshop Preferences, since either may host Adobe Camera Raw, there are only a couple of things I change here. Since several adjustments I make in Camera Raw are corrections for either a quirk of a particular camera (e.g., the chromatic aberration of one lens) or the ISO setting (color noise), I can have the defaults for these corrections refer to the specific camera or setting. A better choice, however, is to use presets (more later).

I also like DNG files to show an up-to-date preview. When I edit them, I have Camera Raw automatically update their previews.

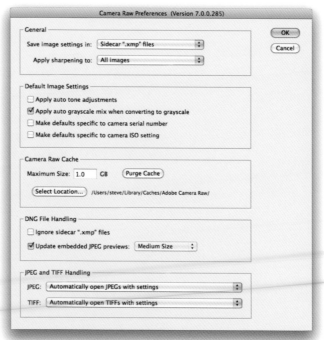

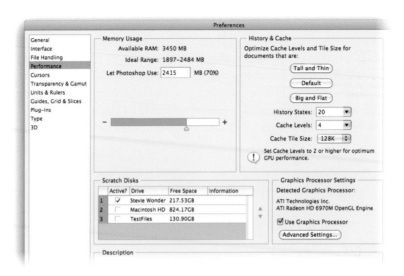

Performance

When finetuning the performance of Photoshop, you will discover many variables. Here, you will be able to choose and examine the parameters, like RAM or the Graphics Processor, that affect performance most.

Among the issues to consider are which graphics card is installed in your computer and whether it supports (and how well) technologies like OpenGL or OpenCL. Click on **Advanced Settings…** to see if your GPU supports those features. You can check Adobe's website to see which ones do if yours does not and you want to shop for another.

Cursors

Not much to change here other than perhaps having a crosshair in the center of your brushes to give more precision when using tools that employ painting. Investigate what Precise cursors look like. Even when the preferences are *not* set to show them, they will display if your Caps Lock is on.

Transparency & Gamut

When Photoshop is trying to show you a hole in your image, or if you've hidden part of it, a gray and white grid will appear. However, you may choose whatever colors you like for this grid.

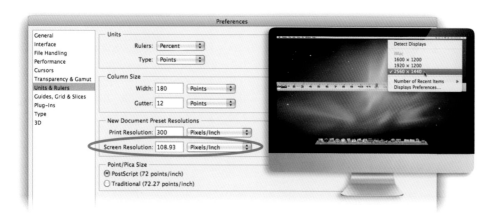

Units & Rulers

Centimeters or inches, picas or percent, you choose the ruler units you need. When you choose to preview on screen what the Print Size of an image is, View>Print Size, Photoshop will likely not know what resolution your monitor is. You may not know either! To find out, check your system's display settings (System Preferences, Display on the Mac, or the Settings tab of your Display Properties on Windows) and note the **pixel width** of your display (the one I'm using is 2560 pixels wide). Measure the physical width of the live part of your screen with a tape measure or similar (be careful not to scratch it). My screen is 23 ½" (59.7cm) wide.

 Divide the pixel width by physical width, and enter that value into the Screen Resolution field:

Pixel Width ÷ Physical Width = Screen Resolution
Example: **2560 ÷ 23.5 = 108.93** (for my monitor)

Plugins

You'll notice mention of Extension Panels here. Photoshop is packed with panels, and now you can make your own, if you choose, using Adobe Configurator. Your panels might access online resources (so you can use the greater Photoshop community to find answers to some questions, perhaps).

 There are many possibilities with Configurator. See the forums on Adobe's site (especially the Photoshop section) for more on how to use Configurator.

Color Settings

As you process the image files from your camera, their color data has to be in sync with where they are in the workflow. That is, your camera captures a very wide range of color. This must be translated into Photoshop's range of color (its Working Space profile, most likely ProPhoto RGB if you follow my advice); then later, that range of color must get squeezed and finessed to fit your printer's color capabilities, as described by its own color profile. To help ensure that this happens as expected, you should configure your Color Settings (Edit>Color Settings) as follows:

1. Start with the settings called *North America Prepress 2.*

2. For consistency with Lightroom and Camera Raw, choose *ProPhoto RGB* as your Working RGB space.

3. Save these settings with a named Settings file so you can share it with your other computers and friends (you can even supply an explanatory note). I chose *Photographer's Handbook* for the name of mine.

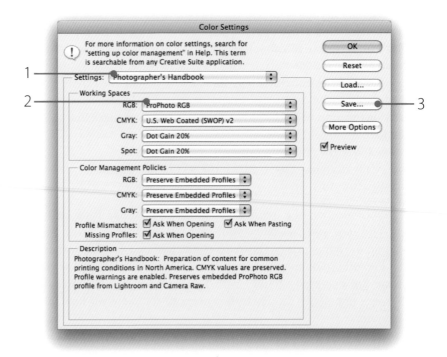

Bridge

One begins a journey through the "prefs" by choosing Bridge>Preferences… (on the Mac) or Edit>Preferences… on Windows. More efficiently, one can use the keyboard shortcut ⌘+K / Ctrl+K .

General

At the top of the dialog box, you'll be able to pick a color theme like you can in Photoshop. I chose one to match my choice in Photoshop.

In the Behavior section, you may wish to have Adobe Photo Downloader launch whenever Bridge detects that you've connected a card reader and memory card or your camera to your computer. I do this on computers that do not use Lightroom as the primary downloading application. I know many photographers who prefer the software from their camera's manufacturer, but I do not.

If you find that you use Adobe Camera Raw (ACR) frequently and that you use Photoshop only once in a while, you might choose to change

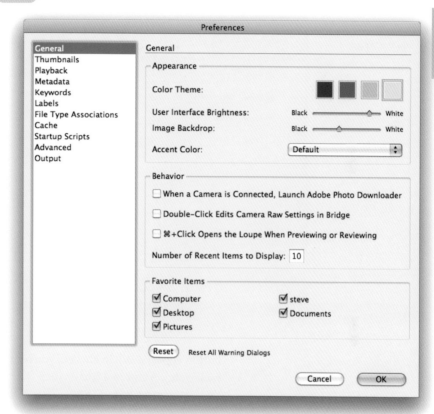

what a simple double-click does. By default, this will launch Photoshop as the host of Camera Raw with the expectation that the image will then be passed along to Photoshop for further editing. Checking **Double-Click Edits Camera Raw Settings in Bridge** will cause Bridge to be Camera Raw's host without the need to wait for Photoshop.

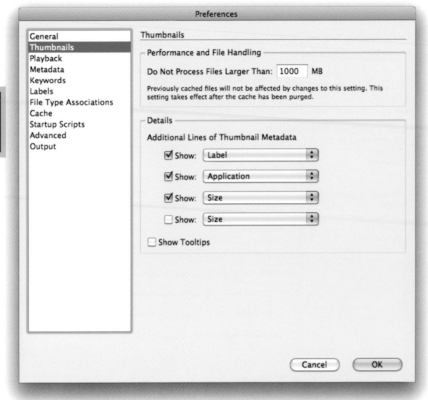

Thumbnails

One of Bridge's primary functions is to view thumbnail previews of images in your computer. Often, it is useful to see a little extra information with each image. For example, I use color labels (see below) to indicate what treatment an image requires. I also like to know the image's file size and what application will launch when I open that image.

You should experiment to see what metadata you prefer.

Playback

Bridge offers clever ways of grouping images for efficient viewing. One of these will stack the thumbnails so only one (presumably a definitive one for the group) is visible. But if you hover your cursor above that thumbnail, a Play button appears. When clicked, you're shown all the images in the stack as if each were a frame in a small video. The rate at which they're shown is set on this Preferences page.

Metadata

There is much data about our images, some of which we rarely, if ever, need to see. When you learn what metadata (data about your data) *you* require, choose it here. Better, hide the metadata you don't need.

Keywords

I'll spend more time later describing how and why we keyword our images. Primarily, keywords give us another way to find images whose names we may have forgotten. Many photographers use geographic locations as keywords. For example, I might have keywords like United Kingdom, England, London, and Blackfriars Pub. You'll note that these are hierarchical: that is, they get more specific as they progress. I might have other London locations that I wish to use as keywords that should be associated with the more general keywords (United Kingdom and England).

When inputting keywords, we can choose, via this preference panel, to use some delimiter (like a forward slash) when typing that will inform Bridge that those keywords are hierarchical.

Labels

My labeling system lets me know at a glance what each image in my view requires. If I see the word "Master" and a blue label, I know that the image is the result of some work and is ready to publish.

If you customize your labels according to my scheme or one like it, be very sure that you do so on each computer you use. In fact, if you also use Lightroom, be certain that you set its labels *identically*, too. If you do not, the thumbnails will show a white label, though the label text will be preserved.

Cache

To speed things up, Bridge uses a cache, a bit of memory to record the thumbnails and previews of your images. When you first look at the contents of a folder, it will take a few seconds (if there aren't too many images) or longer (if there are many) to generate thumbnail images. Be patient! If you don't let Bridge finish, you may corrupt the cache, necessitating its being purged. As you can see, purging can be done from this page in Preferences.

Advanced

Choose whether or not you'd like Bridge to launch automatically at startup so it's handy when you need it.

Output

Upon output, sometimes we need the color profile of an image file to change so it is correct for the recipient. Here,

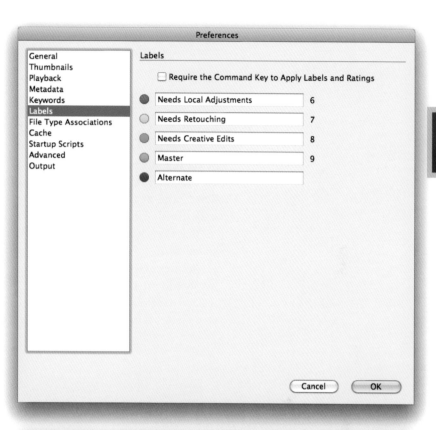

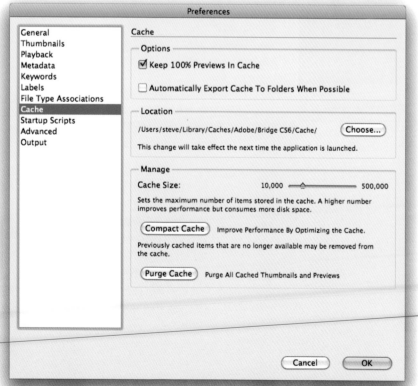

you'll find a checkbox to keep this from happening. In the last chapter, we'll examine whether this box should be checked more often than not.

Adobe Camera Raw (ACR) Workflow Options

We will examine the processing of RAW images carefully later. For now, we'll configure one of the few truly "sticky" settings in the Adobe Camera Raw dialog box: Workflow Options.

To get to this dialog, you may be using Bridge to look at any folder of images. Select one image by single clicking on it. Then control+click / right+click on the image to see a context menu. Choose the option Open in Camera Raw… and at the bottom of the dialog box that appears next, you'll see underlined text in blue. Those are Camera Raw's Workflow Options. Click on that text (it's supposed to look like a hyperlink) to get the dialog illustrated here.

As discussed in the previous chapter's Working Color Spaces section, we should set the Space option to ProPhoto RGB. If Photoshop is configured to use ProPhoto RGB, all the color information will be respected when you open this image in Photoshop. If we choose the robust and widely used AdobeRGB in Photoshop instead, I would still choose ProPhoto here in ACR; the colors will be converted to AdobeRGB when passed to Photoshop.

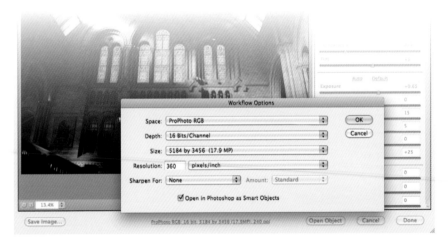

Set the Depth option to 16 bits/channel. 8 bits could be fine if you know you won't do any moderate to major adjustments later, but why take the chance? Many photographers leave this option set to 16 bits just to be safe. The only cost is increased file size and a slight restriction on features that can be used in Photoshop. Hard drive prices are low enough to ease angst about the former, and there are ways around the latter.

Resolution should be set to the default resolution for your typical output: 300 pixels/inch for most print devices, 240 or 360 pixels/inch for Epson inkjet printers, and 72 pixels/inch for web images.

Camera Raw sets the Size option to match the default pixel count for the digital camera used. Other size options are available. An asterisk (*) in the size menu identifies a high quality option for upsampling images from some cameras.

Lightroom

Lightroom is packed with many preferences and settings. As you work with the application, you will no doubt need to refine these to your way of working. But the suggestions that follow are chosen with some care, so I suggest you start with them until you have a reason to choose other settings.

One begins a journey through the preferences by choosing Lightroom> Preferences… (on the Mac) or Edit>Preferences… on Windows. More efficiently, one can use a keyboard shortcut ⌘+, (comma) / Ctrl+, (comma).

General

Most Lightroom users have one all-encompassing **catalog** (Lightroom database) with which they manage their images. Some, however, may have several: for example, one for personal work and another for professional or portfolio work. If you suspect you will have two or more catalogs to choose from, I suggest that you have Lightroom prompt you to choose each time you launch so it's easy to get started.

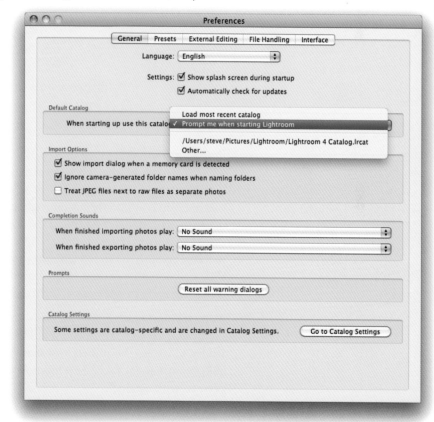

I really enjoy Lightroom's ability to automatically show the Import dialog when I insert a memory card into my card reader. Just be sure that no other software (iPhoto comes to mind) thinks it's supposed to do the same.

If your camera always shoots RAW+JPEG, and you don't want the redundant JPEGs, you will not want to treat them as separate photos.

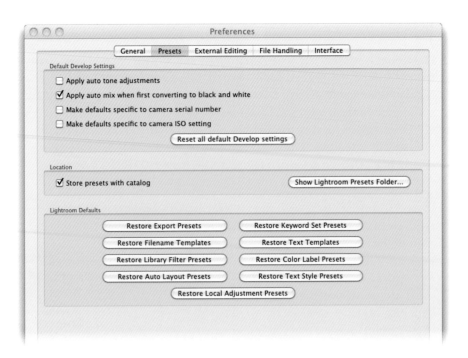

Presets

Some issues we address when developing our images are the result of a particular setting (like increased noise when we use a high ISO) or a specific camera. You may choose customized defaults to be specific to these factors.

Also, as any one Lightroom catalog may find its way from one hard drive to another (from studio machine to laptop, for example), I like the presets I create to be stored with the catalog for easy access to them because they may sometimes need to be moved manually (by you). This choice is best made early in one's use of Lightroom.

Note: If you choose to store presets with the catalog after you've been using Lightroom for some time, you should first use the Show Lightroom Presets Folder to access the presets you may have created. In this way, you'll be able to move them to the new location when Lightroom looks there for the presets "with catalog".

Finally, if you want to reset any of the many types of presets to their installed defaults, this is the place to do so.

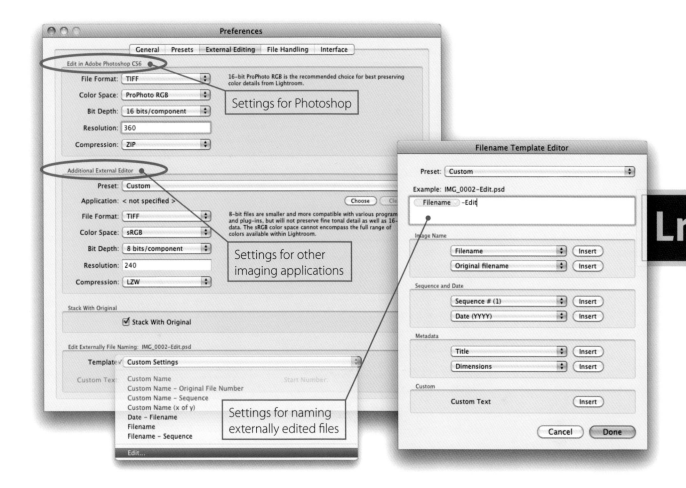

External Editing

The preferences for **External Editing**, *Edit in Adobe Photoshop CS6*, should probably be set as illustrated here. This is especially true if you have configured your color settings as suggested in chapter 1 (this would also make Lightroom consistent with my suggestions for using Adobe Camera Raw).

When you choose to edit a RAW image in Photoshop, Lightroom generates a file format that Photoshop can edit directly. It cannot edit RAW files. So a TIFF is generated with a name you can configure as illustrated here. You may also set options for other image editing programs that you have on your computer.

To open a Lightroom-edited image in Photoshop, select it in the Library Grid, then use either ⌘+E / Ctrl+E or control+click / Right-click on the thumbnail and choose Edit in Adobe Photoshop CS6. Before the document opens in Photoshop, you will see a dialog box. I recommend that you edit a *copy* of your original with Lightroom edits (your global adjustments and light cleanup, for example). You can even Stack this copy with the original so that they stay associated with one another. Edit this new image in Photoshop if it needs more work later.

File Handling

I like it to be easy to use hierarchical keywords. For example:

> Textures
>> Inorganic
>>> Rust
>>> Peeling Paint
>> Organic
>>> Moss
>>> Bark

When typing these keywords in a keyword field, the default way to specify this is "Textures|Inorganic|Rust". But a forward slash would be so much easier to type than the "pipe" (|) character, so I allow it to be a "keyword separator".

Lightroom 4 introduces "Fast Load Data", which increases a RAW file's size slightly, but allows an image to load far more quickly. I think it's worth it.

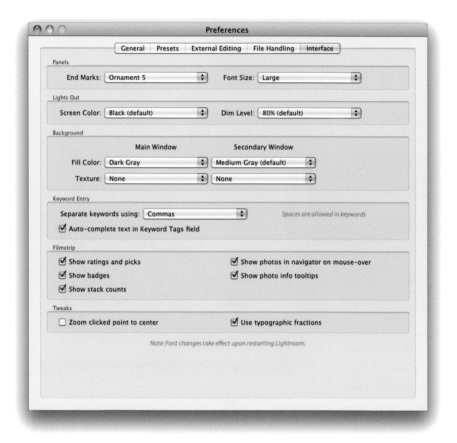

Interface

Lightroom's interface is nicely customizable. Here, you can experiment freely and frequently to find what you like.

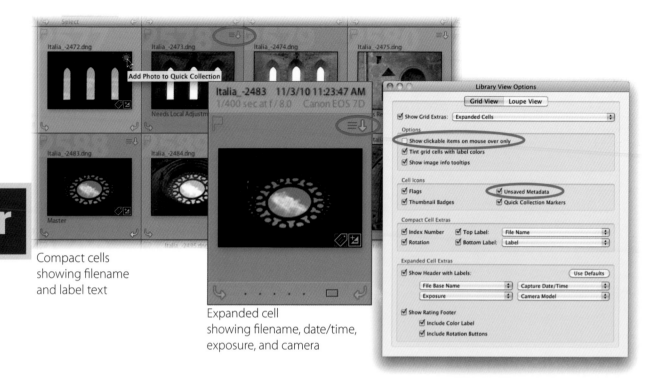

Compact cells
showing filename
and label text

Expanded cell
showing filename, date/time,
exposure, and camera

Library View Options

With View>View Options you'll have the opportunity to establish what data
gets displayed with your image thumbnails. Of course, I have suggestions!

Most important to me is showing if an image has **Unsaved Metadata**.
See "Metadata" in the following Catalog Settings section. For those new to
Lightroom, I suggest unchecking "show clickable items on mouse over only".
It's hard to learn what's there if you can't see it! These include the rotation
arrows and flags (to "pick" or "reject" images). Not included, strangely,
is the small circle one clicks to add an image to the Quick Collection or
another targeted one.

Since there are two kinds of cells in Grid view (compact and expanded),
you can configure the view for each. You can see how I've chosen to do so
in the illustration.

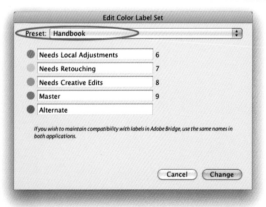

Color Labels

Choose Metadata>Color Label Set>Edit to configure a label-
ling system to mark images for future work. First you build the
set, then save it by using the menu at the top of the dialog box,
choosing Save Current Settings as New Preset.

Note: Be sure to set your Label text **identically** to Bridge's so they
can be viewed successfully in both. By "identically", I mean right
down to capitalization and punctuation. Also, be sure to do this
on each computer you use.

Catalog Settings

Access your Catalog Settings by going to Lightroom>Catalog Settings…
(Mac), Edit>Catalog Settings… (Windows), or the keyboard shortcut:
⌘+option+, (comma) / Ctrl+Alt+, (comma) .

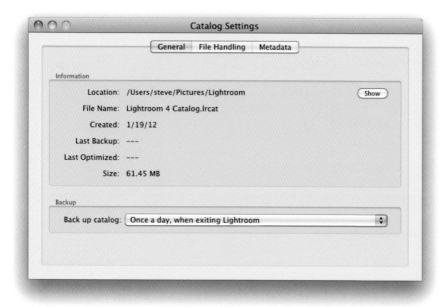

General

I like to have a backup of my Catalog(s) made each day that I use them. Note
that this is *not* a backup of your images, but only of Lightroom's Catalog file
in case it should become corrupt.

If it's behaving poorly (slow to respond), you can also go to File>
Optimize Catalog… to see if Lightroom can heal itself. I find this is also
good to do after any particularly long and complex work session.

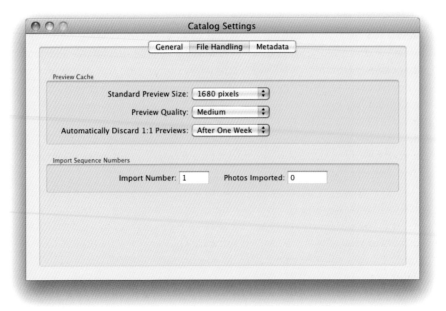

File Handling

Having Lightroom discard its full size previews (1:1 Previews) after a week is a good policy so that your Previews file doesn't grow to an unwieldy size. I also choose a Standard Preview size that is a good fit to my monitor size.

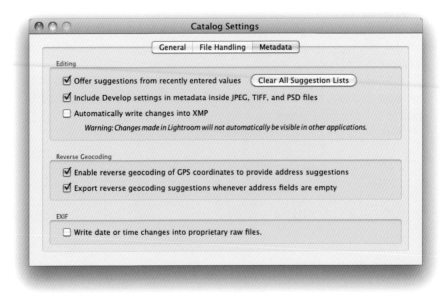

Metadata

Everything that Lightroom does is kept in metadata, and until that metadata is written to the file itself, it is in Lightroom's Catalog only. This is why

I suggest that after working on a set of images, you select those images and press ⌘+S / Ctrl+S (or choose Metadata>Save Metadata to Files).

Why do I recommend that you manually save your metadata to your image files rather than use the preference available here that allows you to "Automatically write changes to XMP"? The answer is performance. As you work, making one subtle adjustment or another, that preference will try to write the adjustment to both the Catalog file and the image file, causing a performance loss that I and many users find unacceptable. So we rely instead on the same keyboard shortcut we use in any other application to save our work: ⌘+S / Ctrl+S.

Some applications outside of Adobe's family of products may not be able to handle reading the more complex development metadata in JPEGs or TIFFs. So if you use those file formats, or if you expect to send those file formats to recipients with limited software choices, then be sure to Export copies in those formats and not use the original JPEGs you've edited in Lightroom.

If you travel, you may forget to change the time in your camera to the time zone of your destination, causing your images to be marked with the wrong date or time. An option in Lightroom allows date or time data to be written directly into proprietary RAW files as well as DNGs!

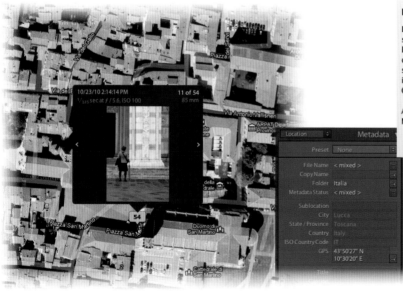

Enable reverse geocoding?

Lightroom can automatically determine the city, state, and country of any photo tagged with a location. To do this, Lightroom needs to send GPS coordinates to Google Maps. No other data will be sent and Adobe does not have access to the information exchanged between Lightroom and Google.

Allow Lightroom to send GPS coordinates to Google Maps to look up addresses?

Disable Enable

Try to set the time in your camera correctly, especially if you consider geocoding your images. Most cameras do not embed GPS (Global Positioning Satellite) data in images. However, there are affordable cameras now from many manufacturers that do. Unfortunately, my main cameras do not. But if I carry a GPS receiver, it will mark the time when I am in various places, creating a "tracklog". Lightroom can import this tracklog, match up the times, and automatically geocode my images!

The Interface: A Hands-on Tour

3

For any workflow to actually flow, one needs to develop comfort with the tools at hand. For example, it becomes tedious and slow to examine an image if one is unfamiliar with the fastest ways to zoom and pan.

Also, our software needs special care and feeding. Without enough disk space, Photoshop becomes unstable. What's enough? More than you might think. Lightroom gets testy if you move an image outside its interface. These and other quirks can cause frustration if not grief.

In this chapter, I'll give you the insight you need to really own your software. We'll learn how to rapidly zoom in and out and pan around even the largest images, how to leap from one image to another, and from one application to another. I'll also examine those features that shouldn't be used hastily!

Even veteran users should look over this chapter, as some best practices may have changed along with some features.

Compass Rose, Hoover Dam

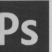

Finding Your Way in Photoshop

This chapter introduces the basic interface and features of Photoshop: its Tools, Panels, Options Bar, and Image Window. The main goal of this chapter is to identify the basic skills and vocabulary of Photoshop, Bridge, and Lightroom that are used throughout this book.

The illustration shows the main elements of Photoshop. Be sure you have an image open if you want to experiment with the interface, as many Photoshop options are not available without an image.

Layers

Many readers of this book may already feel comfortable working with layers. But there is always something new to be learned even for very experienced users. So please review these features.

Understanding layers is the most essential step in understanding Photoshop. The classic way to visualize layers is as stacked sheets of transparent film with images on each one. This stack visually combines to create the final image, with each layer obscuring the layer below it. You may view the layers in a particular document by looking at the **Layers panel**. We'll have more to say about that and other panels a little bit later.

There are three main classes of layers:
► Image layers
► Adjustment layers
► Smart Objects

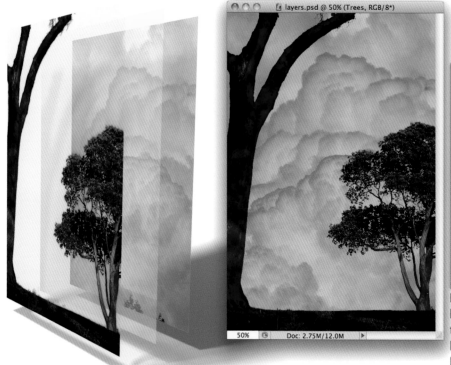

Note: The top layer has both image and mask thumbnails. The adjustment layer affects only the layer below it (the clouds).

This illustration shows two of these. At the bottom, there is an **image layer** with an image of clouds. It was rather flat and gray and needed warming and contrast. An **adjustment layer** was added above it to do just that. At the top, an image layer with an image of two trees against a brilliant blue sky. Where are the blue sky pixels? They have been hidden or **masked** (see Masks later in this chapter).

The net result, the composite image, is the stack of these three layers viewed from the top, down. Almost all Photoshop images are constructed in a similar way, even if we are not combining two or more different images. One layer may contain our retouching, for example, nondestructively applied above our original image. We keep things segregated on different layers so we may return to them later and make new decisions or correct mistakes.

Image Layers

Image layers are independent images that can be stacked on top of one another to form the final image. (Photoshop refers to these simply as Layers, but in this book we'll often use the term *image layers* to distinguish them from other layers.) The **Background**, which is often found at the bottom of the stack, is a limited kind of image layer that may be your original image. It can be renamed and in doing so become a standard image layer. Other layers are often used in conjunction with the **Background** to create a final image. Many file formats (like JPEG) can have no layers except for a simple

Background. So to send our images as JPEGs to most recipients, we have to supply a flattened copy of our layered originals. Our own files, however, should have the layers intact.

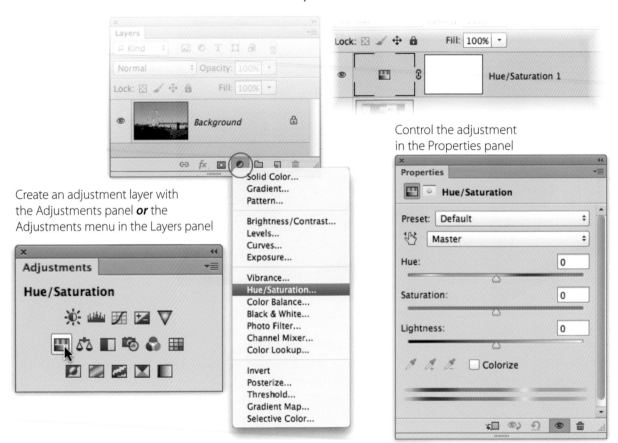

Create an adjustment layer with the Adjustments panel *or* the Adjustments menu in the Layers panel

Control the adjustment in the Properties panel

Adjustment Layers

I always make adjustments using adjustment layers. These act as filters over your image to apply the adjustments as the image is viewed (or printed), but they do not actually alter the underlying image pixels.

Adjustment Layers don't contain image pixels, but visually apply color and/or tonal adjustments to the layer(s) beneath them. You can apply many adjustment layers to your image to change its brightness, contrast, or color.

The whole image is a blend of the stacked image layers and adjustment layers from the bottom up—applied adjustments and added images form the final desired image.

You can create an adjustment layer in several ways. One is to use the Adjustments panel: click on the adjustment you want, and the layer appears in the Layers panel. You may also click on the adjustment layer button at the bottom of the Layers panel. Finally, you may choose the Layer>New Adjustment Layer command, but that is more cumbersome.

Warning: Avoid applying an adjustment directly to the pixels of an image layer by using Image>Adjustments. Once the adjustment is applied, the image is changed; these changes are *irrevocable* once the image is saved and closed.

When you create an adjustment layer, you should consider naming your layer based on the adjustment task that you will perform—like "Brighten" or "Add Contrast"—this makes it much easier to find the appropriate adjustment layer when you are editing the image at a later time. Use the Properties panel to make your adjustment.

The new adjustment layer appears in the Layers panel. Each type of adjustment layer has an icon to identify it (if your thumbnails aren't large enough, make them larger by control+clicking / right+clicking a thumbnail and choosing Large Thumbnails). You can disable or enable the adjustment by clicking on its visibility icon (what I call the "eye-con"), the eye to the left of every layer. Each adjustment layer also has an associated mask. These are completely white (the adjustment evident everywhere) by default, but can be painted black or white to localize where the adjustment should be applied. See the Masks section for more information.

One significant advantage of adjustment layers is the ability to highlight it and return to the Properties panel to fine-tune your adjustments. This is often referred to as "nondestructive" editing, since the underlying image is not actually changed by the adjustment layer, just the displayed or printed image. To change the adjustments in an adjustment layer, click on the adjustment layer that you wish to edit. The Properties Panel will show the previously applied adjustment. You can then fine-tune it. Using multiple adjustment layers makes it easy to develop the cumulative effect desired.

You will use adjustment layers significantly in the Global Adjustments and Local Adjustments sections of the Workflow chapter.

Smart Objects

Smart Objects are layers that contain much more than simple pixel or adjustment data. They might contain several image layers, Camera Raw data, artwork from other software programs like Adobe Illustrator, or color information even if the document containing the Smart Object is grayscale. Many different effects can be applied nondestructively and reversibly to Smart Objects (or SOs) as Smart Filters.

For photographers, their primary use is as layers that "remember" their original condition no matter how much editing (color correction, resizing, applying filters such as sharpening, etc.) is done to them! The use of Smart Objects usually adds to file size, but diminishes worry and hard work when edits need to be reconsidered. Of course, I will be saying more about this strange and powerful feature.

Naming Layers

It is wise to name your layers. Although Photoshop assigns default names to all layers like "Background copy", "Layer 47", or "Curves 1", these provide little useful information. Assigning your own useful names makes it easier to find and edit the appropriate layers later. If you create or duplicate a layer using the Layer menu (or the keyboard shortcuts listed in that menu), Photoshop will provide you with a dialog to name the layer before creating it. Even if you end up with a default name for your layer, double-click that name and Photoshop will let you rename it.

Copying Layers

Drag and Drop! It is possible to copy a layer from one image file to another merely by dragging the layer from the source image's Layers panel and dropping it onto the destination Image window. You can also copy a layer from one image to another by selecting the layer in the source image and using the Layer>Duplicate Layer command. In the Duplicate Layer dialog, change Destination Document to the destination image.

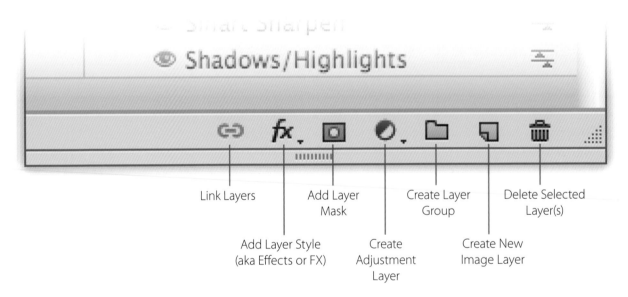

Layers Panel Buttons

Along the bottom of the Layers panel are several button icons you can use to quickly edit your layers.

Click on the Trash button to delete the currently selected layer(s). Or you can drag a layer to the trash button to delete it. Simply tapping your delete or backspace keys also deletes the highlighted layers.

Click on the New Layer button to create a new, empty image layer. Or you can drag any layer to the New Layer button to make a copy of it. Hold down the option / Alt key when using this button, and Photoshop will give you a dialog to name the new copy.

Click on the adjustment layer button to get a pop-up menu for the adjustment layers available in Photoshop. Select one to create it. Hold down the option / Alt key when selecting an adjustment layer, and Photoshop will give you a dialog to name the new adjustment layer.

Click on the **Mask button** to create a new mask. Photoshop creates a mask that is either white everywhere or a mask that mimics a selection if you have a selection in the image. You need to create a mask for image layers only, since adjustment layers automatically have an associated mask. If your image layer already has a mask, it is possible to create another mask (a vector mask), but that flavor of mask is beyond the scope of this book.

Layer Styles (e.g., Drop Shadows) are used by graphic designers and much more rarely by photographers.

Linking layers requires you to highlight two or more layers, then to click on the Link Layers button. From then on, these layers will move and transform in unison.

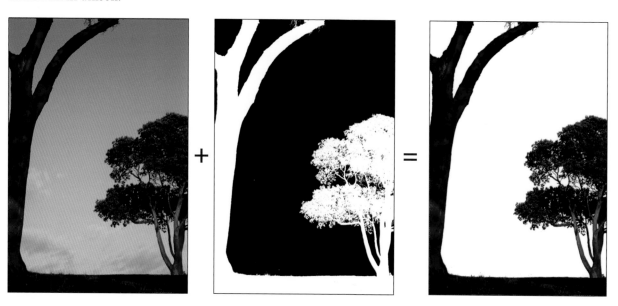

Masks

Masks are usually just grayscale images that enable us to control the opacity of images and some Photoshop effects. Like chess, the rules are simple, but the possibilities are endless. Here's the simple idea: where a mask's pixels are black, the entity with which it's associated is invisible; where the mask is white, the content is visible. Since a mask (or any grayscale image) has 256 shades of gray, that's how many shades of visibility a mask can supply.

You can use a mask to localize the effect of an adjustment layer, or limit where an image layer is visible. By default, new masks are entirely white: that is, the layer is completely visible.

However, masks are most often created from selections. Selections define a region of an image, which can then be converted into masks. Masks

can also be painted with black or white (to conceal or reveal a layer, respectively) or a shade of gray to give partial opacity, using the **Brush** tool.

Masks are a vital part of Photoshop. Though you'll often find yourself painting a mask actively in the Image window, you won't see the black or white paint: just the image appearing or disappearing! A glance at the Layers panel will reveal that the mask has indeed changed.

Photoshop is so invested in nondestructive editing that even masks can be edited in ways that are reversible. Using the Masks panel, you can finesse the edges and extent of your masks. I'll have more to say about masks and their use in the Local Adjustments chapter.

There are other forms of masking in Photoshop as well. We can use one layer's pixels to specify where the layer above is visible. This is called a **Clipping Mask** and is especially handy with adjustment layers.

A Typical Document's Layers

The Background layer, if present, is always labeled *Background*. It is a special type of image layer with key limitations. There can be only one, it must be at the bottom of the Layer Stack, and it can have no mask or any transparency. Its presence is actually optional for the PSD and TIFF formats (so there may not even be one), but for other file formats (e.g., JPEG) it is the *only* layer that can be present. More on these formats and their limitations later.

Each image layer has its own thumbnail displayed to the left and a layer mask, if there is one, to the right of the layer thumbnail.

The active layer (the one currently targeted for editing) is highlighted. Any edits you make apply only to the active layer. You can select more than one layer at a time, but only a few edits (transformation, opacity, and blending mode) can be applied to more than one layer simultaneously.

Each adjustment layer has a thumbnail icon representing the type of adjustment it is to the left, and its associated mask to the right. By default, all adjustment layers have a mask filled with white (and therefore visible and active everywhere).

The eye icon to the left of each layer is what I and my friend, Brad, call the "eye-con"—we cannot resist a bad pun. Click it to make its layer visible or invisible. `option+click` / `Alt+click` on the eye-con for any layer, and all *other* layers toggle their visibility.

1. The picture of the church was originally the **Background**. It was converted to a **Smart Object** and renamed "Church."

2. A new image layer (with the lovely model) was moved to this document from another.

 It, too, was converted to a **Smart Object** and was renamed "Lovely Lady."

3. A careful selection was made of the woman, then a **Layer Mask** was made from it, hiding the original scene behind her.

4. A Smart Sharpen filter was applied to that Smart Object, and its **Smart Filter Mask** was painted on to hide some of that effect.

5. An adjustment layer was introduced to make the "lighting" on the woman better match that of the church.

6. A retouching image layer was added to remove a few distracting elements from the overall picture.

7. To reveal more detail in the woman's coat, a masked adjustment layer was added above all.

8. Finally, to give the whole scene a slightly warmer look, another adjustment layer was added.

9. The last two layers were grouped.

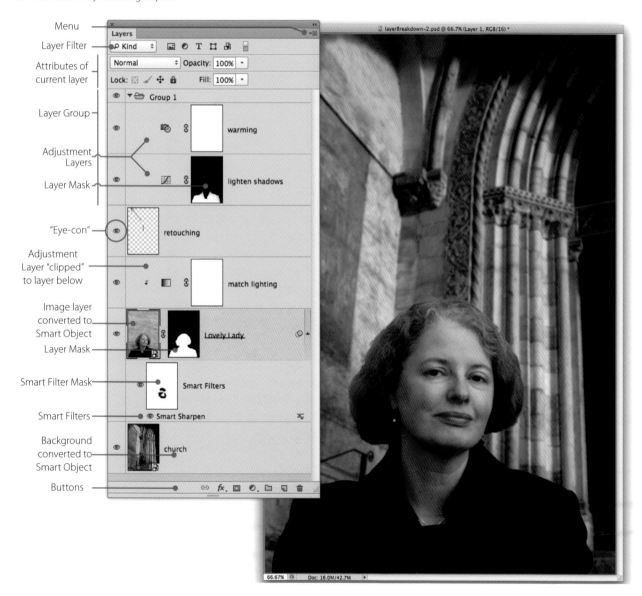

Panels & Workspaces

Photoshop has many different panels for evaluating and editing your image. Panels are very useful for monitoring the various elements of your image, especially as your image becomes more complex.

Panels can be visible, grouped, docked, collapsed to their icons (and names if you like), or hidden.

Drag to resize column width

Click to collapse or expand column

By default, visible panels are docked to the right edge of your screen, with a few groups fully expanded in a column at the far right. Each panel may be dragged by its icon or name. If you drag one away from its dock, you may let it float freely on screen, put it elsewhere in a dock, or even group it with other panels. Try it! It's actually quite easy to customize your workspace this way. Watch for the blue lines that tell you when your panel will dock to another. Notice the blue highlighting that results when you drag a panel below, next to, or atop another. What happens when you drag a panel to the *left* side of the screen?

Docks and free-floating panels in the workspace can be resized. You can resize column widths by dragging the line at the left edge of the column. The double arrows collapse or expand the column. Notice that the arrows change direction when opened or closed.

Visible panels can have other panels grouped with them. These appear as named tabs behind the visible panel's name. To make these panels visible, just click on their tabs. If you look carefully, you'll see that even the icons are in groups.

Panels that are collapsed to icons allow one-click access without cluttering up Photoshop. Collapse the panels you use but do not usually need to see.

Panels are hidden when you close the panel's window. A panel can be made visible again by selecting it from the **Window** menu.

Note: When you need a panel that is not currently visible, find it listed under the Window menu, where all panels are listed. Also, each panel has its own menu with options for customization. This can be accessed by clicking on the tiny menu icon (⬛) in the upper right of each panel.

Managing Panels

When you first run Photoshop, there are three panels immediately available, and another eight that are one click away. For image editing, some of these are seldom used. So let's rearrange the panels.

1. If your panels are untidy (maybe from experiments rearranging panels), let's clean them up by selecting Reset Essentials (default) or choosing Photography (what photographers need most) from the Workspace menu in the upper right.

2. Choose Window>Brush. Brush and Clone Source appear, with Brush expanded. Click on the Brush panel icon to collapse it. Also add the History panel, Window>History, and collapse it.

3. Return to the Workspace menu in the upper right of your screen. Choose Save Workspace… You may now have your own workspace with a name you choose. You'll notice that workspaces can also include modified keyboard shortcuts and menus! Try those alterations later.

You can now access any of the visible and docked panels by clicking on the tab or icon for that panel. Take a look at the panels that are left. You will use the Adjustments, Masks, Info, Histogram, History, Properties, and Layers panels (and occasionally others) throughout this book. As you can see, Adobe software applications are panel-heavy.

You can hide all of the panels (including the Tools Panel and Options Bar) by pressing the tab key; pressing tab again makes them reappear. If you hold the shift key when you hit tab , the tools and the Options Bar will remain while the other panels' visibility is toggled.

Some Important Panels

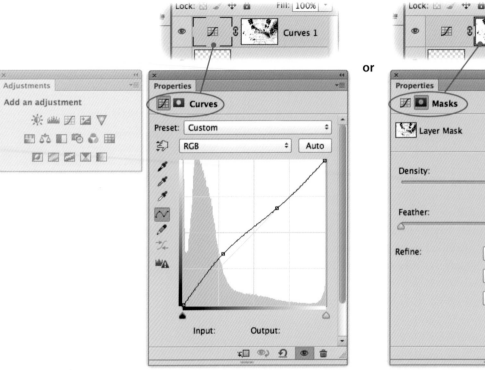

or

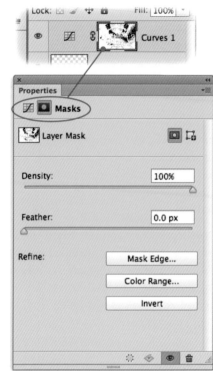

Properties panel This new and very important panel displays whatever adjustment is currently active (highlighted in the Layers panel) or allows one to edit a mask if it is targeted.

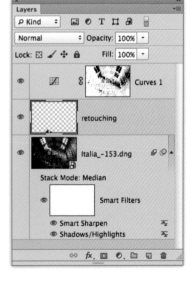

Layers panel Here is where you create and examine the structure of your image file. We'll be looking at layers more later, but you should start to think of them as stacked transparencies or sheets of clear plastic with images on them. Some layers act as color adjustments for the layers below them, much like colored gels might (adjustment layers are what get created when you use the Adjustments panel). Other layer types can have effects and filters put on them, such as sharpening and other corrections.

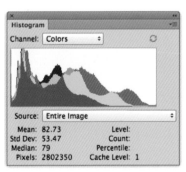

Histogram panel This should look familiar to any photographer who's enabled this feature in-camera. It displays the tones (levels or shades of gray) in our images. On the left are the dark pixels; light ones are on the right. Tall spikes indicate a large number of pixels with a given tonal level.

Adjustments panel This panel is for choosing color or tonal adjustments you wish to apply to your images. Choose the adjustment generically by clicking on the desired adjustment's icon. The adjustments themselves are configured in the Properties panel (above), at the top of which will be presets for the chosen adjustment.

Info panel We use this to display color information for the pixels under the cursor as it is passed over the Image window. It can also give you hints for the tool that is currently in use, the position of the cursor, and the file size of the image. Some Photoshop users never remove this panel from the screen.

Brush panel Yes, photographers have to know how to paint, too. Well, just a little. We use tools that embrace a painting metaphor to mask, retouch, and otherwise adjust areas of images. Building the right brush tip is a very useful skill, and the means to do so are in this panel.

Clone Source panel This panel's purpose will be better understood when I describe retouching later. But briefly, this panel lets you configure those tools we use in retouching so they can automatically scale and rotate material from one part of an image as it's used to repair another.

Channels panel Channels hold the net color data of our image. Harkening back to the world's first color photograph, we think of these as the metaphorical transparencies we discussed in the first chapter, each of which controls how much red, green, or blue light passes through to our eyes. There can be additional channels to store data as grayscale information (which pixels are masked, for example, or which pixels were selected and may need to be again). These extra channels are called *alpha channels*. Also, print professionals work with CMYK channels to establish what percentage of each of those four color inks will be placed on paper. We will restrict our conversation to RGB channels.

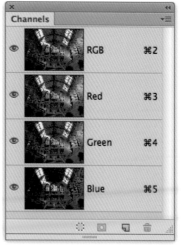

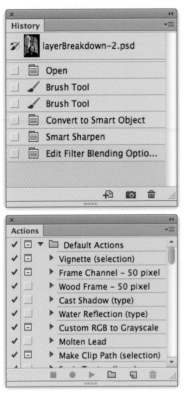

History panel This panel lists past states of the image. Each time you edit the image in some way, that state is recorded. You can use the History panel to quickly jump to former states, much like multiple levels of undo, but better, as you can traverse many states at once. However, this is limited to one editing session: once the image file is closed, the histories are deleted. Also, there is a finite number (20 by default) of states that can be accessed.

Actions panel After you develop fluency in Photoshop, you may want to record sets of actions you regularly perform. This is especially handy for those tedious tasks that need to be performed on many images. Plan to return to this topic after you have explored doing tasks yourself.

The Tools

The tools in this panel allow you to work directly on the image: selecting, painting, adding text, etc. Generally, you'll select a tool, move your mouse pointer over the image, and use the tool directly on the image by clicking or dragging on the image.

Tool Tips The Tool Panel shows **tool tips** for each tool. Hover your cursor over a tool, wait a second, and a tool tip will appear. The tool tip displays the tool name plus the keyboard accelerator used to select it. As seen in the illustration, the Clone Stamp tool can be selected by pressing the S key.

Note: Most of the tools change the cursor when the it moves over the image window to indicate the selected tool.

The Tool Panel includes a number of hidden tools. A tiny black triangle identifies the tools that have hidden tools beneath. Access them by pressing the mouse on a single tool icon and waiting a second, or you may **control+click** / **right-click** on a tool to see its companions immediately.

Each tool has a set of options for customizing its function. When you select any tool, the Options Bar (near the top of the screen) changes to display the options for that tool.

You apply a tool with its current settings by clicking or dragging on the image. For example, clicking on the image with the Brush tool makes Photoshop paint the Foreground Color onto the image. Other tools may require some configuration in the Options Bar before they can be used.

Keyboard Shortcuts & Menu Modification

Keyboard Shortcuts

Although I've already mentioned several keyboard shortcuts, I'm not going to provide a long list of keyboard and mouse-click accelerators. A list is just not a practical way to learn them. But, to learn *some* of them makes it much easier to focus on editing rather than navigating through menus each time you need to find a particular command.

If you strongly wish to see a comprehensive list, you may generate a web page with all the current shortcuts (including your own modifications). To do so, choose Edit>Keyboard Shortcuts, then click on the Summarize button.

Many shortcuts are easy to find right in the Photoshop interface. For example, if you repeatedly use a menu item, note the keyboard shortcut listed just to the right of the command's name, then use it instead. You'll quickly get the hang of it. (This may sound trivial, but few people use this easy technique for learning shortcuts.) Soon, the commands that used to take a lot of time to apply will literally be close at hand.

There are many additional accelerators hidden within Photoshop. I use a number of them, and, as necessary, identify them throughout the book. Photoshop also has a number of context menus that accelerate access to various functions—accessed by a control+click / right-click. Remember that each panel has the tiny menu icon (▾≡) in its upper-right corner. Explore what these are hiding!

Note: Finally, you probably already know about Undo— ⌘+Z / Ctrl+Z. This is likely the most important shortcut in any program. It makes editing safer: it's nice knowing you can always undo a change that doesn't work out. However, the Undo command toggles between Undo and Redo. If you select ⌘+Z / Ctrl+Z once it will undo, but if you select it a second time, it will Redo the previous command. This is great for evaluating the most recent edit, giving a quick "before and after" toggle. To Step Backward, use ⌘+option+Z / Ctrl+Alt+Z

Menu Customization

Photoshop offers you the ability to customize the items that appear in the menus. This is a terrific feature since it allows you to clean up your menus by hiding many of the less frequently used features. I don't use any custom menus in this book, but you may wish to consider this feature as you grow comfortable determining which features you can do without, or use it to highlight in color those items you can't afford to miss. To do so, choose Edit>Menus…

This image at 25% magnification has 16 of its pixels mapped to each monitor pixel (only 1 in 4, or 25%, across as well as up and down)

This image at 100% magnification, or Actual Pixels, has each of its pixels mapped to a monitor pixel. This is the best magnification at which to view an image's details—at least of the part that fits on the display.

Navigation & Viewing

As you edit your image, you will need to change the view of the image—zoom in and out, pan around it, and change the gray background Photoshop displays around it. Two important views are **Fit on Screen** and **Actual pixels**. The keyboard shortcuts for changing the view of the image are very useful since they allow you to change the view at any time, even if you are in the midst of an operation (e.g., defining a crop area with the Crop tool or correcting color with Levels). It can be important to change the view of the image as you make edits.

Fit on Screen

Often, you will want to view the entire image as large as possible within the Photoshop window. This viewing mode is called Fit on Screen; access it by selecting View>Fit on Screen or by pressing ⌘+0 / Ctrl+0 (that's a zero).

In most cases, when the image is sized to Fit on Screen, there are many more pixels in the actual image than can be displayed on the screen. However, Fit on Screen works great in Photoshop to see your whole image in one view.

Actual Pixels

Sometimes you need or really want to see each individual pixel for editing. For this, use the **Actual Pixels** mode; select View>Actual Pixels. In this case, each image pixel is mapped to exactly one screen pixel. In most cases, you will only be able to see a portion of the image on the screen.

You can select View Actual Pixels by double clicking on the zoom tool, or fastest by hitting ⌘+1 / Ctrl+1 (one).

The Hand Tool

The Hand tool is always available. To fully switch to the Hand tool, you would tap the **H** key. But we usually need to use the Hand tool for only a few moments while we're using other tools. So I just *hold down* (not tap) the **H** key to get the Hand tool, then I press somewhere in the image window to get a bird's-eye view; that is, while you're pressing and dragging with the Hand tool, Photoshop temporarily zooms out but shows you a rectangle representing the area to which you are really zoomed. I drag to move the rectangle around. When I choose the area to see close-up, I release the **H** key. It's so much easier to do than to write (or read) about!

The Hand tool used in combination with the zooming key commands allows you to see all of the details of the image. In versions of Photoshop before CS5, one used (and still can use) the Spacebar as a toggle to the Hand tool without the bird's eye view.

Professional Zooming

Would you believe Photoshop offers approximately 20 ways to zoom? However, we usually choose just two or three of these to use in our daily work. It's a question of keyboard-driven ways, mouse, or a combination.

It's easy to zoom in and out of an image from only the keyboard. You can press ⌘+[Plus sign] / Ctrl+[Plus sign] to zoom in or ⌘+[Minus sign] / Ctrl+[Minus sign] to zoom out, both in preset units.

To zoom to *exactly* the area you want, not too much or too little, try this: hold down the **Z** key, then press and *immediately* drag with the magnifier cursor that appears. Dragging right zooms in, and dragging left zooms out. This is my favorite!

Instead of dragging, you can also hold the mouse button down with the cursor centered on the area to which you want to zoom. This will give you an animated zoom. Pressing the mouse button down while holding option+Z / Alt+Z animates zooming out. This method is entertaining but slow.

Use Fit on Screen— ⌘+0 / Ctrl+0 —to see the whole image again.

You can also create a second window of the current image (one for each of two magnifications, perhaps): select Window>Arrange>New Window for [document name]. When any pair of windows need to be seen at once, use the Arrange Documents commands in the Window>Arrange menu. Two windows of the same image file work on the same image pixels, and all your edits will simultaneously show up in both/all. Some users like this so

they can see the big picture in one window while doing delicate edits in a zoomed view.

A Navigation Exercise

The **tab** and **F** keys can be used to quickly change the Photoshop workspace around your Image window. The **tab** key hides and displays all of the Photoshop panels. The **F** key switches Photoshop between **Standard Mode**, **Full Screen Mode with Menus** (your image will be placed center screen on the Photoshop workspace), and **Full Screen Mode** (your image will be placed center screen on a field of black). These allow you to quickly view your image without much clutter. Use the **Z** shortcut (described earlier) to zoom. Try pressing **tab** (hides the panels), **F** *twice* (to go to Full Screen Mode), and **⌘+0** / **Ctrl+0** (zero) to Fit on Screen. Press **tab** and **F** to return to the standard viewing mode.

Note: Watch your cursor for time-saving user interface elements. Instead of fumbling with menu arrows (00% ▾), use Scrubby sliders (drag left and right when they appear, and the value they control changes). Instead of entering numerical values, use dials.

Filters

Filters are the means by which we can affect groups of pixels. A classic and easy-to-use filter is Gaussian Blur. When used, pixels appear to smear into one another. Its dialog box has a small preview window, a preview checkbox for displaying the filter's results in the Image window, and a slider for controlling the amount of blur.

There are more than 100 filters, and some can be very complex. In fact, some were formerly software applications in their own right! In the past, all filters were applied to image layers with results that were difficult or impossible to reverse. With the invention of **Smart Objects**, the destructive nature of most filters has been tamed.

The Gaussian Blur filter dialog box (one of the simple ones)

Smart Filters

When applied to Smart Objects, filters are known as **Smart Filters**. The most complex and exotic filters (e.g., Liquify, Vanishing Point, Blur Gallery) cannot be applied as Smart Filters, and thus are often applied to duplicate image layers if one wants to preserve the original pixels. "Old school," but effective.

An Appeal for Smart Objects

Adjustment Layers are great: they can be applied, revisited, and removed if you change your mind. The same can not be said of Filters and a few other features (such as the correction tool called Shadow/Highlight) unless you convert image layers into Smart Objects. Then we have the luxury of changing our minds even months or years in the future!

To see what I mean, try the following experiment:

1. Open an image in Photoshop. Duplicate the image by choosing Image> Duplicate (give the file a name with the word "smart" in it).

2. Return to the original image.

3. Go to the menu command Filter>Blur>Gaussian Blur. Choose a blur Radius of about 20 pixels, then click OK.

4. Go to the duplicate file. The image will likely be on a **Background**.

5. Convert a **Background** to a Smart Object: control+click / Right-click on the Background's name in the Layers panel and choose Convert to Smart Object.

6. Now for this Smart Object, go to Filter>Blur>Gaussian Blur. Choose a blur Radius of 20 pixels, then click OK.

What you should see is the Gaussian Blur listed below the Smart Object's name. It's a **Smart Filter**! If you change your mind about the strength of the blur, just double click on the name of the filter in the Layers panel, and you can change it. Click on its "eye-con" to turn the filter on and off.

Remember, you can select several layers and convert them all to a single Smart Object. If you later wish to edit any one of those layers, you can double-click on the Smart Object's thumbnail. After a startling dialog box (illustrated here), you will see a new, temporary document window containing those original layers. When you've finished editing them, simply choose File>Save and File>Close. Your Smart Object will update, and any Smart Filters you applied will automatically update, too.

Looks scary, but it isn't. Here's a translation: Photoshop is generating a temporary document with the contents of your Smart Object in it. When you're done editing that document, Save and Close it, and you're good to go.

Finding Your Way in Bridge

Back/Forward

Path Bar

Recent files & folders

Input, Output, & Review options

Preview (with Loupe)

Search (both Bridge & OS)

Sort & Filter

Workspaces

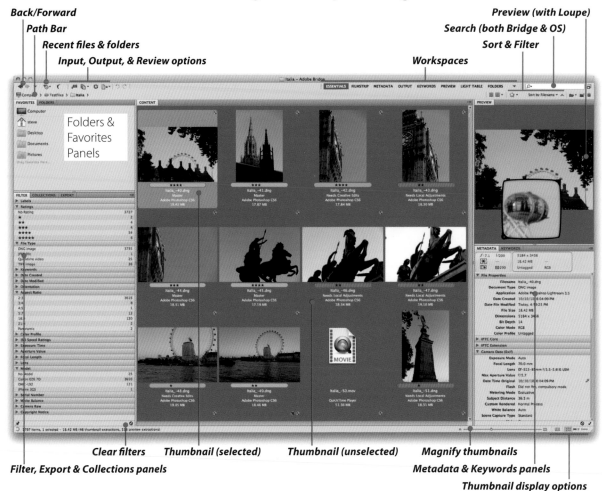

Folders & Favorites Panels

Clear filters

Filter, Export & Collections panels

Thumbnail (selected)

Thumbnail (unselected)

Magnify thumbnails

Metadata & Keywords panels

Thumbnail display options

What is Bridge?

Remember that Bridge is primarily a way to look deeply into a folder of files on your system. It also lets you sort, rate, and organize those images in dozens of ways. But remember that Bridge is not a normal application in that it doesn't open documents, let you work on them, save them, etc. It's a *viewer*.

So it remains up to you where you store your files. Bridge may be able to help you find them, but mostly it's a way for you to enjoy the organizational system that you configure.

Enjoy many of Adobe Bridge's functions without ever leaving Photoshop! Try the Mini Bridge panel.

Exploring Bridge: A Guided Tour

The Bridge window has panels like Photoshop does. You can rearrange, resize, and close these panels. You can access Bridge Workspaces from their menu/names in the upper right (e.g., Light Table with only the Content panel, Metadata with a details view in the Content panel and more space given to the Keywords and Metadata panels, and the Essentials with a good balance of those panels and a Preview panel). Let's use the Essentials.

1. Use the **Favorites** panel to navigate to images in frequently accessed folders on your computer. If you loaded images to your operating system's Pictures folder, click on it.

2. If the images are elsewhere, use the **Folders** panel to navigate as you would in Explorer (Windows) or in the Macintosh list view.

3. When you find a folder with images, click (just *one* click!) on an image thumbnail. (Double-clicking opens the image—that comes later).

4. Notice that the Preview panel is now showing a (probably) larger version of the image.

5. Find another image not adjacent to the first. Hold down ⌘ / Ctrl and click on it. Both are now selected. Or hold down shift and click on another. This selects a range of images.

6. Click on one of the images in the Preview panel. You've discovered the **Loupe**! Drag it around to get a close-up view of the image's pixels. You can use your mouse's scrollwheel or the + or – keys to zoom the Loupe. ⌘+Shift+A / Ctrl+Shift+A deselects all images.

7. Select just one image in the Content panel. Look at the Metadata panel for technical data about that image. Turn down the disclosure triangles to see more data. (IPTC Core holds the data you can apply from a Metadata template when downloading images, like copyright and contact data.)

8. Select several related images. Choose Stacks>Group as Stack or use the shortcut ⌘+G / Ctrl +G. This is a great space-saver! The number tells you how many are in the stack: click on the number to expand or collapse the stack. Clicking the second (shadow) border toggles the selection between just the front image and all images in the stack.

Sorting & Filtering

If the location of the folder you are examining is not shown, choose Window>Path Bar. With a glance to the left, you can see the location of the folder that you are examining. Toward the right, you'll see this menu `Sort by Filename ▾ ▲` for choosing the criteria by which those images are sorted and, with the arrow, in what order (ascending or descending).

The **Filter** panel lets you choose which images are visible. For example, if you see multiple items under the filter category **File Type**, you may click

If there are 10 or more images in a stack, you'll see a "Scrubber" button at the top of the thumbnail when you hover over it. Slide it back and forth to see previews of the images in the stack.

on one to limit the images shown to that file format. In the illustration, there are TIFFs, DNGs, JPEGs, and videos. If I wish to see only my RAW (DNG) files, I'd click on that type and the rest would disappear. Click on the same filter or the ⊘ icon at the panel's base to disable it.

If there are subfolders within the folder you are viewing, and you wish to see their content, choose View>Show Items from Subfolders. Return to the same command to disable this feature.

Metadata

Your digital camera collects more than pixels. It also records data about that image data. It notes the date and time each photo was taken (have you set the *correct* date and time on your camera?), exposure data, some camera settings, what camera it is—right down to the serial number, usually—and much more. We call all this data about your image **metadata**.

Bridge offers ways of sorting through your images and reducing the visual clutter by filtering them based on almost any imaginable combination of metadata.

I'll share more about metadata later. But keep in mind that there are many ways to take advantage of it—and we shall.

Searches & Collections

How would you find a few images in a single folder with thousands of them? If you choose Edit>Find... or use the shortcut ⌘+F / Ctrl+F, you'll get a dialog box that lets you build exacting search criteria. You can add criteria by using the + sign at the right of any of the criteria present. Then you can decide if you want to match any or all of those criteria.

Once the search is complete, the images that meet those criteria are in the Content Panel. You'll notice the search criteria at the top of the Content panel along with a few buttons. The images displayed are the images that match those criteria *right now*. If you want to maintain an ongoing watch for these and newer images, click the **Save As Smart Collection** button (🖿) near the **New Search** button.

The new Smart Collection appears in the Collections panel. From then on, just click on that item, and your search will be performed for you again.

Integration with Other Applications

Finally, for now, I'd like you to look under the **Tools** menu. Later, I'll help you develop a Metadata Template so your most important metadata is automatically attached to all your images directly upon downloading them to your computer via the Adobe Bridge Photo Downloader.

But lower in the Tools menu are submenus for each Adobe application you also have installed. In the case of Photoshop, you may select a number of images in Bridge, then choose Tools>Photoshop>... then one of the choices present for automated production of those images.

For example, if you've correctly shot a series of exposures to be combined as a single High Dynamic Range image (HDR), you would select those files, then choose Tools>Photoshop>Merge to HDR Pro... Then you would be presented with the dialog box that lets you customize the process.

Export & Output

Bridge's Export tab allows you to configure settings for easily uploading images to popular online social media sites like Facebook and Flickr. You may also configure settings for frequently used local hard drive locations.

Using the Output workspace, you may generate a PDF containing many images, or create and upload an entire web gallery.

Finding Your Way in Adobe Camera Raw

It is either in Adobe Camera Raw (ACR) or Lightroom that many of us perform our global image adjustments. So we will spend a lot time examining this dialog box in Chapter 6. For now, navigate to any image using Bridge, then `control+click` / `Right–click` on it choosing Edit in Camera Raw…

Tools

The Tools in ACR allow editing on our RAW image captures. There are tools for cropping, straightening, retouching, and applying local adjustments in either a painterly fashion or as gradients. Unlike Photoshop, these tools operate nondestructively by nature. Like everything else in ACR, the tools make changes not to the image pixels directly, but to metadata only. They are risk-free!

Image Adjustment Panels

To perform global image adjustment tasks, we work our way down each panel and access each via its tab. From simple Brightness and Contrast tweaks to sophisticated corrections for our lenses' defects, we can use these controls to make these changes (again, nondestructively).

Shortcuts & Navigation

Many of the shortcuts that we use in Photoshop apply here in ACR, too. Sadly, for navigation, they're the less intuitive ones from older versions. Nonetheless, here are few useful things to know:

▶ `⌘+Space` / `Ctrl+Space` gets us the Zoom tool, with which we can draw a box around the pixels we want to see closer.

▶ The `Spacebar` allows us to pan with the Hand tool.

▶ If we're editing more than one image and have the filmstrip on the left, we can use `⌘+A` / `Ctrl+A` to select all the images so they're all getting the same treatment as we apply adjustments.

When we're done, we can create copies to send to our clients (the **Save Images…** button), **Open** our documents in Photoshop, or click **Done** to write the metadata "notes" of our work to the documents themselves.

Of course, we can click **Cancel** if we wish to move on without saving our work.

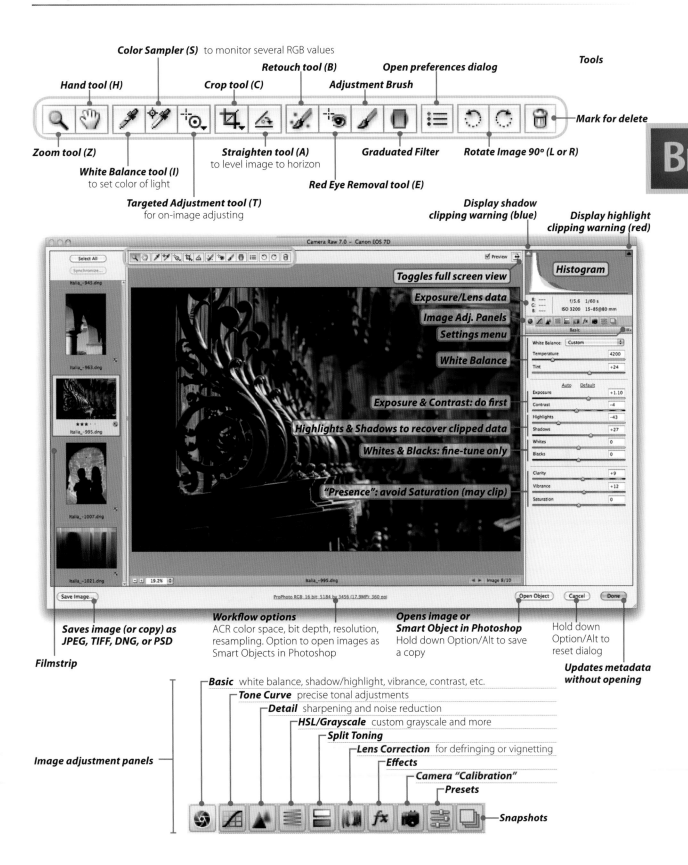

Tools

Color Sampler (S) to monitor several RGB values

Retouch tool (B)

Open preferences dialog

Hand tool (H)

Crop tool (C)

Adjustment Brush

Mark for delete

Zoom tool (Z)

Straighten tool (A)
to level image to horizon

Graduated Filter

Rotate Image 90° (L or R)

White Balance tool (I)
to set color of light

Red Eye Removal tool (E)

Targeted Adjustment tool (T)
for on-image adjusting

Display shadow
clipping warning (blue)

Display highlight
clipping warning (red)

Br

Toggles full screen view

Histogram

Exposure/Lens data

Image Adj. Panels

Settings menu

White Balance

Exposure & Contrast: do first

Highlights & Shadows to recover clipped data

Whites & Blacks: fine-tune only

"Presence": avoid Saturation (may clip)

Saves image (or copy) as
JPEG, TIFF, DNG, or PSD

Workflow options
ACR color space, bit depth, resolution,
resampling. Option to open images as
Smart Objects in Photoshop

Opens image or
Smart Object in Photoshop
Hold down Option/Alt to save
a copy

Hold down
Option/Alt to
reset dialog

Filmstrip

Updates metadata
without opening

Basic white balance, shadow/highlight, vibrance, contrast, etc.

Tone Curve precise tonal adjustments

Detail sharpening and noise reduction

HSL/Grayscale custom grayscale and more

Split Toning

Lens Correction for defringing or vignetting

Effects

Image adjustment panels

Camera "Calibration"

Presets

Snapshots

Finding Your Way in Lightroom

Left-side panels: collections, presets, templates, etc.

Preview/Navigator

Identity Plate (editable)

Right-side panels: where the work gets done

Module Picker

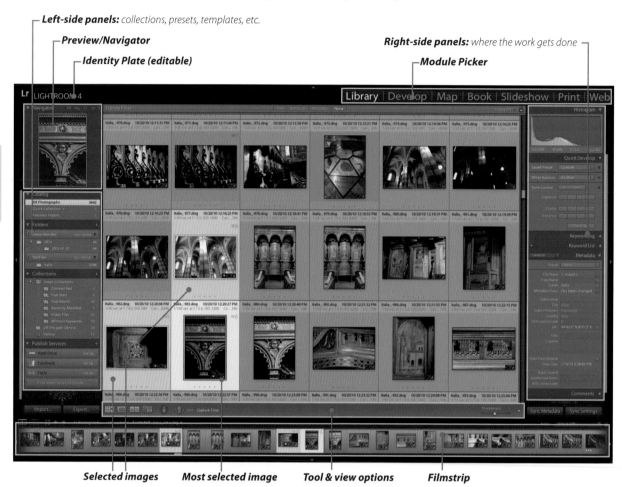

Selected images *Most selected image* *Tool & view options* *Filmstrip*

Illustrated here is the **Library Module**. It is for organizing, searching, applying, and checking metadata (like keywords), and perhaps a little bit of image adjustment or "Development," although I prefer to save that for the next module. This is the module where you interact the most with Lightroom's catalog database. You may set up "publishing" to hard drives or to Flickr or Facebook. You may add more such services over time, too.

Use the other **modules** to perform other functions.

Lightroom is an all-in-one, too. It does all of what Bridge and Adobe Camera Raw can do with image files, plus even more, in a more elegant interface.

Panels & Modules

When you open Lightroom for the first time, it offers a tour of the interface with tips for each module. Read them! If you have already skipped them, you can find those tips in the Help menu. Here are a few highlights:

1. **Module Picker**, where you take images through the workflow;

2. **Panels**, similar to Photoshop's panels, where you achieve your editing tasks;

3. **Filmstrip**, where you can always access your images along the bottom of the screen.

The first thing most Photoshop users notice about Lightroom is that it consists of one huge window. The panels of Photoshop have been replaced by

panels that can slide in and out of the sides of the screen. Although there are menus, we use them very little, and thus spend much of our time in one of the full screen modes—even the one that removes the menu bar!

Click on the name of a Module you want to examine. The panels and controls within them are often set up to work from the top down and the Modules from left to right. Below are examples to explain what they're for.

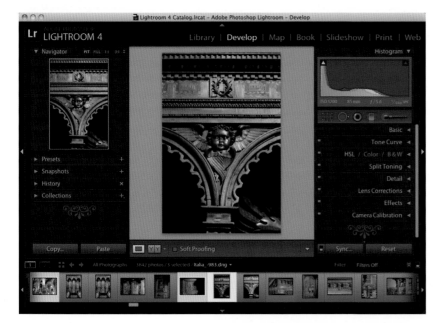

Develop is for image adjustments and light retouching, including painterly enhancements. You can synchronize settings with other images, or return to any state in your images' editing lifetime (yes, a history panel that doesn't clear upon closing the document).

Map allows you to indicate where any photo was captured. You may combine a GPS receiver's tracklog with your images to attach location data to many images at once. I love this feature!

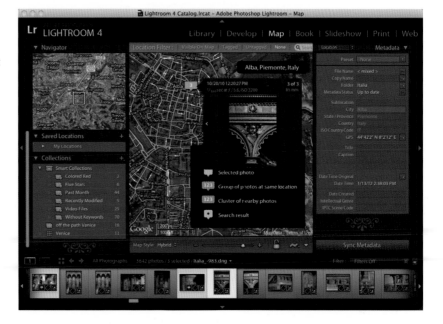

Book is where you can create a layout from the many supplied templates or make your own, then submt it to Blurb from within Lightroom.

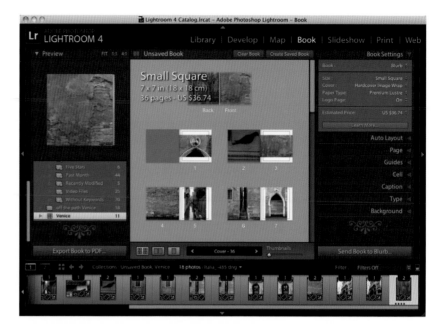

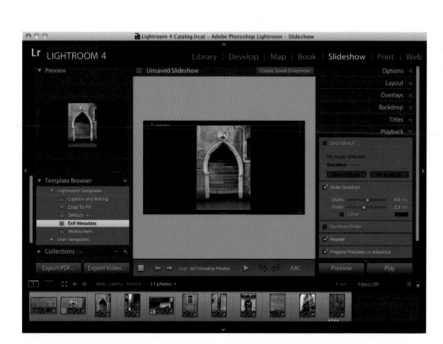

Slideshow is where you can design and present a slideshow with music if you like. You can export your slideshow as a video, PDF, or play it directly in Lightroom.

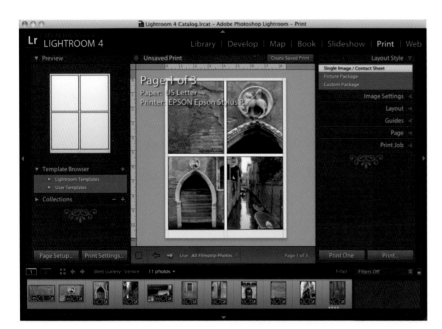

Print is where your image appears on paper. You may print many images on a contact sheet, several copies of one image per sheet, adjust margins, and apply last-minute "printer" sharpening. You may even queue up many images to print and go out to lunch!

Web is where you set up and use site templates for creating online portfolios in either straightforward HTML or Flash. Everything from text to color may be customized, and you get to preview the results in a web browser before uploading. Lightroom can even upload to your web server once you've configured its settings.

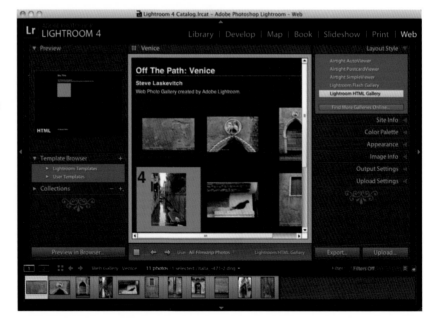

An Easy Exercise: Grid vs. Loupe vs. Compare

While in the Library module, we find several ways merely to look at our images.

▶ Using the Grid view, accessed by the letter **G**, we see our images laid out like slides on a light table. Do you remember slide film?

▶ If we double click on an image, we don't leave the comfort of Lightroom for Photoshop; we find our image magnified in **Loupe** view, occupying the entire main window. You can also use the **L** key to get to Loupe view.

▶ **C** lets you **Compare** a couple of images, perhaps two frames of the same subject, while you try to decide which one is best.

Vital Keyboard Shortcuts

While looking at the interface, try the shortcuts below. When the panels are hidden (by using the (tab) key), you'll see that the triangles on the left and right edges are pointing inward. If you hover your cursor over the left or right edge, the panel will automatically move in so you can use it. Once the cursor moves away, the panel retracts. Use (tab) again to bring all the panels back.

Shortcut	Function
tab	Hides & shows side panels
shift+tab	Hides & shows all panels
F	Cycles Full Screen Mode (to maximize space)
L	Dims the interface except for selected image (partially, blackout, and normal)
⌘+/ [forward slash]/ Ctrl+/ [forward slash]	Brings you Module-specific shortcuts

I'll have a lot more to say about Lightroom (and Bridge and Photoshop) in the next section, **The Workflow.**

Stylish Transit, Firenze

Section 2
The Workflow

A Brief Overview

Any complete workflow has dozens of different tasks. To simplify, I've broken an overall workflow into a series of stages. Each major workflow stage has its own chapter in this section, with several tasks within it, many of which can be performed easily in a few minutes. Although each stage may have two or three software choices, keep in mind these rules:

▶ Shoot in RAW, unless you're shooting snaps.

▶ Do as many of your global or local adjustments as possible in either Adobe Camera Raw (ACR) or Lightroom.

▶ When those tools become less efficient or insufficient, turn to the majesty of Photoshop.

	Stages—Major Task(s)	Application Choices
1	Capture & Import	Camera, then… Bridge Lightroom
2	Organize & Archive	Bridge Lightroom
3	Global Adjustments (Development)	Adobe Camera Raw Lightroom Photoshop
4	Local Adjustments	Adobe Camera Raw Lightroom Photoshop
5	Cleanup & Retouching	Adobe Camera Raw Lightroom Photoshop
6	Creative Edits & Alternates	Adobe Camera Raw Lightroom Photoshop
7	**Output:**	
	Digital Files	Bridge Lightroom Photoshop
	Print	Lightroom Photoshop
	Web	Bridge Lightroom
	Slideshow	Bridge Lightroom

Capture & Import

If you're new to digital photography and image editing, your camera is probably set to capture JPEG files. If setting your camera to capture RAW files sounds like a new and complex idea, don't worry about doing that now. But as soon as you're more comfortable working with your camera, you should set it to capture RAW files. Using RAW, either camera proprietary versions or Adobe's DNG, is a major part of any robust photographic workflow.

Since this is a book predominantly about post-capture workflow, I won't cover the specifics of capture with particular cameras. But there are a few important points to make about image capture. First, ensure good exposure in your images. There's a myth that Photoshop can fix any type of problem in digital images. There are definitely many options for fixing problem images in Photoshop, but it's always best to start with the best possible image. Second, capture a sharp, unfiltered image: use sharp lenses and limit the use of camera filters or other light modifying tricks. Most filter effects, with the very notable exception of polarization, are easily mimicked by our software and with much greater precision and flexibility. I will offer you general tips to ensure that your images are as good as they can be.

When it's time to actually move your images from your camera or memory card to your computer, both Bridge and Lightroom have many options. When your camera or card is attached to your computer, Lightroom can automatically present its Import dialog and Bridge can be set to automatically open **Adobe Photo Downloader**. I'll carefully discuss the options presented in both, including file naming, destination folders and their naming, automatic backup, conversion to the DNG format, and the use of metadata—metadata is the magic hook to find and organize even the biggest image libraries.

Organize & Archive

Create a strategy for keeping your images organized. Lightroom or Bridge (with the Adobe Photo Downloader) can send freshly downloaded images to any specified folder, and can automatically create subfolders using various dating schemes or an arbitrary custom name of your choosing. I will outline a labeling strategy for keeping track of unedited images, images in progress, and finished images, as well as variants. We'll keep closely related images together with Stacks, and broader groupings with Collections. Moving your images through this process will make it easier to find them later and see your progress at a glance.

I'll also discuss a few options for backing up your images. To paraphrase a man from Chicago, "Back up early, back up often."

Global Adjustments

Global adjustments are those made to tone, brightness, contrast, color, crop, sharpness, noise, or other attributes that affect the entire image. If performed well, you can do 90% of your image editing work with a few adjustments. There are many possible adjustments to be found, not only in Photoshop, but also in Adobe Camera Raw (which, despite its name, can now be used with RAW, JPEG, or TIFF images), and Lightroom.

Local Adjustments

Sometimes you'll need to perform adjustments on only a portion of your image: a sky or a person's face, perhaps. In order to localize these adjustments to part of an image, you may need to carefully select those pixels you want to affect in Photoshop and then perform your adjustments. There are also several ways to "paint" adjustments in each of our applications.

Cleanup & Retouching

Basic clean-up may occur at almost any time in the editing process. I've chosen to put it at this late stage because many subtle flaws may be revealed by your global or local adjustments. The fundamental task in cleaning or retouching an image is **spotting** (removing dust spots and other blemishes). Like the Global Adjustments, clean-up can be done in Photoshop, Lightroom, or ACR. Each has its particular quirks and strengths.

Creative Edits & Alternates

This is a catchall step for all the various types of image effects you might want to employ, such as adding soft focus, burning, defocusing parts of the image, and adding film grain or border effects. Most of these techniques are best left until after other image adjustments are done. Some example techniques will be described in this chapter.

Output: Digital Files, Print, Web, & Slideshow

Some tasks are specific to the particular output size and medium. They include final image cropping, print resizing/resampling, and output sharpening.

Most inkjet printers today can make very good photographic prints right out of the box. Photoshop and Lightroom also allow many desktop printers to print using color profiles. Profiles drastically improve printer color accuracy, and these are also handy when preparing images for print by a favorite online vendor.

Web output is eased greatly in these applications. Whether you need to output a few images for your blog or an entire web gallery of images for your family or clients to peruse, Bridge CS6 and Lightroom 4 have tools that make this stage far less painful than even a few years ago.

Lightroom 4 introduces its new Book module. You can layout an entire book with your images and text using many templates and tools. You can then generate a PDF or send your book to Blurb to be printed. Lightroom will even tell you the price.

With both Bridge and Lightroom, you can present slideshows. Bridge offers more transition choices, but Lightroom slideshows can have a soundtrack of your choosing and be exported as movies for viewing on any computer.

Capture & Import

4

Although this chapter will not discuss every possible setting and button on the camera(s) you use, I will ensure that you will know the important things to find and configure.

The bulk of this short chapter will be the myriad import settings found in Bridge (or rather, its companion, Photo Downloader) and Lightroom. Especially if Lightroom is your main image organizing application, be sure to read the File Management section in chapter 5 as well.

Capture

This book predominantly focuses on post-capture workflow. However, I'd like to give a few suggestions on ways to capture images to make that workflow work.

Shoot RAW

By choosing RAW, you give yourself every bit of data that your sensor captured. With any other choice, some assumptions are made as to how the image will be "developed." See your user guide to set your camera to RAW.

Photojournalists sometimes have a need to capture in a mode that some cameras offer called RAW+JPEG. This way, they can upload the smaller JPEGs to their publisher(s), but still have the valuable RAW data to process more carefully later. Most users don't need the added JPEG.

Lens Profile Creator

Adobe provides this free companion application via *adobe.com* that uses photos of special charts (essentially checkerboard patterns) to determine the distortions, vignetting, and other quirks of particular lenses—and corrects many of them **automatically** in Photoshop, ACR, or Lightroom! Many profiles are supplied in those applications, but this utility lets you use your own or other photographers' if your combination is not already listed.

Be careful to read the instructions! Here's an overview of the basics:

▶ **Print a chart**—There are many to choose from. The sizes, and the sizes of the checks within, vary so that you can shoot with a lens from as wide as a fish-eye to a long telephoto. The goal is to make each check no less than about 20 pixels on a side when photographed with the

camera/lens/focal length combination you're profiling. This can take some experimentation! Be sure the print is crisp and sharp, with no color fringing on the squares.

▶ **Photograph the printed chart**—with the camera set to manual. You want to ensure that each capture is exactly the same exposure, and you'll be making nine of them with the chart in different positions in each: one in each corner, the middle of each side, and in the center of the frame, with substantial overlap. See the illustration on the previous page.

▶ **Use the Lens Profile Creator**—Add your images to the profiling project, then let the software know which chart, camera, and lens you've used. With luck, the application will make a profile for Photoshop's Lens Correction filter, ACR, and Lightroom, and many lens issues will simply disappear!

Standard Practices

Exposure

If, like me, you remember shooting with film, then you may wonder if digital sensors behave more like slide film or negative film. Many assume it is like slide film, but I disagree.

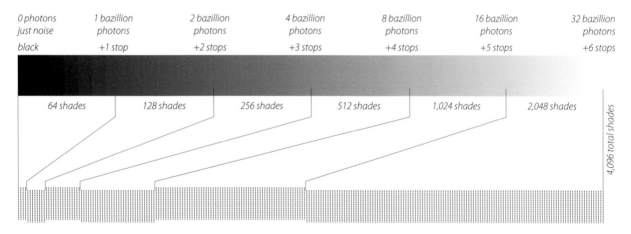

Let's consider a fairly standard digital camera with a modest range of six f-stops (to make my diagram readable). We'll assume that it yields an image that uses 12 bits (short for *binary digits*) for each pixel's red, green, or blue data: it will have a total of 4,096 levels (shades) of each. Regrettably, those levels aren't divided equally amongst those six f-stops.

Recall that as you want to increase your exposure by one f-stop, a small increment *visually*, you have to let twice as much light into the camera. Film, like our eyes, responds to that doubling of light with that small, incremental

change—⅙ of the way from black to white in our example. **Twice as many photons means only a small change in visual tonal value.**

But in a digital camera, twice as many photons need twice as much data to record their impact. So in our example, fully half the data that's delivered to us is for the brightest f-stop only! Half of what's left is for the next brightest stop, and so on, leaving relatively little data for the darkest f-stop.

The bottom line? If your scene requires less than your camera's full dynamic range, then make sure the brightest part of the scene is *very nearly* blown-out in camera. We call this "shooting to the right" because the data in the image's histogram is pressing against the right-hand side (see illustrations on the following page).

Later, when developing the image, we can drag the dark areas back down to black but still have twice as many levels to use in those shadows.

ISO Setting: The Sensor's Sensitivity

The ISO standard for sensor sensitivity is similar in principle to the old film speed standard. Modern high-end cameras may have sensitivity settings of up to 204,800! However, avoid high ISO settings. Some newer cameras may have the marvelous ability to minimize noise when shooting at high sensitivity, but most cameras—maybe yours—will have more trouble at 1600 than at 100. Why? Turn up the volume on your favorite music player with no music playing. Be careful to lower the volume again later! Hear that hiss? What you're hearing is *noise*: the effect of heat and electronic interactions in the device. The analogous phenomenon in digital imaging is colorful speckles in the darkest parts of an image—that is, the area where noise doesn't have much signal (or light) to overwhelm it. This is another incentive to *tend* towards overexposure with an adjustment downward later, which creates a much stronger signal to overwhelm the noise.

Preparing for Panoramas

If you want to "stitch" images together as a panorama, consider these tips:

▶ Use a tripod. If the tripod head has a bubble level (aka, a spirit level), that can be helpful in keeping each exposure on the horizon.

▶ Ensure that each frame overlaps by 20%–30% (for longer lenses and wide-angle lenses, respectively).

▶ If you make many panoramic images, consider purchasing a "Pano" head for your tripod. These make it easier to rotate around a lens' **nodal point.** This is a point, usually near the front element of a wide-angle lens, around which it is best to rotate: it is the point where foreground and background objects no longer move relative to one another in the viewfinder as you rotate. This shifting of postion is called "parallax," and this kind of tripod head minimizes it.

Despite all these best practices, I have seen results that show Photoshop will work with even somewhat haphazard shooting and make decent panoramas anyway! So try it and see if you need extra gear.

Shooting For High Dynamic Range Images
Recall the hypothetical six-stop range on the previous pages. What if the

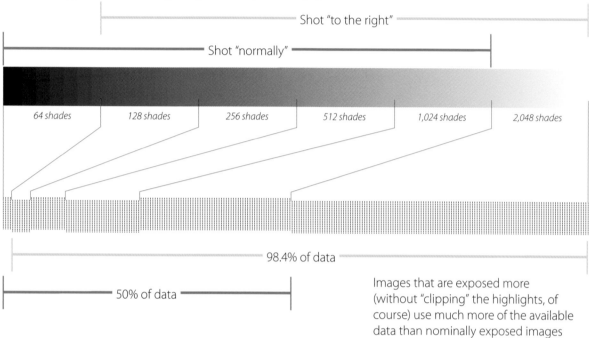

Shot "to the right"

Shot "normally"

64 shades *128 shades* *256 shades* *512 shades* *1,024 shades* *2,048 shades*

98.4% of data

50% of data

Images that are exposed more (without "clipping" the highlights, of course) use much more of the available data than nominally exposed images

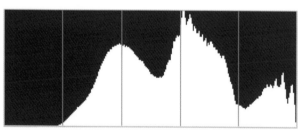

In-camera view, shot "to the right"

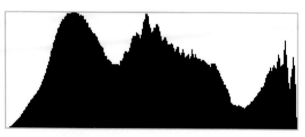

After "development"—what we wanted!

scene requires a range closer to human vision (which is more like 20 stops)? You can combine a series of exposures in one image file! When creating these **High Dynamic Range (HDR)** images, make several frames one to two f-stops apart by varying *shutter speed only* to avoid depth of field differences. Since some of those exposures may be lengthy, a tripod is useful. My main camera has an "auto-bracketing" setting which I find handy for this process.

Make sure the darkest image holds all the important highlight detail, and that the lightest image shows important shadow detail.

Shooting for Passerby Removal

It's considerably easier to remove random content from images if you have made several images of the same scene. Photoshop Extended has a way to note what content is common in several images and disregard the fluctuating content (like sensor noise, passing cars or people, raindrops, etc.). So if you wish to engage in "passerby removal" or noise reduction, make several frames of the same dynamic scene. Later, it will look serene and quiet.

Geocoding or "Where was that image shot?"

My travel camera bag contains a camera body, three lenses (decent but lightweight image-stabilizing zooms, specifically: 10–22mm f/3.5–4.5, 15–85mm f3.5–5.6, and 70–200 f4), waterproof CF card holders, extra batteries, X-Rite ColorChecker Passport, progammable cable release, and a GPS receiver that keeps a tracklog. When I get back to my computer, I synchronize my images with the locations where they were captured using Lightroom's Map module. For this to work, I have to be sure that the capture time is correct. In fact, I use the time in my GPS receiver to set the camera's time.

Digital Negative

Much has been written and said about the Adobe's DNG format. Some camera manufacturers are starting to use it as the RAW format in their cameras. Adobe has said it will be the steward of this published format, but if they should cease to be, the instructions to read a DNG are publicly available.

DNGs hold *all* of the sensor data recorded by the camera (that is, the image itself). They do not require additional files to be created to hold their metadata, as is the case for camera-proprietary RAW formats. These extra files (sidecar files) can be separated too easily from the image files with which they belong: a demoralizing accident. DNGs avoid that problem.

It has been said that DNGs *must* lose data because the file size is sometimes smaller than the camera-proprietary RAW image. Not true! The file size can be smaller because DNGs use *lossless* compression to make the sizes smaller. With the release of Photoshop CS6 and Lightroom 4, there is a new, lossy DNG format that can yield a file size far smaller than the lossless version. This can be useful for cloud and tablet applications that value speed over perfect fidelity. But no worries here either, as you must consciously create a lossy DNG from an existing file; you can't accidentally choose lossy DNG when importing your images. Incidentally, my experiments with this

new format have impressed me. Visually, it is *extremely* difficult to distinguish the lossless from the lossy DNG, even though my lossy files are almost exactly ⅓ the file size of the lossless!

Another fruitless fear that's been expressed to me is that some *metadata* is lost in the conversion. After some research, I discovered that one camera maker embeds some nonstandard metadata in an obscure metadata field. What is it? Information to aid that manufacturer's software to process their RAW files. But since you and I are using Adobe software to do that, we need not concern ourselves a bit with that esoteric metadata. Really!

A final risk in using camera-proprietary RAW files is that the camera maker may not support that format far (or even near) in the future. Since DNG is a publicly published standard, we have far less to worry about with it as a format for archiving.

Therefore, when importing images, I heartily recommend that photographers convert their proprietary RAW files into Digital Negatives.

Import

Deferred Import

Prolific photographers complain about how long it takes to download photos if they are also converting them to DNG at the same time. For them, I recommend downloading the image files from the camera or cards to a waiting folder on their computer. Once all the cards' content has been transferred (using either Lightroom's Import dialog or the Adobe Photo Downloader launched from Bridge), they can then convert all the images at once as they are brought into their proper archive (your Pictures folder, for example).

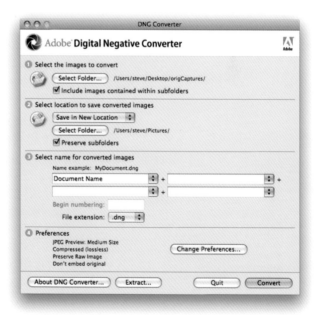

This is only a minor step if you are using Lightroom, as you may select any or all of your images, then convert them *en masse* to DNG.

With Bridge, the creation of DNGs from *downloaded* proprietary RAW files requires the free application **DNG Converter**. You can download it from Adobe's website.

However, if time allows, and regardless of whether you use Bridge or Lightroom, the conversion to DNG should happen when downloading. So let's discuss the major steps involved in that process.

Bridge

You can use Adobe Bridge to import your images from your camera or memory card. There are options for renaming the images, sorting them by folder based on date shot or imported, and even for automatically backing up the original files to another disk or folder in your system or over a network.

The preferences of Apple's Image Capture program let you determine what happens when a card is detected

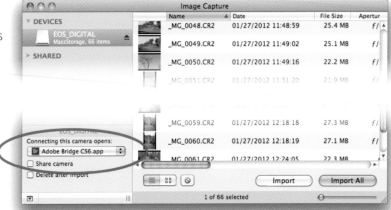

If your operating system lets you launch applications automatically when a memory card is connected, you should have that application be Bridge, so its preference to download automatically when a card is detected can be engaged without conflicts.

Configure Bridge

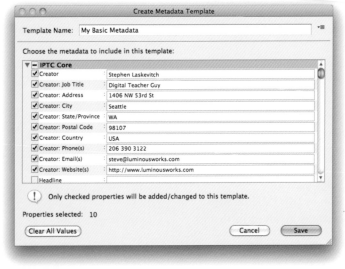

To be confident that Bridge does what you want, you should change a few of the preferences. Go to the Edit menu (Windows) or the Bridge menu (Mac OS) to Preferences.

See Section A, Chapter 2, *System Configuration,* for suggested settings. Also, so you always have your images "stamped with your seal," create a Metadata Template.

To create a metadata template in Bridge CS6, choose Tools>Create Metadata Template.... Fill in fields that you feel are general enough to be applied to any image you make. If you need several variations, make more than one template.

Now let's get some images!

Adobe Photo Downloader

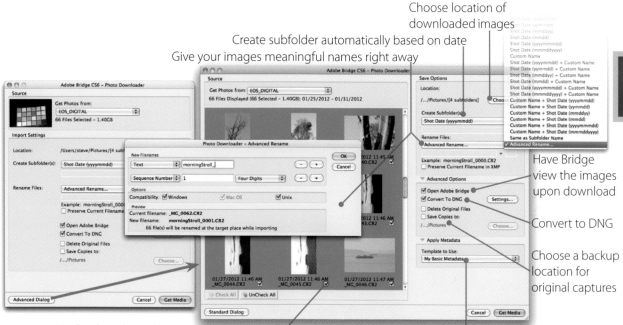

Choose location of downloaded images

Create subfolder automatically based on date

Give your images meaningful names right away

Have Bridge view the images upon download

Convert to DNG

Choose a backup location for original captures

Uncheck undesired images or non-image files

Specify Metadata Template or just name and copyright

When you connect a camera or its memory card to your computer, Bridge should launch its downloader program. The Standard dialog is often good enough, but we'll use the Advanced dialog so we can pick and choose which images we want to download by their thumbnails. There are two other advantages to the Advanced dialog: 1) we get to apply a Metadata Template (if we made one), and 2) we can apply our copyright text as we download the images.

Both the Standard and Advanced dialogs have an option to convert camera-proprietary RAW files into DNGs (recommended), and you can specify a destination for copies made of the camera's original image files. If you click the Choose button, you can specify an awaiting DVD, backup hard drive, or network backup drive, so the files are backed up instantly. Some photographers have other backup preferences.

There is a wonderful option to create subfolders in your download location, preferably named after the date shot. This means that there are already two places where that date is stored: the folder in which the image is located, and in the image file's metadata. When choosing a file naming scheme, give each image a name that is meaningful to the shoot. Adobe Photo Downloader has a field for specifying a custom name, and it can add serial numbers to the end automatically. The last option to mention is to open Bridge with the downloads in a new window (very convenient).

The preferences of Apple's Image Capture program let you determine what happens when a card is detected

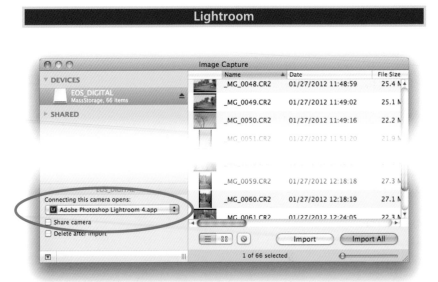

If your operating system lets you launch applications automatically when a memory card is connected, you may have that application be Lightroom.

You can set Lightroom's preferences to open the Import dialog automatically when a card is detected. In this way, Lightroom will automatically launch *and* offer to download images when you connect a camera or card to your computer. Convenient!

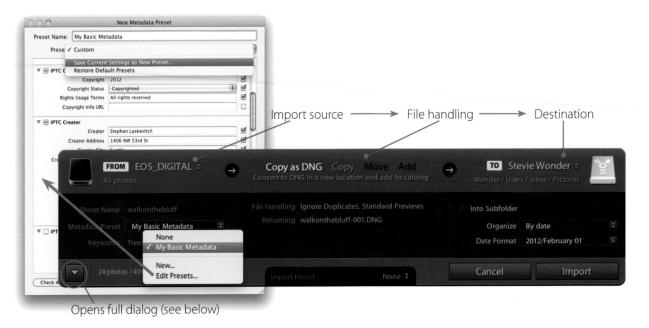

Configure the dialog box to download images to your main image library (or another if you wish). RAW files can automatically be converted to DNG format and named in a usable way. Note that you can also choose to

back up your files straight from the camera to a network backup drive, for example. Some prefer to apply some initial global corrections before using Lightroom's Export feature to create backup files. Lightroom ships with export defaults for burning full-sized JPEGs to disc, exporting DNGs, and even sending files by email.

Some photographers dislike the time it takes to convert to DNG when that conversion happens during import, especially if you have many cards' content to download. So you may consider simply copying your images from your cards or camera to a folder set aside to receive them (see the discussion of a **Watched Folder** below). Depending on the cards and the number of images, this can be a rapid process, even if you have a lot of camera media to import. After your images have been copied to a hard drive, you can then use Lightroom's import (File>Import Photos from Disk…), and convert them all at once and more quickly to DNG. Specify your chosen image repository as the destination.

Convert new images to DNG and import to chosen location

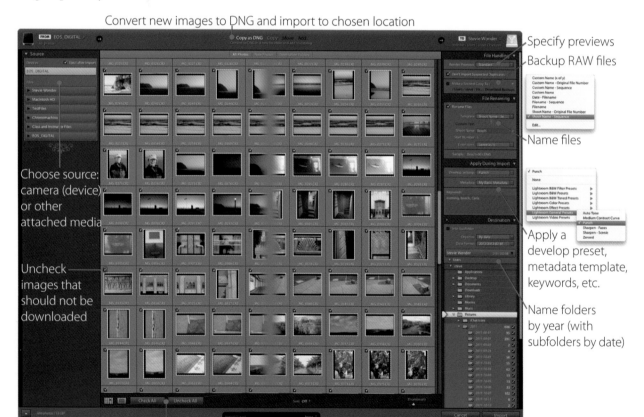

Specify previews

Backup RAW files

Name files

Choose source: camera (device) or other attached media

Apply a develop preset, metadata template, keywords, etc.

Uncheck images that should not be downloaded

Name folders by year (with subfolders by date)

Preview and choose images to download

Automatic Import

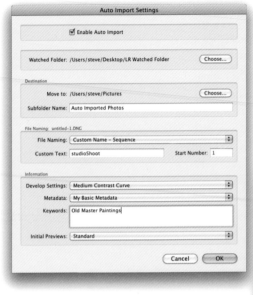

You may import images automatically by setting up a "Watched Folder", the contents of which automatically get imported with settings you establish via File>Auto Import>Auto Import Settings. In this way, you can drop a large number of image files in this folder and know they'll be imported correctly—and automatically.

Tethered Capture

If you connect your camera directly to your computer, you may trigger its shutter from Lightroom and have the images instantly imported. We call this **tethered shooting**. Choose File>Tethered Capture>Start Tethered Capture…, configure the dialog box that appears, and you can shoot from the comfort of your office chair. Just click the big silver button that appears (or use the camera itself), and images will automatically appear in Lightroom, with a develop preset applied if you chose one. It's best to create a preset that flatters models if they can see your monitor!

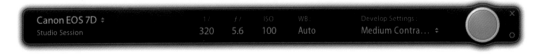

Do NOT Reorganize Outside Lightroom

Note: Lightroom is a database. Importing can be thought of as making this database aware of the images' existence. Even if an image isn't in the database, it may still be on your hard drive somewhere. Likewise, if you move an image outside of Lightroom's interface, the database will think it's missing.

More will be said about this, and much else, in the next chapter.

Organizing & Archiving Images

5

Digital photography has made it easier for photographers of any level to quickly build massive libraries of images. Large-capacity hard drives are so affordable that we may easily store several terabytes of image data. The difficulty, then, lies not in capturing enough images or having enough room for them, but in efficiently rating their quality, processing the best images, and finding them again swiftly when we need them. And because hard drives fail eventually, we need to arrange a backup procedure that is dependable and easy. But organization is a personal thing: what makes sense to one user may be a bad fit for another. In this chapter, I'll discuss several approaches to rating images from which you may derive your own. Likewise, the storage and arrangement of your image files should make it easy for you, not me, to access them. So the approaches I discuss will need to be tailored to your personality. That said, be sure to read the entire chapter before committing to a system. Both Bridge and Lightroom offer many ways to categorize your images, and it's not about how to nest folders anymore!

Enchanted Rock, Texas
© Carla Fraga, *used with permission*

Rating Systems & Methods

Everyone has a different way of specifying the quality of images. Bridge and Lightroom use stars to indicate relative goodness. But deciding how you read those stars is required before applying star ratings to any images.

We have up to five stars to use. Bridge offers an additional catagory: **Reject**. In Lightroom, there are stars and two flags: one to indicate a **Rejected** image, the other **Flagged**. Using some combination of indicators, we'll try to whittle away at the dozens or thousands of images we have just downloaded to reveal just that one image (or five or 20) that we think is definitive and worthy of development. Below I've outlined a few of my favorite rating systems.

These depend on the ability of the application to "filter" images based on their rating. That is, you choose to show images only with the rating(s) you want to see, hiding the others. Usually, you apply ratings while looking at your recently downloaded images, then filter away the lower-rated images, repeating until your representative set is revealed. There's no need to delete, unless you want to, because you can hide images instead.

Method	Procedure
"Build-up"	**Review 1:** rate with ★ or ★★ Filter: ★★ & above, then, if there are too many remaining… **Review 2:** ★★ or ★★★ Filter: ★★★ & above, then, if there are still too many remaining… **Review 3:** ★★★ or ★★★★ Filter for the highest rating you gave.
"Brutally Binary"	**Review 1:** ★ or ★★ *Filter: ★★ & above, then, if there are too many remaining…* **Review 2:** demote to ★ until only the best remain Filter: ★★ & above Alternative: use Flags (Lightroom) or Reject label (Bridge)
"Yes, No, Maybe"	**Review 1:** ★ or ★★ or ★★★ *no maybe yes* Filter: ★★ only, then, if there are any remaining… **Review 2:** change to ★ or ★★★ until none show Finally, filter ★★★ & above
"The Decider"	**Review once** ★ or ★★ or ★★★ or ★★★★ that's it

I reserve five stars for only those images I think should win a Pulitzer Prize!

I've mostly used the methods I call "Build-up" and "Yes, No, Maybe." "Build-up" gives a range of quality from which to choose, and can be

revisited later. Both give an opportunity for cycling through the images and deferring a final decision.

I like star rating as soon after download as possible so I know if images have been evaluated or not. If an image has at least ★ then I know it's been reviewed and that it's ready for development.

<div style="text-align: center">**Bridge**</div>

Rating in Bridge

After the images have been imported, Bridge should now be showing the images. It's time to pick the keepers, choosing the images that deserve further attention. For this, we'll use Bridge's star rating system.

To apply star ratings, select an image (or many or all in a shoot), then:

1. Choose Label>*[the star rating you want, 1 through 5]*. This is far too tedious, so consider…

2. Use the commands ⌘+[1-5]/ Ctrl+[1-5]. If using the modifier key gets tedious, too, you can just type the number if you change the Label preference in Edit>Preferences (Windows) or Bridge>Preferences (Mac OS): uncheck the box that says you need to use the modifier to apply Labels and Ratings.

 Then, if you're using a full keyboard, you can place your fingers over the number pad (the numbers on the right-hand side), and your thumb over the arrow keys. Tapping the Right-Arrow moves focus to the next image, then tapping on a number gives that many stars.

3. Choose View>Review Mode. This gives a larger view of each image and lets you see the next and previous image as well as the one being reviewed. Your arrow keys let you progress through the images, the number keys apply stars, and if you click in an image, you get a loupe to check for sharpness and detail. Although the loupe remains as you change images, it takes a few seconds to resolve the magnified area.

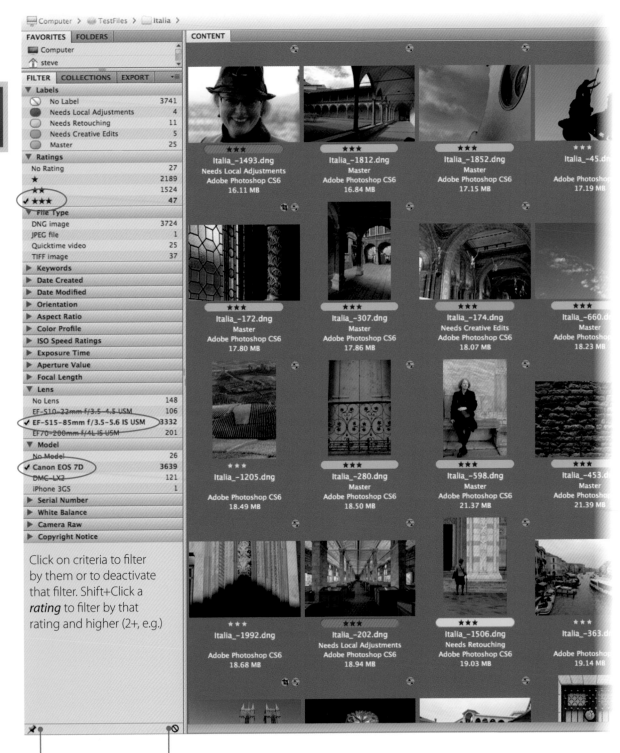

Click on criteria to filter by them or to deactivate that filter. Shift+Click a *rating* to filter by that rating and higher (2+, e.g.)

Keeps filters applied as you browse other folders

Clears all applied filters

Filtering in Bridge

To filter the view in Bridge, click on one or more criteria in the Filter panel (lower left by default). To show only those images that have been rated, for example ★★, you merely have to click on the ★★ row in the Filter Panel in Bridge.

If you decide to be *very* specific, and activate many criteria by which to filter, it's easier to use the Clear Filter button or use the shortcut ⌘+option+A / Ctrl+Alt+A when done.

Rating in Lightroom

If you wish to star-rate the images you have just imported into Lightroom, you can use one of several views in the Library Module.

Grid · Loupe · Compare · Survey

Grid View (your lightbox, as it were), Loupe View (where you can zoom in to gauge sharpness, etc.), Compare View (to judge between two images: the Select and the Candidate), and Survey View (for deciding from among several candidate images). I usually use Loupe view while rating, navigating with the Filmstrip at the bottom of the screen. That is, I'll use my arrow keys to move to the next or previous images, evaluating the large image in the image window, but noting what images are coming or past in the Filmstrip.

The tip I offered in the section on rating using Bridge (proceeding through the images using your thumb on the right arrow key, and using your fingers to press a number 1–5 to set a rating) is useful here. After going through and rating the images, you may wish to filter for, say, three stars or higher.

Filter Switch

Filtering in Lightroom

Lightroom offers two places to set a filter: to the lower-right, just above the Filmstrip; and along the top of the grid in Grid View only.

Above the Filmstrip, you can click on a star and then to the immediate left of the stars, a symbol (≥ , ≤ , or =). The symbol is actually a menu that lets you choose Rating is greater than or equal to, Rating is less than or equal to, or Rating is equal to. Finally, there is a small switch icon with which you can disable or enable your chosen filters.

At the top of the Grid, a very similar interface lets you build a filter based on a Rating **Attribute**, or a Label, Flag, or Copy Status attribute. But it has the additional ability to let you build a complex filter using any **Text** Lightroom finds in an image file's data, or indeed any **Metadata** that concerns you.

Choose the qualities by which to filter

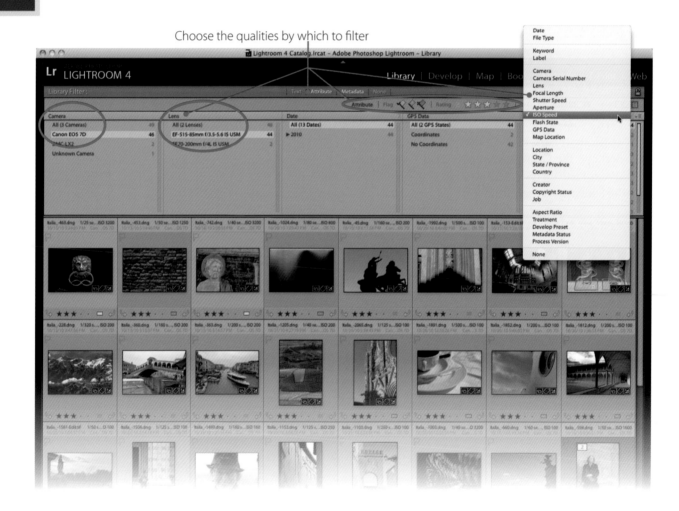

Keywords & Other Metadata

Of course you know your images and will recognize them when you see them. But first you have to find them in a sea of thousands. Also, you may not remember just where you were, who your subject was, or some other fact that should be associated with a particular image. These facts can be entwined with your images' other data as **Keywords** either at the time you download them or later.

These and more general data about your images are collectively called *metadata*. An important set of metadata that you should have associated with your images is your copyright and contact data. This core data, or any metadata, can be saved as a template (Bridge) or preset (Lightroom) that can be applied easily when importing your images.

Be sure your first template/preset is appropriate for *every* image you shoot: name, address, title, and other contact data; and, if applicable, copyright notice including at least a copyright symbol (option+g / Alt+0169), year of publication, and your name. I also recommend, unless you are using a code-based system (e.g. from useplus.com or creativecommons.org), using "All Rights Reserved" for the Rights Usage Terms.

Keywords

The keywording of images is a laborious task while you're doing it, but will save you tons of time when you search for images later. That's my way of saying, "take your medicine and do your keywording."

To have a robust list of keyword tags, you may use those made for you by a stock photo agency or other service (like Controlled Vocabulary) or your own. If you'd like to build (or buy) a set of keywords, it's best if they're in some kind of heirarchy. For example, **North America|United States| Washington|Seattle** or **Textures|Metal|Rust** (see figure below).

You can use the tools available in Bridge or Lightroom to do this (see next pages) or you may create a text file to import many of your keywords at once. If you are proficient in Microsoft Excel, you may choose to use that tool to lay out a grid of keywords, then export them as a tab-delimited, plain text file which can be imported into either Bridge or Lightroom. Or bypass the middleman and compose the text file (UTF-8 or ASCII) yourself following these simple rules:

▶ Each keyword tag is on its own line.

▶ Any keyword with one or more tabs before it (that is, having had the tab key pressed before it was typed) is the "child" of the nearest keyword above it with fewer (or no) tabs before it.

```
Textures
<tab>  Metal
<tab>  <tab>  Rust
<tab>  <tab>  Patinated Bronze
<tab>  Wood
<tab>  <tab>  Peeling Bark
<tab>  <tab>  Polished Mahogany...
```

Copyright & Contact Data: Bridge Metadata Templates

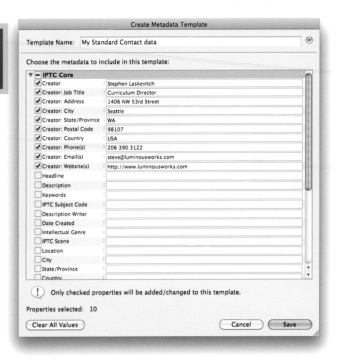

To construct your primary Metadata Template in Bridge, choose Tools>Create Metadata Template…

First, give your template a name (at the top). Then, fill in the important fields discussed on the previous page: your contact data, copyright, etc. Then click Save.

Now you may use that template when using the Adobe Photo Downloader (in its Advanced mode) by choosing the template from the Template to Use menu as shown above.

Keywords in Bridge

If you chose to build a keyword list as a tab-delimited text file, you should use the Metadata panel menu to load it. If it's your first set of keywords and you wish to be rid of the defaults, choose Clear and Import… Now your keywords will own the list. Notice the Export choice for sharing keywords with Bridge on other computers or with Lightroom.

To use Bridge to build a set of keywords, use the buttons at the bottom of the Keywords panel 🔖 ➕ 🗑 to add sub-keywords, keywords, or to delete keywords. To make the task of keyword generation less overwhelming, many prefer to add keywords as they're needed, applying them to images shortly after they are downloaded.

To apply a keyword to one or more images, you should select the image(s): click on a thumbnail to select one image, then **shift+click** on another image to select it and all the images in between, or use the ⌘/**Ctrl** key to select noncontiguously. Then simply click on a keyword's checkbox or **shift+click** to apply that keyword *and* its parent(s).

Lightroom

Copyright & Contact Data: Lightroom Metadata Presets

As early as upon import, you can apply keywords and your metadata preset—if you've built one. To do so, choose Metadata>Edit Metadata Presets... The areas to deal with first are IPTC Copyright and Creator. Fill in those key fields that are appropriate for *every* image you shoot: contact data, copyright notice, etc.

Note: When you have filled in the important fields, use the **Preset menu** at the top of the dialog box, and choose Save Current Settings as New Preset... which presents *another* dialog box. Give your preset a name like "My Standard Metadata" or similar.

When you're done, click **Done.** You can create more presets later for special circumstances, and apply metadata to each image that meets those circumstances.

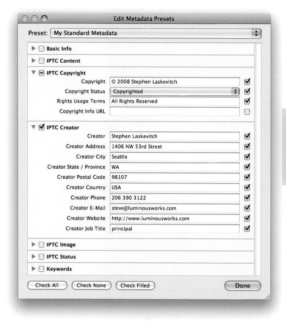

Keywords in Lightroom

To import a tab-delimited text file, choose Metadata> Import Keywords (use Export Keywords to create a text file from your current keywords). Just above the Metadata panel are the **Keywording** and **Keyword List** panels. Here is where you can quickly add keywords as they come to mind for selected images. As you add Keywords, they will appear in the Keyword List panel.

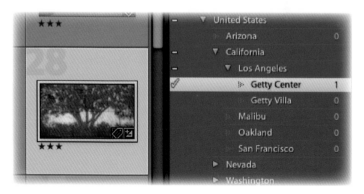

In the Keyword List panel, you'll see your growing list of keywords. As this list grows, organize it: for example, Neidpath Castle is near the town of Peebles in Scotland, so you can put the *Neidpath Castle* keyword tag under *Peebles*, and *Peebles* under *Scotland*.

Sometimes you may need to send images to others who may not have Lightroom. If you want those "Parent" or containing keyword tags to be exported with the images, you should control+click / Right-click on the keyword and choose Edit Keyword Tag. In the dialog that appears, you can specify synonyms (in case you forget the real keyword and use a synonym during a search) and ensure that the "Containing" keywords accompany any "child" keyword.

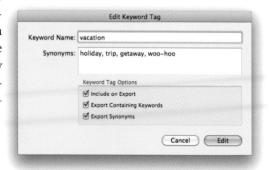

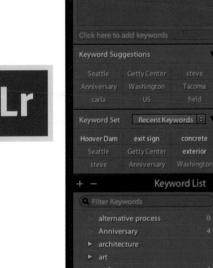

Keywords applied to selected image

Suggestions based on capture time and other criteria

Sets of 9 that can be applied with your keyboard's number keys

List of all keywords applied to images in Catalog

Click on box to apply keyword

How to Apply Keywords in Lightroom

In The Import Dialog Box

The easiest time to apply keywords is when you import images. A rule I try to obey when shooting is to keep each distinct shoot (scene, subject, etc.) on separate media (CF or SD cards). In this way, when I download images, I can enter keywords that are appropriate to all the images on each card.

One At A Time Or In Batches While Browsing

If you have many images to keyword, and they are already imported, you may select them in the Grid view of the Library module, then select one or more keywords. These will then be applied to all the selected images.

You select a keyword in one of several ways. You may notice that the one you want is being suggested by Lightroom in the Keyword Suggestions section of the Keywording panel. These are sets of nine keywords that Lightroom suspects are likely to be appropriate, based on similarities to other images with those keywords applied.

You can find the keyword listed alphabetically in the Keyword List panel. Be warned that you may have to click on a disclosure triangle to find a "child" keyword.

You may also use your keyboard's number keys. Hold down the option / Alt key: note the numbers that appear next to the keywords in the Keyword Set section of the Keywording panel. These can be the nine most recent keywords or any set of nine you would care to create. You can also apply these to a selected image by clicking on the keyword. To apply keywords from the keyboard: hold option / Alt and press one of the numbers 1–9 on your keyboard. Notice how the numbers correspond nicely to the layout of the number pad on an extended keyboard.

Paint Them On

Use the Painter can. Once you select it from the bottom of the Grid, you may type what keyword(s) you want it to "paint" onto the images you'll click on. You can apply many kinds of metadata this way—"Keywords" is actually one menu choice of many! When you're done, click the **Done** button, place the Painter can onto the circle, *or* press the esc key.

GPS Location Data

Some cameras (like the iPhone) can embed location data in their images. My primary SLR does not. Before Lightroom 4, I made an extra photo with my iPhone to manually use its GPS data to inform my SLR photos made at nearly the same time. This required my camera's time to be correct.

Now, I carry a small, affordable GPS receiver. I just turn it on in the morning of a day of shooting, throw it in my camera bag, and go. Like most of these devices, mine creates a tracklog: every few seconds it notes the time and its location (and mine) at that moment. Lightroom 4 merges these data, matching my location with the time of an image's creation.

Alas, on a recent visit to New York City, I forgot to adjust my camera's time. Luckily, Lightroom offers a quick fix: I selected all the images from that location (three hours later than my native Pacific time zone), then used the command Metadata>Edit Capture Time….

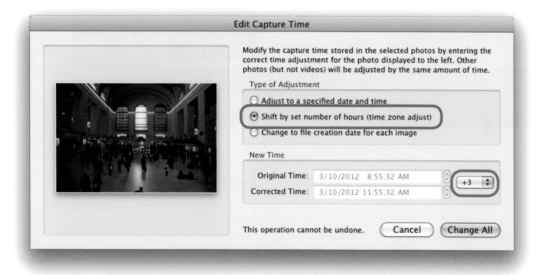

Then, in the Map module, I married the images to my GPS receiver's tracklog. This is my favorite way of tagging my images with location data. You may also simply drag images from the filmstrip onto the map, singly or many at once. To Auto-Tag, do the following:

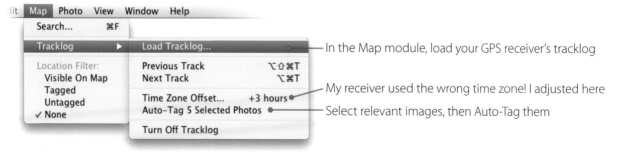

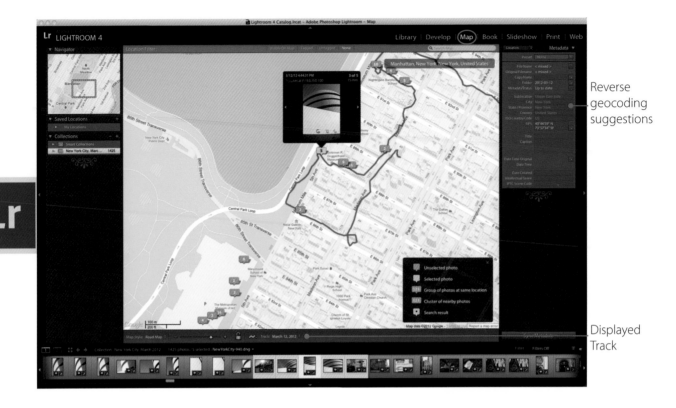

Reverse geocoding suggestions

Displayed Track

Labels: Workflow Landmarks

All images get imported & organized. Some (indicated by stars or flags) deserve Global Adjustments. Some need more. Here's how I label images as they pass through my workflow:

Needs Local Adjustment	Needs Retouching	Needs Creative Edits	Master	Alternate
An *area* of an image may need color or tonal fixes, sharpening/blurring, etc.	Spot & blemish removal, cosmetic retouching, etc.	Composite imagery, HDR, panoramas, toned B&W, etc.	Ready to share & archive!	A variation in crop or other treatment

As you progress through the workflow, you will need to know how far along a particular image has proceeded, or what else it needs. You may just want to label an image as "Ready to go." In the past, we depended on elaborate hierarchies of folders to govern our original files, copies we made for different purposes, other copies in various file formats for different clients, and possibly more for images prepared for specific output. The folder location of those files was the indicator of where they were in the workflow.

Photoshop and Bridge (through ACR) give us ways of nondestructively correcting and adjusting our images without maintaining all these copies. That is, we can make many changes to color, tone, sharpness, and even remove dust or other artifacts, all without really altering the original data. So if we make a mistake, or wish to make a different creative decision,

we simply make the new corrections. Much of this can be done in ACR and Lightroom, even more of course in Photoshop. In ACR and Lightroom, we can apply Camera Raw corrections to JPEGs and TIFFs, as well as proprietary RAW files and DNGs (Digital Negative format).

One image file can therefore be moved through the workflow, and even moved backward in it, without risking the original data captured by the camera. The trick is remembering where in the workflow a particular file is. So it is important to establish a labeling system that clearly identifies a file's status. The default labels attempt to do this, but somewhat generically. I propose some label names to match my workflow, but you should use phrasing that is meaningful to you.

In Bridge's Preferences, you can change the label text, but not the label color or order. In Lightroom, you may have several **Label Sets**, which are defined in the dialog box accessed via Metadata> Color Label Set> Edit...

In Bridge, you can also simplify the keystrokes (modifier key plus a number) you use to apply a particular label by unchecking the box at the top of that Preference page.

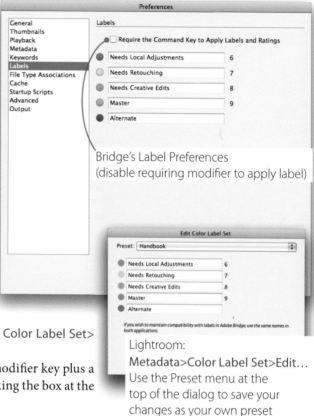

Bridge's Label Preferences
(disable requiring modifier to apply label)

Lightroom:
Metadata>Color Label Set>Edit...
Use the Preset menu at the top of the dialog to save your changes as your own preset

File Management

Folders vs. Collections

I just wrote that "in the past" we needed many folders to contain our images. But what about now? Both the Adobe Photo Downloader and Lightroom's Import dialog give you a chance to download your image to one all-encompassing folder (your Pictures folder, perhaps, or an external hard drive), and these dialogs can *automatically* create subfolders based on date.

However, you may also want more arbitrary arrangements: a Collection of images based on an ongoing series, or all pictures of family and friends. Fortunately, both applications (Bridge and Lightroom) have a feature called **Collections**. A Collection contains a reference to any image you want it to without the need to make copies that dwell in different folders. In fact, if you want, you can download all your images to one mighty folder, then use metadata filtering and your Collections to find the images you need. I'm not quite so brave, so I use the automatic date-based folders, too.

A Collection can contain images from many different folders, and one image can belong to many Collections. I like to think of Collections as clubs

to which an image belongs: just as one individual can belong to several organizations, an image can belong to several Collections.

For example, you may have a Collection for photos of trees and another for photos of friends. An image of a friend standing beneath a tree could belong to both without your having to make any copies!

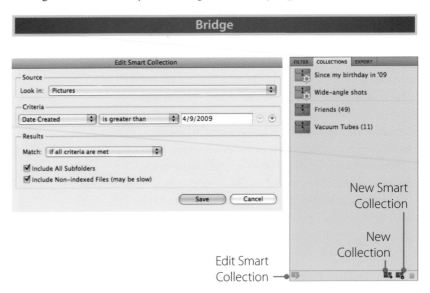

Edit Smart Collection

Sharing space with the Filter panel is the Collections panel. Along its bottom are buttons to create and edit your Collections. A feature that builds a Collection's content automatically is the **Smart Collection**. When editing a Smart Collection, you define criteria very much like search criteria. Later, if new images match these criteria, they are added to the collection.

Standard Collections can have images dragged to them. Or, when creating a Collection, a dialog asks if you want to include images that are selected in the Content area.

Lightroom

Lightroom also has Standard Collections and Smart ones. You may also have Sets of Collections so that you can establish a hierarchy.

To create a Collection or Collection Set, click on the + in the upper right of the Collections panel. If you choose a Standard Collection, you'll have the option to include photos that are selected and to make virtual copies (an option I rarely choose here). Remember to give your Collection a good name.

To edit an existing Smart Collection, double-click on its name.

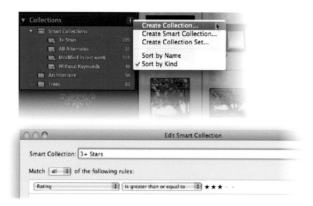

Lightroom also has a **Quick Collection**. When you press the **B** key, any image that's selected joins this temporary Collection. It's a fast way to, say, prepare a slideshow of quickly selected images. *Any* collection can be targeted as the destination when pressing the **B** key: control+click / Right-click on a Collection (not Smart ones) and choose Set as Target Collection.

Metadata Challenges

All the processing we do in Adobe Camera Raw and Lightroom, all the rating and labeling we do in Bridge or Lightroom, and much more is recorded as metadata: data about our images' data. But where?

Depending on the application and the files under discussion, the answer may not be obvious.

XMP Sidecar Files

For camera proprietary RAW files, to which very little data can be written from our Adobe applications, a small, separate file, referred to as a "side-car" file, contains our metadata in format standard known as eXtensible Metadata Platform or XMP. The danger with this is that we'll have two files to manage, the image and its metadata. Also, I get uneasy without my copyright data residing in the image document itself. These are really good reasons to use DNG format for RAW images, as the metadata will reside within the file.

The Document

For DNG, JPEG, and TIFF files, the document itself may contain the metadata. If imported into Lightroom or browsed by Bridge, a document with metadata will show that metadata (star ratings, GPS coordinates, develop settings, etc.).

However, in Lightroom, the "file" we edit as we work is a database (the Lightroom Catalog) and **not** the image file.

Lightroom

Catalog = Database

When you work in Lightroom, the document you've opened and are editing is not an image file, but a database with a name like **Lightroom 4 Catalog.lrcat**. This file is the first place your images' metadata resides.

When you're done with an editing session, I recommend selecting all the images you may have edited then choosing the command Metadata>Save Metadata to File. Note that there is no Save command in Lightroom's File menu. That's because the Catalog is saving itself continuously. But the image files won't "know" they've been edited until and unless the metadata within them (or their XMP sidecar files) have been updated. That is, no metadata will be embedded in the image file until you request that it is. And yes, I think this is just fine!

Resist the temptation to enable the preference for automatic saving of metadata to your files, as that constant disk activity will slow the application's performance dramatically. Just remind yourself to save your metadata when you are done with an editing session. Recall the shortcut for the Save command in every program you use: ⌘+S / Ctrl+S . It is no coincidence that this is the shortcut for saving your metadata in Lightroom! My fingers now instinctively move to Select All ⌘+A / Ctrl+A then immediately to Save (Metadata to Files) ⌘+S / Ctrl+S .

Moving & Archiving Files

You may choose to have your main backup system back up your image files. Some photographers use a mirrored RAID (Redundant Array of Independent Disks) as their main repository of image files, and thus have two (or more) physical disks each holding all the images. If one drive fails, the other(s) will still have the data. Many solutions like this exist from drive makers like G-Technology (g-technology.com) or independents like the Drobo from Data Robotics (drobo.com).

Although having redundant storage on site is good for protecting your data from device failure, it won't help in the case of fire, flood, or theft. So I use another external hard drive that I either carry with me when leaving my main devices at home, or that I store at another site. Yet another alternative is backup via the Internet to a server.

Bridge

After you've done all the work of sorting, organizing, and developing, you'll likely want to backup your images, too. Select the images to be backed up, then control+click / Right-click on one of them. In the menu that appears, choose Copy to> *[choose a backup volume & folder]*. This could be a waiting DVD or external hard drive that you store in a bank vault. It really should be a medium **not** inside your computer. Insurance may cover a stolen or flooded computer, but it won't cover lost files!

Take care to select only archival CDs or DVDs and to store them in a protected environment, e.g., away from light. Also, be advised that archiving with CDs or DVDs consumes lots of time and disks. The other mode of archiving, onto removable hard drives, is not archival: if left unused for many years, the data can be corrupted. Someday, perhaps, there will be a perfect solution. For now, store redundant files—just in case.

Lightroom

Catalog Backup & System Backup

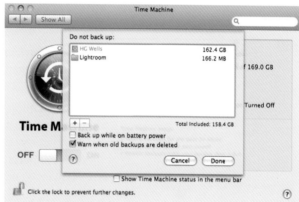

Have your automatic backup system exclude your Lightroom Catalog files (right) and have Lightroom take care of those every time you quit the app.

Depending on the choice you've made in your Catalog Settings, Lightroom will prompt you to back up the Catalog file when it launches (from every time to once a month to never—a bad idea). When it does offer the opportunity, you can also choose where this important file will be saved. I choose the same volume I'm using for my main backup.

Those of us who use an automatic backup solution, like Apple's Time Machine, should be aware of a risk. If this regularly scheduled backup occurs while you're working in Lightroom, there's a chance that the database file could become corrupted! So set your system backup to exclude your Lightroom catalogs and preview data files. Instead, let Lightroom's own backup take care of that. You should still back up your preset files, however.

Export as Catalog

To manually move or back up your work from Lightroom to an external drive or distant location, you'll want the relevant database information, all the metadata, and, of course, the image files. To do all that in one go, I use Lightroom's File>Export as Catalog... command. You may choose to create a backup Catalog for only some selected images or all the images in the current Catalog. I include all the "negative files" (our image files, whether they're JPEGs, TIFFs, PSDs, or RAW files) and the previews Lightroom has made. Sadly, we must manually move our presets and plugins.

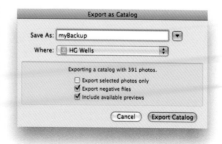

Multi-Computer Image Management: Two Examples

Bridge

If you use a laptop in the field, then need to move the files to your desktop computer, you may use the Copy To command discussed previously. Or, if you want to delete the images on the laptop as they are transferred to the new location, you can `control+click` / `Right-click` on your selected images, then choose Move to> *[choose the destination volume or folder]*. Copy or move the files either to your desktop via a network or to an intermediate hard drive.

Lightroom

Many of us have more than one computer and need to safely move images and our metadata from one to the other. It is not complicated to do so, but it's still easy to get Lightroom confused. So try these steps:

1. **From a laptop**, I choose File>Export as Catalog... and choose an external drive (see previous page) as the place to export. I export everything: the "negative files" and the previews. A liberating fact is that the name of this exported catalog is completely unimportant, as it's only an intermediary. Note that Presets aren't included in this export.

 I then eject the external drive before I attach that drive to my home/studio machine (or wherever the ultimate destination is).

2. **On the destination computer**, I launch Lightroom using my usual Catalog file there, and I choose File>Import from Another Catalog... I navigate to the external hard drive and the temporary catalog I exported from my laptop.

 I choose to *copy* the photos from their current location (the external drive) to the regular folder or directory on the destination computer. Upon clicking Import, all the images and their data will now be where they are needed.

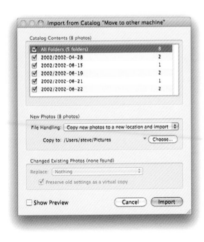

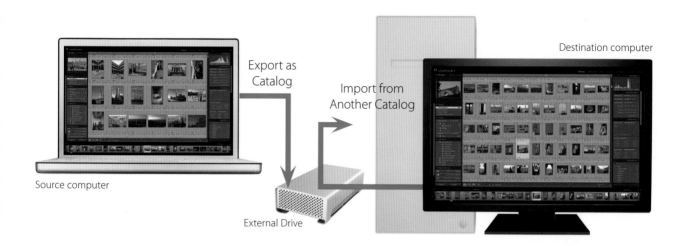

Source computer

Export as
Catalog

Import from
Another Catalog

Destination computer

External Drive

Global Adjustments

6

The big picture: does the image need a crop? Is it too blue overall? Or is it too flat? In this chapter, I'll focus on making the biggest difference to your images quickly so you can judge what else, if anything, needs to be done. For each major task, I'll start with defining the problem. I'll go over the things you should look for and consider correcting. Then I'll get into the details of fixing them.

Fortunately, many of these adjustments can be made in any of your applications: Adobe Camera Raw and Lightroom let you deal beautifully with the freshly captured image, and Photoshop has much to contribute at any point in the workflow.

I have organized this chapter primarily by the problems to be solved, in the order in which we often approach them. Find the issue, then engage your application of choice. I suggest that you read the solutions for all the applications so that you can decide for yourself which is best for you.

Nondestructive Editing: A Lifestyle

Your image files will likely be in one of three common formats: TIFF, JPEG, or RAW. Any of these can be edited by ACR or Lightroom, and *all* likely formats can be directly edited by Photoshop *except* RAW.

Nearly all the color and tone adjustments described for Photoshop use **adjustment layers** because adjustments made directly to the image are difficult or impossible to reverse. Lens correction and sharpening filters will be applied to Smart Objects. Use the Adjustments panel or Layer>New Adjustment Layer, *not* Image>Adjustments. Adjustments in ACR and Lightroom are *inherently* nondestructive; they are recorded as metadata settings and do not ever change the value of even a single pixel.

Getting Started

Opening a JPEG or TIFF image file by double-clicking on it in Bridge opens the file in Photoshop. If it's a RAW file, Adobe Camera Raw (ACR) will open, hosted by Photoshop, so you'll still have to wait for Photoshop to launch if it's not already running. However, there's a sure way to have ACR open, hosted by Bridge (no waiting for Photoshop), for JPEGs, TIFFs, *and* RAW files. Select one or more image files, control+click / Right-click on one of them, then choose Open in Camera Raw. Now you'll be able to make the majority of your global adjustments to one or all of the opened images, using tools that are nondestructive: they exist only in the file's metadata, and thus can be revisited many times, removed, copied, pasted to other images saved as Develop Settings, and more.

As well as the control+click / Right-click method of opening RAW files through Bridge, you can set Bridge's General preferences to have Bridge host ACR.

To make adjustments in Lightroom, select a folder, collection, or single image in the Library module, then choose the **Develop** module. Although you may have more than one image selected, your adjustments will be applied only to the image that is most selected unless you enable **Auto-sync**. After an image has received its adjustments, you may choose to synchronize those adjustments with other images.

White Balance

Key Concept

An odd but essential shorthand for quantifying the color of light is **White Balance**. The number used (e.g., 2850 or 6500) is actually a temperature in the Kelvin scale (for more common units, just subtract 273 to get a temperature in Celsius). Why would anyone use a temperature to describe color? If one heats what is known as a "black body" (imagine a chunk of matte black metal which absorbs all light), it will eventually glow visibly. A temperature of about 3000K is equivalent to a standard tungsten light. In our software, 6500K is considered the same as daylight. That's why 6500K is a target for the white glow of a computer monitor.

When adjusting our images in Camera Raw or Lightroom, one of the first things we do is set the White Balance, specifying the color of the light in the scene so the software can adjust all else. So if the light was very yellow indoor lighting, the 2850K tungsten preset may add the right amount of blue to compensate.

For less predictable lighting, both software programs offer a White Balance tool to sample a light gray in the image. Since the software assumes that it's a light *gray*, it will choose the right color temperature (and accompanying tint) to make it gray if it isn't already.

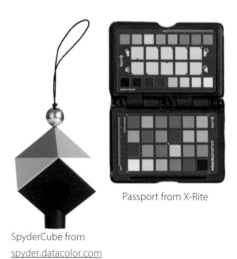

Passport from X-Rite

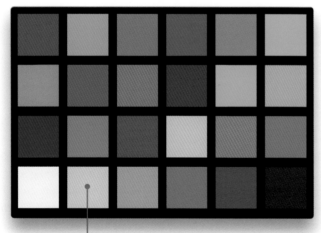

The perfect gray for reading White Balance. This chart is the Color Checker from X-Rite: xrite.com/colorchecker.

SpyderCube from
spyder.datacolor.com

If there are no light grays in your subject, add one! Carry a Color Checker or similar product (right) or, as I do, carry a light gray camera bag for a convenient gray patch.

Procedure

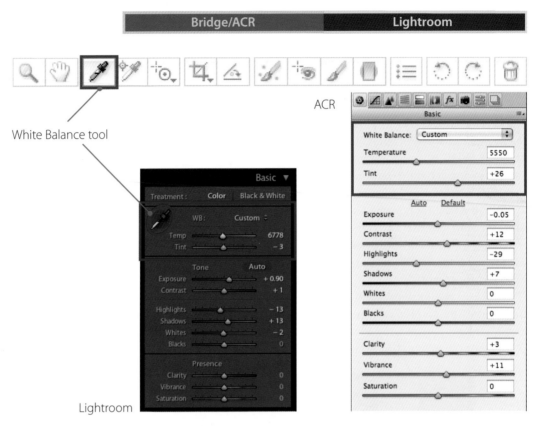

White Balance tool

ACR

Lightroom

Basic, the first adjustment panel, has the most important controls for global adjustments. The White Balance control sets the overall color balance of the image. The default As Shot setting uses the control values set in the camera when the image was shot. As Shot values often work well, but if the image color seems off, try adjusting the Temperature. The Temperature control makes the image appear warmer (more yellow) or cooler (more blue). The Tint control makes the image appear more green or more magenta.

If there is a light gray in the image, or rather an area that should be light gray, you may try clicking on it with the **White Balance tool**. This one click will set both the Temperature and Tint sliders to make the area on which you clicked a neutral gray. As this is based on the light in the scene, you can choose a light area (not too light, however; there needs to be some tone where you click).

The White Balance eyedropper, located in the Basic panel, acts like a docked cursor. When you click on it, it becomes your cursor and is joined by a very magnified pixel grid (a Loupe) so you know exactly which pixels you're using to set the image's White Point.

While that tool is active, you can zoom the Loupe by mouse scrolling or by using the Scale slider at the bottom of the image (that slider isn't there

unless the White Balance tool is active). Once you set your White Balance by clicking, the tool will automatically dismiss itself, returning to its home in the Basic panel.

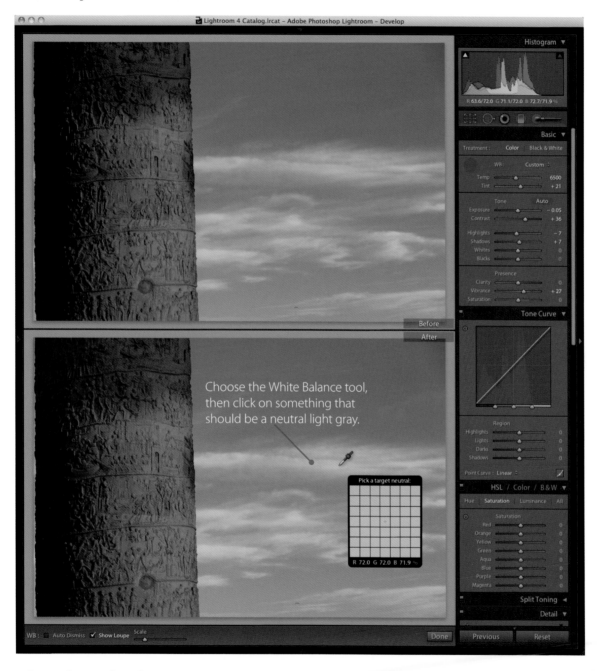

White Balance is best done in Camera Raw or Lightroom. Really. There are tools in Photoshop that, with a lot of work, can get close, but nothing beats the efficiency of a one-click correction!

Tone

Key Concepts

Histograms

From photography's beginning, tone has formed the heart of image adjustment, so I thought we should spend a few minutes going over the key concept of **histograms** before we start working. If these ideas are familiar, skip ahead to the actual procedures.

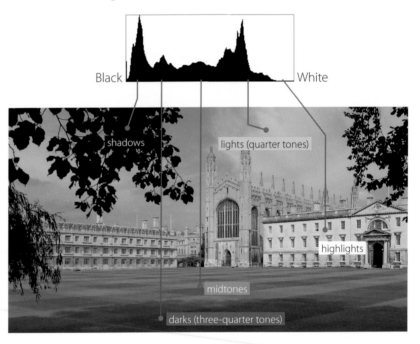

The histogram is one of the key tools for objectively analyzing digital images. It provides a graph of the density values of an image. The histogram shows the relative quantity of pixels at each density value. The left-most point of the histogram is pure black (most dense) and the right-most point is pure white (no density). A big peak in any of these regions means the image has lots of pixels at this density; an open gap in the histogram means there are no pixels at this density.

Use the distribution of the histogram to determine the overall exposure of an image. The rule of thumb is that many images look best if they contain values at both the dark and light ends. Without some dark and light values, the image may lack contrast and appear flat. If you have a strong peak at the black or white end of the histogram, it's possible your image is under- or over-exposed. Much depends on the individual image and personal aesthetic.

Consider the five examples below:

1. Underexposed image, or a dark subject with much black

2. Properly adjusted

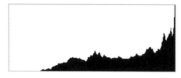

3. Overexposed image, or a light subject with much white

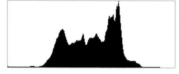

4. Probably too "flat" (lacking contrast)—or a foggy day

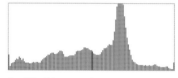

5. "Flat" image that was over-corrected; now posterized

1. A histogram representing an image that is likely underexposed with a spike at the black end indicating that many pixels "clipped" (black, without detail).

2. A smooth histogram representing an image with a full range of tones.

3. A histogram of an overexposed image, clipped at the white end.

4. A histogram representing an image that is likely too "flat", and therefore possessing neither highlights nor shadows; or, it's a histogram of an image of a flat scene correctly rendered.

5. A histogram with a comb-like appearance representing an image with sparse tones. This image may appear banded or blotchy (posterized), especially when printed.

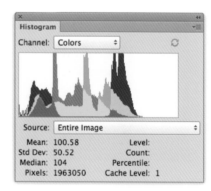

Expanded Photoshop Histogram panel

Photoshop's histogram panel provides a real-time histogram of the active image as it is being edited. In the **Photography** workspace, it's the top panel that shares a window with both the Navigator and Info panels.

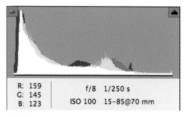

ACR histogram

Keep these things in mind when using Photoshop's Histogram panel:

▶ First, make the histogram display as large as possible. Do this by opening the histogram panel menu and selecting Expanded View or All Channels View.

▶ Second, the Histogram panel uses cached data to update the histogram in real-time, but this cache quickly becomes out-of-date and inaccurate. When this happens, Photoshop displays a warning icon ⚠. Click on this icon to update the panel and get an accurate histogram.

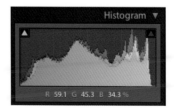

Lightroom histogram

Of course, Lightroom and ACR show a very similar panel. Lightroom's is even interactive: if you drag left or right on different parts of the histogram, tones change in the image.

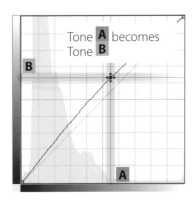

Tone Curves

All three of our applications have an interactive graph for adjusting tone (and in Photoshop's case, color as well). The horizontal axis represents our tones from black (at left) to white. The vertical axis has black at the bottom. A straight line going from the lower left to the upper right, the default, indicates that the tones coming into the adjustment leave unaffected. But if you caused the center of the curve to bow upwards, then the midtones would be lightened while black and white would remain unadjusted.

Some Sample Curves

You can effect great tonal changes with Curves. In fact, some Photoshop gurus claim they can do almost everything using Curves. Here are a couple of basic examples for changing image brightness and adding contrast.

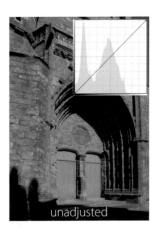

unadjusted

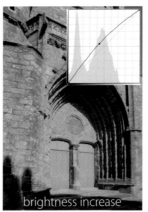

brightness increase

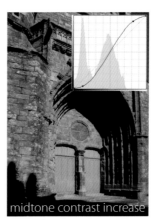

midtone contrast increase

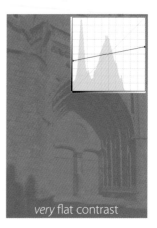

very flat contrast

To change image brightness, click near the center of a point curve to create a point, and drag it upward. This makes most of the image brighter (except the very brightest and darkest parts).

To add contrast to an image, create a point at the quarter tone of the image (about ¼ of the way from the white point) and another at the three-quarter tone of the image (about ¼ of the way from the black point). Move the quarter tone point upward (brightening the brighter parts of the image). Move the three-quarter tone point downward (darkening the darker parts). Now we have a classic S-curve. Contrast is added by darkening the dark pixels and lightening the bright pixels. The result is a curve that is *steeper* through the midtones without clipping white or black.

Finally, remove all the points (just drag them off the line) and try moving the white point straight down almost halfway, and the black point up almost halfway. The curve is now almost a flat line. The image has almost no contrast. Could this be why a low-contrast image is referred to as flat?

Note: Where a curve is steepest, the contrast is greatest. When you add contrast to one part of the tonal range, you borrow it from the adjacent part(s).

Procedures

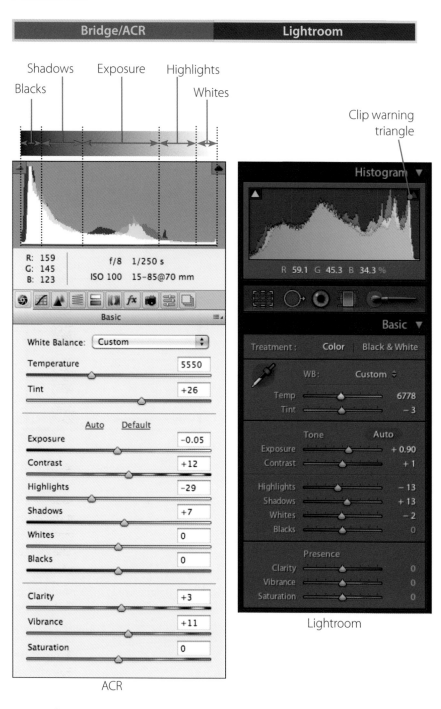

ACR

Basic adjustments are the most important RAW adjustments. Adjust the sliders Exposure through Blacks to achieve a mostly balanced image. Watch the histogram to make sure you're not losing data (unless you want to do so). The following descriptions of these sliders will be helpful.

One thing to note in Lightroom is that instead of ACR's panels, which you can see only one at a time, you have panels that can all be expanded and scrolled through. However, some find this to be quite a lot of scrolling. To see one panel at a time, control+click / Right-click on a panel's header (on the word "Basic" for example), then choose Solo Mode. Each panel's solid disclosure triangle becomes dotted, and as you go from one development panel to another, the previous panel will automatically close. Also, on the left edge of all the Develop panel headers (except Basic), there is an on/off switch like we saw with the Filters. This is a nice, quick way of seeing a before and after just for sharpening, for example, or perhaps toggling a color adjustment on and off.

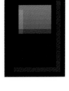

ACR

Lightroom
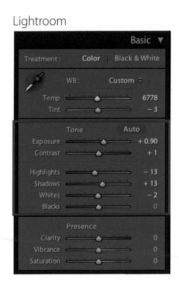

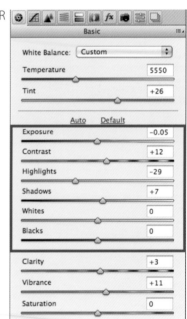

Exposure & Contrast

If you need to see those bright and/or dark details, pull the Exposure slider left or Blacks slider right. Now, if the bright areas look muddied or the shadows still need more light, move the sliders to points where the image looks good overall, even if there's clipping in the highlights. If there is, you'll need to adjust Highlights and Shadows.

Highlights & Shadows

Take a look at the histogram to see if there is clipping in the image. A helpful aid will be the triangles at the top corners. If one or the other is no longer a dark gray, then you know that some pixels are lost in the highlights or shadows. Other signs of clipping are spikes at each end of the histogram. Click

on a triangle to highlight the pixels that are being clipped. It's not always bad to clip: you may want mysterious shadows or bright reflections without detail. But if important detail is lost, these sliders can help.

If Highlights and Shadows can give only a compromise between good overall brightness and clipping, then you can pull down the brightest pixels with Whites and illuminate the dark areas (but not the very darkest blacks) with Blacks.

Whites & Blacks

These sliders adjust clipping in the light and dark ends of the dynamic range. As you move these even slightly, you'll notice that clipping gets either worse or cured very quickly. If you need to make a reflection sparkle a bit more, you can introduce highlight clipping by dragging Whites to the right. You can make shadows inky black by dragging Blacks to the left.

Tone Curve Panel

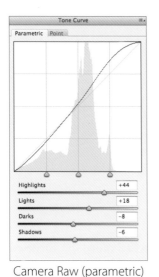 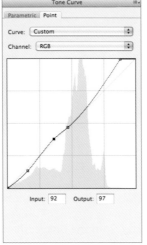 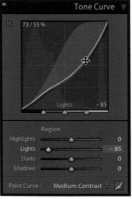 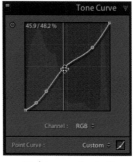

Camera Raw (parametric) Camera Raw (point) Lightroom (parametric) Lightroom (point)

Tone curves are often challenging to new users. But the **Tone Curve** of ACR and Lightroom offers a powerful and more intuitive way to make curve adjustments: the "Parametric" interface. It has sliders for each of the four parts of the tonal range, from lightest to darkest. As you drag each slider, the curve changes, as does the image. In ACR, tap the "**P**" key to get a before-and-after view; in Lightroom, use the small switch near the name of the panel. Again, I encourage you to watch the histogram to be sure you're not losing important detail.

The three sliders along the bottom of the curve grid are for changing each range's tonal width, e.g., where **Highlights** give way to **Lights**, or **Darks** to **Shadows**.

You may also choose a Point Curve. ACR has a tab at the top of its Tone Curve panel and Lightroom a button in the lower right. Click along the line (that is, curve-to-be), to create a point at which to control tone. Dragging the point up or down lightens or darkens that tone. With either method, note that contrast is enhanced when the curve is steeper through the peaks in the histogram you can see under the curve. You may also make adjustments channel-by-channel much as you can in Photoshop (see page 155).

See the Sample Curves above for experiments you might try.

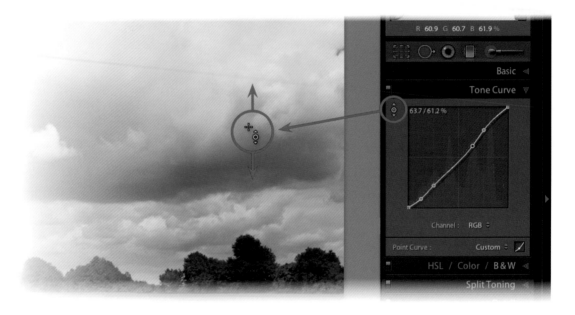

To choose tones directly from the image, there is a tool called the **Targeted Adjustment Tool** (or **TAT**). Once you have it, move the cursor over the image. The crosshair is the actual cursor; the target with arrows above and below it is there as a hint. As you move over the image, the curve shows you the tones under the cursor; if you press and drag up and down on the image, you most affect tones like those just under the cursor. So if you press and drag vertically on a very light pixel, your image's highlights will be adjusted, and so on. This will spoil you—luckily, there *is* a similar "on-image" editing ability with Photoshop's Curves adjustment, too.

Note: Be sure to dismiss the TAT when done with it to prevent accidental adjustments. In Lightroom, click the Done button below the image window. In ACR, choose another tool (I prefer the Hand) to dismiss the TAT.

When adding any adjustment layer (via the Adjustments panel), you will notice a new layer appears and that the new (in CS6) Properties panel displays the controls for that adjustment. The following are great ways to adjust tone in an image. Later, we'll add color to the conversation.

Each adjustment discussed has an example to illustrate it. But keep in mind that every image offers its own special challenges, and therefore sometimes you will need to use more than one of the following to achieve your goals.

Brightness/Contrast

CS6's new Auto Tone is the simplest way to adjust these attributes. Once dismissed as horrible, this tool is now quite useful, though it offers little control. You may find that this tool works great if the color does not need to be adjusted.

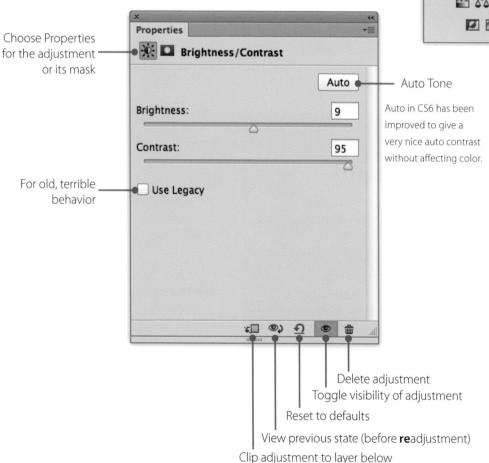

Choose Properties for the adjustment or its mask

Auto Tone

Auto in CS6 has been improved to give a very nice auto contrast without affecting color.

For old, terrible behavior — Use Legacy

Delete adjustment
Toggle visibility of adjustment
Reset to defaults
View previous state (before **re**adjustment)
Clip adjustment to layer below

Let's consider an example of an image that is very flat but has decent color.

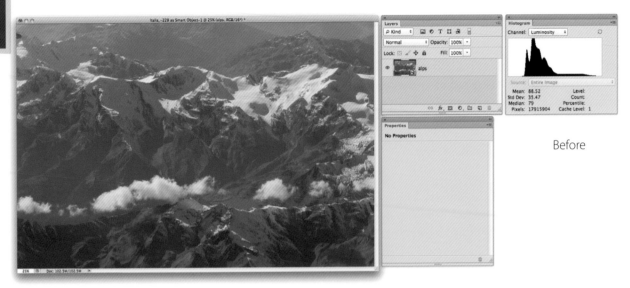

Before

We can see that the conditions were somewhat hazy, preventing this from being as lovely an image as we'd like it to be. So we added a Brightness/ Contrast adjustment.

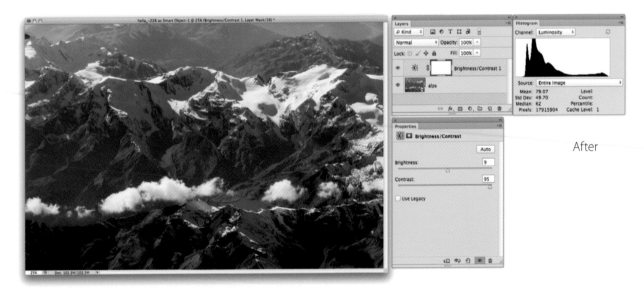

After

Pressing Auto increases the Brightness slightly and the Contrast substantially. I also tried this manually, and found that I chose very nearly the same values! The histogram may look only slightly different, but you can see that there are many more lighter pixels and that the darkest pixels have become somewhat darker, too.

Levels

To make more precise tonal adjustments in Photoshop, use the Levels Adjustment. It's a great tool for defining black and white points, making the overall image lighter or darker, and doing quick color corrections. To access Levels, select the appropriate button in the Adjustments panel.

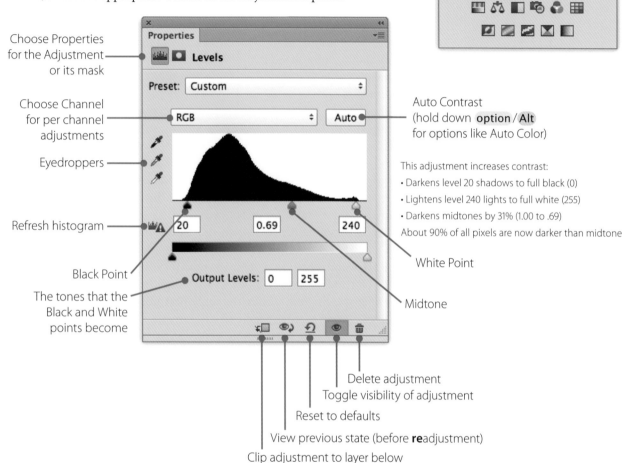

Choose Properties for the Adjustment or its mask

Choose Channel for per channel adjustments

Eyedroppers

Refresh histogram

Black Point

The tones that the Black and White points become

Auto Contrast (hold down **option / Alt** for options like Auto Color)

This adjustment increases contrast:
- Darkens level 20 shadows to full black (0)
- Lightens level 240 lights to full white (255)
- Darkens midtones by 31% (1.00 to .69)

About 90% of all pixels are now darker than midtone

White Point

Midtone

Delete adjustment
Toggle visibility of adjustment
Reset to defaults
View previous state (before **re**adjustment)
Clip adjustment to layer below

The Levels dialog contains a histogram with slider controls:

▶ The black point slider, to darken shadows

▶ The midpoint slider, to lighten or darken overall

▶ The white point slider, to lighten highlights

Note: watch the Histogram panel while making adjustments.

The black point slider can be moved to set dark pixels to pure black. All the pixels represented in the histogram directly above and to the left of the black point slider will be changed to total black, clipping them, and all the other pixels in the image will therefore be closer to the black point, making the image darker.

The white point slider similarly sets the full-white pixels and makes the image brighter.

Adjusting both the black and white point sliders stretches the histogram towards both the black and white ends, resulting in an increase in image contrast.

The midpoint slider sets the middle-gray pixels. At the same time, it sets all the pixels to its left darker than middle gray, and those to the right brighter than middle gray. This may seem counterintuitive since you slide the midpoint slider towards the right (closer to the white slider) to make the image darker, but the image preview displays the change to the image as you adjust it.

The preview buttons (the eyes at the bottom of the panel) are key to adjustments in Photoshop. Leave the adjustment visibility on to see the effect of the current adjustment in the Image window, and off to see the image before any adjustment was done. This is great for checking out subtle changes to your image. The "Previous State" preview button is helpful when you return to an adjustment that was done earlier. When pressed, it shows the image before your most recent tweak.

Levels is commonly used with two basic adjustment types: 1) setting black and white points and 2) changing image brightness.

A black and white point adjustment is very simple: drag the black and white point sliders in far enough so the image has some black pixels and some white pixels. This is often the single best adjustment you can make to an image, since it ensures good overall contrast.

A brightness adjustment using Levels is also very simple: drag the midpoint slider to the left or right to alter overall image brightness. One of the advantages of the Levels adjustment is that it allows changes to the brightness of midpoint pixels without major changes to shadow (black) or highlight (white) pixels. The Levels adjustments discussed so far, including Auto, are monochromatic: that is, they don't have much effect on color.

But our images are made of three grayscale images (the channels) that govern red, green, and blue. These can be adjusted individually to affect color. This is called a *per channel contrast* adjustment. If you hold option/Alt as you press Auto, you can at least begin such an adjustment automatically.

Example: Precise Black & White Point Adjustment

Most images should have full contrast, from a rich, maximum black to bright white. However, just as there should be good highlight detail, the density of maximum black should be set precisely so the shadows still retain some density variation. A balance is difficult to achieve just by eye. Levels is excellent for precisely adjusting the image pixels to these values.

1. To create a new Levels Adjustment: click the Levels button in the Adjustments panel.

2. Examine the histogram for your image; ideally, the histogram will cover the full range of tones from black to white. Note which end(s) falls short.

3. Holding option / Alt , slide the black input slider to the right. As you drag, the view of the image will go white, with a few small areas of black and/or color. These ares will be clipped by this adjustment. Don't go too far! When you release, the image will be darker with some black.

4. Pressing option/Alt while moving the white input slider will show the areas that will be clipped to white. Typically, the white point should be set so that just a few pixels will display as pure white; you may even wish to pull back the white point from making any pixels pure white (as in portraiture). Solid white parts of the image often appear artificial and may lack smooth details that you might expect in your highlights.

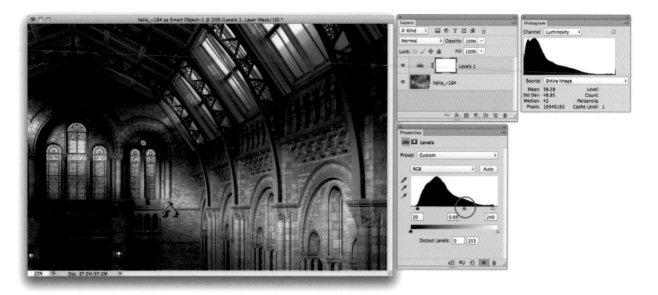

5. In this image, our white and black point adjustments needed to be minimal to preserve detail, but still left us in need of contrast. So we moved the midpoint slider right to make more of the image darker

while leaving the highlights intact. Note that the bulk of the histogram is to the left of this slider (darker than middle gray).

For images with smooth highlights (such as portraits), you may wish to maintain a separation between the highlights and pure white. Pushing the whites of a portrait to pure white, even on just one channel, may appear ghastly.

Curves (Take 1)

To refine your image tones with far more precision than Levels, use the Curves adjustment. Curves is commonly used to adjust contrast in the image and to make precise adjustments to individual tonal ranges in the image. It does everything Levels does and much more!

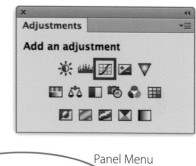

To access the Curves dialog, click the Curves button in the Adjustments panel. Manipulate the adjustment in the Properties panel.

The horizontal axis represents the input values for the tones; the vertical axis represents the output values. The tones are displayed on the bottom and left of the curve as a black to white gradient. Use this gradient to visualize the various tones as you adjust your image. The default curve is a straight diagonal line. This straight line maps the input values to the output values, leaving the image unchanged.

To make a simple lightening adjustment, click on the curve (line) to create an adjustment point, and drag the point upward. (**Note:** You can also use the keyboard arrow keys to move adjustment points.)

Click on another part of the curve to add a second point and drag it up or down to see the effect on the curve. Points can be removed by simply dragging them outside of the Curves graph.

In grayscale images, Photoshop reverses the direction of the input and output gradients (from light to dark rather than dark to light), so the metaphor for pushing the curve upward is that you're adding ink or pigment rather than light. To change the metaphor from light to pigment and back, access the panel menu and choose Curves Display Options. I use this dialog box to show 10% increments so I can enjoy finer control of my adjustments.

Following is a Curves adjustment using the Targeted Adjustment Tool.

In this example, I wanted to bring out more shadow detail in the bronze sculpture without affecting the sky too much. This would be helped by the fact that the tones in the sculpture and the sky are very distinct: note the

two clearly separate humps in the histogram. So I created a new Curves adjustment.

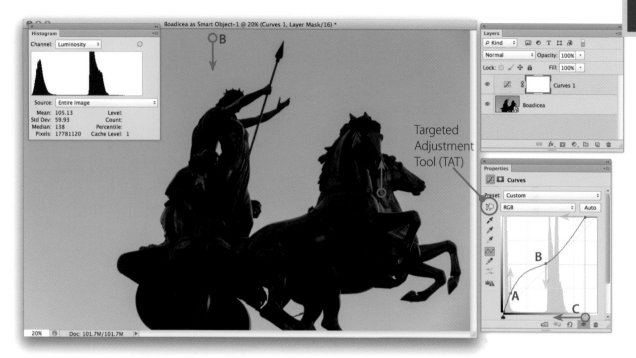

I clicked on the pointing finger icon in the Curves Properties to enable the Targeted Adjustment Tool.

You want to be sure that as you sample, you are not misled by some stray dark pixel in a predominantly light area, or a light pixel in a mostly dark area. So control+click / Right–click somewhere in the image, and you'll be presented with a list of dimensions that Photoshop will sample and average, ranging from a single pixel (Point Sample) to an area of over 10,000 pixels (101 x 101 Average). Choose a size that is consistent with the pixel dimensions of your image (larger for a 12-megapixel camera than for a 6-megapixel camera) and the details in your image (e.g., larger for fabric to average over a weave, smaller for smooth surfaces). In this image, I chose 11 by 11.

I then found a light part in the bronze. Using the TAT, I clicked and dragged upward (**A**), making that tone lighter while leaving black unadjusted. Note in the Curves Properties that a point has appeared on the curve and has moved the entire curve upward. This brought out much detail in the statue, but also lightened the sky far too much.

I *may have* prevented this by first clicking (without dragging) somewhere in the sky (perhaps where my **B** point eventually will be). But I did not fully anticipate that need. So I put my cursor over a darker part of the sky, then clicked and dragged downward, creating another adjustment point (**B**). Now look at the curve and its histogram. The curve is now steeper

through the darkest parts of the image (the leftmost spike in the histogram) but is fairly flat in the lighter areas (the other spikes to the right). The tones between my A and B points have been flattened a great deal, but the absence of any humps in the histogram in that region means that no part of *this* image actually has those tones.

To make the curve to the right of the B point less flat, I dragged the white point slider left. Notice I did not bring it too close to the rightmost spikes. I did, however, try to get the curve to be as steep (diagonal) as it was when we started, so the sky would have roughly the same contrast as it did then.

Shadows/Highlights

After making the tonal adjustments so far discussed, the result should have good overall tone. However, in some images, correcting the shadows and/or highlights results in flat areas with little detail.

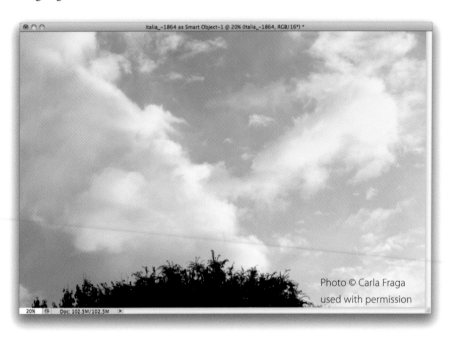

Photo © Carla Fraga
used with permission

The **Shadows/Highlights** adjustment is an effective and fairly easy-to-use tool that allows you to restore some of the detail within the shadows and/or highlights without making significant changes to the overall tone. With Shadows/Highlights, you are able to edit the local contrast within these areas.

Note: The biggest limitation of Shadows/Highlights is that it is not available as an adjustment layer, therefore not through the Adjustments panel. You will need to make a Smart Object (see chapter 3) because this "adjustment" is really a Photoshop filter (it just hides in the Adjustments menu). So later,

since it's been applied to a Smart Object, we'll be able to revisit it or mask its effects!

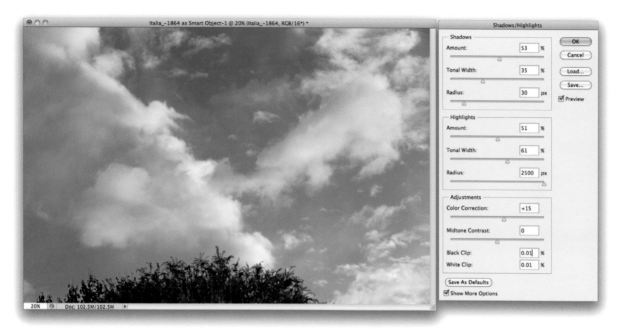

To create a new Smart Object on which to perform the adjustment, select all the layers that make up the image that needs to be adjusted.

control+click / Right-click on one of them and choose Convert to Smart Object from the context menu. The Smart Object will get the name of the former top layer; you may wish to rename it. To get to your original layers again, you simply double-click on the Smart Object's thumbnail and follow the directions that appear.

Open the Shadows/Highlights tool by selecting Image>Adjustments> Shadows/Highlights…

Check the box to "Show More Options." Make the smallest adjustments to **Amount** that help the image. If your shadow or highlight areas cover a large part of the image, like clouds or the shadows of buildings, then use a large **Radius** value. In this image, the "highlights" have a radius of thousands of pixels, but the "shadows" are small branches only tens of pixels across. Adjust with an eye to the important details in the image. **Tonal Width** is a measure of how far the adjustment should extend from extreme white or black. Experiment to find the appropriate value (I find that it often works well at about 33%). In this example, I wanted to darken the highlights through the midtones, so the "highlight" tonal width is set very high.

After you've made the adjustment and clicked OK, you'll see that the Smart Object now has "Smart Filters". This adjustment is really a filter and thus can be treated like one. As a Smart Filter, it can be masked, readjusted (just double-click on it), and have its Blending Options adjusted.

HDR Toning

Not really a way to create High Dynamic Range images, but rather a way to get a style of image that has become rather popular, HDR Toning was introduced in CS5. It is an adjustment that can be applied only to a Background,

not to Smart Objects or any other layers, nor can it be applied as an adjustment layer. You'll have to duplicate the entire image to apply this adjustment without harming your original. Choose Image>Duplicate..., and give the new document a name. Then choose Image> Adjustments>HDR Toning...

The settings here may give you a starting point from which to begin your own exploration. Clearly, this adjustment is for creating interpretations of our starting image. In the next section, we'll look at less impactful ways of doing that.

Photo by Carla Fraga
used with permission

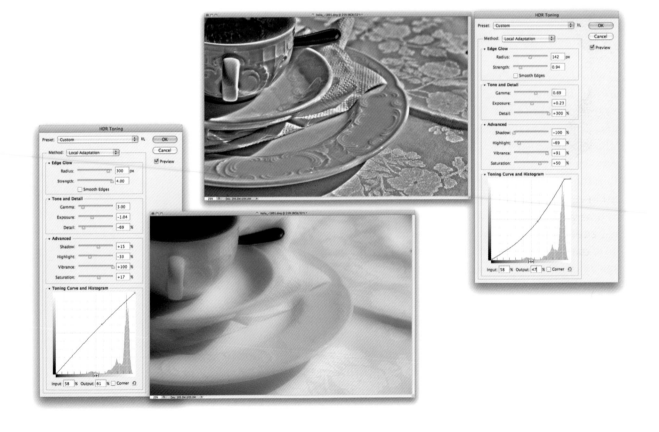

Color & Presence

Color adjustments are usually more subjective than tonal adjustments. Mood is set with these. Whether we're making colors more or less intense, or removing them entirely, we are expressing ourselves in the image. Diminishing local contrast can take years off the apparent age of a model; increasing it can make a subtle texture rich and almost tactile.

Contrast is a complex idea in photography: it is the juxtaposition of differences within an image. Contrast can involve tone, form, texture, color, saturation, or focus. I'll mostly focus on tonal contrast or color contrasts, but these are interesting ideas to keep in mind as you create your images.

Key Concepts

Hue, Saturation, & Luminance

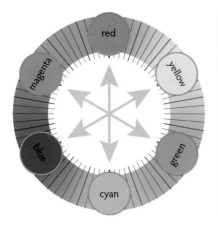 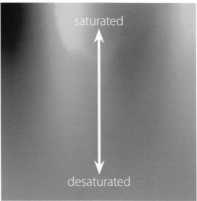

Most of our images may be composed of red, green, and blue data, but we may interact with them in other ways, too. Consider the phrase, "dark, intense red." Those three words describe Luminance, Saturation, and Hue.

Of course, **Luminance** is a way to express brightness (image geeks may complain that there's a difference between luminance and brightness, but for most of us, that is an academic concern). **Hue** is often expressed as an angle on the color wheel. A 180° change in Hue means changing a color to its opposite (or complement). **Saturation** is a measure of the purity of the Hue: if many hues are mixed, the color becomes grayer, whereas a purer hue is very intense.

Split Toning

Split toning has traditionally been a chemical process done to photographic prints to give tints to different parts of the tonal range. In our adjustments, we can give the darker areas a bluish tint, for example, while giving a yellower tint to the highlights to simulate a warm-toned paper.

Procedures

Clarity

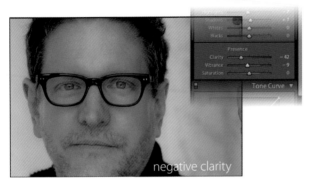

negative clarity

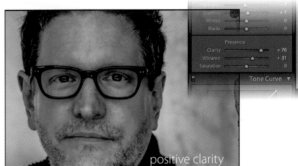

positive clarity

Clarity is what Adobe calls local contrast—contrast at the edges of things. Its effects are similar to sharpening, so a modest change in Clarity can change the apparent sharpness in an image. This slider can be used for a soft-focus effect by dragging it to the left. Portrait photographers may find the effect pleasing. In this image, that sad, old face is made both a bit younger (left) and older (right) with the Clarity slider in Lightroom. The original reality is somewhere in between. So although this is a tonal adjustment, Adobe and I include it in a different catagory because it has a greater influence on the feel of the image than its overall tonality.

Vibrance & Saturation

Vibrance and Saturation are very similar to one another. Either can be used to enhance or subdue the color intensity in an image. The difference is that Saturation can cause a loss of detail in one or more of the color channels (red, green, or blue); i.e., it causes color clipping if the Saturation level is too high.

HSL

These adjustments control eight different hues from red through magenta. You can shift hues (e.g., make oranges more red or more yellow), make them more or less saturated (take red out of someone's face), or make them lighter or darker (make a sky's blue darker and more rich). This is a marvelous way to emphasize some colors and de-emphasize others, unlike the saturation controls under the **Basic** panel which are global.

original

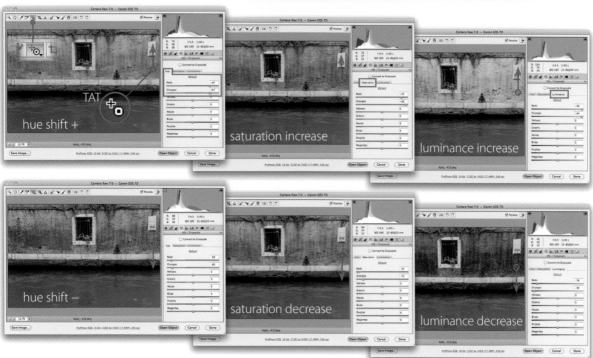

hue shift +

saturation increase

luminance increase

hue shift −

saturation decrease

luminance decrease

► **HSL** Hue, Saturation, and Luminance, like ACR's shown here. You're given a list of hues, and you use sliders to shift those hues, or their saturation, or luminance.

► **Color** Lightroom only. Each hue has three sliders grouped with it for adjusting hue, saturation, or luminance. Same idea, different arrangement.

In both ACR and Lightroom, I choose which of these three attributes I wish to change (H, S, or L), then use the Targeted Adjustment Tool (TAT) to click on the hue that I wish to change. Then I drag up or down to increase or decrease that attribute.

Black-and-White

If you check the **Convert to Grayscale** box (ACR) or on **B&W** (Lightroom), you will see eight sliders, one per hue, to control the tones of those hues in the original color image. Remember, no data is lost in ACR or Lightroom—all the color is still there but merely hidden.

This mixing is similar to, but infinitely more flexible than, what photographers shooting black and white film would do with colored filters on their lenses. For example, in this image we can decide to emphasize or hide the numbers by lightening or darkening the oranges and yellows in the grayscale conversion.

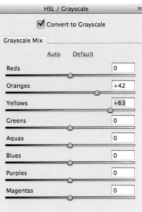

Above, the yellow/orange numbers in the image are lightened

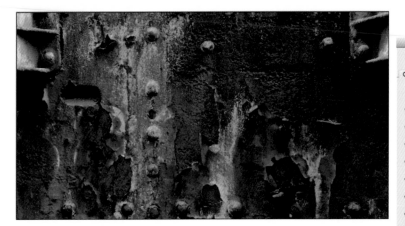

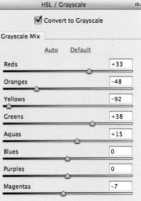

Here, they're darkened to almost match the surrounding rust

Split Toning

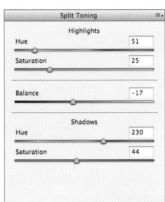

Especially useful for grayscale images, but not exclusively so, split toning is the process of colorizing the darker areas of an image with one hue and the highlights with another. This can simulate the look of toned silver (or platinum, etc.) on a differently toned paper.

1. Move both Saturation sliders up about halfway (this will be too much, but we'll fix it later).

2. Adjust Hues for highlights and shadows (here, I have a warm yellow hue for highlights to simulate a warm paper, and a blue for shadows to simulate cold-toned metal).

3. Readjust the Saturation sliders so they're more tastefully set.

4. *Optional:* Adjust Balance to favor one hue over the other.

Vibrance

Just like in Lightroom or ACR, Vibrance and Saturation can be used to enhance or subdue the color intensity in an image. The difference is that Saturation can cause a loss of detail in one or more of the color channels; that is, it can cause color clipping if the Saturation level is too high. I recommend using the Vibrance slider if you want to make a global saturation enhancement.

Hue/Saturation

To make more dramatic changes to all or individual hues in the image, use the Hue/Saturation adjustment. With it, you can make changes to individual ranges of colors in the image; e.g., you can change cyan areas to make them more blue, or you can change the red areas to make them more saturated. This is a powerful tool for making subtle and effective, or overt and bold changes to colors.

When Hue/Saturation Properties is viewed, it defaults to global editing. Adjusting the Saturation slider increases or decreases the saturation for every color. Adjusting the Hue slider shifts every color in the image; usually, this is not the desired result. Adjusting Hue means shifting colors around the color wheel—in the example, yellows are shifted to magenta, cyans (the water) to yellow, and so on. The color bars at the bottom of the panel display these color shifts.

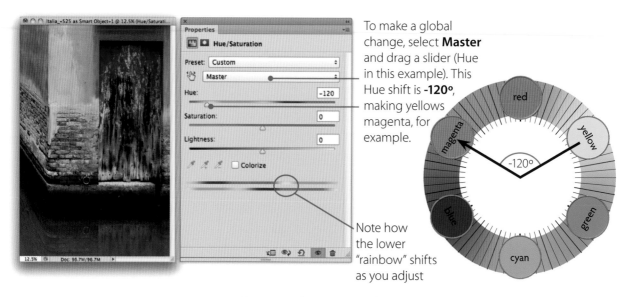

To make a global change, select **Master** and drag a slider (Hue in this example). This Hue shift is **-120°**, making yellows magenta, for example.

Note how the lower "rainbow" shifts as you adjust

Hue/Saturation becomes much more powerful when it is localized to affect only a narrow range of colors. Change the Edit option from Master to one

of the listed hues. Now a range is displayed between the color bars (rainbows) near the bottom of the panel.

To more precisely select a specific color to edit, use the Targeted Adjustment Tool (the pointing hand/scrubby cursor). When held over the image, it will look like an eyedropper. Press and drag on a hue to change its saturation or ⌘+drag / Ctrl+drag to shift its hue. In this example, I've made the rather cyan water purple (a hue shift) and made the yellows in the image more saturated. Note the gray bands between the color bars at the bottom of the panel. The hue above the dark gray are affected completely by the adjustment. The lighter gray bands are under the hues that are affected less. Beyond that zone, no hues are affected at all.

Try this: carefully click and drag one of the light gray bands and see what happens. This is how you can broaden or narrow the range of hues being affected!

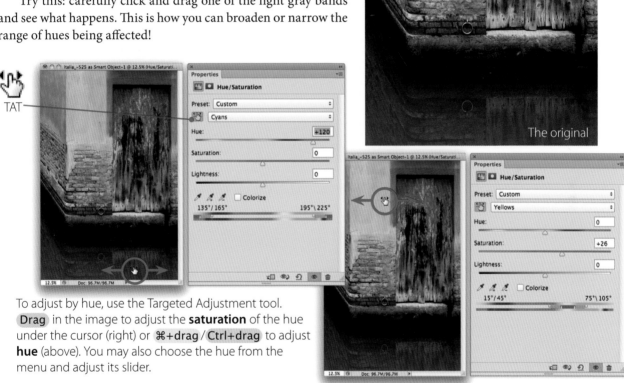

The original

To adjust by hue, use the Targeted Adjustment tool. Drag in the image to adjust the **saturation** of the hue under the cursor (right) or ⌘+drag / Ctrl+drag to adjust **hue** (above). You may also choose the hue from the menu and adjust its slider.

Photo Filter

Often, balanced or neutral color is not enough—or not what pleases. Photoshop provides a nice, simple tool for mimicking color filters attached to a lens. A Photo Filter will add some depth to images that have merely adequate color. In this case, I wanted more of the golden light of sunset.

1. Create a new Photo Filter adjustment layer via the Adjustments panel.

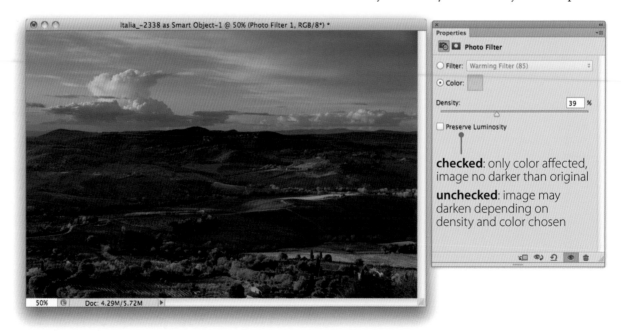

2. In the Photo Filter Properties, choose a Filter from the menu or, if none

of those achieve the desired result, you can click on the color chip and use the Color Picker to specify precisely what color your filter should be. The Warming Filter 85 is often a pleasing filter; it creates a nice warming effect without being obvious. In this example, that is where I started, then I chose a slightly different yellow. Adjust the Density (intensity) to increase or decrease the effect.

3. Note the Preserve Luminosity checkbox in the Properties panel. This is equivalent to a photographer adjusting exposure after putting a filter in front of the lens. I chose here to let the image darken a little.

Done! The warming filter adds just a touch of extra color to your image.

Curves (Take 2): Per Channel Contrast Adjustment

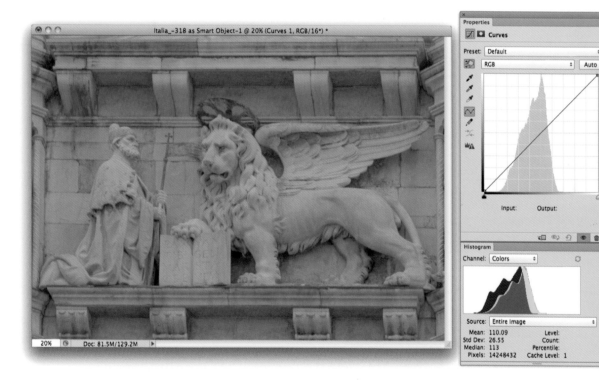

The image displayed here has a serious lack of contrast (it's flat) and it also has a notable yellow/green cast (note the yellow band in the Histogram panel). One way to understand the color cast is that the red and green channels are too light and are letting through too much of those colors of light. But the image is flat overall because each of the color channels is too flat. So we need to increase the contrast of each one.

Create a Curves Adjustment. You can use shortcuts to examine your channels visually, and similar shortcuts to target them for adjustment in Curves. Note that you can do per channel point curves adjustments in Lightroom and ACR as well. Photoshop, however, offers the most control.

Channel	To view in Image window	To target for Adjustment
Composite (RGB)	⌘+2 / Ctrl+2	option+2 / Alt+2
Red	⌘+3 / Ctrl+3	option+3 / Alt+3
Green	⌘+4 / Ctrl+4	option+4 / Alt+4
Blue	⌘+5 / Ctrl+5	option+5 / Alt+5

Note: These are different shortcuts than the ones Photoshop had a few versions ago. If you have a need to use pre-CS4 channel-switching shortcuts, then use Edit>Keyboard Shortcuts and Menus. You will see a checkbox labeled "Use Legacy Channel Shortcuts."

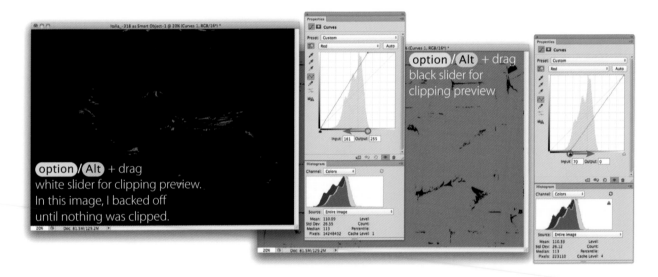

Using the shortcuts above, you may view each channel as a grayscale image (that's what each channel is). If you don't, you may have to go to the composite channel first (⌘+2 / Ctrl+2), *then* to the individual channels.

To manually correct an image, target each channel and increase its contrast by dragging the white point and black point sliders inward toward the first pixels in the histogram. Only upon the last slider do you know if it will work! To help indicate that you have made the darkest areas black or the lightest white, hold down option / Alt as you drag the sliders. On the color channels, the black slider will make the image window turn color (red, green, or blue) until you reach the darkest areas which will be indicated by black. All goes black with the white slider, and you'll see color when you clip the lightest pixels.

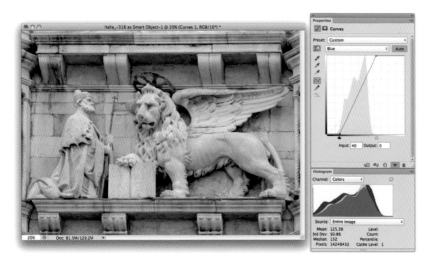

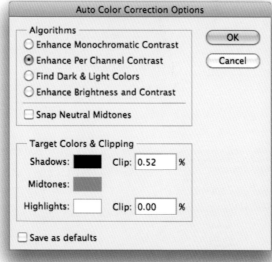

Proceed from the Red Channel to Green to Blue (option / Alt + 3, 4, then 5) and on the last slider the image may look nicely balanced!

Controlling Photoshop's Auto Button

Photoshop provides a tool for automatic color correction. The Auto button in Curves and Levels can achieve with one click what we linger over above. But please don't just click Auto! You can do even better with it if you hold down that key that has been so helpful: option / Alt .

1. In the Curves (or Levels) Adjustment Properties, hold down option / Alt and click on the Auto button.

2. The default Auto Correction options (Content Aware Brightness and Contrast in CS6) are not always the most effective, especially if there's a color cast like in our image. But these options can be adjusted. Try both "Find Dark & Light Colors" and "Per Channel Contrast" to see which does a more pleasing *overall* job of color balance.

3. Next, set the Target Clipping values to 0.00% for both the Shadows and Highlights. Place the cursor in each of those fields, then increase the values with your keyboard's up/down arrow keys to taste.

4. Try "Snap Neutral Midtones." Often, this auto color correction improves the midtones' color, but still may not perfectly color balance the image. One step to improve this is to set the Target Color for the midtones. By default, Photoshop tries to lock the middle tones to an exact gray value, but sometimes these middle tones should actually be close to, but not exactly, gray. Click on that gray chip (Midtones Target Color) to change its color if you wish. Choose a color that provides for a better overall

color balance. Once you have picked a color that makes your image look good to your eye, press OK to accept the color from the Color Picker, and click OK to accept the Auto Correction options. It's unlikely that you will want to make your color choice a new default, so click "No" in the dialog that asks.

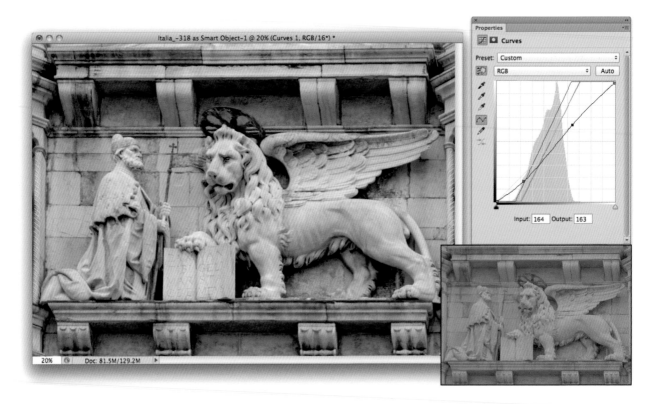

Even if the image looks neutral at this stage, you may still want to tweak overall contrast via the RGB curve to make it perfect.

Color Balance

To refine the image's overall color balance and eliminate any color cast, use Color Balance. With this tool you can add or remove Red, Green, and Blue from the image. Whereas Curves and Levels are for correcting both tone and color, this tool restricts itself almost entirely to color.

To access the Color Balance dialog, click on its icon in the Adjustments panel.

Color Balance actually makes a lot of sense once you understand the basic color wheel used in photography and digital imaging. In photography and in computers, color is created by mixing Red, Green, and Blue values from the RGB color wheel. (You may have heard of other color wheels used in painting.) Colors complementary to Red, Green, and Blue are Cyan, Magenta, and Yellow—so changes in R, G, & B also force changes in the

values of C, M, & Y. It follows then that adding one color automatically implies removing its complement. Adding Red is the same as removing Cyan.

Therefore, Color Balance is very simple to use. If your image has too much Green overall, then add Magenta (and remove Green) by moving the slider between Magenta and Green left towards Magenta. Be careful when using Color Balance to identify the various color casts in your image. Often what appears as a Blue cast (especially blue in shadows) is actually a Blue/Cyan cast, which requires adding Yellow and Red.

Color Balance also allows you to adjust the colors differently in the Highlights, Midtones, and Shadows. By default, the tone balance is set to Midtones, so that color changes appear strongest in Midtones and weaker in Shadows and Highlights. This setting works best for applying overall changes to the image color balance. It is also possible to make color changes that are localized to the shadows or highlights in your image by switching to Shadows or Highlights, like in this image which needed its shadows to be less Blue/Cyan.

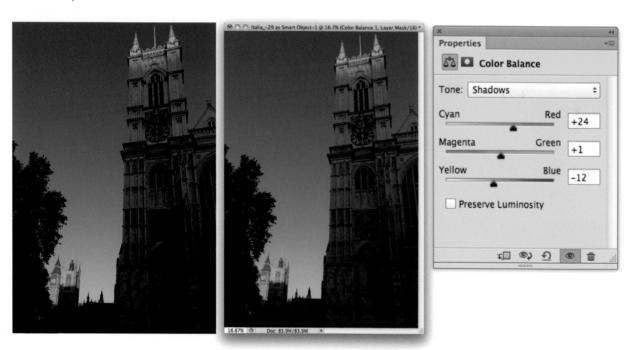

Color Balance is useful in order to learn the basics of editing color in digital images because it makes the color "arithmetic" directly accessible.

Black-and-White

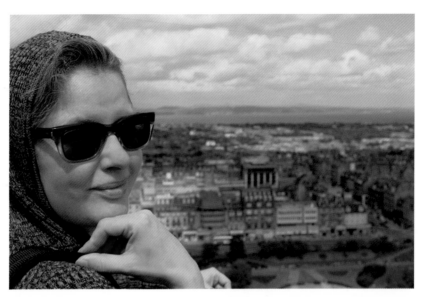

Despite the fact that many designers and art directors choose black and white images only to control costs, black and white photography continues to evolve and create its own artistic path. Since black and white images are inherently abstract, they provide great creative opportunities. Many equate fine art photography with monochromatic images. Most enjoyably, we can edit and manipulate the images in so many ways.

In the digital realm, images are rarely shot in black and white, but rather they are shot in color and converted to black and white. This gives you more flexibility in how individual colors are translated into various black and white tones. If you use a digital camera, shoot all your images in color. If you are comfortable shooting black and white film, definitely continue to do so! "If it ain't broke, don't fix it", is the old saying. But, many opportunities are available in Photoshop to customize a conversion from color to black and white.

Start with a color image that has good density by performing the basic white and black point, brightness, and contrast adjustments on the color image (it is easier to convert a color image to black and white if it starts with good density).

If you query 100 Photoshop experts as to what is the best way to convert from color to black and white, you'll receive about 50 answers. Here, I'll provide a few that have served me well. I will assume you've tried the direct Image>Mode>Grayscale method and found it lacking.

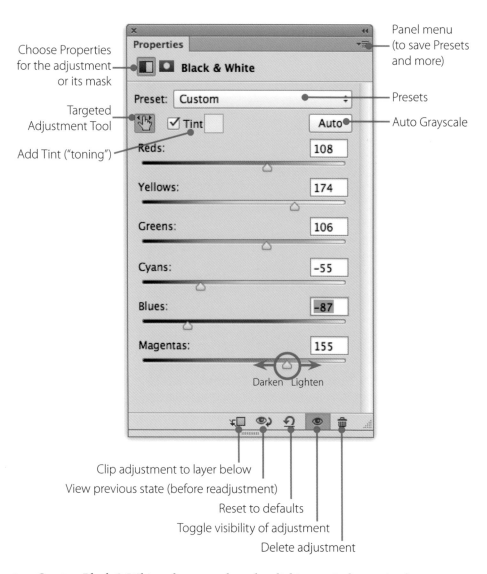

Choose Properties for the adjustment or its mask

Panel menu (to save Presets and more)

Targeted Adjustment Tool

Presets

Add Tint ("toning")

Auto Grayscale

Darken Lighten

Clip adjustment to layer below
View previous state (before readjustment)
Reset to defaults
Toggle visibility of adjustment
Delete adjustment

1. Create a Black & White adjustment layer by clicking on its button in the Adjustments panel.

2. There are many presets that can be chosen at the top of the panel. If you choose none, you'll get a generic conversion. If you press the Auto button, Photoshop tries to give a good balance of tones based on the colors in the image. For this image, that isn't such a great choice, though it serves well much of the time. For pictures of people with a wide variety of skin tones, the Red Filter preset is a better starting point.

To adjust the influence of certain hues on the resulting black and white image, use the Targeted Adjustment Tool. Drag in the image to adjust the **luminosity** of the hue under the cursor. You may also drag the slider in the Properties panel.

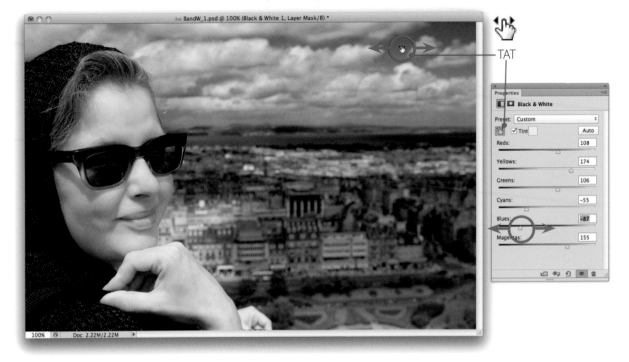

3. Do you remember what color each part of the image was? You don't have to: use the TAT and click with your cursor over the image, and the correct slider's number field highlights! But it gets better: don't simply click, but *drag* in the image, and the hue under the cursor when you started to drag it will get lighter or darker. You can even see the slider moving as you drag in the image.

4. If you like what you've done and want to apply the results to other images, save your settings as a Preset. At this point, you could click OK to commit to the adjustment. If the image truly needs to be in Grayscale mode, I usually recommend making a duplicate.

5. To apply a color tone to the image, click the Tint checkbox. Then choose a color with which to tone the image.

Note: To make a true Grayscale image (with only one channel), choose Image>Duplicate. In the resulting dialog, give a name that indicates that this is (or will be) Grayscale, and check **Duplicate Merged Layers Only**. Then convert this copy to grayscale (Image>Mode>Grayscale). You'll have a grayscale image *and* your intact original.

Split Toning

As long as your image is in RGB mode (if it's in Grayscale, use Image>Mode>RGB), you can tone it to your liking. Split toning is an effect that uses more than one color to tone the image.

We'll do this by applying colors that map to the image's shadows and highlights, and transition between these extremes. To do this, we'll use a Gradient Map Adjustment.

1. Create a Gradient Map adjustment layer by clicking on its icon in the Adjustments panel.

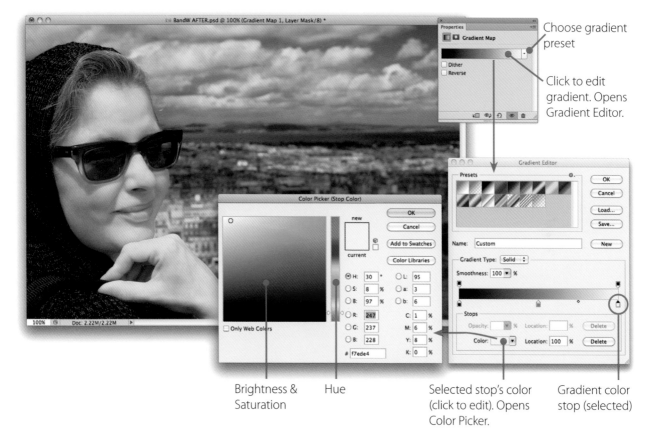

Choose gradient preset

Click to edit gradient. Opens Gradient Editor.

Brightness & Saturation

Hue

Selected stop's color (click to edit). Opens Color Picker.

Gradient color stop (selected)

2. Don't be alarmed! It's very likely that the colors applied are *not* the ones you want. If there's a Gradient Preset that does have colors you like, choose it from the small menu to the right of the gradient preview. Otherwise, click on the preview itself to edit the gradient.

3. When you click on the gradient preview, you get the Gradient Editor dialog. This dialog would get a chapter of its own if the world were just. But here's the heart of the matter: the Color Stops along the bottom of the gradient can be double-clicked to change the color they give to the gradient. For the Gradient Map Adjustment, the color at left maps or

replaces black in the image, and the color at the right replaces white. So, if you want an "old-fashioned" image, you can make a cool-toned shadow area transitioning to a cream-colored highlight (mimicking warm-toned paper).

4. When you double-click on the Color Stops, you get the Color Picker. Here, I chose a dark green to map to black, and a cream to map to white.

5. You can even add more colors to map to intermediate tones. Here, I chose a 50% brightness brown to map to the original's midtones. Note the Location field for the position of the selected Color Stop. You can think of a Color Stop like its near namesake, the organ stop. Whereas an organ stop lets air through to certain chosen pipes, the Color Stop lets color through to certain parts of the gradient. In both cases, we try to be harmonious!

Details: Sharpening & Noise Reduction

Key Concepts

Sharpness

Whether the lens was not as focused as it should have been, or whether we are just dealing with the inherent *softness* in digital images, a touch (or more) of sharpening can be required. Since we can't actually refocus the world after the exposure was made, we rely on the trick of enhancing the contrast near the edges in our images. Of course, we have to do this subtly so as not to create halos around those edges.

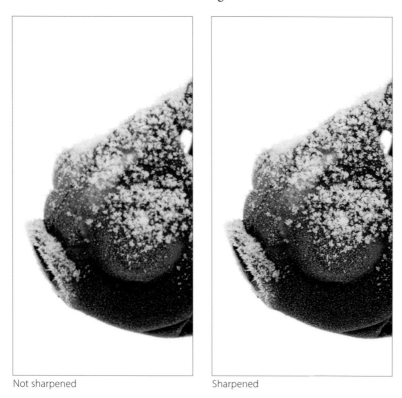

Not sharpened

Sharpened

I agree with most other Photoshop pros that when it's time to print, you may find yourself doing a tiny bit of sharpening then, too.

Noise

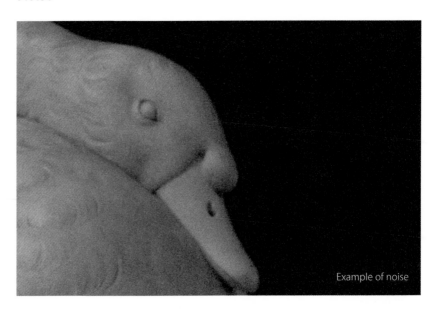

Example of noise

It lurks in the shadows! And its cause is the fact that digital cameras are electronic devices. The sensors work by maintaining an electrical charge which changes when light hits them. The trouble is that the charge fluctuates constantly. Imagine a music system with the volume way up but with no music playing. The hiss you hear is the result of random electrical fluctuations. (If you really tried this, be sure to lower the volume again!)

In our images, that "noise" is exhibited by colorful speckles in the dark areas (mostly) that incoming light hasn't been able to overwhelm. Sophisticated blurring is what we'll use to fix that. If your camera's ISO (speed) setting is high, there is more charge on the sensors and more risk of unacceptable noise. That is the cause of the noise in the image above.

Not only is there the more common color noise, there is also a great deal of luminance noise: noise that conflicts with the tonal details of the image. The best place to deal with noise is either ACR or Lightroom, and the best version of your image to work on is a RAW one.

Procedures

Bridge/ACR	Lightroom

Sharpening

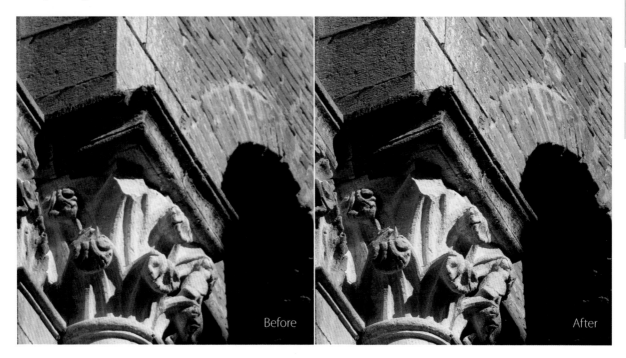

Before After

Four lovely sliders live in both Lightroom and ACR to give us images that are far more acceptably sharp than when they were born. Bear in mind that sharpening is a trick: we're just increasing contrast near the edges of things in our images, so we should show a little bit of restraint and caution.

To see what you're doing, zoom to 1:1 (aka 100% or Actual Pixels). In the Details panel, note these sliders:

▶ **Amount**—how much that edge contrast is being enhanced. Too high and we risk making the image look "crunchy." option+drag / Alt+drag this slider to see a grayscale preview.

▶ **Radius**—Sharpening is a trick that increases contrast at edges. When the Radius is too high, you'll see halos near those edges. It's our job to keep the halos subliminally small. The default of 1 pixel is fine for most digital cameras. If yours is a lower resolution (3–5 megapixels), you should consider a smaller radius. If you acquire 20 megapixels a click, then you may go higher. option+drag / Alt+drag this slider to see a preview of those "halos."

▶ **Detail**—the level of detail getting most sharpened: the lowest values weight sharpening to larger edges (good for portraiture); higher values give weight to fine, important texture (as in photos of wood or stone). option+drag / Alt+drag this slider to see a preview: if you can see tiny details, then they are likely getting sharpened.

▶ **Masking**—a fantastic way of limiting what gets sharpened. Whereas Detail *emphasizes* texture or larger details, Masking can actually keep areas from being sharpened at all. option+drag / Alt+drag this slider to see a preview: white=sharpened areas, black=unchanged areas.

If you option+drag / Alt+drag the sliders, you get a preview that helps you determine how much effect you want. See the text for more information.

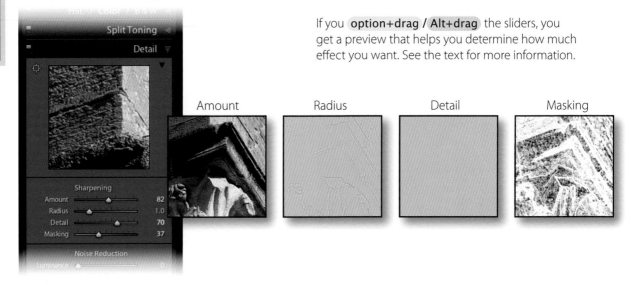

Amount Radius Detail Masking

Noise Reduction

Area illustrated below

ACR and Lightroom have ways to address both color and luminance noise. As with sharpening, it's best to zoom in to a 1:1 magnification to better observe your progress.

Before

After

There are two key sliders and several more that aid them.

▶ **Luminance**—Reduces luminance noise. Luminance noise reduction is normally set to 0 (zero) because it *may* cause loss of details in an image.

▶ **Detail**—Allows you to set the balance between luminance noise and fine detail in an image. Higher values can be more noisy, lower values more smooth.

▶ **Contrast**—Controls luminance contrast to make edges more or less strong. Higher values preserve edges but may exhibit mottling. Lower values produce softer edges and textures.

▶ **Color**—Reduces color noise. By default, there is a small amount (25) of Color noise reduction applied in ACR and Lightroom.

▶ **Detail**—Allows you to set the balance between color noise and small color details in an image. Higher values protect those tiny color details, while lower values remove color noise but may result in color loss in small areas (piping in garments, etc).

Photoshop

Smart Sharpen

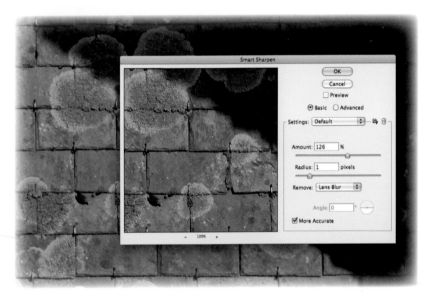

Photoshop CS2 introduced an excellent tool for sharpening images: the Smart Sharpen filter. This tool is both easier to use and sharpens better than the venerable Unsharp Mask. You should consider sharpening after you have resampled your image (as you might just before printing).

If you want to be able to revisit your sharpening decisions, add a Step "0" to your sharpening tasks:

0. **Optional but recommended:** If you are not working on a Smart Object layer, convert the **Background** or **Layers** you are working on to a single **Smart Object**: highlight the layer(s) in the Layers panel, then control+click / Right-click on a layer name and choose Convert to Smart Object. After you sharpen, you'll be able to revisit the sharpening settings at any time.

1. It's best if you View>Actual Pixels, so you can preview the image well.

2. Select Filter>Sharpen>Smart Sharpen.

3. Within the Smart Sharpen dialog, set the Amount to 100%, the Radius
 to about 1.0 (see previous page), and the Remove option to **Lens Blur**
 so Photoshop will try to detect edges in the image, or **Gaussian Blur**
 if you want a more global effect. Turn on More Accurate, which will
 slow down the filter, but the time that you allow this filter to run is well
 worth it. No, I have no idea why anyone would want "Less Accurate."

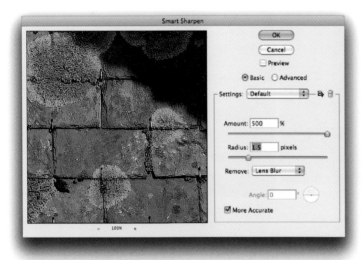

Over-sharpening…too easy to do.

4. Now adjust the Amount carefully: don't let the image look over-
 processed. If you find the Amount getting toward 300%, it may be that
 the image is simply too "soft." Learn to like it that way, or use another
 image. You may wish to experiment with the Amount to obtain the best
 sharpening, but be cautious, as too much can create harsh black and
 white lines ("halos") around any edges in your image.

Reduce Noise Filter

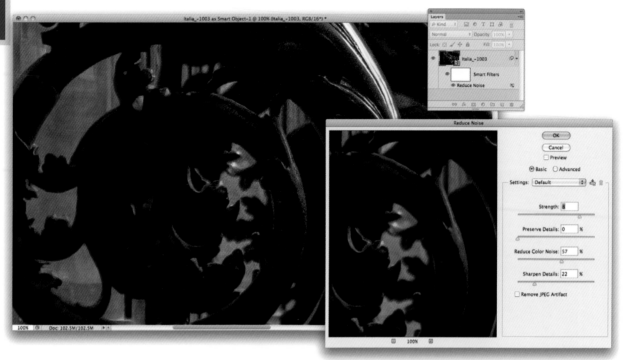

This filter is not as effective as the noise reduction we find in ACR or Lightroom, especially if you have the RAW file to work with.

Select Filter>Noise>Reduce Noise to access the Reduce Noise dialog.

Turn off the Preview option in this dialog and look for digital noise. Noise is most noticeable in dark, smooth-toned areas.

Turn on the Preview. Note that for most images, the Photoshop default settings for the Reduce Noise dialog are good. Increasing the strength may further reduce noise, but it often begins to soften the image. Don't increase the Sharpen Details option beyond 25%—you can better sharpen the image later.

If you choose Advanced mode, adjust the noise reduction on each color channel, then go back to Overall to make final tweaks.

Lens & Composition Corrections

Key Concepts

Example of barrel distortion

Example of pincushion distortion

Example of convergence

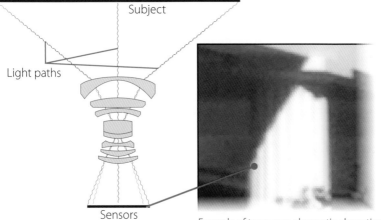
Example of transverse chromatic aberration

Example of vignetting

Cropping & Straightening

Cropping and straightening are tightly intertwined. In each application, a crop may be freely rotated by dragging outside the crop interface's box. You may set an arbitrary aspect ratio or use the original's. Also, as you use lens corrections, the image may become non-rectangular. So each of the applications can keep the crop constrained to the live image.

Barrel & Pincushion Distortions

When lines in an image that should be parallel bow outward or inward, we say that the image is suffering from barrel or pincushion distortion, respectively. Both of these effects and chromatic aberration are more common in less expensive zoom lenses. They can be corrected with the **Distortion** control.

Convergence

When you aim your camera sharply up, notice how the subject's vertical lines converge as they go up. We can correct for some of this convergence with the **Vertical** and/or **Horizontal Perspective** controls.

Vignetting

With some lenses, you may notice that the corners of your images are darkened. All of our applications have a provision to lighten those shadows—or add them.

Chromatic Aberration

When a lens can't focus all the colors to the same point, you may see fringes of color at sharp edges like tree branches or architectural elements. Most commonly, these fringes are red/cyan, but blue/yellow can be present, too. You won't see this in the center of the frame, where all the light rays go straight through the lens, but rather toward the edges of the frame. Purple and green are more difficult to fix, as these can be anywhere in an image, but Lightroom 4.1 and ACR 7.1 have tools to manage these fringes, too.

Procedures

Crop & Straighten

When you choose Photoshop's or ACR's **Crop Tool** or Lightroom's **Crop Overlay**, the image is surrounded by an interactive box with a grid to help determine whether elements in the photo are straight. Dragging just outside that box allows you to rotate the image within the crop.

While adjusting the crop, Lightroom and Photoshop give you a choice of compositional overlays, like a Golden Spiral and Rule of Thirds grid.

If there is a notable but crooked horizon in the image (or a line that *should* be vertical but isn't), choose the Straighten Tool (apparent in Lightroom and Photoshop while working with a crop). Press and drag along the line you noted. When you release the mouse, that line will be perfectly horizontal (or vertical).

Crop tool (C) *Straighten tool (A)*

Immediately after using ACR's Straighten Tool, the active tool changes to the Crop Tool so you can refine the crop that was made to straighten the image. Similarly, Lightroom automatically dismisses its Straighten Tool for

the same reason. If you would like to specify an aspect ratio (shape of the final image), you may do so by a click and hold while over ACR's Crop Tool. Lightroom has a special menu for that in the Crop panel. When you're finished, simply choose another tool in ACR or close Lightroom's panel.

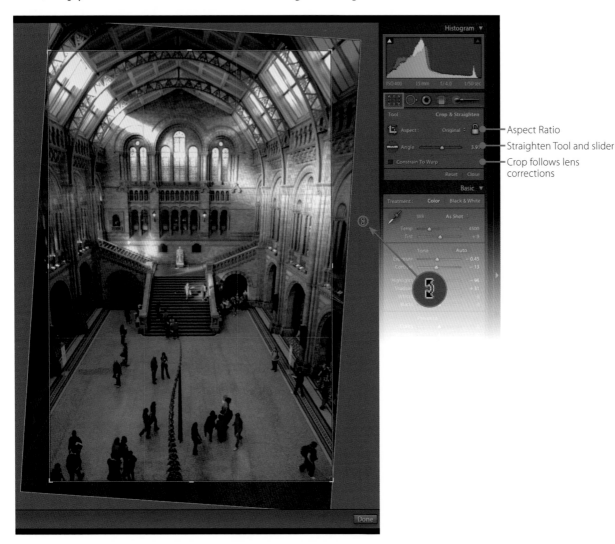

Aspect Ratio

Straighten Tool and slider

Crop follows lens corrections

Tip: In Lightroom, tap the O key for different visual composition aids.

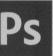

Select the Crop tool for very precise cropping. Uncheck the box labeled "Delete Cropped Pixels." Then you will have the option of hiding cropped pixels rather than deleting them. Zoom in for careful adjustments.

If you know the exact size of the final image, choose or enter specific dimensions from the aspect ratio menu in the Options Bar. When you are finished with your crop, remember to clear the options by clicking the Clear

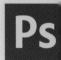

button. Leaving the Width and Height clear allows for an image of any size or shape.

When you choose the Crop tool in Photoshop CS6, a crop interface is set to the edges of the image. Simply adjust the crop by dragging a corner or edge of the box. The faded area outside the crop (the "Shield") dims the areas that will be (seemingly) eliminated.

Dragging outside the crop box rotates the image. If you extend the crop beyond the image's original edge, you will have to add image to those undefined regions, perhaps using the **Content Aware Fill** or another retouching technique.

If your cursor is close to the edge of the document window, you may experience the "Snap to Document Bounds" feature. This feature is handy except when you wish to move the cursor close to the edge without acutally touching it. To temporarily disable this feature, hold down the `control`/`Ctrl`.

Press the `Enter/Return` key to commit the crop.

To straighten quickly (*and* crop), choose the Crop Tool and then use its Straighten Tool. Drag along what should be straight, then it will be!

Lens Correction Profiles & Tools

Even the best lenses can have flaws. When we use wide-angle lenses, especially zooms, and especially on SLRs, there will often be color fringing at the edges of the frame. This is because the lens can't focus all the colors onto the same exact spot. Thus, if you zoom in *very* close (e.g., 400%) on one edge of your image, and you see fringes of red and cyan or blue and yellow, then these adjustments can be your friend. Move the sliders (or scrubby sliders) only a little at a time. **Red/Cyan** fringing is more common than **Blue/Yellow**, but if what you see is **Magenta/Green**, then you have both.

If you used a filter on your lens, or used the wrong lens hood, then you might have darker corners, or vignetting, in your final image.

With a large and growing list of **Lens Profiles**, corrections for the major lens issues listed above are no longer difficult or time-consuming. Simply Enable Profile Corrections while doing Lens Corrections in any of the applications, and if your exact camera and lens models are found, the correction is done in a moment! If the exact combination isn't available, you may still choose the Make and Model from the available menus. Barrel and pincushion distortions, chromatic aberrations, and lens vignetting are all corrected. If you wish to work with rotation or convergence issues, choose Manual (Lightroom and ACR) or Custom (Photoshop). You may also do adjustments for the issues that a lens profile may not completely remedy.

You may use the **Lens Vignetting** sliders to lighten corners further. If you've cropped the image and now want to *add* some dark (or light) corners, use the **Post-Crop Vignette** in the Effects panel of ACR or Lightroom.

Visit Adobe's website to find more on making your own lens profiles and downloading those of other users.

Lens Correction

Access the Lens Correction panel in ACR

Enable Lens Profile Corrections. If your camera/lens combination is in the large and growing database, many lens issues will simply disappear.

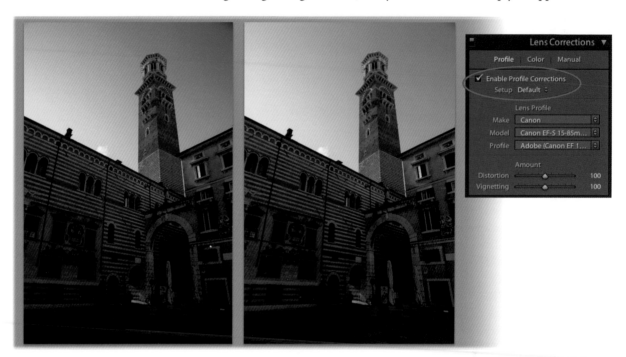

You may have to choose your camera and lens individually from the menus available. The Amount sliders allow you to fine-tune how much of the corrections get applied. In this way, if your lens is slightly different than the one that was profiled at Adobe, you may still benefit from that profile.

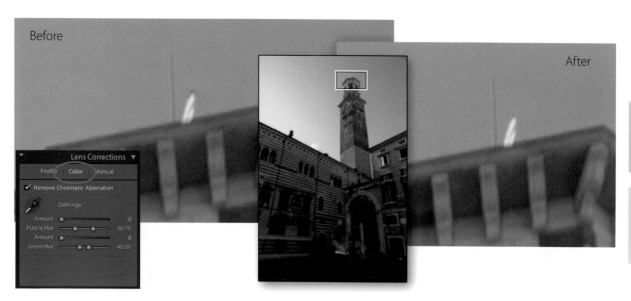

For transverse chromatic aberration (red/cyan or blue/yellow), the algorithm has been so improved that we no longer need to adjust the amounts—we merely enable it, and the color fringes are gone! Purple/green fringes around strongly backlit subjects can be reduced with the Defringe controls.

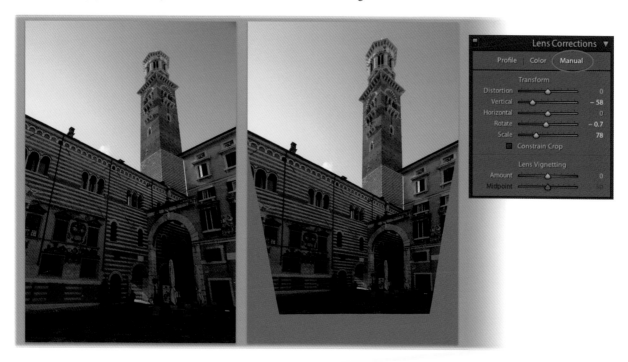

Perspective, rotation, and scaling are Manual adjustments. These may yield a mildly or severely trapezoidal image which then can be cropped with the crop tools in any of our applications. You may also use Constrain Crop, but this may not crop the image as you would choose.

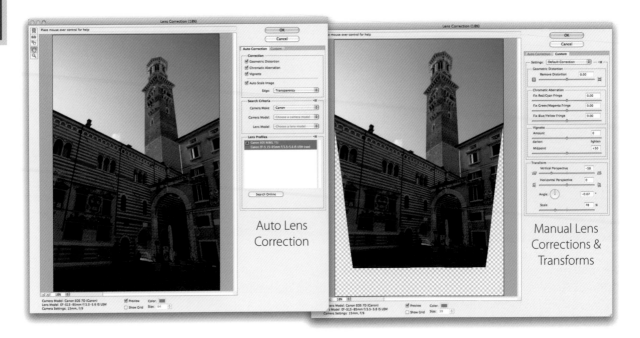

Auto Lens Correction

Manual Lens Corrections & Transforms

Photoshop's tool for performing these adjustments is Filter>Lens Correction. Within the filter's interface, you'll find a set of tools for straightening, removing barrel or pincushion distortions, correcting for perspective (by straightening converging lines), and removing the fringes caused by chromatic aberration. I don't recommend this filter's option to scale up the image for cropping, however. For that, I prefer the control of the Crop Tool.

This filter also uses a database of profiles for camera/lens combinations. You can even create these profiles yourself with the free Adobe Lens Profiler application. Luckily, the combination used here, Canon 7D with a recent lens, is one of the supplied profiles.

Saving & Sharing Develop Settings

Presets & Copying Color Corrections

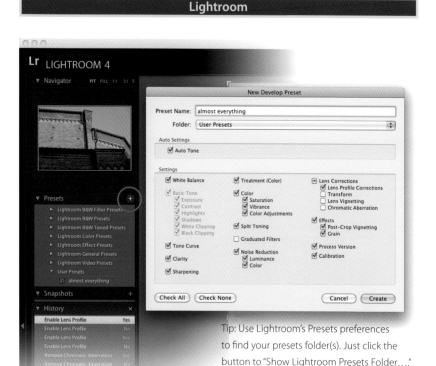

Tip: Use Lightroom's Presets preferences to find your presets folder(s). Just click the button to "Show Lightroom Presets Folder…." Move/Copy these to any computer that should use the same presets.

Once you have adjusted an image, you may wish to save the settings, or some of them, so they can be easily applied to other images. Remember that as you import images, you can apply a Develop Preset *right in the Import dialog*! So, if you have settings that work very well for conditions under which you shoot often (a studio, perhaps), you should save them and apply them automatically when downloading images from those conditions.

Of course, you can apply saved Presets anytime by clicking on a Preset's name in the Develop module's Presets panel (on the left side of your screen). To the right of the word "Preset" is a "+" sign: this is what you click to save any or all of your current Develop settings as a preset.

Copying & Disabling Settings

In the History panel (left side in the Develop module) you'll see a growing list of edits as you work. The difference between this panel and Photoshop's History panel is that the items here never go away unless you clear them! You can return to any stage in the image's life with a single click. Since all

the edits you do in Lightroom are nondestructive, and all the edits are metadata, it's easy to do this. So relax and enjoy the process.

The **Previous** and **Reset** buttons at the bottom of the Develop panel apply the settings from the last image developed or clear all settings to their starting points, respectively. You can **Copy** and **Paste** Develop settings via buttons under the History panel. When you choose to copy settings, a dialog box lets you decide which settings you want to copy and which you don't.

Note: Copying the **Spot Removal** settings is a handy way to remove sensor dust spots in one image, then paste those repairs into all the images that share the same dust problem. Check each image later to be sure it worked as expected.

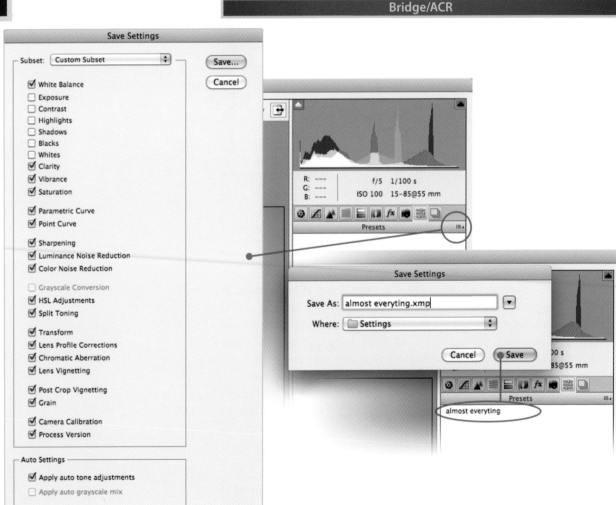

Bridge captures Develop settings as well. If any of the many settings we've examined need to be applied to other images, especially from future shoots, then you may wish to save them as presets.

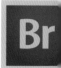

When you click the tiny menu icon on the right of the Presets panel, choose Save Settings…

In the dialog that appears, you can choose which settings you want to save: individually or by type (via the menu at the top). This makes it easy to choose a particular group of settings that can be applied at once or in sequence (e.g., a White Balance for *Brand X* lights, another for *Brand Y* lights). These presets can later be found in the Presets panel.

Once a preset is saved in ACR, you may also apply it in Bridge by selecting one or more image thumbnails, then `control+click`/`Right-click` on one of them. From the context menu, choose Develop Settings>[*preset name*].

Using ACR with Multiple Images

ACR can apply the settings to multiple images. This is especially useful for images shot under similar lighting conditions. Images processed together may show some variation in lighting, depending on exposure, but appear to come from the same scene thanks to consistent white balance. Processing multiple images together is fairly straighforward:

1. In Bridge, select multiple image files and `control+click`/`Right-click` on one of the images. Choose Open in Camera Raw… You should probably select images shot under the same or similar lighting conditions.

2. In ACR, click the **Select All** button at the top of the filmstrip to select all of the images. You can also click on one thumbnail, then use the `shift` key to select a range, or the `⌘`/`Ctrl` key to select discontiguous images.

3. Make adjustments to the Exposure, White Balance, etc., as you would for one image. Evaluate the displayed image as you make these adjustments. Examine the other images (without deselecting) by using the small arrows at the lower right of the Image window.

4. Once the displayed image appears accurate, select the individual images in the filmstrip (click on each) to inspect the effect of these settings on each image. Make small adjustments to each image as necessary.

5. Click **Done** if you're finished adjusting the images (for now).

Creating Copies for Photoshop Editing

▶ While editing a number of images in ACR, select the images that you'll want to open immediately in Photoshop, then Click on **Open Images** to process and open those images in Photoshop. It can take some time to open many images.

▶ Or, click on **Save Images** to process your selected images and save them. Since you cannot save processed RAW files, save them in another file format; Photoshop (.psd) is a good choice. If there are many images to process, the image files will save in the background. You'll see a process report near the **Save Images** button. You may open the first processed image and begin working as soon as it's saved back to the folder.

Photoshop

There are many times when you might wish to apply the same color correction to a number of different images. This generally happens when you have a number of images that were shot under very similar conditions.

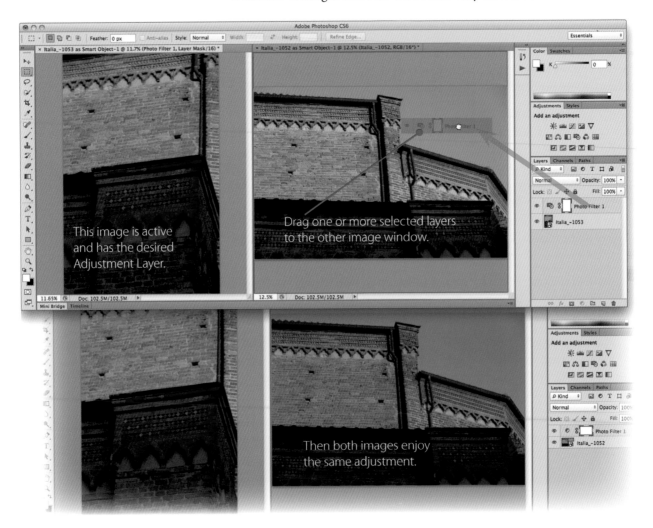

It is possible to copy one or more color correction adjustment layers (or any layer) onto another image merely by dragging from the source document and dropping the layer onto the destination image.

You can also copy layers from one open image to another by selecting them in the *source* image (use the shift key to select a range, or the ⌘ / Ctrl key to select discontiguous layers) and then using the Layer>Duplicate Layer(s) command; in the Duplicate Layer dialog, choose a Destination Document from the menu. The destination has to be an open image document.

Ps

Local Adjustments

7

In traditional photography, a number of techniques allowed us to alter one part of an image differently than another. In camera, we would use graduated density filters, perhaps tinted ones. The darkroom afforded many more methods: burning (increased exposure), dodging (blocked exposure), highlight and shadow masking, and pre-exposure. Most photographers have never dabbled in the latter two—and perhaps they should be thankful, as I found them difficult, time-consuming, and prone to dust!

Photoshop has embraced software metaphors for these and other photographic techniques. It's called Photoshop, after all. Lightroom and Camera Raw have graduated filters and painted adjustments. Combined with Photoshop's many tools for masking adjustments, it has become easier than ever to apply precisely the adjustment we want, and upon only the areas that require it.

In this chapter, then, we will focus on local adjustments, and the selection and masking tools that make them possible. In the following pages we'll start an adventure that may never end: in a room of Photoshop gurus, it's their masking techniques that they show off to each other. Now let's begin to develop yours!

Sun spot

Defining an Adjustment's Scope

Each of our applications has a mechanism for applying adjustments that affect only parts of an image, or are stronger in one area than in another. We will proceed from the least precise (graduated) of these to the most, using Photoshop's array of selection tools.

Adjustments in Lightroom and Adobe Camera Raw are additive. By this I mean two things. First, if you apply a local adjustment, it is intuitively applied where you add it. Simple. Second, where you apply possibly conflicting adjustments, the total effect is added up for each pixel. So if you globally darken an image, then lighten a part of it, that area will experience no net adjustment, rather than showing the wear of two adjustments.

This is somewhat different in Photoshop. In Photoshop we add adjustment layers which would normally affect an entire image. By utilizing those layers' masks, we prevent or remove the adjustment from targeted areas. So I think of the process of creating area or local adjustments as subtractive. Also, if we apply too many conflicting adjustments on one area of an image, it will likely look posterized or otherwise degraded.

To do this, especially in Photoshop, we'll have to master the concept of **Masks** (see page 57).

Graduated Adjustments

The first method I'll examine is producing a graduated filter. These adjustments are intended to remind photographers of the filters with variably tinted glass that we'd put on the front of our lenses. These are used to make part of our image darker or more pink, for example, than the rest.

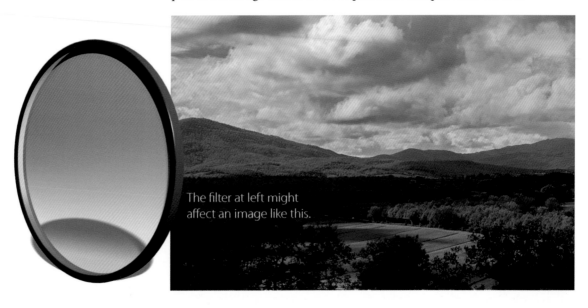

The filter at left might affect an image like this.

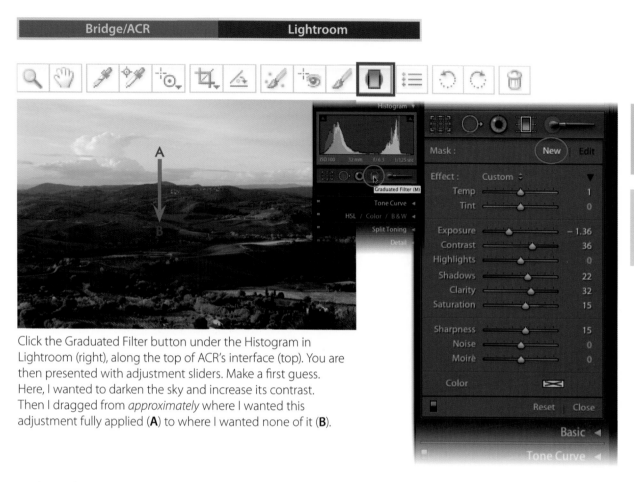

Click the Graduated Filter button under the Histogram in Lightroom (right), along the top of ACR's interface (top). You are then presented with adjustment sliders. Make a first guess. Here, I wanted to darken the sky and increase its contrast. Then I dragged from *approximately* where I wanted this adjustment fully applied (**A**) to where I wanted none of it (**B**).

To begin building a Graduated Filter, choose the Graduated Filter tool. Options will immediately appear. ACR's tool is illustrated above, Lightroom's below. The tools are similar, so I'll focus on Lightroom for this example.

The options are not as plentiful as those for a global correction, but they are more powerful than any piece of glass we put in front of our lenses. They're created as follows:

1. Click on Graduated Filter (or press "M" in Lightroom, "G" in ACR). Settings drawer appears with **New** highlighted.

2. Configure settings. Just guess! If you want to darken, pull Exposure leftward. Soft focus? Down with Clarity and Sharpness. *You can change the settings later.*

3. Drag from where you want the full effect to where you want none.

4. Adjust to taste:
 ► Move filter by dragging the Pin
 ► Compress or expand graduation
 ► Rotate filter
 ► Adjust settings. Note that **Edit** is now highlighted
 ► Click **New** to create another filter

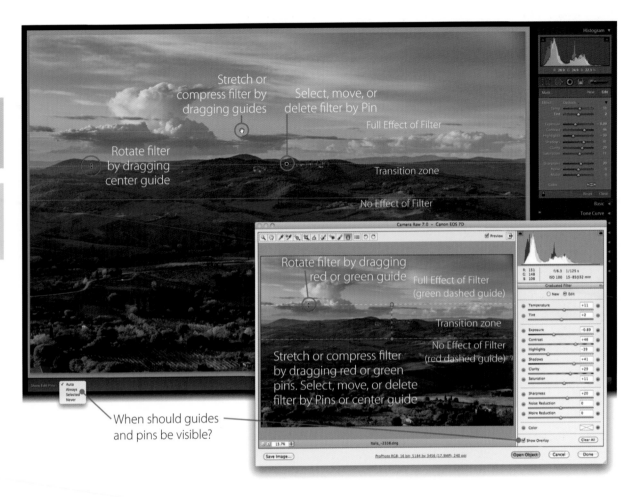

In this example, I am creating a "warming density" filter to compensate for the bright, hazy distance. I'll need contrast, diminished exposure, and a warmer white balance.

I did not need to colorize the Graduated Filter. If I wished to, I could have clicked on the color box and chosen a Hue and Saturation from the Color Picker. In fact, you can press and drag the eye dropper from the picker to anywhere on screen to select a color there!

Then I adjusted my adjustment. I made sure that my filter was in Edit mode, so as I used the sliders or moved the filter itself I could see my image change.

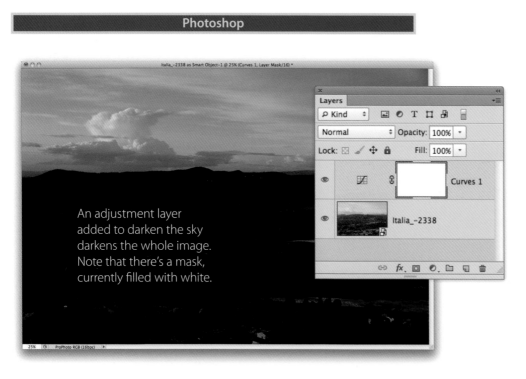

An adjustment layer added to darken the sky darkens the whole image. Note that there's a mask, currently filled with white.

In Photoshop, we can make any adjustment a graduated one. There isn't one specific tool for the task, but instead, we use both adjustment layers and the Gradient tool, which can make many different types of gradients. I usually set my Gradient tool to create a Linear, Foreground Color-to-Transparent gradient, with my Foreground color set to black.

Create an adjustment that corrects the part of the image that needs adjusting. Note that this adjustment layer has a white-filled mask. It's on this mask that we're going to put the gradient.

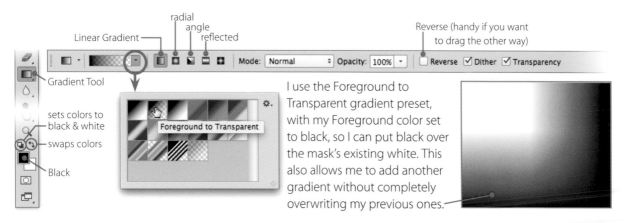

I use the Foreground to Transparent gradient preset, with my Foreground color set to black, so I can put black over the mask's existing white. This also allows me to add another gradient without completely overwriting my previous ones.

Choose the Gradient tool. The Options Bar will show a preview of the gradient that you'll be drawing. The small button to the right of the preview accesses a menu of gradient presets from which we should choose

"Foreground to Transparent." Just to be sure nothing is amiss, access the Properties panel: be sure you see "Layer Mask" at the top. If not, click the mask button at the top to bring it to the fore. You still have the Gradient tool, right?

Since the gradient begins with black, we will be dragging from where we want no adjustment (as black will hide it) to where we want full, unmasked adjustment. If you need the gradient to be perfectly horizontal or vertical, hold the **shift** key down as you complete it. Use the Reverse checkbox in the Options Bar if you prefer to drag the opposite way (full effect to none).

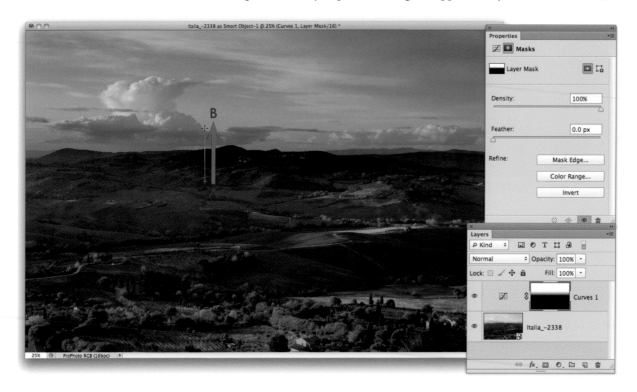

Have a look at your workspace: the mask on the adjustment layer will gradually go from black to white. You should see this in both the Layers panel and the Properties panel. If it's backwards (the area that should be adjusted isn't), click **Invert** in the Properties panel.

Painting Adjustments

Key Concepts

Graduated adjustments are fine for when a correction needs to gradually diminish across an image. When you need to apply a correction to more arbitrary areas of an image, Painting becomes a much more powerful method.

The brushes with which we paint have size, opacity, and hardness. In Photoshop, one can control *many* other attributes, too. But these three can be very effective in controlling where we apply corrections. A large, soft brush can be used to apply a correction in a way that is similar to a gradient in its looseness. But by making the brush smaller and smaller, we can more precisely control the adjustment's application—from lightening a face to increasing the contrast of the eyes to desaturating just the whites of the eyes, for example.

To have an adjustment end abruptly, we'd use a harder brush. To gently fade the adjustment, we'd use a softer one. For increased precision, ACR and Lightroom offer Auto Mask, which attempts to keep your "paint" from slopping into areas of the image that are different from the areas where you started to paint. Photoshop, as we'll see in the next section of this chapter, offers unparalleled precision with its many selection tools.

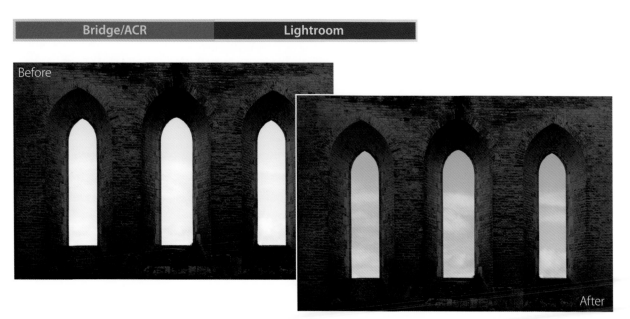

Procedures

Bridge/ACR	Lightroom

Before

After

The adjustments that are available for the Adjustment Brush are the same as those for Graduated Filters. There are additional controls for affecting

the qualities of the brush one is using to apply those adjustments, such as size and hardness. One additional control that is worthy of exploration and experimentation is **Auto Mask**. When active, this feature samples the pixels where you start to paint your adjustment, then applies that adjustment only to similar pixels.

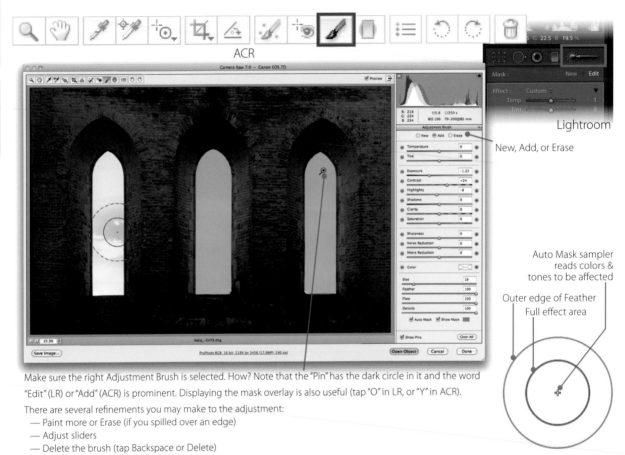

ACR

Lightroom

New, Add, or Erase

Auto Mask sampler
reads colors &
tones to be affected

Outer edge of Feather
Full effect area

Make sure the right Adjustment Brush is selected. How? Note that the "Pin" has the dark circle in it and the word "Edit" (LR) or "Add" (ACR) is prominent. Displaying the mask overlay is also useful (tap "O" in LR, or "Y" in ACR).

There are several refinements you may make to the adjustment:
— Paint more or Erase (if you spilled over an edge)
— Adjust sliders
— Delete the brush (tap Backspace or Delete)

Choose the Adjustment Brush from the tools (top of ACR's window; just under the histogram in Lightroom).

▶ In this example, to reveal detail in the sky in the windows, I configured the brush to darken and increase contrast. With the new (2012) Process Version, there are many more attributes we can "paint."

▶ To make the brush soft, use the Feather Slider. If you're worried about "spilling" adjustment onto surrounding areas, use…

▶ **Auto Mask**. Once checked, you paint the area that should be adjusted, preventing the central crosshair of the cursor from touching tones/colors that should remain unchanged. Note the brush at work in the image above.

▶ Hover over a pin to see its mask Overlay and know where the adjustment is being applied. Or tap "O" in Lightroom (Shift+O to cycle through overlay colors); "Y" or the checkbox (lower right) in ACR.

Tip: In Lightroom, hover the cursor over the pin. Press and drag left or right. Dragging left diminishes the effect of the adjustment, while dragging right increases it. If any of the sliders that control the adjustment are at maximum or minimum, however, you may not be allowed to exceed those values.

You may apply more than one Adjustment Brush, too. Just click on **New**, change the settings, then begin painting. You may also readjust the effect of any brush by clicking on its Pin, then moving the sliders. If you select a brush's Pin, then click Erase, you may paint away the effect. Using Backspace or Delete removes the pin and its adjustment.

Photoshop

Painting Tools & Brush Presets

There are many tools in Photoshop that use a painting metaphor (above); that is, as you press or drag your cursor across your image, either color or an effect builds up. Although there are many possible configurations of brush settings, we will focus on the three primary brush qualities that all the major painting tools share: **Size**, **Hardness**, and **Opacity**.

Usually, a brush appears as a circle as you move the cursor over the image. The ability to edit the brush quickly and easily makes overall editing much easier. The basic techniques for manipulating brushes are so important that I have listed the steps here. Refer to these shortcuts whenever I introduce a new tool that uses brushes.

Choosing & Building Brushes

Size

When you move a brush over your image, Photoshop usually displays a circle that represents the size of the brush. If very small, Photoshop displays a small crosshair.

You can change the brush size easily in one of three ways:

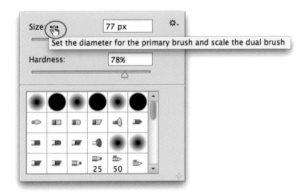
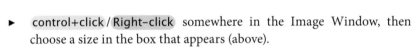

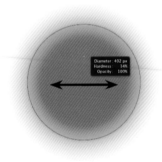

▶ control+click / Right-click somewhere in the Image Window, then choose a size in the box that appears (above).

▶ Use the square bracket keys, "[" (for smaller) *or* "]" (for larger).

▶ control+option+drag / Alt+Right-drag *horizontally* while watching the orange mask grow or shrink (left).

Once you become accustomed to the keys, it is much easier to select an appropriate brush size.

Brush Hardness

Sometimes you'll want to control how the "paint" blends into what's already there. So we set an appropriate Hardness for the brush, from 0% for very soft, to 100% for a sharp edge.

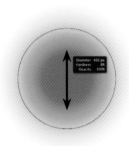

▶ In the Image Window, control+click / Right-click , then use the slider to choose a hardness value in the box that appears.

▶ Press shift + [*or*]

▶ control+option+drag / Alt+Right-drag **vertically** while watching the orange mask get fuzzier or sharper-edged (left).

There are two General Preferences with choices related to the Heads-Up Display (HUD): 1) HUD Color Picker appearance and 2) whether brush hardness is controlled with mouse movement (above).

Brush Opacity

There are times when you'll want to apply a brush stroke lightly or heavily. In general, do not change brush color to change density—rather, change brush opacity. When using the Brush Tool, opacity represents the amount of color a brush puts down as you drag the cursor across your image. By changing opacity, you change how thickly you apply the color with the brush: 10% opacity for very thin coverage, 50% for heavier coverage, etc.

You can change the opacity level via the Opacity slider in the Options Bar or by pressing the number keys: 1 for 10% opacity, 2 for 20%…up to 9 for 90% and 0 for 100%. When you press these keys, note how the brush opacity changes in the Options Bar. Press two numbers rapidly for more precision. For the Brush Tool, this is literally the opacity of the stroke, but for tools like the Blur Tool, Opacity is called "Strength" and is a measure of the intensity of effect.

Choosing a Color

Color & Swatches panels:

Look for the thin white border in the Color panel. Here, it's on the Foreground color. Just pick a color from the spectrum or use the sliders. One click on that bordered chip brings up the Color Picker. The Background color chip can be targeted by single clicking on it.

One click on a swatch sets that color for painting.

Color Picker:

Summoned when you click on the **Foreground** or **Background** color at the bottom of the Tool panel. Colors may be specified numerically or by choosing a hue (bar in center), then choosing brightness and saturation on the left.

Swap
Defaults
Foreground color
Background color

HUD (Heads-Up Display):

Access by **control+option+⌘+click** / **Alt+Shift+right-click** and hold. You may release the keys, but not the mouse button, to keep HUD active.

The Brush Tool uses the Foreground color as its paint color; interestingly, the Eraser Tool uses the Background color as its color, but only on the *Background*. For Layer and Filter Masks, the best colors for painting are often the **default colors** of humble black and white. Use the **D** key to set the default colors.

If you need to swap the Foreground and Background colors, use the **X** key or click on the small, two-headed arrow near the foreground and background colors.

If you click on the foreground or background color squares, Photoshop will display the Color Picker. Use this or the **HUD** (Heads-up Display) to select colors. When the Color Picker is open, click on a Hue from the bar of color near the center, then choose from the large square on the left to specify how light (top to bottom) and how saturated (left to right) a color you want. **Remember:** the Color Picker almost always requires at least two clicks. On the right are fields where you might enter numerical values for colors. To summon the HUD instead, **control+option+⌘+click** / **Alt+Shift+right-click** and hold the mouse button down while choosing a color. This takes a little practice, but becomes much faster than the Picker.

A Simple Exercise with the Paint Brush

1. Select the Brush Tool or simply press **B**.

2. Create a new layer: Layer>New>Layer… Give it a name like "painting exercise."

3. Move the cursor over your image and you'll see a circle, i.e., the brush. Resize the brush via the methods listed above.

4. Use the HUD or click on the foreground color and choose a color from the Color Picker. Paint with the brush on your image. Change the hardness of the brush.

5. Change the Opacity using the number keys. Recall that 0 (zero) is 100% opacity. Paint more. Click on the background color square and choose a color. Click OK. Switch between the foreground and background colors by using the **X** key. Note how easy it is to paint first with one color, switch them, then to paint with the other color.

6. Next, create a new adjustment layer. Brightness/Contrast is good for an experiment. Use the adjustment's Properties panel to make a strong adjustment.

7. Click the **Masks** button at the top of the Properties panel to target the mask. Reset your colors back to the defaults by clicking the **D** key. Reset the opacity to full.

8. Remember, pressing X switches the foreground and background colors. With black as the foreground color, you should be able to mask the adjustment.

9. Experiment with changing the brush size, edge hardness, and opacity. Notice how using a soft-edged brush and a moderate opacity can make the painted edges appear softer.

Painting Adjustments Example: Dodging & Burning

In traditional darkroom photography, dodging results in lightening parts of the image while burning darkens parts of the image. This technique is a way to salvage just those highlights and shadows we care to. In the darkroom, it was difficult to dodge or burn areas of small or irregular sizes. And we certainly did not have Undo! In Photoshop, we will use two adjustment layers, one that lightens and one that darkens. We'll use masks to hide those layers everywhere but where we paint with white. We will be able to paint darkness in or out as we need.

Let's see how we can use this technique to help this image.

Dodging

1. Create a lightening Curves adjustment with the Adjustments panel.

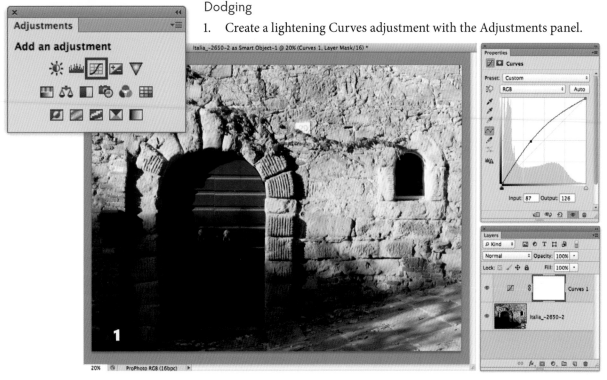

2. At the top of the Properties panel, click the Masks button. Use the Invert button to hide the lightening effect—the mask is now filled with black.

3. Choose the Brush Tool and reset colors to their default. Adjust the size of the brush and choose low hardness. To dodge with subtlety, set the Opacity low. We'll be more bold here and leave the Opacity at full.

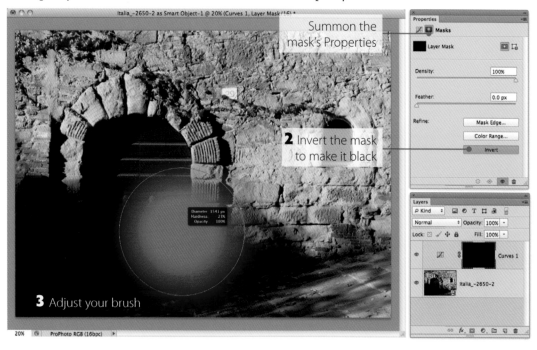

4. Paint with white on the dodge layer's mask. With a soft-edged brush, the effect is subtle at the edges.

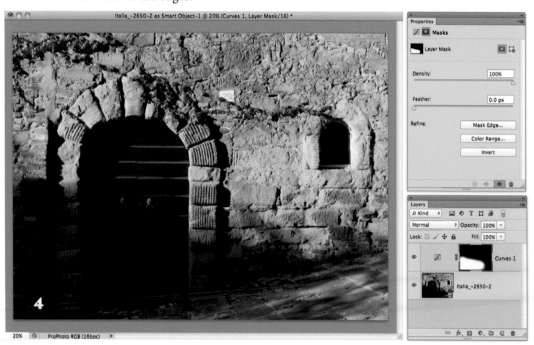

Burning

1. Create a darkening Curves adjustment with the Adjustments panel.

2. Target the mask and use the Invert button in the Properties panel to hide the darkening effect.

3. Adjust the size of the brush and choose a low hardness. Also, to burn with subtlety, you can use low Opacity.

4. Paint with white on the burning layer's mask. If the brush opacity is low, you can build up effect by repeatedly painting over an area.

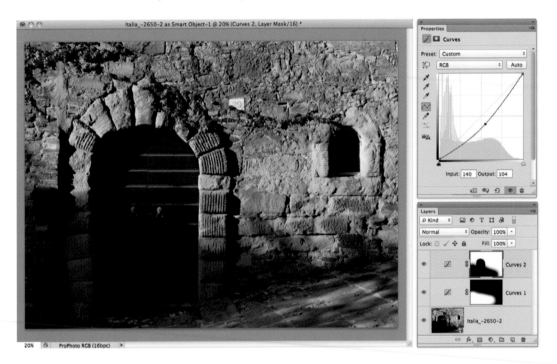

Precise Area Adjustments

Key Concepts

So far, the local adjustments we've done have been rather loose. True, you might use very small brushes to slowly apply subtle adjustments, but sometimes you need to be precise *and* efficient. For that combination, creating good selections and generating masked adjustments from them is the ideal course.

Selections are like stencils or masking tape, which prevent the next things you do in Photoshop from going beyond edges you designate. Unlike a stencil, however, selections can have edges that are crisp or fuzzy, or both, like the masks we have been painting. Indeed, you can think of selections as ad hoc, temporary masks. The selections we're going to make in this section will become "real" masks on adjustment layers.

Procedures

To-do: Select, Create an Adjustment, Refine the Mask

I have to say it: it's as easy as 1-2-3! However, each of these three steps can be involved. I'll summarize them below, then I'll go into the details involved in each step, explaining their vocabulary and concepts.

1. **Make a selection**. Once you've identified the image area to adjust, make a selection of this area. There are several good selection tools to use: the Quick Selection Tool, Color Range, the Marquee tools, and the Lassos. Try to use the most appropriate tool to make an initial selection, but this selection doesn't have to be perfect. You can add to the selection with any selection tool using the shift key, subtract from it with the option / Alt key, or invert it using the Select>Inverse command.

 You may also combine selection tools with painting tools using a **Quick Mask**. You might need to delicately refine that selection, especially around difficult areas like grass, hair, and other wispy things using the Select>Refine Edge command.

2. **Make the adjustment**. Create a new adjustment layer from the Adjustments panel. Photoshop automatically creates a mask based on the selection you created! Any pixels that were partially selected will be partially adjusted. The mask makes the adjustment apply only in the area of the selection you made.

 Work with the adjustment until it provides the correct result. Don't worry if the area of the adjustment is imperfect at this point. It'll be good enough to visualize the adjustment.

3. **Refine the mask, if necessary**. Despite our best efforts while making

selections, we sometimes don't see small errors until we have created the adjustment. So a final mask refinement is sometimes necessary.

There are several tools for editing a mask. With adjustment layers, the mask is automatically selected for any edits. The most common options for editing a mask can be found in the Properties panel (Feather, Invert, and Refine Edge). It is also common to paint on a mask using the Brush Tool. The Refine Edge option is the same powerful tool we use for making selections, but it can be used on masks, too.

Note: One adjustment you might want to make is Shadows/Highlights, but it is not available as an adjustment layer. To perform this adjustment non-destructively, you must apply it to a Smart Object. Once you have a Smart Object, select Shadows/Highlights from the Image>Adjustment menu. You'll notice it's applied as a "Smart Filter." Indeed, you can apply many filters to a Smart Object, and they will be masked to your initial selection.

Select

Selection Tools & Methods

Given the task list for localized adjustments, you need to familiarize yourself with selection techniques. Selections can be quick and easy; most take less than 60 seconds. Some are more difficult. Users often try way too hard to create a very precise selection. With the basic selection tools, this can be very frustrating. There are definitely times when a very precise selection is needed, but most often a fairly simple selection is a great start.

Here are some of my favorite selection techniques that I use most often. They're not listed in any particular order of preference. Try them all! The best way to learn them is to experiment with them. Don't get caught using one tool all the time; it might be great for some selections, but very difficult for others.

You may also use the tools in combination. You can start with one tool, add to your selection with another, and remove areas from the selection with a third. The Options bar will display four buttons to help you do this. You may also use the shift (to add) or the option / Alt (to subtract) keys—or both (to intersect).

New selection

Add to selection

Subtract from selection

Intersect with current selection

Marquee Tools

The Rectangular and Elliptical Marquee Tools are often maligned because of their simplicity. But with a few clicks of these tools, sometimes with a feathering of their edge, you can have a good selection quickly. Pick the Elliptical Marquee Tool from the Tools panel. If the Rectangular Marquee is displayed, click and hold it to display the Elliptical Marquee Tool underneath it. (You can also select the current Marquee Tool by pressing the **M** key, and switch between the Rectangular and Elliptical Marquee Tools by pressing shift+M).

Drag diagonally with a Marquee Tool over the image part you want to select. You will find that the shift key can do two things to aid you. First, it can constrain the selection to a perfect square or circle if you *finish* dragging with the shift held down. Second, if you *start* a second or subsequent marquee with the shift held down, as mentioned above, you'll add these new shapes to your existing selection. To *both* add to a selection *and* constrain the shape, begin your marquee with shift, then while dragging *momentarily* release it, and then finish your marquee with it held down. Tricky!

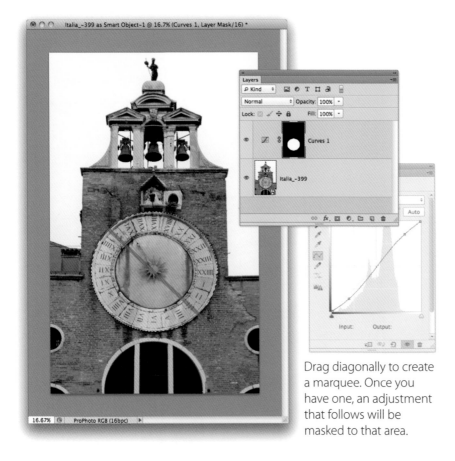

Drag diagonally to create a marquee. Once you have one, an adjustment that follows will be masked to that area.

If you select too much of the image, you can undo the most recent addition easily by hitting ⌘+Z / Ctrl+Z, or you can subtract a piece from the current selection by holding down the option / Alt key while making a Marquee over the part you want to remove. This is an easy way to take a quick bite out of an existing selection.

The Lasso & Polygonal Lasso Tools

The Lasso Tools are easy tools for making quick, loose selections of irregular-shaped objects. You can then feather these selections to soften the roughness. I prefer the Polygonal Lasso Tool over the traditional Lasso Tool as it feels a bit easier on my overused wrist (a lot of years on computers).

The Lasso Tool simply requires you to draw a selection on the screen in a freehand manner. You simply hold down the mouse button, drag a loose shape, and release when you're close to where you started. The Polygonal Lasso requires a series of clicks—more for greater precision, and fewer for a less precise, more faceted selection. It's also great for any selection involving straight lines, like building façades. Choose the Polygonal Lasso Tool from the Tools panel. If the Lasso Tool is displayed, click and hold it to display the Polygonal Lasso Tool underneath. (You can also select the current Lasso Tool by pressing the L key, and switch between the Lasso Tools by hitting shift+L .)

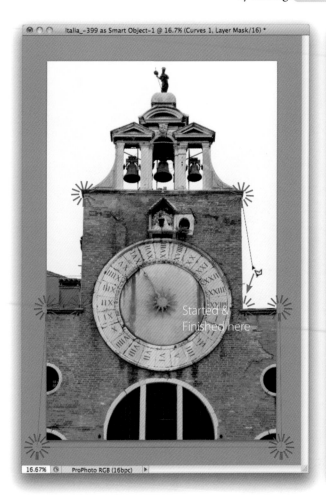 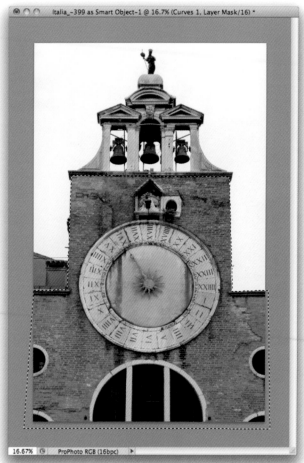

Use the Polygonal Lasso by clicking along the edge of the area you want to select. I like working with the image window a bit bigger than the image or in one of the Full Screen modes (accessed by tapping the F key). If you come to the edge of the image, click outside of the image (in the gray or black around it) to select the pixels right along the edge. Click on the first point to complete the selection.

Quick Selection Tool

Choose this tool in the Tools panel or tap the **W** key. This tool selects pixels intelligently, and it gets more intelligent as you build a selection! If you are trying to select an object in a photo, like the door in the example below, simply drag the cursor much like you would paint. Photoshop reads the colors and tones within the brush's radius, then automatically expands to include similar colors and tones near to where you dragged, stopping at edges it detects!

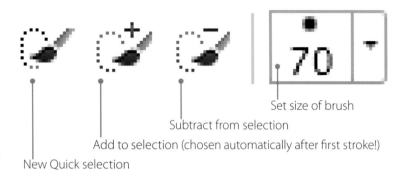

Set size of brush

Subtract from selection

Add to selection (chosen automatically after first stroke!)

New Quick selection

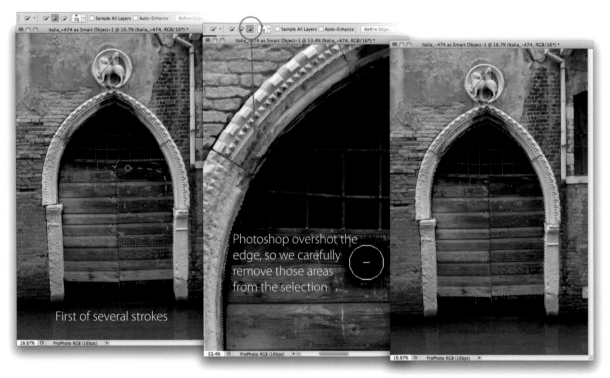

First of several strokes

Photoshop overshot the edge, so we carefully remove those areas from the selection

Since it's learning from you, take care to avoid brushing over areas you don't want selected. Note that in the Options bar you set the size of the brush and whether that brush is adding to the selection or removing unwanted areas from it. In the subtraction mode, avoid areas you want selected. With this tool, you can build a complex selection very quickly. As with painting tools, you can change the size (and less usefully, the hardness) of the brush you use to make selections (see "Size" on page 196).

Edit in
Quick Mask

Visualizing Selections: Quick Mask

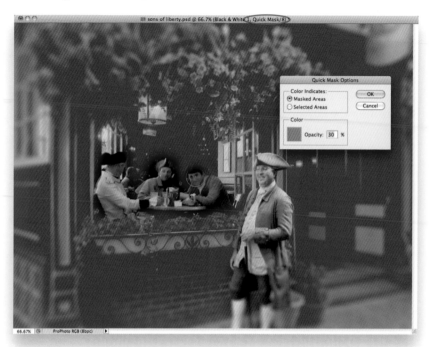

Quick Mask is a fast and easy way to visualize which areas of an image are selected by placing a translucent orange overlay over the unselected areas. The marquee (also known as "marching ants") disappears and you see this overlay instead.

Engage Quick Mask Mode by pressing the **Q** key. Turn it off by pressing **Q** again. You can also enter Quick Mask Mode from the bottom of the Tools panel, or use Select>Edit in Quick Mask Mode. Photoshop reminds you that you're in Quick Mask Mode by displaying "Quick Mask" in the image title bar. In a very real sense, you are viewing and potentially editing this orange-and-clear image and *not* your photograph anymore.

Warning: Be careful in Quick Mask Mode. Quick Mask Mode temporarily changes your selection into an image that overlays the main image. Most of the standard Photoshop tools still work in Quick Mask Mode, including the selection tools, so that you can edit this image and therefore the selection it represents! It's usually best to have a selection, switch to Quick Mask Mode, view and/or edit the selection, and then switch right out of Quick Mask Mode again.

Quick Mask Mode is an easy way to *edit* a selection by simply painting using the Brush Tool. Quick Mask Mode makes it possible to edit a selection this way because it is, for the moment, an image. Strangely, white paints clear (selected) in Quick Mask, and black paints orange (unselected). In the example above, I began with a selection of Mr. Franklin (right), entered Quick Mask Mode, then used the Brush Tool to paint with white to include

Mr. Adams, Mr. Revere, and Gen. Washington. Incidentally, it is interesting whom you encounter in Boston!

Double clicking on the Quick Mask Mode button in the Tools panel accesses the Options dialog in which you may set the color for the Quick Mask. The bright red-orange color works for most images. If you want to change the color to something that will contrast with a particular image, click on the color square to bring up the Color Picker. Pick a different color, change its visual opacity, and click OK to close the Quick Mask Options dialog.

To ensure you're painting with the default colors of black and white simply press **D**, then paint knowing you're getting full selection or deselection. Press the **X** key to swap the colors. Press the **Q** key to switch out of Quick Mask Mode and display your selection as marching ants again.

Inverting the Selection

It's often easier to select an area that you don't want and then invert the selection than to directly select the area you do want. Just make a selection of everything you don't want, and then invert the selection by using the Select>Inverse command. In this example, it's easy to select the door with the Quick Selection Tool and then invert the selection to make a selection of the walls, window, and pavement.

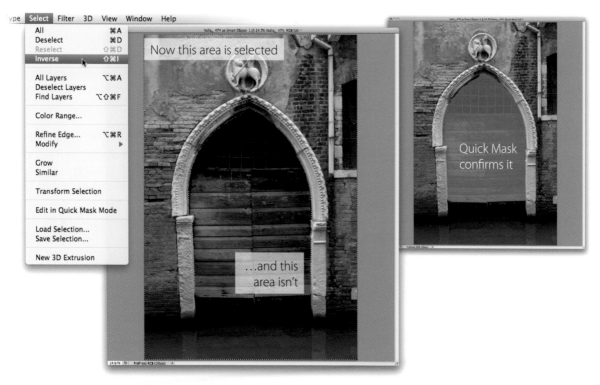

Color Range: Highlights, Midtones, Shadows

Color Range lets you select a range of tones or colors in your image. Choose the Select>Color Range… command to open the dialog. Use the Select menu at the top of that dialog box to access the options for Highlights, Midtones, or Shadows, as well as preset colors, Skin Tones (with facial recognition), or Sampled Colors. In this first example, we'll make a selection based on tone. We'll select everything except the brightest areas of the image in preparation for an adjustment to lighten.

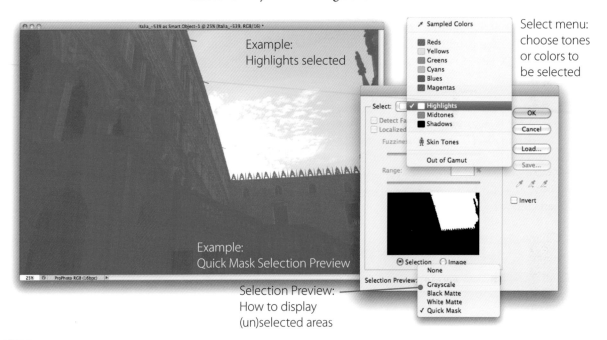

When you choose Highlights from the select menu, the dialog displays a small map with the areas that will be selected (in this case, highlights) shown as white, and the unselected areas as black. Any grays you see represent partially selected areas. Choosing a Selection Preview uses the main image window to show a larger map.

▶ Grayscale—a large version of the small preview, with white representing the selected areas, black the unselected areas

▶ Black Matte—white is removed from the preview, showing the selected part of the image instead, and black remains

▶ White Matte—white is removed from the preview, showing the selected part of the image instead, and black is replaced with white

▶ Quick Mask—white is removed from the preview, showing the selected part of the image instead, and black is replaced with translucent red/orange

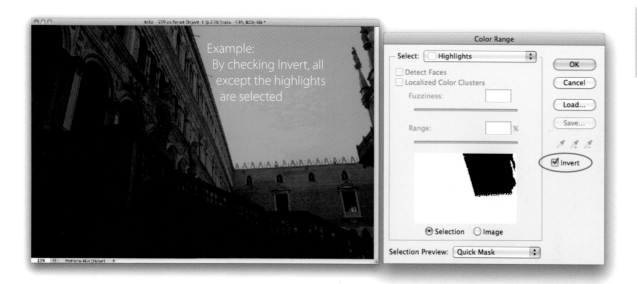

In our example, I'm trying to select all *but* the highlights. So I'll check the Invert box. Now the areas that need to be adjusted are selected, so we click OK, then create the necessary adjustment.

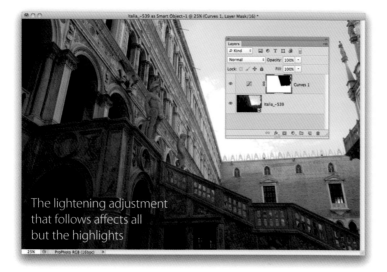

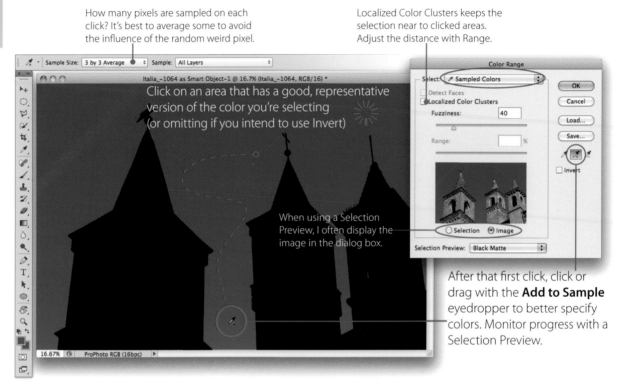

Color Range: Sampled Colors

How many pixels are sampled on each click? It's best to average some to avoid the influence of the random weird pixel.

Localized Color Clusters keeps the selection near to clicked areas. Adjust the distance with Range.

Click on an area that has a good, representative version of the color you're selecting (or omitting if you intend to use Invert)

When using a Selection Preview, I often display the image in the dialog box.

After that first click, click or drag with the **Add to Sample** eyedropper to better specify colors. Monitor progress with a Selection Preview.

Most often, Color Range is used to select a range of colors based on those you click on with one of the eyedroppers. Open the Color Range dialog by using the Select>Color Range menu command. Choose Sampled Colors from the Select menu, then click on a color in the Image Window. You may use the Options Bar or control+click / Right-click to set the size of the sample. The window in the Color Range dialog displays a black-and-white version of the selection it creates.

If you would like it to use proximity to where you click as well as color similarity, check the box for **Localized Color Clusters**. This engages a feature much like the Quick Selection Tool's. The Range slider affects the size of the area within which you make the selection.

Color Range has one significant advantage over other tools. Like them, it completely selects colors that are very similar to the colors on which you click. But it also *partially* selects areas that are only somewhat similar to those clicked, thus providing built-in feathering based on the sampled colors. The Fuzziness slider lets you adjust how broad of a range of colors will be selected or partially selected; increasing the fuzziness results in a larger selection.

You will also use the "Add to Sample" and "Subtract from Sample" eyedroppers to increase or decrease the range being selected. Combined with

Fuzziness, these allow you to define a very specific range of colors to be selected.

If Color Range selects too many pixels, try reducing Fuzziness to limit the number of selected pixels. If Color Range selects too small an area (very common), don't immediately increase Fuzziness. Rather, sample additional colors by using the Add to Sample dropper or by holding the shift key and clicking more areas.

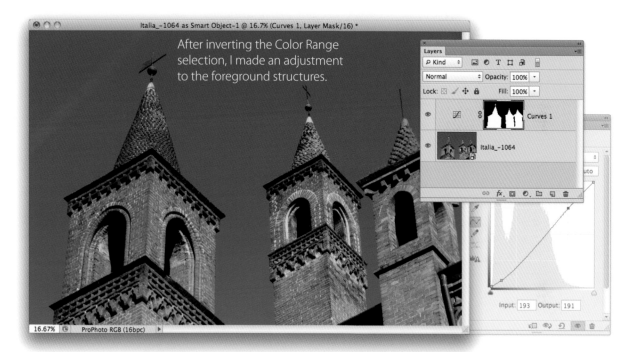

After inverting the Color Range selection, I made an adjustment to the foreground structures.

You can restrict the area Color Range sees by making a marquee *before* you choose Color Range. For example, if you want to select just one of several green objects in an image, you can make a loose selection using a simple tool like the Lasso. When you open Color Range, the selection it makes is restricted to the area inside the Lasso selection.

Refining Selections

Selections can be built by combining multiple selection tools: in fact, it's often easiest to do so. With any of the Tools panel selection tools, hold down the shift key while starting a new Marquee to add the new area to the existing selection. Remember to *build* a selection rather than expect one tool to make a great selection in one quick step.

Take a chunk out of a selection by holding down the option/Alt key while starting a new Marquee to subtract it from the existing selection.

Feathering

When making a selection using a Marquee or Lasso tool, you often will want to feather it to soften its edge. This is especially true in nature photography where perfect rectangles, ellipses, and polygons are rare. If you make the edges soft enough, the irregular edges of the selection won't be noticeable in the final image.

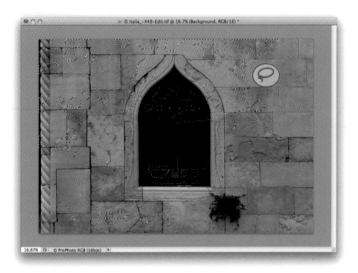

After a hard-edged selection is made, choose Select>Refine Edge. This selection was made with the Lasso. I wanted it to be like areas of sunlight streaming between branches and hitting the wall.

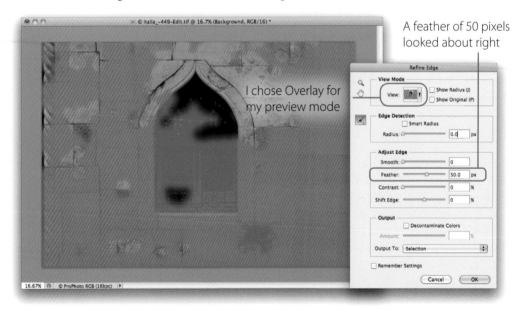

Choose a Preview that allows you to judge the quality of the edge of the selection. See Refine Edge on the next page for more on these choices.

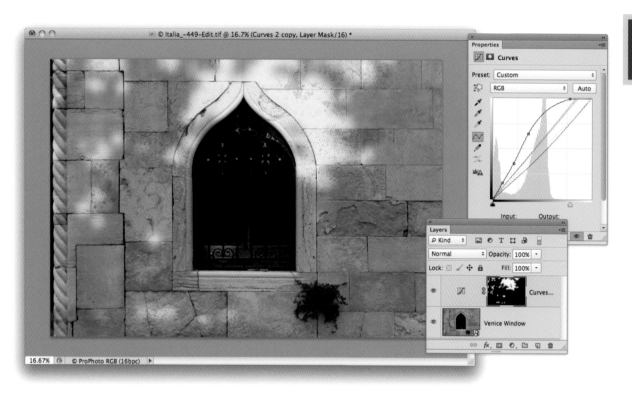

In this example, I followed the feathered selection with an adjustment that looks like sunlight on the wall...dappled sunlight.

Refine Edge

Photoshop offers an elegant interface to refine your selection before you add an adjustment layer or Smart Filter. As you saw in the above example, Refine Edge is my favorite way to feather a selection so it has a softer edge. This interface allows you to clearly visualize your selection and to refine its edge precisely at the same time.

Choose Select>Refine Edge... or use the button in the Options Bar (present when any selection tool is active).

When you open the dialog, you'll see five sliders, a couple of menus and checkboxes, and a few tools. The **View Mode** menu lets you visualize the selection and its refinement in seven ways! I usually press the **F** key to cycle through them and the **X** key to toggle them on and off. Hover your cursor over each choice for an explanatory note.

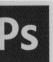

The goal was to increase contrast only on the artwork, not the wall or lighter parts of the frame. I started with a Polygonal Lasso centered on the frame's edge.

I most often use **Overlay**, **Black & White**, and either **On Black** or **On White** to contrast with a subject's background. In the example above, Overlay allows me to see the unselected areas as well as the selected ones.

Engaging Radius means engaging edge detection: Photoshop snaps the selection to image edges. To see just how wide a Radius you've set, check **Show Radius**. You're not seeing the selection, but only the area where edge detection is taking place.
In this example, I wanted that to be the frame, where I wish to select only the dark parts, leaving the light areas unselected.

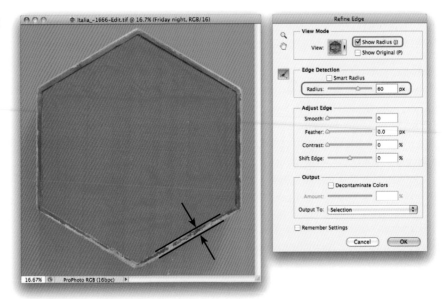

Radius sets the width around the original selection edge within which Photoshop will look for edges in the image. The selection will try to follow those edges! **Smart Radius** will try to tighten the radius around edges automatically within your slider-specified radius.

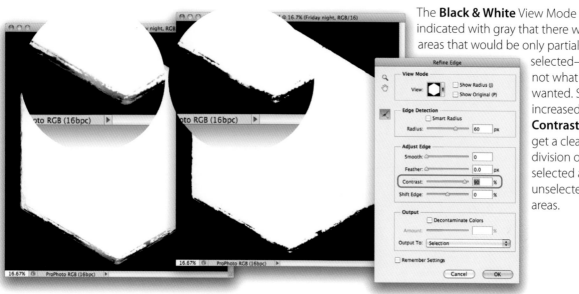

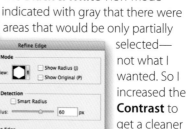

The **Black & White** View Mode indicated with gray that there were areas that would be only partially selected—not what I wanted. So I increased the **Contrast** to get a cleaner division of selected and unselected areas.

Contrast makes fuzzy selection edges look sharper. Use the **Black & White** View mode (tap the K key) to see what I mean. If there are fuzzy edges to the selection, then increase the Contrast to see how Contrast diminishes feathering.

Smooth smooths rough, "crinkly" edge selections. Use Feather *and* Contrast if you need a larger effect than Smooth produces.

Feather, as mentioned above, gives a blurry edge to the selection so it blends into its surroundings.

Feathering a selection makes some of the pixels along the edge of the selection "partially" selected. Partially selected pixels result in a mask with some intermediate (gray) value, neither completely masked (black) nor completely visible (white). Pixels that have a gray mask have only a portion of an adjustment applied. This provides for a range of pixels along the edge of the selection to display a smooth transition from the complete adjustment to no adjustment.

Shift Edge is especially good with fuzzy selections when they're a little too big or small. Beware: the higher your Feather or Radius, the more this slider will affect your selection!

The Refine Radius Tool allows you to paint more (or less) radius where you feel it's needed (on hair or splashing water, perhaps).

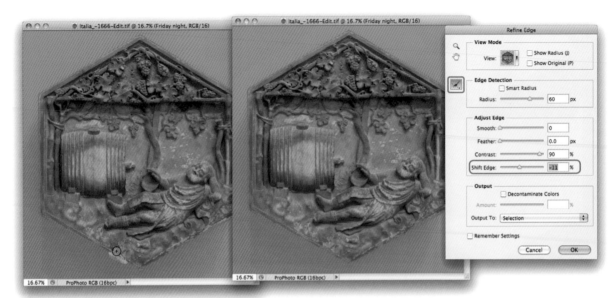

The **Refine Radius Tool** allows us to manually indicate where we want edge detection to take place. Here, I noticed that it would be helpful in a few spots to have the selection track edges just within the frame. So I "painted" there and the selection found more edges to track! To pull in the selection a bit more tightly, I used **Shift Edge** inward (negative) a small amount.

Let experimentation guide you. You'll soon find that selections of objects that are translucent will benefit from liberal painting with the Refine Radius Tool. Those involving hair seem to benefit from either large radii or generous painting with the Refine Radius Tool. Larger file sizes, i.e., pixel-rich images, will need higher values in all sliders than smaller images.

Here are the resulting marching ants and contrast increase

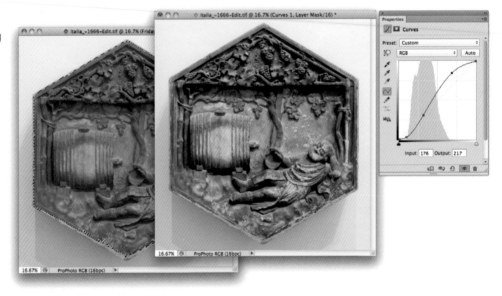

Saving Selections

There are times when you want to save a complex selection, perhaps to continue its refinement, or in case clients change their minds. When you use the Select>Save Selection… command, you create an extra channel in the Channels panel. These extra channels, called alpha channels, are rarely seen by anyone but you, the imagemaker. The first few channels (Red, Green, and Blue) are the foundation of your image. I liken the extra ones to stuff I store in my basement, amidst my house's foundation.

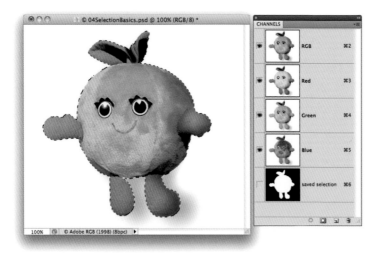

You're storing these channels in order to reload them later. Also, there are some Photoshop functions that can use alpha channels to limit their scope (like Content Aware Scaling) or to indicate depth (like the Lens Blur Filter). For now, let's focus on the simple use of saving a selection.

Alpha channels are grayscale images that can be edited. This is yet *another* way to refine a selection. You may paint on an alpha channel, or use filters on it, or even do tonal adjustments to affect the balance of light to dark pixels. Why would you? Because when you reload an alpha channel as a selection (Select>Load Selection…), the light areas are selected and the dark pixels are unselected. After using Color Range and Refine Edge, this should sound familiar.

To have the power of image editing tools while working with selections, without the overhead of extra channels, consider Quick Mask Mode. This creates a *temporary* channel on which you do image edits. Leaving Quick Mask Mode returns a Marquee.

Create an Adjustment

Once you have made your selection and refined it, immediately create the adjustment layer or Smart Filter for your target adjustment. I often say that selections have little purpose other than to be converted into masks.

Create an adjustment layer and perform the specific adjustment you determined at the beginning of this process. Photoshop automatically converts the selection into a mask for this adjustment layer.

If you need to convert a layer into a Smart Object (because the adjustment, such as Shadows/Highlights or Lens Correction, is not available as an adjustment layer), control+click / Right-click on the layer's name in the Layers panel and choose Convert to Smart Object.

Now you can apply the Filter or Adjustment as a Smart Filter. The result should be an adjustment layer or Smart Object Layer that contains the appropriate adjustment, and a mask that localizes this adjustment to a part of the image.

Refine the Mask

The final task for localizing adjustments is editing the mask. Often the mask is just fine for the adjustment you want, in which case you can skip this step. But the mask might be further improved by some basic edits.

I use two main methods to fine-tune a mask: painting and refining.

Paint on the Mask

Make some simple changes to a mask by painting on it. Be sure to target the mask for editing—otherwise you might paint on your image! See *Painting Adjustments* (page 200) for more details.

Refine the Mask Edge

This is identical to refining the edge of a selection. This means you might make your rough selection, create the adjustment, then you can refine the mask with an eye on the final product results.

To permanently and irreversibly blur a mask, simply select Filter>Blur> Gaussian Blur and adjust the radius of the blur. The filter previews the result of this edit. You can use any filter on a mask, provided it can be used on a grayscale image. This opens up many possibilities! But to do a simple blur, you may also use the mask Properties panel's Feather slider. This provides a reversible way to blur a mask.

Example: Reducing Local Color Casts

Teeth Whitening, Marble Cleaning, etc.

A photograph can exhibit skin tones with too much red or magenta. Daylight shadows exhibit too much blue. And those of us who photograph people often find ourselves needing to whiten and polish teeth in Photoshop, too.

Each of these issues can be dealt with fairly easily with a fast selection and an easy adjustment.

1. Make a rough selection of the area that has the color cast (select the red-faced person's face, the yellowish teeth, or the bluish shadows, excluding things of the same hue that shouldn't be adjusted).

2. Create an adjustment layer via the Adjustments panel. Photo Filter can be handy for color casts, but since I wish to de-yellow the marble in the photo below, I'll need Hue/Saturation.

Select, at least roughly, the pixels to be adjusted. Here, I used the Quick Selection tool on the yellowed marble

Tip: For teeth whitening, start with yellows, click on a tooth with the TAT, then desaturate and lighten

Choose the hue to be affected by name

Further refine the affected hue by narrowing the range of hues—the darker gray is under the hues most adjusted. Dragging the lighter gray patches broadens or narrows the range of hues.

3. In the menu at the top of the panel, pick the hue that needs help. If, for example, you are trying to make a magenta cast in skin merely red-dish, choose Magentas. In the example above, I selected Yellows. You may also click on the problematic color in the Image Window with the Targeted Adjustment Tool (TAT).

4. Refine the range of color affected by moving/narrowing the adjustment slider (between the spectra at the bottom of the panel).

5. For this example and the others mentioned, lowering the saturation is one adjustment that helps reduce a cast. I also lightened this example a bit.

6. If necessary, paint white or black on the adjustment layer's mask to spread or limit, respectively, the effect of your adjustment.

Cleaning & Retouching

8

I was once asked to be interviewed on the radio on the topic of photography. I was apprehensive, as radio is not the most visual medium. But it became clear that I wouldn't have to find my inner poet to describe pictures. The interviewer was deeply interested in the power of Photoshop to change photographs, and the ethics around that power.

It's easy get into a discussion about the ethics of retouching. But there are many kinds of retouching, from the wholesale reshaping of people to removing the traces of sensor dust. In this chapter, I hope to introduce you to the tools that can get you into many interesting conversations!

A few adjustments may fall into the retouching category: Clarity reduction on a face to remove a few years, or Desaturating yellowed teeth for a bright, sparkling smile, for example. I refer the reader to the Adjustments chapters (6 and 7) for those uses.

Removing Dust & Defects

Key Concepts

Cloning

The way retouching has been done from the very early versions of Photoshop is by "cloning" pixels from one part of an image and using them to obscure blemishes we don't want. The mechanism is a tool that uses a brush metaphor, called the Clone Stamp Tool in Photoshop, or Spot Removal in Lightroom and ACR. Quite simply, it is like *very* quickly selecting an area, copying it, then pasting it elsewhere. In nondestructive workflows, including those involving Smart Objects, the cloned pixels go onto their own layer above our source image.

Healing

An advancement over cloning, the healing function uses the same painting procedure as cloning—but rather than only making identical copies, it then blends them into the new area by pulling color and luminosity from the surrounding pixels. In a way, healing copies texture only, drawing on the context where it's placed to determine color and tone.

In Photoshop, there are three tools that can "heal": the **Spot Healing Brush**, the **Healing Brush** (my favorite), and the **Patch Tool** (which is layer-specific, sadly). The **Spot Removal Tool** of ACR and Lightroom can be set to either clone or heal.

Sampling, Sources, & Alignment

All of these tools pull data from elsewhere in the image (in Photoshop, we can pull from other images, too). The Spot Healing Brush chooses its source automatically, and the Spot Removal Tool can also do so. The Clone Stamp tends to use a source that is *relative* in position to where you apply it (40 pixels above and 90 pixels to the right, for example). We say it is **Aligned**.

The Healing Brush Tool tends to pull data from the same source again and again because it can: it contextualizes the data to blend into its new surroundings. We say that it is not aligned.

Content Awareness

Content Awareness (CA) is a feature that several tools in Photoshop can use. The Fill command, the Spot Healing Brush, the Patch Tool, and (surprise) the Content-Aware Move Tool can automatically fill a designated area of an image with semi-random content from elsewhere in the image. Content Awareness sometimes does odd and humorous things, but most often it astonishes.

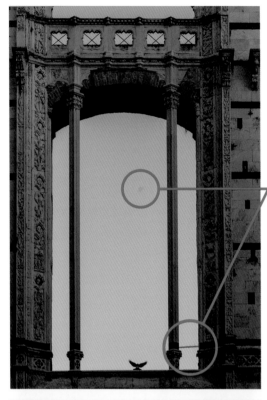

The original image suffers from sensor dust and an unattractive element in the lower right

Content-Aware Fill dealt with this flaw by finding similar content from the image

Cloning the area indicated by the crosshair to obscure the dust fails because the source is lighter than the target

Healing from the same source works because it contextualizes the source data to blend in

Procedures

Bridge/ACR	Lightroom

Spot Removal Tool

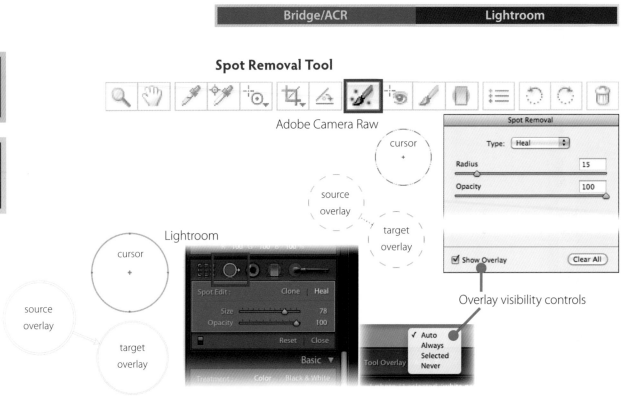

Adobe Camera Raw

Lightroom

Overlay visibility controls

The Spot Removal Tool is at the upper left in Adobe Camera Raw or just below the histogram in Lightroom. Since I use both, I have to be aware of the similarities and differences in each application.

First, what they share:

1. Line up the cursor on the *center* of the flaw you wish to remove. Optional: adjust the size of the brush before use by using the [and] keys. Click.

2. There is now a circle around the flaw (target) and around the source of the repair.

3. Adjust the source or target positions, if necessary. You may move either the source or the target areas by dragging them from their centers. You may also resize either area by dragging on its edge.

4. To delete a Spot Removal repair (spot removal removal?), select it with the Spot Removal Tool, then tap your delete/backspace key.

The differences are few but notable:

1. To toggle the visibility of the overlay, tap **V** in ACR or **H** in Lightroom.

2. If instead of only clicking to place the target you press and drag, you will be *resizing* the target and source in ACR, but will be *positioning* the source in Lightroom! Very different behavior that I trip on frequently.

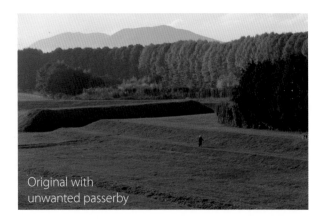

Original with
unwanted passerby

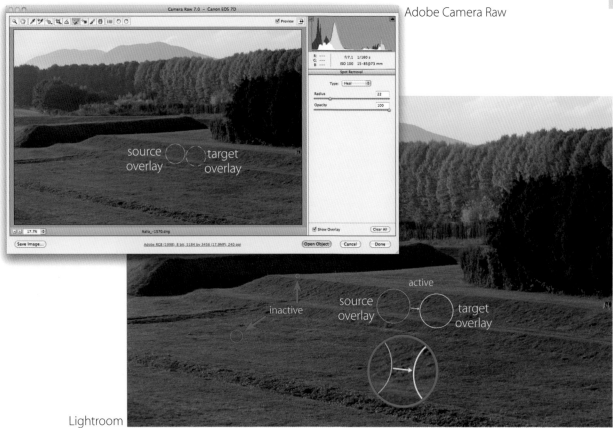

Adobe Camera Raw

source
overlay target
overlay

inactive active

source
overlay target
overlay

Lightroom

Healing to Cloning & Back Again

You may select a Spot Removal target and choose *later* whether it should be
a clone or healing repair! The choice is at the top of the Spot Removal panel
in either ACR or Lightroom.

Vital Preliminaries

In Photoshop, we employ three essential tools for spot removal: the **Healing Brush**, the **Spot Healing Brush**, and the **Clone Stamp**. These work by sampling "clean" pixels and using them to repair or replace defective pixels. As you may make a mistake or change your mind, I recommend creating a separate layer just above the original image to hold your retouching in case it needs to be revisited. It *seems* more difficult at first, but saves much woe later!

Note that I put this between my original layer or Smart Object and any adjustment layers I may have. Just create the retouching layer, then move it if it's in the wrong place.

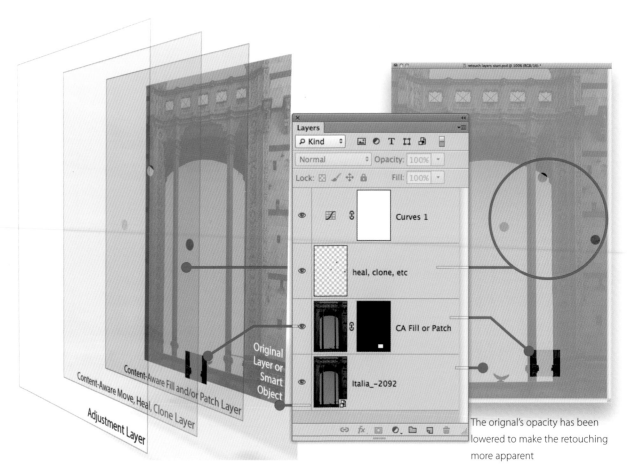

Content-Aware Fill and/or Patch Layer

Content-Aware Move, Heal, Clone Layer

Adjustment Layer

Original Layer or Smart Object

The orignal's opacity has been lowered to make the retouching more apparent

You must configure each of the retouching tools to pull the "clean" pixels from the layer(s) below. So for each tool, note the item in the Options Bar labeled **Sample**. Choose Current & Below to use material from the original

and your repairs. Since this layer is below any adjustments, it is affected by them exactly as the original is. If we chose to use All Layers, we could risk putting adjusted pixels where they'll get adjusted again. If this sounds confusing, that's because it is! But it will make more sense the more you use these tools. You will note that the Spot Healing Brush has only a checkbox labeled "Sample All Layers." It is safe to use this, as *this* tool is smart enough to do the right thing automatically.

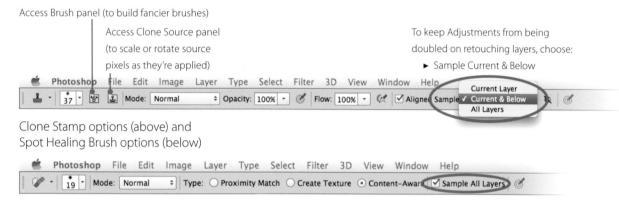

Access Brush panel (to build fancier brushes)

Access Clone Source panel
(to scale or rotate source
pixels as they're applied)

To keep Adjustments from being
doubled on retouching layers, choose:
► Sample Current & Below

Clone Stamp options (above) and
Spot Healing Brush options (below)

Summary: For each retouching tool, use the item in the Options Bar labeled "Sample" to choose Current & Below for sampling data from the original image plus your repairs while wisely working on a separate retouching layer. Check the "Sample All Layers" box for the Spot Healing Brush Tool.

Larger defects are repaired by using **Content-Aware Fill** (CAF), the **Patch Tool**, or the **Content-Aware Move Tool** (new in CS6). Sadly, CAF cannot sample other layers. The Patch tool can in its new CA mode, but not in its Normal (healing) mode. So if we wish to use CAF or the awesome healing Patch tool nondestructively, we need to duplicate our original layer. If that original is a Smart Object, we then rasterize the duplicate by choosing Layer>Smart Object>Rasterize (see the illustration above). I usually mask or delete the excess pixels on this layer when I'm done Patching or Filling.

Removing Small Defects

Clone Stamp Tool

In Photoshop, it is rare to use the traditional Copy and Paste functions. One reason is that when you copy something, it can be many megabytes of material that clogs your computer's memory. There are more useful and elegant ways of copying material.

Use the Clone Stamp to copy a piece of an image and "stamp" it onto another area of the image. This tool cleverly uses a painting metaphor: larger brushes copy more pixels, and softer brushes blend the copied pixels

into their new surroundings. You can even alter the opacity of the brush to make the clone only partial. Use the same shortcuts you would use with the Brush Tool to change brush attributes.

option / **Alt** click to set the source point.
In this example, I chose a point to the right and slightly above the distracting bits I was about to be rid of.

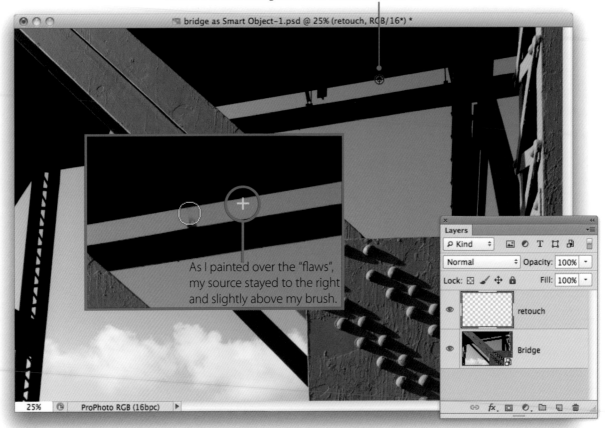

As I painted over the "flaws", my source stayed to the right and slightly above my brush.

1. Zoom in. View>Actual Pixels makes it easier to see dust spots and defects you might otherwise miss. Periodically hold the **H** key to access the Hand tool. Use this to move along to new areas to retouch. Release the **H** key to resume retouching. If you are startled by the "Bird's Eye View" zooming effect, you may use the spacebar instead. It also accesses the Hand tool without the zooming.

2. Find a flaw in the image and note an adjacent area without a blemish but with a similar texture, color, and density. You'll clone from this clean area onto the blemish or spot. If the flaw is along an edge, choose a point further along the same edge (as in the example above).

3. If the defect is small like a dust speck, select a brush slightly larger than the defect. Otherwise, a brush of between 20 and 100 pixels will be fine.

4. Place the cursor over the clean area of the image. It appears as a circle the same size as the selected brush. Hold down option/Alt to display a small target, then click on the clean area to designate it as the source. **Important:** Once you designate the clean area as your Clone Source, release option/Alt.

5. Move the cursor over the spot to be removed. Notice how the cursor displays the material that you will be painting shortly. If you have an adjustment layer above the retouch layer, the material may look discolored, but it will paint correctly if, in the Options Bar, you choose to sample Current [*layer*] and Below.

6. Paint over the spot. You will see two cursors *while you paint*: the center of your source marked with a + cursor, and the circle of your brush. There is a spatial relationship between them that will be maintained until you define a new source point. So, if you define a source above and to the right of where you paint, when you paint elsewhere in the image, the source will be above and to the left of the cursor in its new location. The trick is to keep an eye on each cursor to be sure that as you paint, your source doesn't drift toward areas inappropriate to cover your blemishes. The difficulty is that the source cursor is visible only while you paint! Use your inner eye, I suppose.

7. Repeat for each defect. Remember that you need to set a source point only when the alignment between source and brush no longer serves.

I strongly suggest that for larger defects, and for areas with many defects, you change your source point alignment frequently to avoid noticeable repeats of a pattern.

Healing Brush

The Healing Brush tool is very similar to the Clone Stamp in that you specify a source point by option/Alt clicking, then paint away defects. It also loads the cursor with the sampled material. But there is a huge difference.

 When you paint over a defect, **you must paint it completely gone in one brush stroke.** While you do so, you may *think* you chose the wrong source—what you're painting may look a bit dark or light. But when you release the mouse, Photoshop does its magic: it uses the *texture* of the source pixels, but then uses the color and density surrounding the flaw, or more precisely, where you painted. So there had better be no flaw left! Even if your source pixels are very different in color and density from the flawed area, but have a similar texture, the resulting repair will be seamless. Essentially, you define a texture to use, then fix areas with the same texture (sky texture for defects in a sky, or stone texture for defects in stone, etc.).

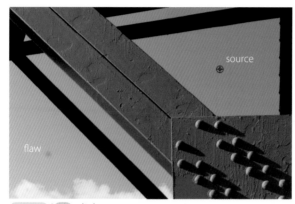

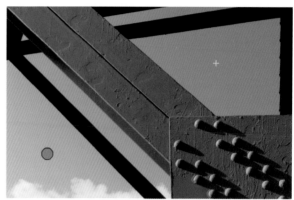

option / Alt click to set source point.
In this example, I chose a point anywhere in
the sky. I just needed smooth sky texture.

As I paint, I simply ensure that I cover the
entire flaw. When I release the mouse, my
retina adjusts, and the flaw is gone.

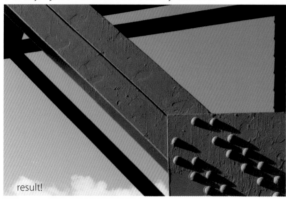

Note: Unlike the Clone Stamp, the Healing
Brush will use the same source location until
you change it. The source does not stay aligned
with the brush cursor. It doesn't need to as long
as you need just the same texture to fix things.

In short, you control the source texture, and Photoshop sweats the other
details! Use the Clone Stamp when you need a literal copy of pixels. Use the
Healing Brushes when a copy is the wrong color, density, or both.

Sometimes the Healing Brush fails and creates an obnoxious smudge.
This is common if the dust spot is right along a strong edge, or especially if
the flaw is in a corner of the image. If this happens, press ⌘+Z / Ctrl+Z. If
the flaw is in a corner, first use the Clone Stamp, *then* Heal. For flaws along
edges, use a source point further along the same edge.

Spot Healing Brush

The Spot Healing Brush is an alternate version of the Healing Brush. It
works by merely painting on a dust spot or defect in the image without first
defining a source.

Click or paint on the defect, and Photoshop eliminates it—usually. It
picks its own source material. If it chooses inappropriately, use the Healing
Brush or Clone Stamp.

The Spot Healing Brush has several options. But I keep the Detail Mode
set to Normal and the Type set to Content-Aware.

The Spot Healing Brush works best with a hard-edged brush—a soft-edged brush doesn't completely fix a defect. If you should accidentaly soften the brush, control+click / Right-click anywhere on the image to increase the brush's hardness.

Save the Clean Image

After you have completed the image clean-up, use File>Save. If the file is a RAW image, you may be presented with the Save As dialog, as Photoshop edits cannot be saved directly into RAW files. JPEGs cannot hold Layers, so Photoshop will give a Save As dialog for them, too.

Remember to change the label, so you know that the file has been cleaned and whether it needs more work.

Larger Defects

It can be tedious to repair large image areas. But a few tools can make a great start or even complete the job in a few clicks if we're lucky. However, to do this reversibly, as you know I recommend, we have to do a little more setup.

Setup Note: Some of the following methods don't sample any layer but the active one. So, to work on a extra layer while preserving your original:

1. Duplicate your original layer or Smart Object: Layer>Duplicate Layer…

2. If you now have two Smart Objects, you'll have to rasterize the duplicate: Layer>Smart Object>Rasterize.

Or, if you've already created other layers, including adjustments, that you would like to play an active role in fixing more of the image, you may follow these steps instead:

1. Create a new, empty layer via Layer>New>Layer… and give it a reasonable name.

2. Merge a copy of the image into this new layer by using the shortcut ⌘+option+shift+E / Ctrl+Alt+Shift+E . This merges a copy of everything you see into this one layer, preserving the others—just in case.

That's it. Now we can safely proceed—or reverse if we really make a mess.

Content-Aware Fill

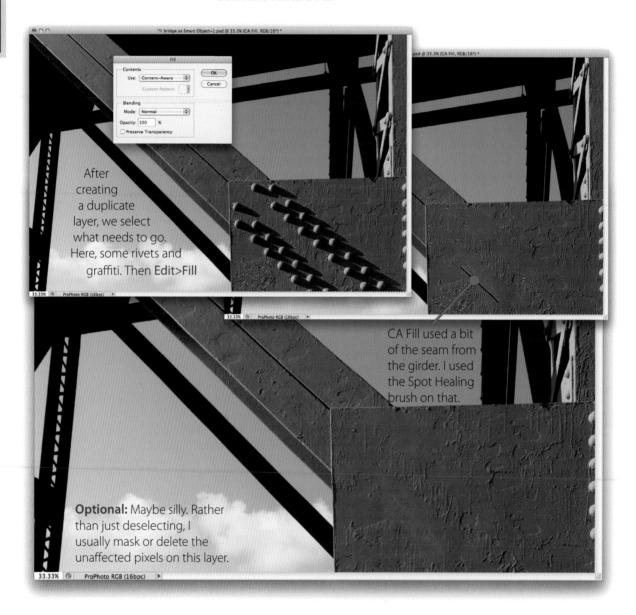

After creating a duplicate layer, we select what needs to go. Here, some rivets and graffiti. Then **Edit>Fill**

CA Fill used a bit of the seam from the girder. I used the Spot Healing brush on that.

Optional: Maybe silly. Rather than just deselecting, I usually mask or delete the unaffected pixels on this layer.

To convincingly remove large areas quickly had always been somewhat difficult. Today, we can simply select an area, fill it with "content awareness", and Photoshop will find bits and pieces of the image to fill in that selection.

1. (Re)read the setup note on the previous page.

2. Make a slightly loose selection around the flaw with any selection tool.

3. Choose Edit>Fill… In the Fill dialog box, choose Content-Aware.

4. Click OK, then retrieve your jaw from the floor.

Patch Tool

The Patch Tool is like a custom-shaped, extremely large Healing Brush. Rather than painting, we use selections to indicate what should be fixed—or with what to fix our flaws. Unfortunately, only the Patch Tool's new Content Aware mode works on empty layers by sampling below. If we wish to use its healing power, we must work directly on standard image pixels.

Like the Spot Healing Brush

Content-Aware options (above) and Normal "Healing" options (below)

Choose what needs patching: Source, if you've selected the flaw, or Destination if you've selected good repair material.

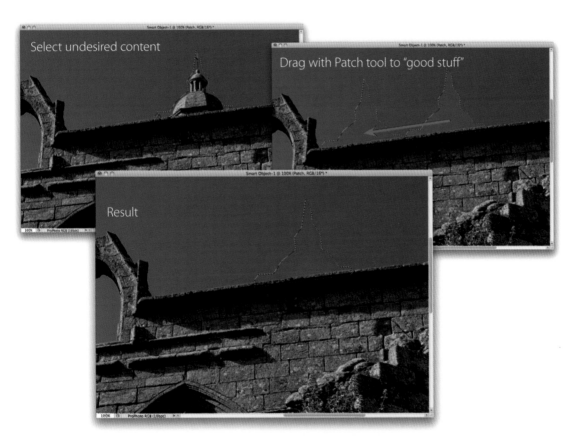

Select undesired content

Drag with Patch tool to "good stuff"

Result

To patch:

1. (Re)read the setup note on page 233.

2. Make a slightly loose selection around the flaw with any selection tool, including the Patch Tool itself.

3. Now the cool part: with the Patch Tool, drag the selection to an area you would like to use as your patch; that is, good pixels that can be used for their texture and detail. If you're using Normal mode, don't worry about color or lightness as there will be a healing calculation when you release the mouse. If you want the content to be shuffled about a bit as it acts as a patch, choose Content-Aware mode.

4. Release the mouse and deselect. Nice!

Content-Aware Move Tool

New in CS6, I have so far found this tool impressive only in the demos given by Adobe folks. As of this writing, I have found it less useful than the tools mentioned above, especially when used with those discussed below. However, it seems that smaller items surrounded by nondescript imagery work best. I look forward to writing an enthusiastic update.

Transformations

Bending images is both fun and practical, if more extreme than removing dust. Let's look at a couple of ways to get images to fit your visualization.

Free Transform

Free Transform scales (and skews, etc.) all the pixels that are selected. However, you have a few modes to choose from. The standard transform is rectilinear and wholesale.

Choose Edit>Free Transform or use the keyboard shortcut ⌘+T / Ctrl+T. Once in the interface (a box with handles on the edges), you may drag a corner or edge. If you have a specific amount of distortion in mind, you may enter it in the fields in the Options Bar. You may also set the interpolation method used when you scale. Use the Enter key to commit the transformation.

You may also engage Warp mode to get a more fluid transformation. Choose Warp mode with the button that appears on the right side of the Options Bar when Free Transform is active. You may choose a preset Warp like Flag (left), or create your own via Custom. With the Custom interface, you may drag on the grid or the "handles" along the edge to sculpt the selected pixels in fluid and natural ways.

Liquify Filter

For a painterly distortion, use the Liquify Filter. Access it by Filter>Liquify and choose a tool in the upper left. Adjust the characteristics of the tool, always brush-like, on the right side of the interface. Advanced mode yields many more options, though few use them.

But the fun is had in the middle. Paint with the Warp Tool, and you sculpt pixels. Use the Pucker or Bloat Tools, and you can see why this filter is used extensively in fashion and catalog photography.

Since Liquify cannot be applied to Smart Objects but only to typical image pixels, recall how to preserve your data and adjust a copy:

1. Duplicate your original layer or Smart Object: Layer>Duplicate Layer…

2. If you now have two Smart Objects, you'll have to rasterize the duplicate: Layer>Smart Object>Rasterize

Or:

1. Create a new, empty layer via Layer>New>Layer… and give it a reasonable name.

2. Merge a copy of the image into this new layer by using the shortcut ⌘+option+shift+E / Ctrl+Alt+Shift+E. This merges a copy of everything you see into this one layer, preserving the others—just in case.

Then:

3. Choose Filter>Liquify. Use tools like Warp, Pucker, and Bloat to "sculpt" the image. Use the Reconstruct Tool to paint the image back to its original form.

4. Have fun!

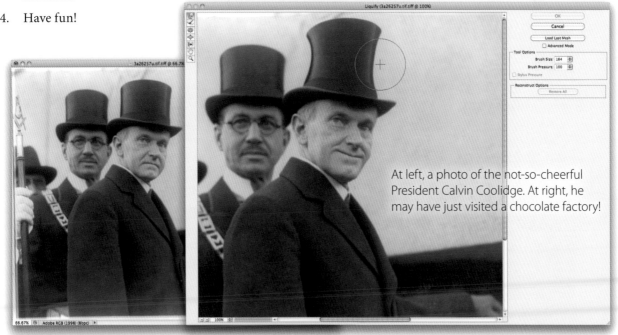

At left, a photo of the not-so-cheerful President Calvin Coolidge. At right, he may have just visited a chocolate factory!

Content Aware Scaling (CAS)

CAS is like Free Transform, but treats your content with respect.

You may choose Edit>Content-Aware Scale or use ⌘+option+shift+C / Ctrl+Alt+Shift+C to engage this function. What you'll notice when you drag an edge or corner is that areas with fine detail distort far less than areas that are more homogeneous.

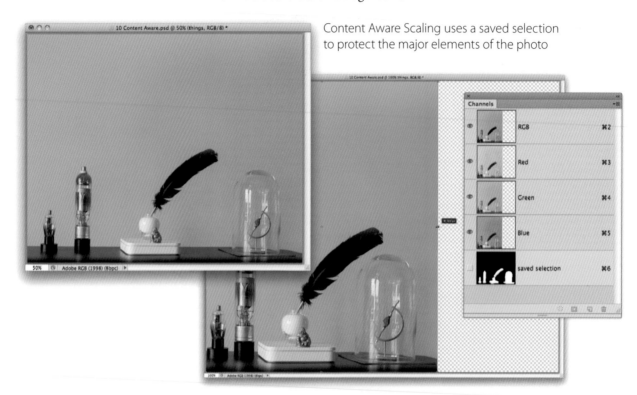

Content Aware Scaling uses a saved selection to protect the major elements of the photo

Even more powerful is the combination of this tool with a saved selection. If you first create a Marquee (perhaps with the Quick Selection Tool), then save that selection, you'll see the name of that saved selection in the Options Bar under the Protect menu.

1. Create a selection around important content, especially if it contains areas without fine detail.

2. Choose Select>Save Selection… and give your selection channel a name.

3. With a single image layer selected, but not a Smart Object, choose Edit> Content-Aware Scale or use ⌘+option+shift+C / Ctrl+Alt+Shift+C .

4. In the Options Bar, choose the name of your saved selection from the Protect menu.

5. Scale the layer.

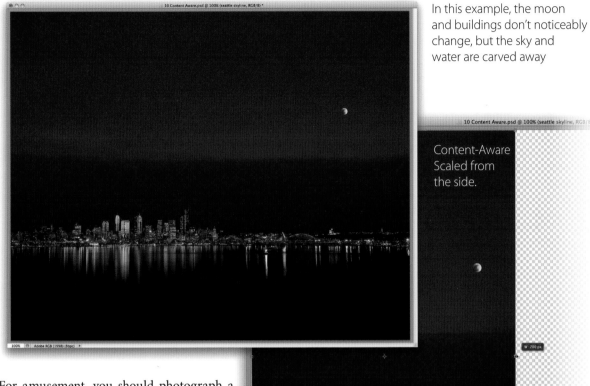

In this example, the moon and buildings don't noticeably change, but the sky and water are carved away

Content-Aware Scaled from the side.

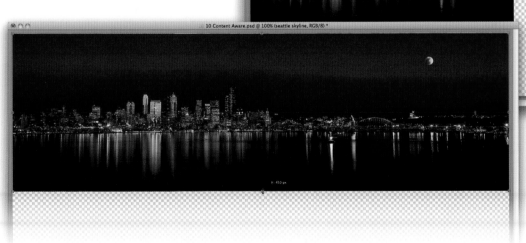

For amusement, you should photograph a small automobile and Content-Aware Scale it upward. That is, make it longer. Imagine a Mini as a limousine.

Content-Aware Scaled from the bottom

Creative Edits & Alternates

9

As Ansel Adams long espoused, photographers seek to make the images they visualize. The visualized image may or may not perfectly reflect the scene before the eyes of the photographer. After all, Adams and many others used dense filters and extreme darkroom techniques to bend the image to their desire, bringing strong contrast where the world offered little, grayscale where there was color, and clarity where there was haze.

Masters in the darkroom can achieve much, and with our digital darkroom, the possibilities are multiplied many times. For the creative image maker, the ability to more easily combine images, to blend and stitch them, and to bend and twist them is dizzying! For journalists and documentarians, these techniques and abilities raise difficult questions. But the same features used to add or remove people from a photo, a journalistically questionable act, can be used to create panoramic images that raise no eyebrows. Tools that are used to color-correct images can be used to recolor them, too.

Although in this chapter I will discuss these features and tools in a creative or even radical way, remember that they can be used in a more mundane and innocent fashion, too.

Managing Versions

As we go through these adventures, we will often want to keep several versions of our images. Here are just a few ways we can keep those without too much clutter.

Bridge/ACR	Lightroom

Virtual Copies & Snapshots

Some edits are much more than technical: they are experimental and/or aesthetic. Many of these Creative Edits (as I call them in this book) can be achieved in Lightroom and ACR. Consider some of the Develop Presets that come with Lightroom: Antique Grayscale, Sepia Tone, etc. Often, you'll want to apply these only to copies of your images.

In Lightroom, I recommend that you make a **Virtual Copy**. To do so, `control click`/`Right-click` on an image or its thumbnail and choose Create Virtual Copy. This Virtual Copy's thumbnail will have a "page-turn" icon in its lower left corner. There is no extra image file on your hard drive. This is merely a convenient, visual representation of an independent set of metadata for your original image. Go wild!

In Camera Raw, you may use the last panel, Snapshots, to capture metadata sets. Clicking on a snapshot immediately changes the image to the configuration that was present when the snapshot was made.

Layer Comps

Although there is no virtual copy feature in Photoshop per se, you can use different Layers and settings, then capture these with **Layer Comps**. This feature is so useful, yet so simple to use, you'll wonder how you got along without it! To make a Layer Comp:

1. Make some layers of a document visible, and others invisible (click on the eye icon to the left of the layer).

2. Optionally, you may move the content of one or more visible layers and adjust the parameters of any Layer Style (Drop Shadows, etc.).

3. Click the New Layer Comp button at the bottom of the Layer Comps panel. Give your Comp a name and description. I usually also check all three boxes as I will often affect all of those attributes (Visibility, Position, and Appearance).

4. Later, when you need to get back to the state of the document that was saved as a Layer Comp, click in the space to the left of the Comp's name.

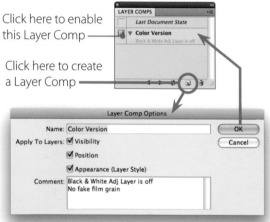

Click here to enable this Layer Comp

Click here to create a Layer Comp

Saving Copies

As in many other applications, we can use File>Save As… to create other documents. Photoshop also offers Image>Duplicate… I prefer this so I can have both original and duplicate open at the same time right away and compare them.

Combining Images

Compositing Two or More Images

There are times when the image you want is the marriage of two or more images in your library. Here, I want to show you a typical method (but far from the only one) for combining images to make one coherent composition.

To be successful, one has to be proficient at making selections. So you may wish to review "Selection Tools & Methods" (page 204), especially the section on "Refine Edge" (page 215). It would also be wise to review the basics of Photoshop's "Layers" (page 52) through "A Typical Document's Layers" (page 58).

We're going to send Carla to New York! I don't wish to send the vegetation with her, but I do want to leave most of her hair intact. Here's what needs doing:

- ► Copy layer to other document
- ► Rough selection of Carla
- ► Refine that selection
- ► Create a Layer Mask
- ► Possibly adjust color and/ or contrast of Carla to fit in

Here's a rather thorough list of common steps in compositing two images. But bear in mind that every pair of images may offer unique challenges.

1. Name your layers! You'll thank yourself later as they proliferate and you won't have to puzzle over what "Layer 47" contains.

2. Decide whether you want to hide the unwanted areas (mask) before or after moving one image to another. In this example, I will move first, mask later. It's really up to you.

3. Since both photographs were shot with the same camera and haven't been cropped, we know they have the same pixel dimensions. If that hadn't been the case, we would have to plan on scaling one of them later, perhaps with **Free Transform**.

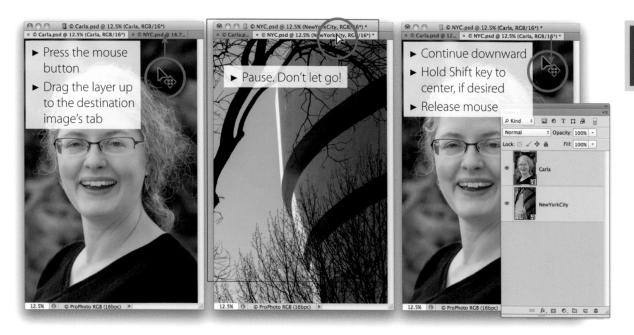

4. Get the Move Tool. Chant the following: Press Mouse, Move Up, Pause, Move Down, Release Mouse. Use the Move Tool to drag one image to the other's tab, wait for the other image to appear, then continue dragging into the Image Window and release the mouse.

 Tip: If you're holding down your shift key as you release the mouse, the image you're dragging will be centered on the destination.

 Don't be timid: be sure the cursor makes the journey all the way into the destination image before releasing. Drag the new layer around to recompose if needed.

5. Plan your mask. Often, the best way to make a **Layer Mask** is to select the pixels that should remain *visible*, then click the **Add a Mask** button in the Layers panel. Which tool should you use to select? The Quick Selection Tool is great for edge detection. Color Range is frequently the ideal tool for complex selections based on color or tone and, in CS6, it does face detection. For approximate selections, the Lassos are your first choice.

 This image needed a combination. I used the Quick Selection from the bottom of the image up to the hair. Then, aware of how Refine Edge works, I made a loose selection from there upward, selecting the face and the parts of the hair that should remain solidly selected. So, in about 10 seconds I was ready for Select>Refine Edge....

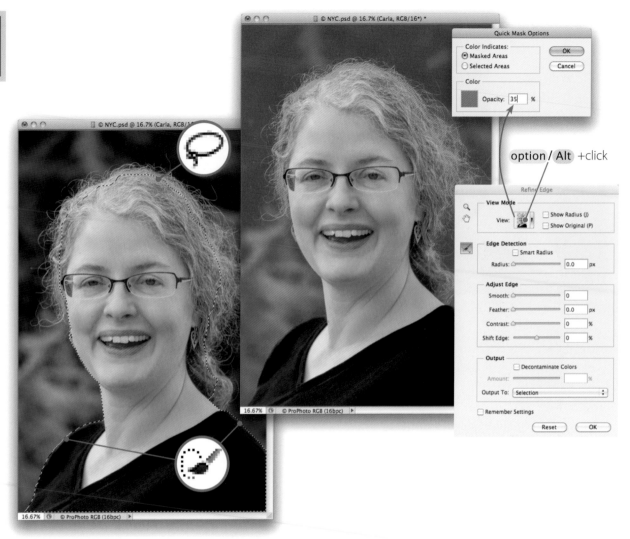

To see what I was doing, I chose Overlay View Mode which lets me see both the selected and unselected areas. However, the overlay was too opaque, So I option / Alt clicked on the tiny view preview to change the overlay's opacity. See the illustration above.

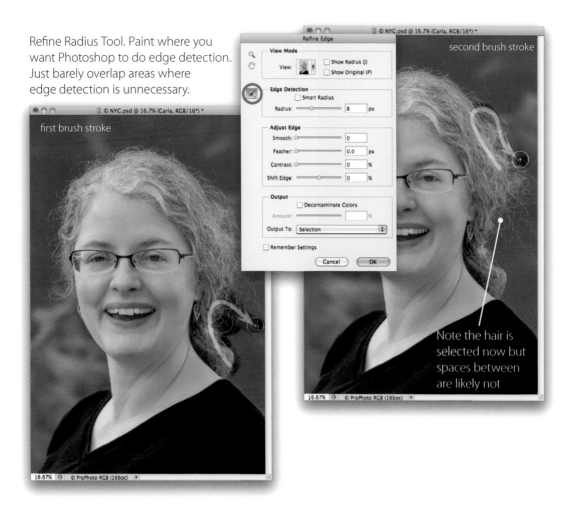

Refine Radius Tool. Paint where you want Photoshop to do edge detection. Just barely overlap areas where edge detection is unnecessary.

first brush stroke

second brush stroke

Note the hair is selected now but spaces between are likely not

6. **Radius** is the term used to denote the area where Photoshop uses edge-detection to build a selection. For uniform fuzziness around the edge of an original selection, we could use the Radius slider. For areas of *variable* wispiness, like Carla's hair, we use the Refine Radius Tool. Note that the active cursor is already the Refine Radius Tool's brush. Set its size as you would any brush cursor. Use this to paint the areas in which Photoshop should detect wispy edges, barely overlapping areas of the image that should remain fully selected (no edge detection required). As I released the mouse after each brush stroke, I could see Photoshop finding and selecting the hair where I painted.

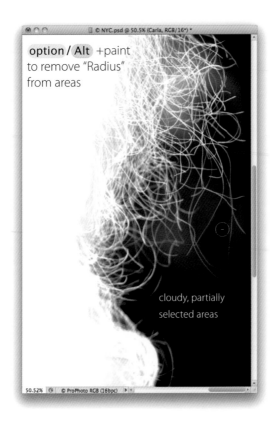

7. It's wise to check different View Modes to see if Photoshop is missing anything or finding too much. Hold down option / Alt as you paint on areas Photoshop should ignore. **Contrast** and **Shift Edge** can also tighten a too-loose selection. When using the **On Layers** preview mode, you may notice that some color from the masked areas contaminates what's left. Use **Decontaminate Colors** to remedy this. It will trigger the creation of a new layer since color will be added to the image pixels. Our original image will remain untouched and hidden when we're done.

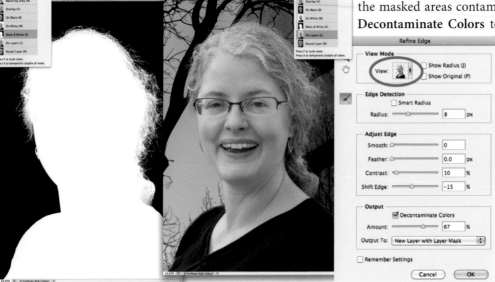

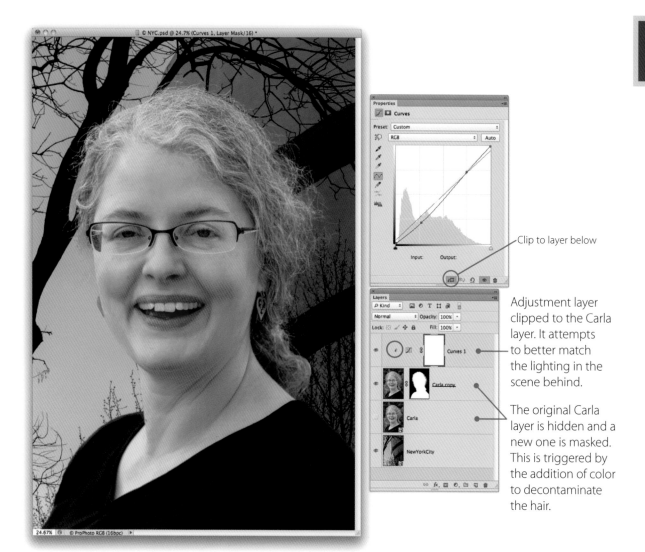

Clip to layer below

Adjustment layer clipped to the Carla layer. It attempts to better match the lighting in the scene behind.

The original Carla layer is hidden and a new one is masked. This is triggered by the addition of color to decontaminate the hair.

8. Press OK! A new layer is born, the original is below and hidden.

9. Note the result. Joyous! Carla has now been teleported to Fifth Avenue in New York City!

Blending

In the example above, we moved one image into another, combining them. To see a bit of each, we used masking to hide parts of the top layer. There are other ways to combine images once they are layers in the same document. Chief among these are Opacity and Blending Modes.

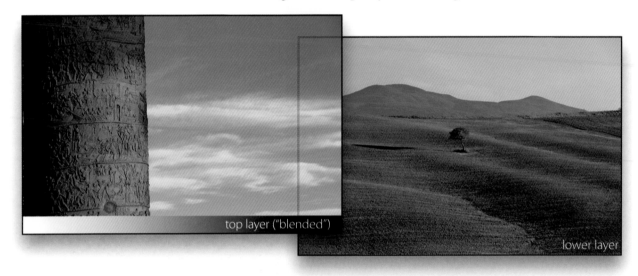

top layer ("blended")

lower layer

Opacity

The opacity of a layer is easy to understand. Lowering the opacity makes the image semi-transparent. Opacity is the opposite of transparency. A 100% opaque layer can't be seen through at all; at 50% opacity, the layer is 50% transparent, and the layer blends 50/50 with the pixels below; at 0% opacity, the layer is 100% transparent, and you can see right through it. Just select the topmost layer in your image and change the opacity of the layer to experiment with it.

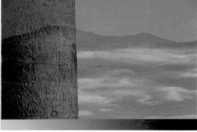

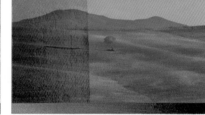

70% opacity 30% opacity

Blending Modes

The Blending Mode for a layer sets how the pixels in that layer visually blend with the pixels in layers below it. The default "Normal" Blending Mode is simply no blending.

Most of the modes calculate a color for each pixel. These are based on the color numbers of each pixel on the blended layer and the pixels visible on the layer(s) beneath. This is why so many have mathematical names (Multiply, Subtract, Divide, etc.). Some are evaluative; that is, each pixel on the blended layer is compared with the visible pixel beneath it and one is chosen (Darker Color, Lighter Color). Finally, others break down an image into components and show only one or two of those (Hue, Saturation, Color, and Luminosity).

Let's look at them in the same groupings as we find them in the Blending Mode menu.

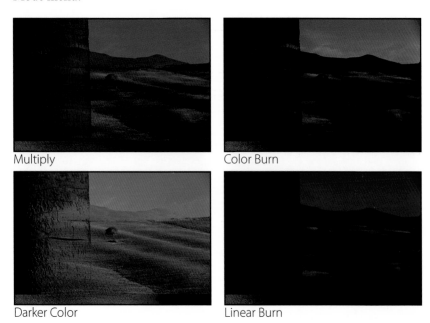

Multiply Color Burn

Darker Color Linear Burn

These darkening modes make the resulting image darker by either yielding the darkest pixels of the blending layers (via the comparative modes Darken and Darker Color), or by using the colors of each layer to reinforce each other. Multiply is probably the most definitive of the group. Imagine stacking two photographic slides one upon the other, then looking at the two on a light box: this is the same visual result as Multiply.

Screen

top layer

lower layer

Color Dodge

Linear Dodge

Lighter Color

The next group tends to make the resulting image lighter by either comparing the blended layer with the layer below and showing the lighter pixels (Lighten and Lighter Color) or by using the lightness of the blended layer to brighten the layer below (Screen).

Overlay

Soft Light

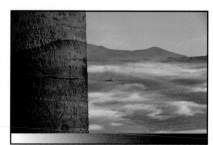

Hard Light

Vivid Light

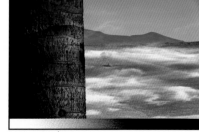

Linear Light

Pin Light

The largest group tends to increase contrast. These modes make the result darker where the blended layer is darker than middle gray, and lighter where that layer is lighter than middle gray. The definitive one here is Hard Light: where the layer is lighter than middle gray, it "Screens"; where it's darker than middle gray, it "Multiplies." What about where it's exactly middle

gray? Then it's completely invisible (see the gradient in the blended layer, especially with Hard Light). Overlay is probably more commonly used than Hard Light, however, as it leaves more of the underlying colors and textures present and "feels" more subtle.

Difference

Subtract

Divide

The next set is easy to understand but produces interesting and sometimes vibrant results. Difference compares your blended layer with what is visible below. If there is no difference (the layers are identical), the result is black. I use this mode to establish when two very similar layers are well aligned to one another. If the layers are very different, the results can be really wild. Subtract literally subtracts the color numbers of the blended layer's pixels (scaled so that 255 is 1.0, 127 is 0.5, etc) from the underlying ones. Results of zero and below yield black.

Hue

top layer

lower layer

Saturation

Color

Luminosity

The Color modes cause the blended layer to retain only one aspect of the image: Hue, Saturation, Color (Hue+Saturation), or Luminosity (density). The two that get the most use are the last two, as they are complementary ingredients of an image. That is, choosing Luminosity removes the color

from an image, and all you're left with is the Luminosity (the grayscale or detail part) of the image. Color is somewhat more abstract. If you look through colored glass, it changes the colors you see but not the luminosity as much. Similarly, if you paint with colors on a layer to which Color mode has been applied, then you can simulate "hand-tinting" (see image below), changing its color but not its tonal details.

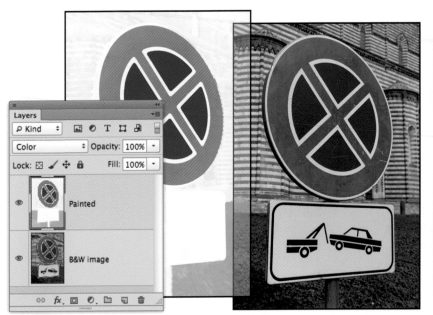

Blending Adjustments

Even after many years, I sometimes make adjustments that are the right kind but too much. Opacity is a great way to "turn down" an adjustment layer. If you decide during the editing process that a particular adjustment layer is a bit too strong, you can reduce it by merely reducing the opacity of that layer. An adjustment layer set to 50% opacity is essentially the same as applying half the adjustment.

I want to give this image more contrast, but I do *not* want its color to shift

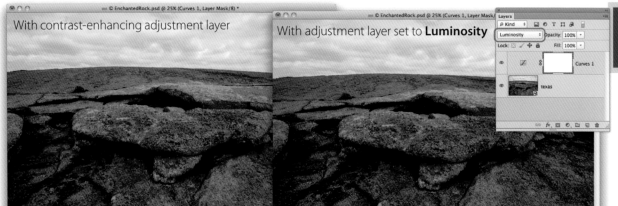

The Luminosity mode is especially useful with adjustment layers if you want an adjustment to change only the luminosity (or density) of the image and not its color. It is common for adjustment layers that apply significant density changes to also produce some moderate color changes. In the example above, a Curves adjustment layer that adds contrast also results in a slight change in color. Changing the Blending Mode of this Curves adjustment layer forces the layer to affect only luminosity and not color.

The Color Blending Modes can be used for most common adjustment layers that adjust brightness, contrast, color, or saturation. In general, a brightness or contrast layer should only change luminosity (so the Blending Mode should be set to Luminosity); a color or saturation layer should change only color or saturation.

Smart Objects & Smart Filters

Adjusting the opacity or blending is great for Smart Objects and any Smart Filter applied to them.

1. Try this yourself. Convert the layer into a Smart Object if it isn't already one: `control+click` / `Right-click` on the layer and choose Convert to Smart Object.

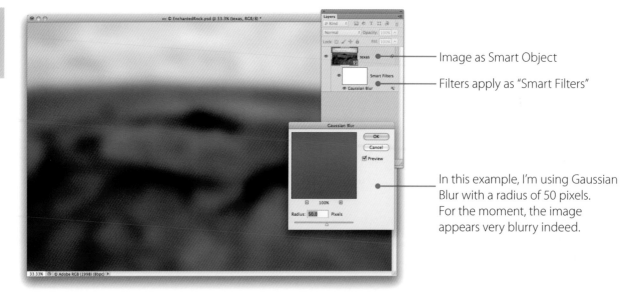

Image as Smart Object

Filters apply as "Smart Filters"

In this example, I'm using Gaussian Blur with a radius of 50 pixels. For the moment, the image appears very blurry indeed.

2. Choose a filter (I chose Filter>Gaussian Blur, 50 pixels in Radius).

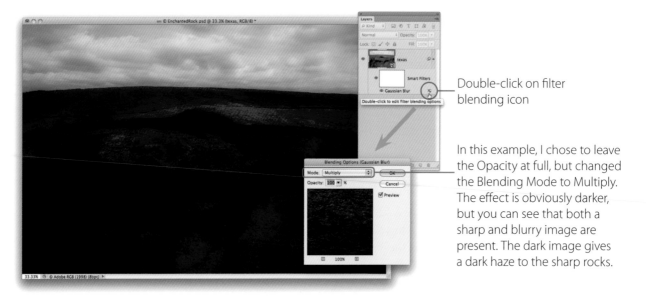

Double-click on filter blending icon

In this example, I chose to leave the Opacity at full, but changed the Blending Mode to Multiply. The effect is obviously darker, but you can see that both a sharp and blurry image are present. The dark image gives a dark haze to the sharp rocks.

3. To adjust the filter's opacity or other blending options, double click on the slider icon (⇥) to the right of the filter's name in the Layers Panel (see above). Then you may change the Opacity or the Blending Mode.

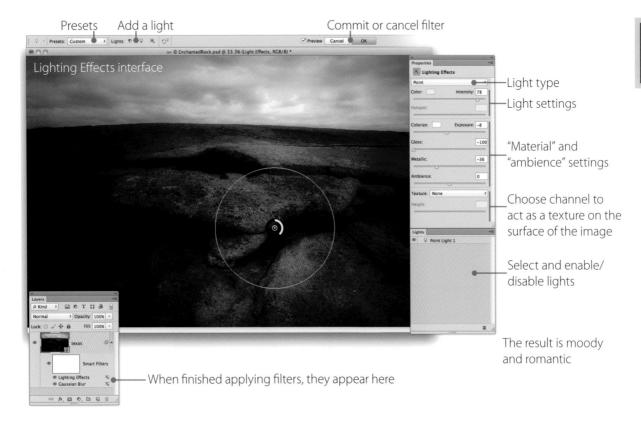

Presets Add a light Commit or cancel filter

Lighting Effects interface

Light type

Light settings

"Material" and "ambience" settings

Choose channel to act as a texture on the surface of the image

Select and enable/ disable lights

The result is moody and romantic

When finished applying filters, they appear here

4. Although some filters cannot be applied to a Smart Object, many can. And we can apply multiple filters to each Smart Object, each with its own blending. In this example, I added just one more filter, Lighting Effects, to illuminate the foreground again. Long neglected, this filter has been substantially enhanced in CS6. To use it, choose Filter> Render>Lighting Effects. No dialog box appears, but the usual panels are replaced with the filter's. Add and adjust lights, then click OK in the Options Bar.

Merging Images

Photoshop is a marvelous tool for combining not only completely different images, but also multiple frames of the same or similar subjects. Let's look at ways of combining exposures to make High Dynamic Range images, overlapping frames to make panoramas, or merging images with sharp focus on different planes into one image with apparent sharp focus throughout.

HDR: High Dynamic Range Images

If you have a subject with extremes of light and dark that cannot be captured in one exposure despite the powerful highlight and shadow recovery of Adobe Camera Raw, you can instead bracket several exposures, one to two f-stops apart, using shutter speed only.

The process that follows creates a Photoshop HDR (High Dynamic Range) image, which cleverly uses 32 bits per channel to describe an immense range of tonal detail.

To get started, it's easiest to push the files from Bridge or Lightroom. In Bridge, select the images to be merged, then choose Tools>Photoshop> Merge to HDR Pro…. In Lightroom, select the images to be merged, then control+click / Right-click on a thumbnail image to choose Edit in>Merge to HDR Pro in Photoshop…. Photoshop will launch, you will witness a good deal of activity, then you will be presented with a large dialog box and an image with more detail than any of the several you just sent to Photoshop.

In the field, I bracketed my exposures. Although it is best to change only the shutter speed (to keep depth of field constant), I find I can often get away with using my camera's auto bracketing, which may let aperture change as well.

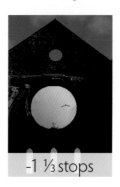
-1 ⅓ stops

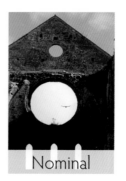
Nominal

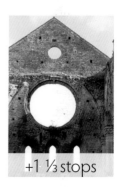
+1 ⅓ stops

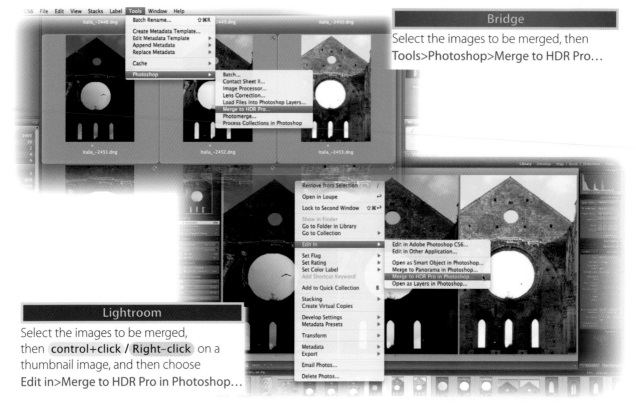

Bridge

Select the images to be merged, then Tools>Photoshop>Merge to HDR Pro…

Lightroom

Select the images to be merged, then control+click / Right-click on a thumbnail image, and then choose Edit in>Merge to HDR Pro in Photoshop…

1. Welcome to the HDR preview window. Almost everything you need to create the perfect image is here. Start near the top and work down.

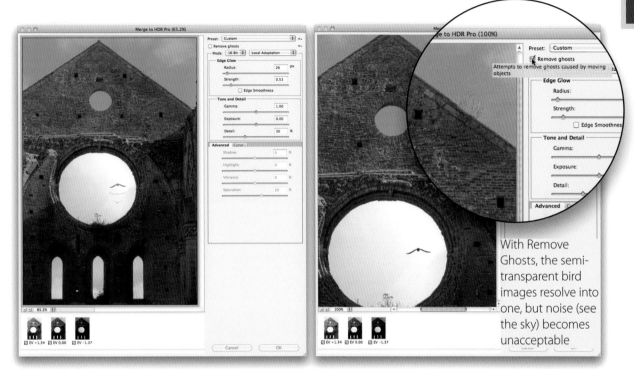

With Remove Ghosts, the semi-transparent bird images resolve into one, but noise (see the sky) becomes unacceptable

▶ **Remove Ghosts**—If something moves between exposures, it can appear as several "ghost" images (like the bird in the example here). Checking the box does indeed yield one, solid bird, but noise also becomes very apparent. Sometimes, as here, I leave the ghosts and retouch them later.

▶ **Mode**—Choose 32 bit if you want to keep the HDR data, downsampling later to 16- or 8-bit images; or choose those bit-depths now.

▶ **Conversion Methods**—The default, Local Adaptation, offers the greatest control. Although the others offer few if any options, try **Equalize Histogram**, **Exposure and Gamma**, and **Highlight Compression** to see if one simply delivers the perfect image with no further intervention.

▶ **Edge Glow Radius**—Defines the size of what Adobe calls the "glow effect." I prefer to think of it as helping to define tonal regions in an image. If the light and dark areas are large and distinct, I will set the Radius rather high so Photoshop will calculate contrast within each region more pleasingly. If the lighter and darker areas are more entangled, a lower radius would serve better.

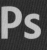

▶ **Edge Glow Strength**—Controls the intensity of the glow (edge contrast).

▶ **Gamma**—This is a control of contrast.

▶ **Exposure**—This moves you through the image's tones as if you were changing the camera's exposure. Very useful.

▶ **Detail**—Similar to Lightroom and ACR's Clarity, this controls local contrast.

▶ **Shadow & Highlight**—These control the lightness of the shadows and highlights. If your shadows need a bit more light, drag the slider right.

▶ **Vibrance & Saturation**—Most images require these adjustments after the HDR process. I prefer to use Vibrance first, then Saturation if I need more.

▶ **Curve**—A tone curve finesses the journey from darkest shadow to brightest highlight. Very handy to get pleasing contrast.

2. Hit OK.

Usually last, a tweak to the tone curve.

After hitting OK, we attend to any last cleanup, as here

3. Adjust as you would any other image to fine-tune. Here, I retouched away the ghost birds.

Panoramic Images

When combining overlapping images of a subject too expansive to capture in one go, Photoshop's Photomerge is brilliant. Whether you're trying to simulate a fisheye effect, or stitching a series of photos covering a full 360°, this tool is the ticket.

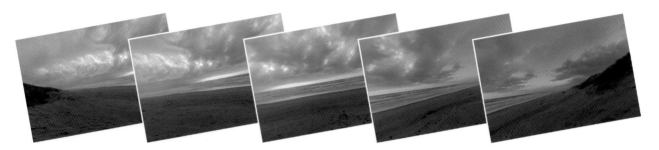

1. To merge images for a panorama, do one of the following:

▶ In Bridge, select the images that should make up the panoramic image, then choose Tools>Photoshop>Photomerge….

▶ In Lightroom, select the images for the panorama, control+click / Right-click on a thumbnail image, then choose Edit in>Merge to Panorama in Photoshop….

2. Set Photomerge options.

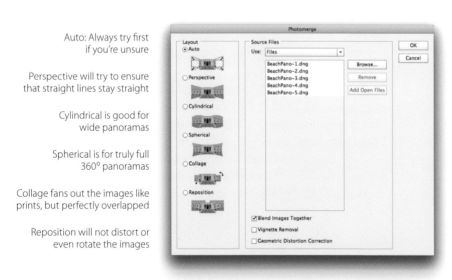

Auto: Always try first if you're unsure

Perspective will try to ensure that straight lines stay straight

Cylindrical is good for wide panoramas

Spherical is for truly full 360° panoramas

Collage fans out the images like prints, but perfectly overlapped

Reposition will not distort or even rotate the images

When you gather images for Photomerge, either from Bridge or Lightroom, you have a number of options. Along the left edge of the dialog box, you'll see choices for the layout of the images. Auto is always a great place to start. If it fails, simply don't save the result and try again.

A couple of other choices are at the bottom. **Blend Images Together** creates intricate (read: hard to edit later) Layer Masks. The edges of

these masks are intelligently along edges that have similar tone and color, and thus usually help line up images.

If your images have darkened corners, and you haven't removed these vignettes in Lightroom or ACR (Lens Correction), check the box for **Vignette Removal**. If there is a lens profile for the lens you used, the vignetting will be cured!

The same is true to compensate *somewhat* for fisheye, barrel, or pincushion distortions in the individual images. Choose **Geometric Distortion Correction** to engage a lens profile correction. The new **Adaptive Wide Angle** filter (below) does even more. Pressing OK begins the intensive process.

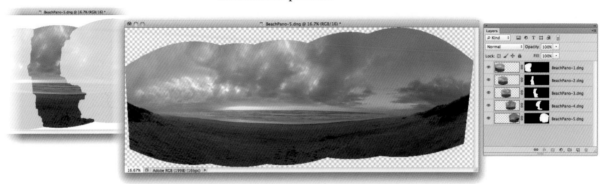

The layers are carved with masks into intricate shapes. Note that the right edge of one layer *exactly* corresponds to the left edge of the layer below. If this result is satisfactory, you're done. I usually go further.

For example, what about those empty areas? Or the slightly curved horizon?

3. **Merge layers**. I almost never merge layers because I usually want to preserve the ability to edit my masks and individual layers. But a Photomerge document's masks are so intricate that I never edit them. If I need to redo the panorama, I start again in Bridge or Lightroom.

 Note that when the panoramic image is presented, its layers are all selected. To merge them, either choose Layer>Merge Layers, or use the shortcut ⌘+E / Ctrl+E . This also makes the next steps easier.

4. If needed, use the new **Adaptive Wide Angle** (AWA) filter. In this image,
 it instantly straightened the horizon!

To uncurve edges
(as in a fisheye
image), use the
Constraint tools.
Drag along lines
that ought to
be straight, and
they will be! For
doorways, e.g.,
the Polygon
Constraint is great.

Set the correction based on the
image type (pano, fisheye, etc)

Scale image as
necessary to fit
it on the canvas

Lens metadata is
how AWA "knows"
how straight
lines are curved

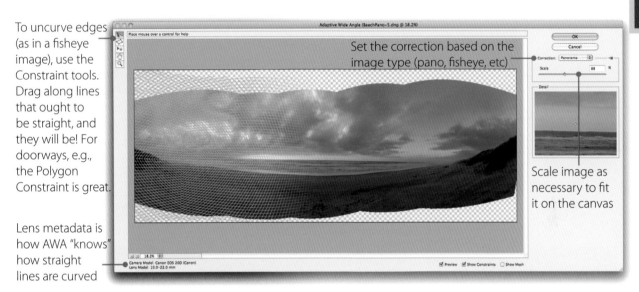

In the following last steps, we trim the image to the edge of the live pixels,
select the transparency plus the now fuzzy edge pixels, then use Content
Aware Fill.

5. Trim 6. Select Pixels 7. Contract Selection

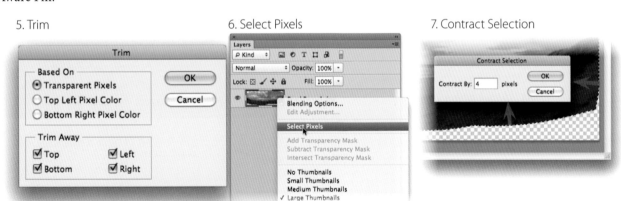

5. To trim off the excess transparency, I use Image>Trim….

6. To select the transparent pixels and the first few pixels all around
 the edge, I started with the opposite: the live pixels minus a few.
 control+click / Right-click on the layer thumbnail and choose Select
 Pixels.

7. To exclude the funky edge pixels, I used Select>Modify>Contract…
 with a value of about 4 pixels.

8. Choose Select>Inverse.

9. My favorite part! Now that we've selected the area that needs data, we attempt to supply it with Content-Aware Fill. Choose Edit>Fill... In the Use menu, choose Content-Aware. Press OK and Photoshop finds content to fill in the blanks.

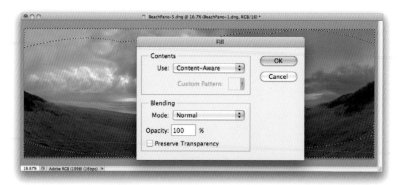

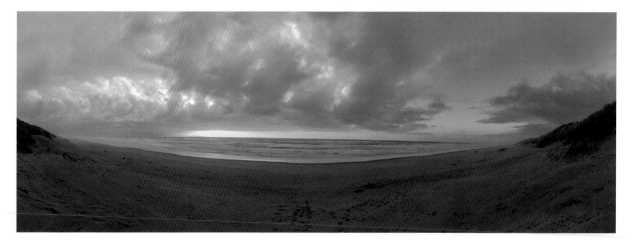

After Content-Aware Fill, you may have to do a bit of light retouching, but in this image, I've done none.

Focus Merge

Another method of merging is combining images focused on different planes to create a single image that appears to have the whole depth in focus. I've often had less than satisfying results with this feature. However, your results may be more favorable.

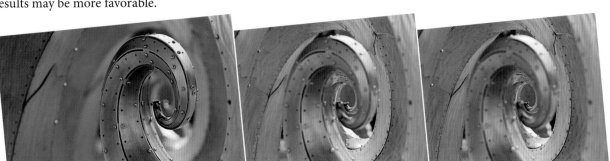

close focus medium focus distant focus

So here's how to do it:

1. Load the images into Photoshop as layers.

▶ **From Bridge**—Select the images with various planes in focus, then choose Tools>Photoshop>Load Files into Photoshop Layers….

▶ **From Lightroom**—Select images with various planes in focus, control+click / Right-click on a thumbnail image, then choose Edit in>Open as Layers in Photoshop….

2. Select all the layers: ⌘+option+A / Ctrl+Alt+A

3. Choose Edit>Auto-Blend Layers…. Check the box for Seamless Tones and Colors. Click OK.

Passerby Removal

Has the following ever happened to you? You're trying to photograph a scene, but vehicles, animals, or people keep passing in and out of it. Photoshop Extended has a feature that will examine multiple images and average them—those parts of the scene that are static and consistent remain, but those that move from frame to frame *disappear*. The more images you make of a scene, the better this feature works.

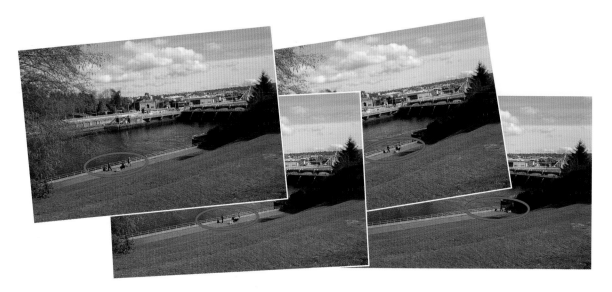

Pull the images into Photoshop by choosing File>Scripts>Statistics.... Choose Median as the Stack Mode, and "Browse" to the files you wish to average. After some processing, the images will be averaged, grain and noise will be reduced, and random elements should vanish. Very cool!

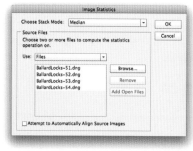

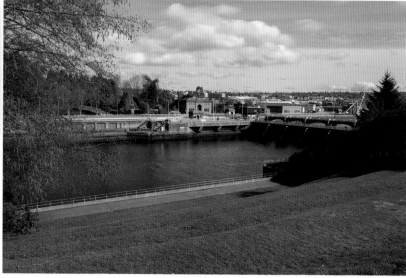

Smoothing Motion

If you engage nearly the identical procedure used for passerby removal (above), but replace the Stack Mode Median with Mean, you will see ghosts in the resulting image. This ghosting is what smooths water and other moving objects.

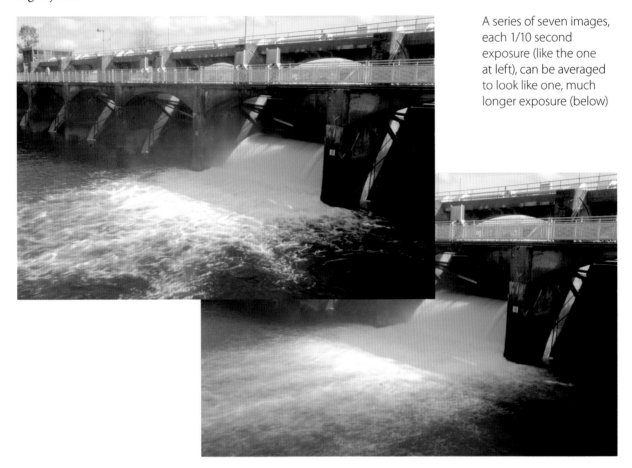

A series of seven images, each 1/10 second exposure (like the one at left), can be averaged to look like one, much longer exposure (below)

Photographic Effects

Focus Effects

Photoshop has about 110 filters, enough to fill a weekend with experiments. Most of them can be applied to Smart Objects; however, there are several worthy exceptions. Among them is a filter for adding blur in much the same way you might in-camera if you had the right equipment.

Blur Gallery

Three blurs in one filter! They may be listed separately in the Filter menu, but choosing any one of these will give access to an interface in which you can combine these blurring methods. They are:

► **Field Blur**—Allows you to have blurry and sharp areas arbitrarily placed anywhere in your image.

► **Iris Blur**—Enables you to place and configure a (usually) elliptical zone of focus with fall-off that can be abrupt or gradual. In fact, you can have more than one.

► **Tilt-Shift**—Typically creates a narrow, linear zone of focus with blurred areas above and below, much like what can be achieved with a view camera or tilt-shift lens. This zone can be extended or rotated, and this blur also has provision for geometric distortion in the blurry areas.

What follows are the fundamentals of this filter with a few examples. Your own experiments will cement your knowledge.

1. Create a duplicate layer on which to perform your Blurs. If you have only a single layer, duplicate it by selecting Layer>Duplicate Layer…. Name this "Blur Gallery" so you know what has been done to it. If your image is currently composed of several layers, select them all (⌘+option+A / Ctrl+Alt+A), then hold down option / Alt and choose Layer>Merge Layers. This creates a merged duplicate.

2. If the original layer was a Smart Object, then you will have to rasterize its duplicate: choose Layer>Rasterize>Smart Object.

3. Choose the first blur you want to try: Filter>Blur>Tilt-Shift, for example.

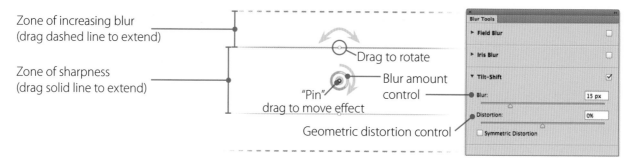

Zone of increasing blur
(drag dashed line to extend)

Zone of sharpness
(drag solid line to extend)

Drag to rotate

"Pin"
drag to move effect

Blur amount
control

Geometric distortion control

4. Adjust the blur's position, angle, and intensity. If desired, adjust the Distortion. Extend or contract the zone of sharpness. In this example, I'm pleased by the effect except for treetops in the lower left: they should have the blur of the objects in the foreground.

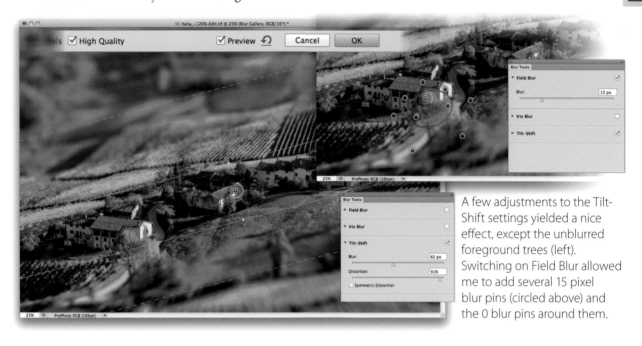

A few adjustments to the Tilt-Shift settings yielded a nice effect, except the unblurred foreground trees (left). Switching on Field Blur allowed me to add several 15 pixel blur pins (circled above) and the 0 blur pins around them.

5. To blur the treetops, I added a Field Blur effect by checking its box. By clicking on the tops of the trees, I added "pins" whose blur I adjusted. Unfortunately, the blur of these three pins extended too far. So I surrounded these with several more set to 0 blur, cutting off the field blur effect. In the Options Bar, I checked High Quality and clicked OK.

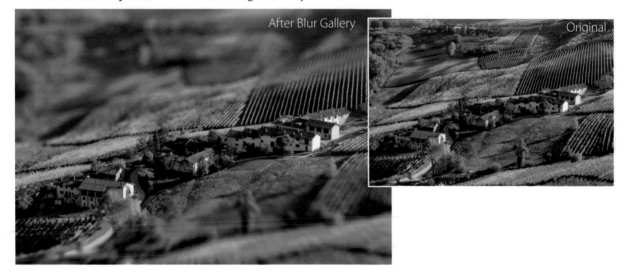

Ps

Iris Blur is similar. Experiment with its control points, especially while holding down option / Alt to fine-tune one control point at a time. You should also vary the settings for Bokeh effects.

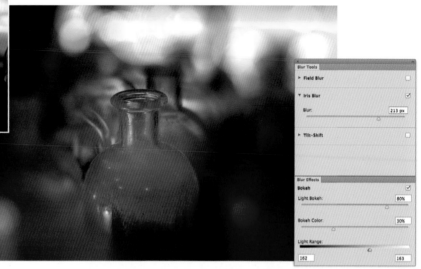

Example of Iris Blurring. In this image, I used the Bokeh controls. Note that it's very helpful to severely narrow the Light Range to get a more attractive Bokeh effect.

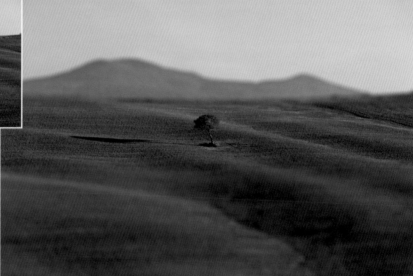

Example of Tilt-Shift blurring. The lonely tree appears even more isolated.

Lens Blur Filter

You may have an image with a distinctly shaped subject and a distracting background. The Blur Gallery may be too imprecise to get focus and blur exactly where you want them, but the Lens Blur Filter is an excellent, if time-consuming, tool for defocusing *precise* parts of an image.

1. Create a duplicate layer on which to perform your blur. If you only have one layer, duplicate it by selecting Layer>Duplicate Layer…. Name this layer "Lens Blur" so you know what has been done. If your image is currently composed of several layers, select them all (⌘+option+A / Ctrl+Alt+A), then hold down option / Alt and choose Layer>Merge Layers to create a merged duplicate. Yes, there's a shortcut for that, too: ⌘+option+E / Ctrl+Alt+E !

2. If the original layer was a Smart Object, then so is your duplicate. Sadly, Lens Blur cannot be applied to a Smart Object, so you will have to rasterize it: choose Layer>Rasterize>Smart Object. At this point we'll be working on ordinary pixels.

3. Make a selection around the subject. Use whichever tool best suits the image. I used the Quick Selection Tool to make the initial selection around the person in this image (a soggy me), then Refine Edge to make the edge more delicate.

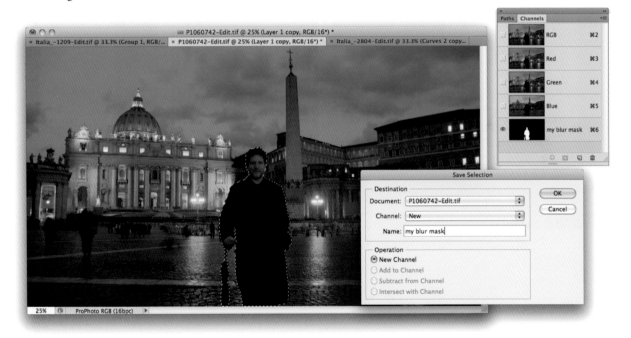

4. Once you have a good selection, save it by selecting Select>Save Selection…. and provide a name for the selection that refers to the blur: perhaps "my blur mask." After saving the selection, deselect (Select>Deselect).

Note: This creates a channel with white where we had selection (the subject, which will remain sharp) and black elsewhere. Lens Blur can use this channel's grays to control the amount of blur: 256 levels of gray means 256 levels of blur!

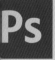

5. If necessary or desired, you may edit the resulting channel. In this example, I used white on the channel (level 255) to indicate sharp areas. Noting that the foreground should remain *somewhat* sharper than the background, I added a partially transparent white-to-transparent gradient from the bottom of the image to about my waist level.

 This will give some small amount of the blur along the bottom, progressing to full higher up.

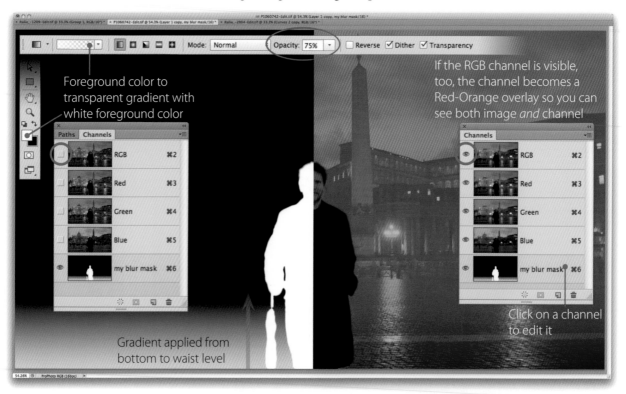

Foreground color to transparent gradient with white foreground color

If the RGB channel is visible, too, the channel becomes a Red-Orange overlay so you can see both image *and* channel

Click on a channel to edit it

Gradient applied from bottom to waist level

6. Select the Lens Blur Filter, Filter>Blur>Lens Blur…. Use the Source menu under Depth Map and choose the selection that you saved. This defines where the blur should occur. Actually, the grays in the saved selection channel are referenced by the Blur Focal Distance slider: 0 equals black, and 255 is white. So in our case, the channel is white where we want focus, so we set that slider to 255. If the subject becomes blurred (rather than the background), just reach into the image and click on the part that should be sharp! Yes, Photoshop has autofocus. Drag the Radius option on the right to set the amount of blur. More blur is often desired, but a stronger blur will also make flaws in a less-than-perfect selection more obvious.

There are many different options available for fine tuning the Lens Blur that mimic the effects of real photographic lenses.

7. When specular highlights are present, a real photographic lens will shape them into the shape of its aperture. The Lens Blur Filter can simulate that in the Iris section. Here we used a heptagonal aperture simulation. You can see this subtly demonstrated in the shape of the blurred lights.

8. To control how strong those specular highlights are, and what brightness in the image triggers their presence, you can adjust the Brightness and Threshold sliders respectively.

9. Finally, since blurring removes grain, noise, and other artifacts that a real lens wouldn't, this filter has a provision for introducing noise that is proportional to the amount of blur.

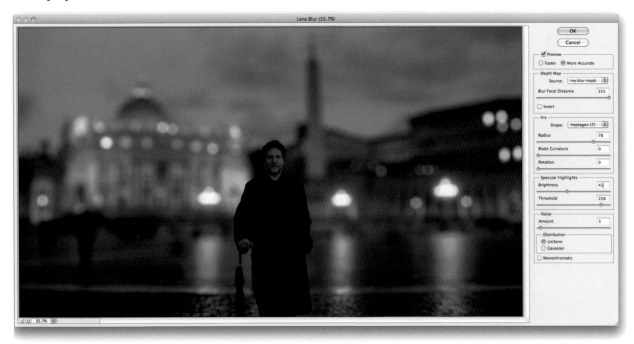

Film Grain

Film Grain in photographic film may be due to the clumps of silver or dye in the emulsion, but it has its own important aesthetic in photography. You may wish to *add* simulated film grain to bring abstraction to your images, create a more classic or dreamy appearance, or even to mask softness or digital noise. This technique will also demonstrate how to apply Photoshop filters that are not immediately available in 16 Bits/Channel Mode. Even Lightroom and ACR offer a Film Grain effect!

Bridge/ACR	Lightroom

If you wish to add a film grain effect to a RAW image, use the Effects panel in either Lightroom or Adobe Camera Raw.

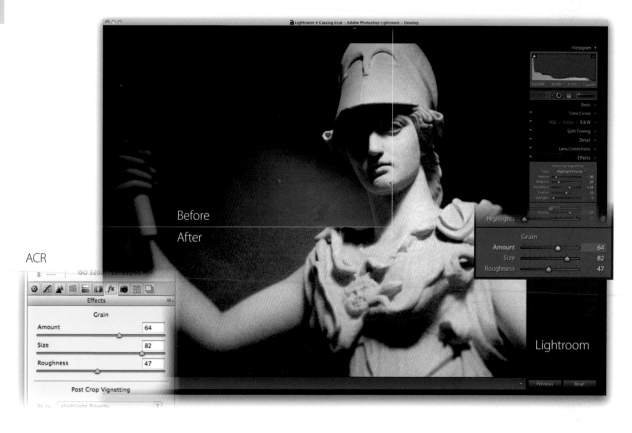

Photoshop

In Photoshop, we take advantage of the Blending Options of Smart Filters. Make sure that you are applying this effect to a single Smart Object.

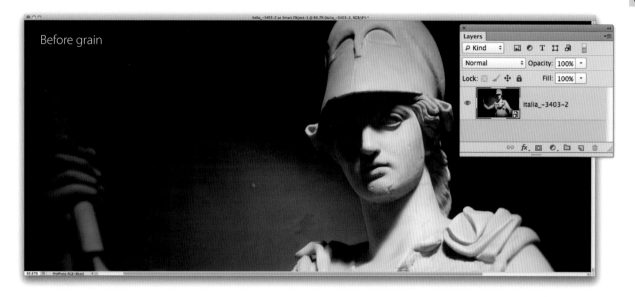

1. Select all the image and adjustment layers that are used to "construct" your image, then use the Layers panel menu or choose Layer>Smart Objects>Convert to Smart Object.

2. If the image is not in 8 Bits/Channel Mode, use Image>Mode>8 Bits/Channel. The Smart Object's contents retain their greater bit depth, *and* you can apply filters that you couldn't while in 16 Bits/Channel!

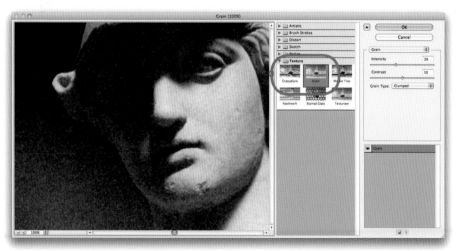

To begin adding grain, find the Grain filter in the Texture category of the Filter Gallery

3. There are many filter choices at this point, but a good place to start is Filter>Filter Gallery…. It will present you with a lot of filters, but choose

Texture as the category. One of the textures is Grain. In this image, I chose Clumped. Don't worry about how colorful it is—we'll deal with that shortly.

4. When the filter is applied (it will be a Smart Filter), edit its Blending Options by double-clicking on the icon to the right of the filter's name. Choose Luminosity as the Mode so the grain's *color* will disappear. I've also lowered its opacity.

Video

Both Lightroom 4 and Photoshop CS6 offer light but useful video editing functions. Think of these as conveniences rather than replacements for fully functional video editing applications like Final Cut Pro or Premiere.

Move cursor across thumbnail to scrub video in Grid

Lightroom

Lightroom allows us to import video in several common formats, apply metadata to them, make Virtual Copies, and apply develop presets (with limitations). While in the Grid view, you can move your cursor over a thumbnail to scrub the video. I find that to be a lovely touch. As usual, double-click the thumbnail to get to Loupe view.

Note: The Develop module is not available to video files. If you synchronize settings between a still image (including a still extracted from a video), the only develop settings that get applied are these: White Balance, Exposure, Contrast, Whites, Blacks, Saturation, Vibrance, Tone Curve, Black & White Treatment, and Split Toning.

In point. Drag to set.　　　　　Out point. Drag to set.

Click gear to expand to see sequence, scrub, or trim video

Current time indicator. Drag to scrub. Use **Shift+I** to set the in point at the current frame, **Shift+O** to set out point.

Click frame button to extract frame as JPEG or to set poster

Sync an extracted, adjusted frame and its video to apply adjustments to the video

Ps

Photoshop

Photoshop has had an Animation panel for many years. In CS6, it is known as the Timeline. It has been augmented to give us powerful, yet simple and elegant ways to combine video clips and add transitions and audio to them.

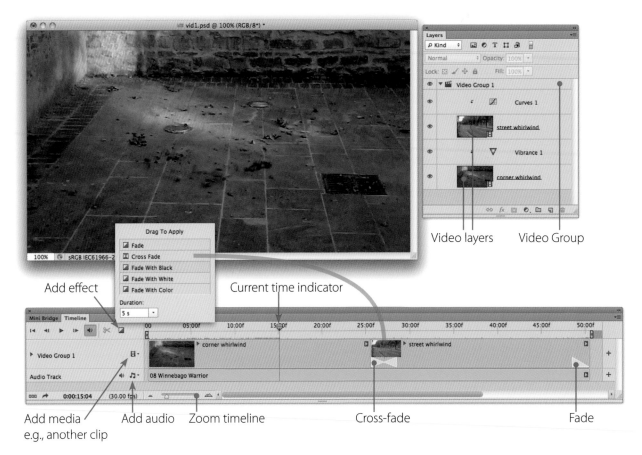

Video layers Video Group

Add effect Current time indicator

Add media Add audio Zoom timeline Cross-fade Fade
e.g., another clip

When you open a video file in Photoshop, it will appear as a Video Layer within a Video Group in the Layers panel. The Timeline panel shows you the duration of the video and allows you to scrub or play the video. With the various buttons, you can add other videos as clips, fade or cross fade between them with drag-and-drop ease, add audio, and more. What's wonderful and amazing is that you can add adjustment layers, masks, layer styles, and many other "ordinary" Photoshop elements and they just work with the video!

When you've finished tweaking, you render the video by choosing File> Export>Render Video…. Fortunately, the default Format (H.264) is good, if not universal. The old joke comes to mind: "Standards are great. That's why there are so many of them."

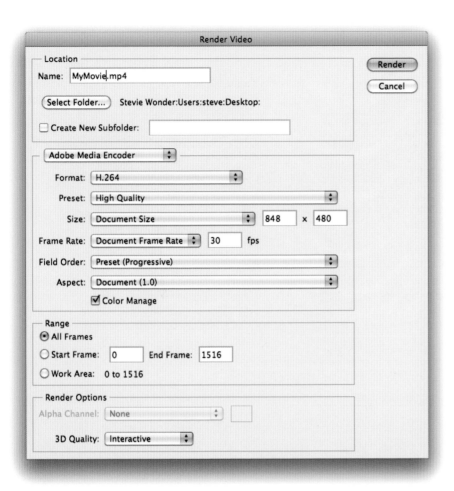

Output

10

Output is the creation of what I call deliverables, whether that is a print, a book, a web site, or a digital file.

Printing should be easier than it is, especially after all these years of digital imaging. With this release of Photoshop, the method I outline is simpler than ever. But since it uses profiles that describe your printer's characteristics to achieve stunning consistency and optimal results, you'll have to keep focused nonetheless. This method can also allow you to experiment with many more papers than your printer manufacturer supplies.

Some photographers like to produce books of their work. Lightroom 4's powerful Book feature makes this a convenient possibility.

Today, more images are placed onto the web than printed. The web has become a primary medium for communication, and images are as important on the web as they are for any print media. This chapter covers some considerations for web images and provides some tasks useful for creating images for the web. It does not describe the entire process for creating websites, nor for creating complex web elements like rollovers and buttons, as these topics would certainly require much more space than these few pages.

It is important for anyone involved in image creation and editing to know a few essential steps for targeting images for the web. Some of these tasks can be done in a simple way, such as saving a JPEG to send via email, and others will allow you to quickly build whole web galleries.

Finally, I'll have something to say about presenting slideshows of your images.

Digital Deliverables

Save a Copy

First, save your original first!

When sending files to someone else, you should determine just what your recipient can open. Ask which file format is preferred. Another question that your recipient may not be able to answer is about color space. If you get a blank in response to your inquiry, presume that they need sRGB. Choose Edit>Convert to Profile.... and choose sRGB as the destination.

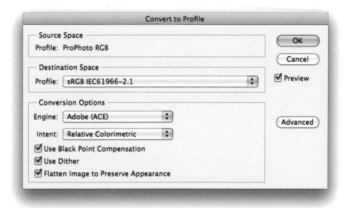

Choose File>Save As.... and choose a file format your recipient can open (usually TIFF or JPEG). Notice that if you choose JPEG that the box labeled "As a Copy" may check itself automatically in an attempt to preserve and protect a layered original. Indeed, the box labeled "Layers" will be unchecked, as JPEGs cannot have layers. If you choose a format that can have layers, you may not wish to share them with others. Unchecking that box will also trigger the creation of a copy. If your original is already flattened (as may happen when converting to sRGB), you'll need to choose "As a Copy" manually.

Image Processor

If you have many images to deliver, saving them one at a time is not efficient. Luckily, there is a lovely script accessed from Bridge that can make many copies, in multiple file formats if desired, very easily.

Select in Bridge the images you need to provide. Choose Tools> Photoshop>Image Processor…. Set the options you need, especially location and file formats and (optional) resizing. Note that the JPEGs can be converted to sRGB on the fly! "Resize to Fit" will not distort an image, it merely indicates the maximum width and height your processed image will have.

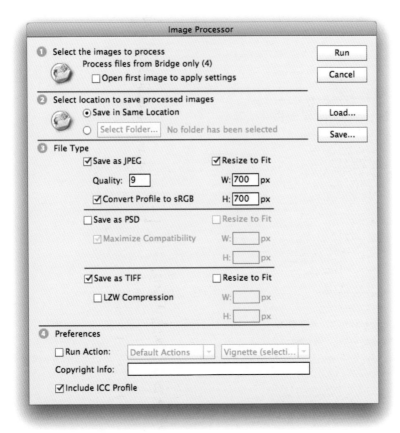

Lightroom

Lightroom offers many ways to share images. This is important, since what we see in Lightroom is often only a visual representation of our metadata and not actual, sharable pixels. Lightroom's Web Gallery will be discussed later in the chapter, but there are several other methods we will discuss now.

Export

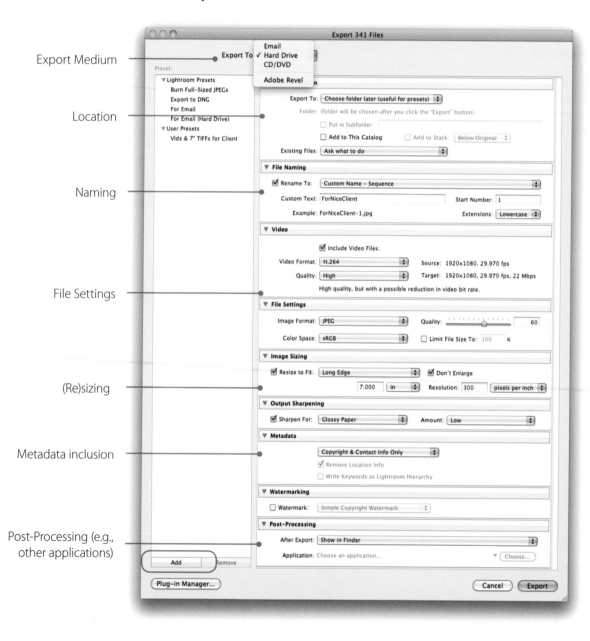

Exporting is one of the most important means of actualizing your images. Lightroom even allows you to create wonderfully elaborate presets to expedite future exports.

Lightroom can supervise export to several media, including DVDs, JPEGs for email, and Adobe Revel (the online photo sharing/synchronizing/editing service). To make it easy to replicate your settings, be sure to Add a User Preset. To use it later, select images in the Grid, then choose File>Export with Preset>[your preset's name]. There is also File>Export with Previous.

Publish Services

These are very similar to export presets but with a twist: the "service" notes if a previously published image has changed, then queues it for republishing.

To use these services, you must set them up. For example, if you have a Flickr account, you would click "Set up…" next to the Flickr button and configure your login and how you wish your images to upload. When you first log in, Flickr will attempt to verify that it is really you, and then it will allow future uploads.

To queue images for publishing, simply drag them onto the service that appears under the account type (Flickr, Facebook, etc.) When you're ready to upload, click on your service, then use the Publish button in the main window. If an image has been edited, you will see it listed for republishing.

Print Output

Best Practices

The real challenge in printing is to accurately match your printer colors to the Photoshop image colors. A print image may more accurately match the color of the image as displayed on your monitor if you follow three key steps of Color Management:

1. Calibrate and profile your monitor. You want an honest window onto your Photoshop image.

2. In Photoshop, set up a "working" color space.

3. Configure your printer driver compatibly with Photoshop's print dialog box or Lightroom's Print Job panel. Your image must pass through several pieces of software before ink hits paper.

Following these steps will allow the monitor and printer images to match as closely as the laws of physics allow.

Components of a Good Print

Printer

Many people believe only expensive, dedicated photo printers produce excellent images. But many desktop printers print very well. The biggest advantage of dedicated photo printers is prints that may last many years; some manufacturers claim over 100 years. This isn't trivial if you want your photos to last. The best photographers look to the newer photo printers with inks designed to print extremely rich colors and gorgeous black and whites.

But don't run out and buy a new, expensive photo printer right away. First, learn the process for good image editing and printing on your current printer. If you're in the market to buy one, at least buy an inexpensive, modern desktop printer. As you learn, you'll better determine your own needs and will be able to make a more informed choice when you buy a professional-level printer.

Paper

Paper is one of the most important components of a good-looking print, yet it is often the most overlooked. Even inexpensive printers can produce excellent prints with the correct premium paper. Most printers and papers are manufactured to work specifically and especially well with each other. Check your printer manual for papers designed specifically for your printer. For basic printing, use the printer manufacturer's premium photo papers. Advanced printing using printer profiles allows for a vast array of papers from various manufacturers. However, you should still stick to using your printer manufacturer's inks.

Color Profiles

The main advantage of printing with profiles is a more precise match between the edited image, the monitor, and the printer. This allows careful editing of print colors on the computer before you print, and the ability to use most or all of the color range available from your printer. In order to print with profiles, you will need to obtain the appropriate profiles for your printer/paper combination.

Manufacturer Printer and Paper Profiles

The easiest source of profiles is from the appropriate paper manufacturer (including the printer manufacturer for the papers that they sell for that printer). Profiles are widely available for many photo printers on the websites of a number of paper manufacturers. Many make excellent profiles for their papers on a number of printers popular with professional print makers. Epson, Ilford, Legion (Moab) Paper, Red River Paper, Pictorico, and others provide printer profiles for their papers via the Internet. Often the paper's included instructions provide a website URL for profiles.

You need to obtain profiles for your specific printer model *and* paper type. Usually, profiles are only available for the printer manufacturer's inks, but if the printer can use multiple types of ink (like the Epson R2880), be careful about which inks you use. For example, if your printer uses either matte or "photo" black ink, you need to use a profile for the black that is in use by your printer. Additionally, find specific instructions that may be included for each profile on how to configure the printer driver.

Note: If the driver settings are not configured the same on your computer as they were when the printer profile was created, the colors will be wrong.

The specific settings to look for are media type (a paper supported by the printer), resolution, and quality setting. Other items may be specified.

Custom Profiles

You can also have custom profiles made for you by a professional profile service. These have some advantages but cost money. A web search for "custom printer profiles" found several services for around $40. These companies provide a test target and instructions on how to best print this target. You print the target, snail mail the physical target to the profile service, and they email you the specific profile or a link to it. It is necessary to purchase a profile for each paper type you'll be using. One service that makes this process a bit easier, including the installation of the profiles (see next page), is provided by a company called Chromix.

Some photographers choose to make their own custom profiles. However, this requires expensive hardware and software, plus a solid understanding of color management practices.

Installing Profiles

Once you download the profiles, you need to install them. Some of the manufacturer's profiles include an installer that installs the profile for you, but most require that you install them yourself.

On Mac OSX, copy the profiles to the appropriate directory. If you have administrator privileges for your computer (most users running their own desktop computers have such privileges), use the <drive>/Library/ColorSync/Profiles folder. Just move the profile files to this location. If you don't have administrator privileges, use the ~Library/ColorSync/Profiles folder. In Mac OS 10.7 (Lion), you need to use the Finder's Go menu while holding down `option`, and choose Library. Then you can get to the ColorSync folder. Once installed, you'll be able to use these profiles from within Photoshop, or indeed with any program.

With Windows 7, use the Color Management control panel to add profiles for any number of devices.

Printer Driver Settings

The printer driver includes settings for specifically supported papers, print quality, and color correction. It is important that all are set properly. Check your printer manual for specific instructions. The number one cause of bad prints is incorrect printer driver settings. I'll have some tips regarding things to look for later in this chapter.

Viewing Lights

Printers are generally designed to create images that look accurate when viewed under daylight. But most people view their prints indoors under tungsten lights, which are much more yellow and dimmer than sunlight. Viewing under tungsten lights results in images that appear to have little shadow detail. It's best to get a good viewing light. Professionals use expensive D50 (5000K is another designation) or D65 viewing lamps available from quality lighting stores. Many office supply stores carry more moderately priced desktop daylight fluorescent lights. Other photographers use desktop halogen lights—the 20W–35W models produce a good bright light. Even though halogen light is still noticeably more yellow than daylight, it is often considered a better match for viewing prints indoors. Not all of us can do what a friend of mine does: he goes outside to view his prints—but he lives in Southern California where he enjoys extended periods of "daylight balanced" outdoor lighting—as well as warm breezes.

The Final Print Process

Up to this point, the work that you have done to your image isn't particularly dependent on the final size or print medium. But now you will perform edits on your image that are. We often don't know how our images will be printed when we start working on them, or we want to be able to print an image in a few different ways; so we make sure that these printer-specific steps are performed after we have completed all of our other edits, and have saved and labeled the edited image. In fact, we often create a separate, duplicate image made specifically for a given print medium and size.

Here's a summary of what follows:

▶ **Save the Edited Image**—You have been working on your image for a couple of hours now, and before you rush into printing it, save it. The printing process involves several steps that alter your image in ways that are specific to a particular size or paper type. So first save the file to keep all of the edits and layers.

▶ **Create a Flattened Duplicate Image**—Once you have saved your master file, the duplicate will not need to have all those layers; in fact, it's often much faster to print flat files.

▶ **Crop the Image (if needed)**—Often, the final print needs to match a particular aspect ratio (e.g., 8" x 10" or 5" x 7"). If you need to match a specific height and width, then you will likely need to crop the image to fit.

▶ **Resize/Resample the Image**—Resize/resample the image to the target print size (e.g., 8" x 10") *and* to the appropriate printer resolution.

▶ **Sharpen the Image**—Digital images generally improve with a modest amount of sharpening after resampling.

▶ **Soft Proof**—Use Photoshop's Proof Setup to visualize the printed version on your monitor.

▶ **Print**—Make sure you have Photoshop *and* the printer driver set to the optimal settings for your particular paper.

▶ **Save the Print File**—If you like the results, save the print file; this file is specific to a particular print size. If you're not satisfied, go back to the master file you saved in the first step and continue editing.

Now, let's look at each of these steps in detail.

Save the Edited Image

Likely, you will already have a saved file for your edited image. After you have completed all of your other edits and are confident that it reflects your vision, save this image so that you have a protected version that includes all your edits and layers (File>Save). In Bridge, label the image as your Master (I use the blue label for this).

Create a Flattened Duplicate

Duplicate your master image. This may be is overly cautious, but I recommend making a duplicate of your edited image so you can perform all of your print prep steps with far less concern or confusion. Select Image>Duplicate…. In the Duplicate Dialog, change the name to "[My Image]_Print" (or an even more specific name that includes the printer and size, like "Tower of London E3880 8x10 matte"). Select Duplicate Merged Layers Only to flatten the image.

Save this duplicate in the same folder as your original. Before you forget, you should use Bridge to label it as an Alternate (purple), then "Stack" it with the original so you can always tell the master from this duplicate.

Crop Your Image

Often your image is not the right shape to fit your final print. Typically, images from digital cameras mimic the long format of 35mm film, a format that has the proportions of 4" x 6". If you want to fit this into a more traditional print proportion, like 5" x 7" or 8" x 10", you will need to crop off some of the long dimension.

1. Select the Crop Tool from the Tool Panel.

2. In the Options Bar for the Crop Tool, input the aspect ratio for the target print; this will ensure that you crop to these specific proportions.

3. Adjust the crop area as necessary.

Once you have drawn and positioned the crop to fit your final image, hit the **Enter** key to accept the crop.

Resize/Resample the Image

Note: You should not have resampled your image at any point yet—there should be as many pixels in the uncropped area as there were when the image was born. Computers are very good at resampling and scaling images, but there are some potential problems with resampling. Generally, you should only resample your image once—when you are getting ready to output.

The resolution of your image doesn't really matter to Photoshop; Photoshop views the image merely as a large array of pixels without any specific "size." As you edit, your image may have a wide range of possible resolutions—many digital camera images use a resolution of 72ppi, and sizes around 20" x 24"; scanned 35mm film usually has a resolution around 4000ppi, and a size of about 1" x 1½". You'll set the appropriate size and resolution just before you print.

To resize and/or resample, select Image>Image Size to open the Image Size dialog.

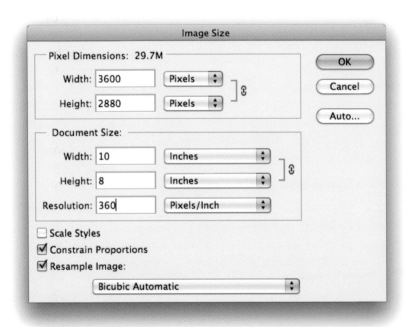

Make sure that the option for Constrain Proportions is set to ensure that you don't stretch or squish your image. Also, make sure the option for Resample Image is set.

Input the target Width or Height; since these will change in proportion, changing one will also change the other.

Input the target Resolution for your printer. Almost all print devices print at a resolution of ~300ppi; if you don't know your printer's resolution,

set it to 300ppi. For Epson printers, use a resolution of 240ppi. For images with very sharp details printed onto glossy papers or film, Epson printers can also use a resolution of 360ppi.

Some printers used by online services to print onto traditional photographic papers (like Lightjet, Chromira, or Frontier printers) have unusual resolutions like 304.6ppi. But these printers generally do a very good job of resizing your image to this exact resolution. So for these printers, set the resolution to 300ppi.

Finally, you need to set the appropriate resample algorithm. Up at the top of the dialog are the new (and old) pixel dimensions for this image; if the new dimension is larger than the old one (you are adding pixels to your image), then set the resample algorithm to Bicubic Smoother; if the new dimension is smaller than the older one, set the resample algorithm to Bicubic Sharper. Photoshop CS6 introduces Bicubic Automatic, which chooses one of the above based on whether you are up- or downsampling.

There are lots of add-on tools for Photoshop that perform sophisticated resampling algorithms; these tools often provide some benefit for resizing images to large sizes while maintaining sharp detail. This was a major issue for earlier versions of Photoshop, but the options available beginning with Photoshop CS2 are quite good for most images.

Output Sharpening

Output sharpening is a step often overlooked in printing. After resampling an image, it is important to reclaim some of the image's original sharpness.

1. Convert the Background or your only Layer into a Smart Object: simply control+click / Right-click on the layer's name in the Layers panel and choose Convert to Smart Object.

2. Select Filter>Sharpen>Smart Sharpen.

3. Note that the Smart Filter has a mask. Select the Brush Tool, set the default colors, switch these so that the foreground color is black, and paint over the image where you want to hide the sharpening. This allows the sharpening to be focused on the important parts of your image if desired.

On-Screen Proof

One advantage of printing with profiles is the ability to soft proof the image before printing. Soft proofing allows Photoshop to mimic the look of the final print on the monitor!

To set up a soft proof, select View>Proof Setup>Custom....

1. For Device to Simulate, select the printer profile for the printer/paper combination you'll use to print. You may also choose a printing press condition if you intend to print a simulation of that press on your own printer!

2. Set Rendering Intent to Relative Colorimetric and turn on Black Point Compensation. This matches the black point in your image to the darkest black of the chosen printer profile. Compare with Perceptual rendering while studying saturated areas in your image. Perceptual better preserves details in saturated areas but Relative tends to be more accurate. Compare, then decide which should be used for the image you're about to print.

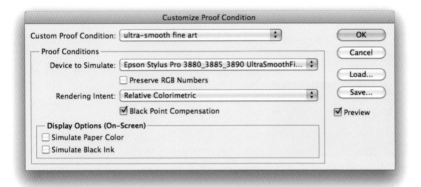

3. Save a proof setup you use often by clicking the "Save…" button. Give it a useful name incorporating the printer and paper names, like "EP 3880 Prem Luster Rel Col." This name then appears at the bottom of the View>Proof Setup menu for easy access in the future.

4. Photoshop now displays a soft proof of how your image will print using this profile. There may be some minor color shifts. ⌘+Y / Ctrl+Y disables/enables soft proofing.

Add an Annotation

With annotations, you can add notes to the print file. Select the Note Tool from the Tool Panel (behind the Eyedropper) and click on the image. Type in details like the printer, paper, printer settings, profiles, etc. Months from now, you'll thank yourself, especially if the printer settings were unusual.

Print Dialog

1. Select File>Print….

2. In the Print dialog, choose the printer, number of prints, and orientation. The print preview on the left will show your image centered on the paper size you selected. If your image appears too large or small, you probably didn't resize your image properly. Cancel out of the Print dialog, then resize the image as described earlier.

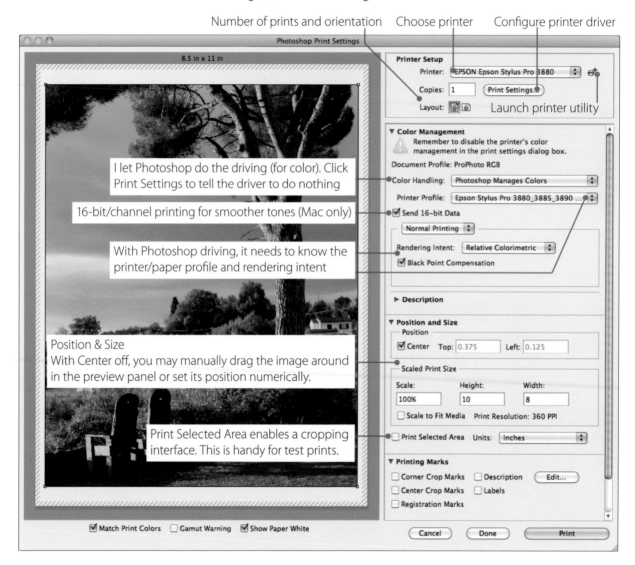

3. Set **Color Handling** to Photoshop Manages Color. Notice the little note that appears immediately under the choice that says: "Remember to disable the printer's color management in the print settings dialog box." You will shortly! Choose the **Printer Profile** for your printer/paper/ink combination (likely the one you soft proofed). This section is also where

you set the **Rendering Intent** (method used by Photoshop to convert to your printer's color profile). Some downloadable (and custom) profiles indicate an Intent. I suggest experimenting with two.

Choose either **Perceptual** or **Relative Colorimetric**. The difference is this: Relative Colorimetric will give a better match to your edited images' colors, but may lose gradations in *very* saturated areas (e.g., intense blue skies). Perceptual won't clip your saturated colors, but it tends to make colors throughout the image more bland and shadows less deep.

According to the documentation:

Perceptual aims to preserve the visual relationship between colors so it's perceived as natural to the human eye, even though the color values themselves may change. This intent is suitable for photographic images with lots of out-of-gamut colors. This is the standard rendering intent for the Japanese printing industry.

Relative Colorimetric compares the extreme highlight of the source color space to that of the destination color space and shifts all colors accordingly. Out-of-gamut colors are shifted to the closest reproducible color in the destination color space. Relative Colorimetric preserves more of the original colors in an image than Perceptual. This is the standard rendering intent for printing in North America and Europe.

4. Click **Print Settings**. This is where you synchronize the printer software with your Photoshop settings. Set paper size and type (very important), as well as other options.

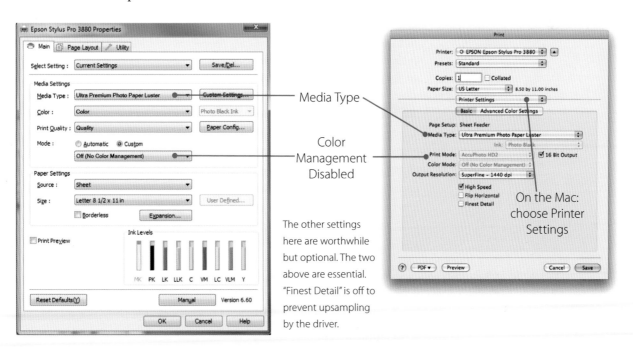

Media Type

Color Management Disabled

On the Mac: choose Printer Settings

The other settings here are worthwhile but optional. The two above are essential. "Finest Detail" is off to prevent upsampling by the driver.

Note: In the Mac OS Print Settings dialog, choose the Printer Settings option from the menu to access the settings for your printer driver.

These settings differ for each type of printer, but almost all printer drivers have options for Paper (or Media) Type and Quality. Set Paper Type to match the paper you're using. (You'll only have choices of the manufacturer's papers; for example, Epson's "Ultra Premium Photo Paper Luster", which always amuses me.) Choose a color mode and set Resolution, if available, to the highest setting that will not upsample the image data (here, 1440dpi). Check your printer's manual for details on these printer settings.

Most critical is to be sure that only one piece of software does the color handling. We chose Photoshop, so if it hasn't been done automatically (as illustrated), change the Color Mode or Correction option to Off (*or* None *or* No Color Adjustment, depending on the printer). Sometimes this is difficult to find. For example, the Windows driver for my printer requires that you click a button labeled "Custom" before you see this choice.

When finished, click OK or Save. Now we can finish configuring the Print dialog.

5. You may also add Printing Marks (like crop marks) and other options such as bleed.

Save the Print File

Once you have a print file that yields a good print, and you suspect you may print it again in the same way, save it under a name that will help you to identify the image and printing process later. Include the print size and print technique in the file name, perhaps: "My Image Print 3880_8x10" for an Epson 3880 print at 8" x 10". Save the Print file as a TIFF or PSD file.

Lightroom

For all of Lightroom's output modules, it's extremely useful to have Collections in place to segregate the images you're sharing. Not only does this make it easier to know just which images you're printing, but also the collection will *remember* each output module's settings! So the next time you print from the same collection, all your configurations will be in place!

Printing Directly

There are several things you should do consistently to print successfully from Lightroom.

1. **Collect Your Images to Print**—Create Collections for the purpose.

2. **Choose a Template in the Print Module**—This may be only a starting point that will be refined. Essentially, the big decision is whether this is a Single Image, Contact Sheet, Picture Package, or Custom Package.

3. **Fine-tune Layout settings**—These include everything from spacing between multiples to overlays, watermarking, and more.

4. **Set up Print Job Panel**—This is where our color management, output sharpening, and resolution choices are.

5. **Configure and Save Printer Driver Settings.**

6. **Print**—Use the Print One button to use all the settings as they are, or the Print button to have one last chance to change the driver options, including the number of copies.

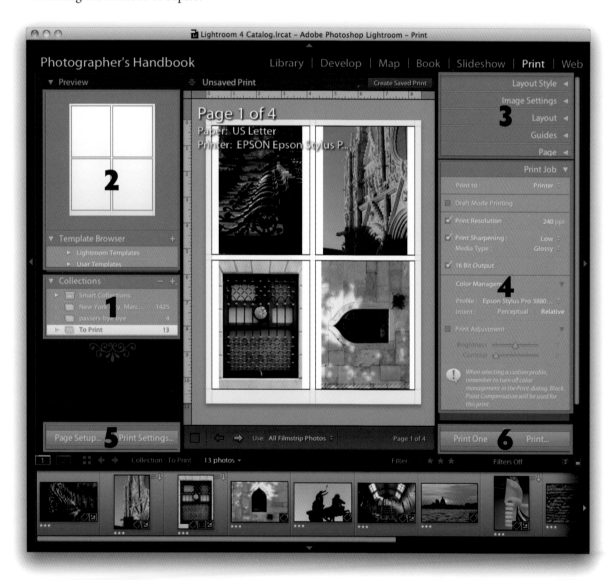

1. Collect Your Images

Create a collection for your output (either in the Library Grid or output module).
Then, add images to the collection. I like to set the collection as a Target then either click the small circle in the upper right of thumbnails, or highlight the thumbnail and tap the B key.

Create an ordinary Collection in the Library module, or create a Print Collection in the Print module. Either will remember the settings you last used for any output, but a Print Collection at least has a special icon to remind you what it's for.

To add images to the collection, first control+click / Right-click on the collection and set it as the "Target." Then go through your Library selecting images and tapping the B key, or clicking on the circle in a thumbnail's upper right when you hover over the thumbnail. You can even designate the Painter to add images to a Target Collection. When you're ready, select the Collection.

2. Choose a Template

As you hover your cursor over the templates in the Template Browser panel, the Preview panel will give you an idea of the layout. By name and preview, you should choose a template as a starting point. Then the fun begins.

Be sure you have a few images selected so that the template populates with images, giving a more solid idea of the final output. In the following example, we'll start out with the "2x2 Cells" template. Of course, you may experiment with any layout.

3. Layout Settings

There are three layout engines that you can use: **Single Image/Contact Sheet** for one or more uniformly sized prints, **Picture Package** for printing a variety of sizes of each image (like portrait studios often produce), or **Custom Package** for more elaborate and unique layouts.

For all, identity plates and watermarks can be used to mark your prints and discourage unwelcome reproduction.

Image Settings, Layout, & Guides Panels

You may have chosen a template to start with, but that doesn't mean you can't make modifications! In the illustration below, you'll note that I checked the box Rotate to Fit in the Image Settings panel. That way, both portrait and landscape format images will make the best use of the space in their cells.

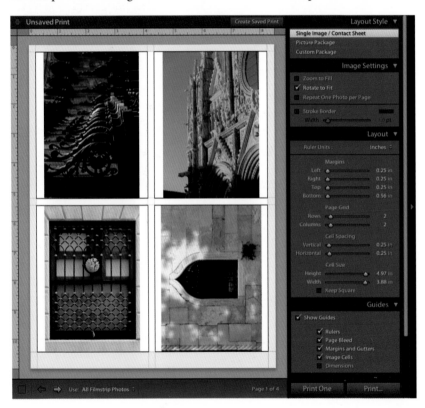

In that same panel, you can apply a border to the images or have the images fill their cells completely. The remaining option, Repeat One Photo per Page, fills each template page with one of your selected images, so if you needed four each of 12 images, this would be a quick way of getting there.

The Margins can also be adjusted a bit to make room for the Crop Marks. Under Guides, it may be tempting to turn off a few things, but only one is redundant: Image Cells. Page Bleed grays out the outer parts of the page on which the printer can't reliably print.

Page Panel

You may want a little bit of text to help you or your clients identify which images are which.

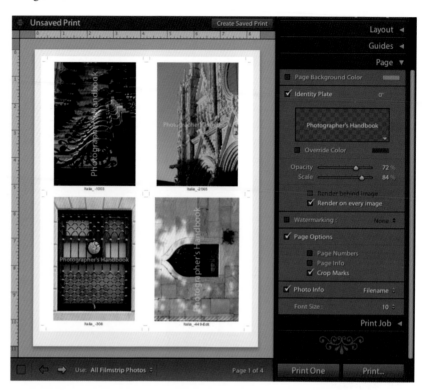

Aside from the Identity Plate, there doesn't *appear* to be much other information you can attach to the image. We can add Crop Marks, as promised, and we can turn on Photo Info, too, for Contact Sheets. When you look at the menu to decide *which* file info to add, the list is short, but it includes Edit. When you choose that, you find a dialog box in which you can construct quite a string of info, including text you type in yourself.

▶ In the field at the top, insert your cursor where you'd like some data to be inserted.

▶ Then find the data in the list below, and click Insert when you've found it.

▶ Add text to the field where and how you'd like, perhaps adding punctuation or other arbitrary text.

▶ When done, save your customization as a preset so you can use it again later.

Watermarking

This allows you to add opaque or translucent text in almost any position, font, and color. In the Page panel, check the box for Watermark, then use the menu to create one or more watermarks. After they have been created, you may choose them at any time.

Single Image/Contact Sheet

Single Image/Contact Sheet uses a grid which you define in the panels below Layout Style. Customizing a few templates will quickly reveal the kinds of options here. The most crucial, however, are in the Image Settings panel. Those four little checkboxes make a huge difference in what you see. Zoom to Fill has caused many photographers to wonder why Lightroom was cropping their pictures.

Picture Package

Picture Package creates multiple sizes of each image printed. There are many choices for how many images and what sizes. Auto Layout is handy for at least lending ideas when you're unsure of what sizes fit well with others. As you add more images, Lightroom may add more pages, or you may do so yourself with the New Page button.

Custom Package

Custom Package allows for sophisticated and elegant (or riotous and cluttered) layout. You may freely add cells of whatever size, then drag images from the filmstrip into the cells, which may then be resized and repositioned. With multiple pages, you can create your own sequencing and patterns.

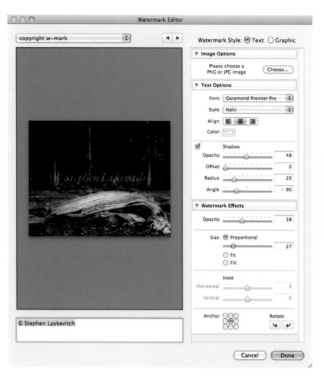

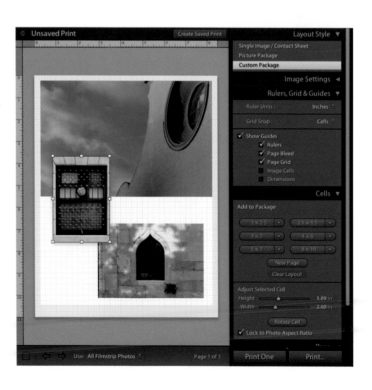

4. Print Job Panel

This panel is more approachable if you've been printing from Photoshop. What's different? You may do resampling right from here, if desired. Since resampling may result in diminished sharpness, you may also apply some sharpening. You can choose "Glossy" for paper surfaces other than matte.

Importantly, Color Management is governed here. I recommend printing with profiles from Lightroom. However, the first time you look at the Profile menu, you won't see a list of profiles at all! You'll see Managed by Printer and Other…. Choose Other to see the list you're looking for. What's nice about this interface is that you can choose which profiles you will see in the Profile menu later. Click the checkboxes of the profiles for the papers/printers you use and click OK.

From then on, you can choose your profiles from a mercifully short list.

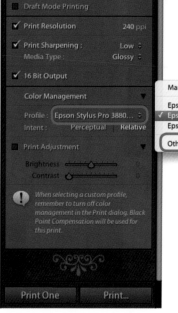

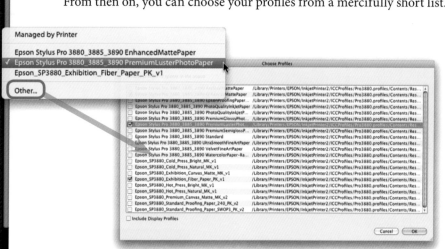

5. Printer Driver Settings

The settings here are identical to those you would have selected had you been printing from Photoshop. For those options, see the Mac and Windows examples earlier in this chapter.

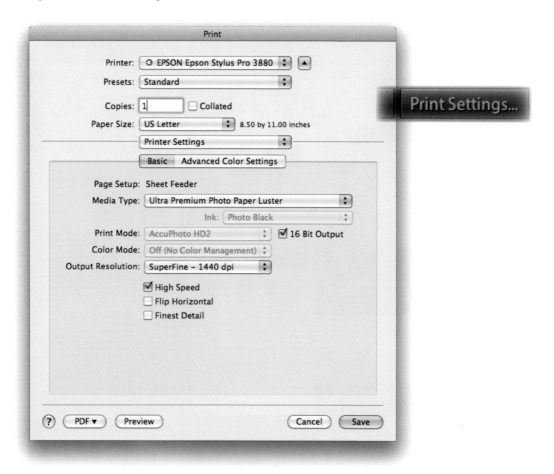

Note the button that commits your choices: it says Save. Once you've saved your settings, they're set until you change them.

6. Print

All that remains is clicking the **Print One** button or **Print...** button at the bottom right. Since you've chosen to let Lightroom manage color, remember to disable color management/correction in your printer's driver should you want to change anything there.

Book

You may generate a book layout that can be made as a PDF or printed by Blurb. There are a few things you should do consistently to print successfully from Lightroom.

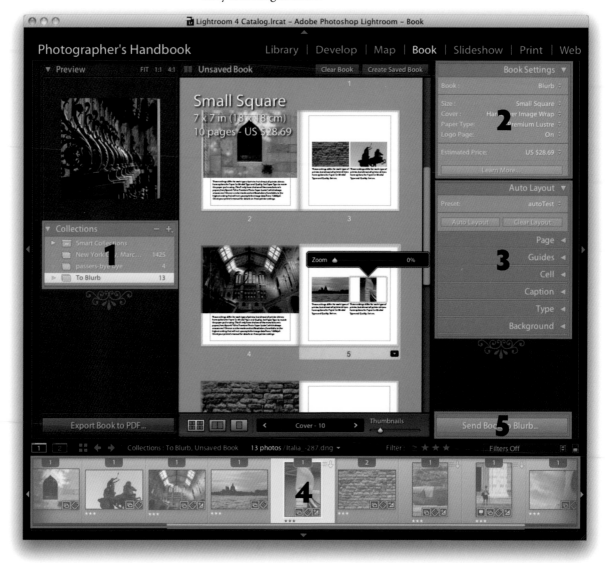

1. **Collect Your Images to Print**—Create Collections for this purpose.

2. **Choose a Layout and Output**—Decide whether you're producing a PDF or a physical book via Blurb. Choose the format and cover, and you will see the Blurb price right here!

3. **Fine-tune Layout settings**—These include text, caption generation from metadata, background images, and more.

4. **Drag images from Film Strip**—populate the layout yourself or choose Auto Layout. You may continue to refine your layout choices page by page, zoom images to better fit the cell in which they are placed, and add text.

5. **Create Book**—If you're using Blurb, you will be prompted to log in.

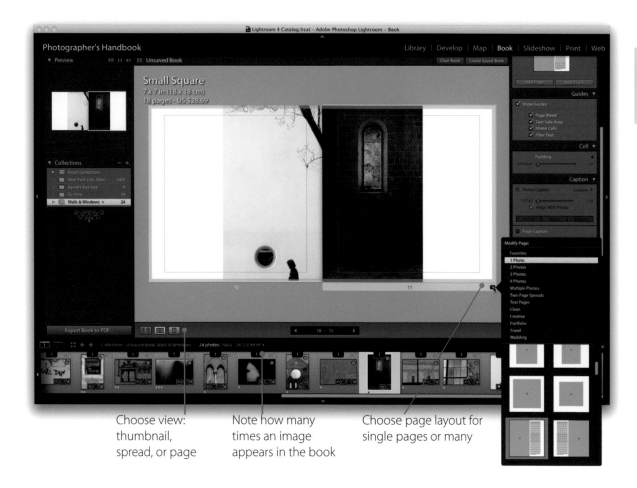

Choose view: thumbnail, spread, or page

Note how many times an image appears in the book

Choose page layout for single pages or many

Web

A Note on Web Images

Images made for the web are almost always JPEGs and will almost certainly use the sRGB color space profile. Luckily, the products we're using have this consideration baked into their code.

Photoshop

Images with fewer than about 7.5 megapixels can be output as JPEGs with Adobe's Save for Web. Larger images may need to be dealt with manually. I'll start with the latter.

A Fully Manual Approach

Note: Save your full-size image before proceeding. We're about to make a copy for the web, and we don't want our master image to be damaged in the process.

Convert to sRGB

The web assumes images are in the sRGB color space. If your RGB working space is Adobe RGB or another color space, then you will need to convert all of your images to sRGB before saving them for the web. This is essential, since your Adobe RGB images will appear flat and desaturated when they are displayed in most browsers.

To convert an image to sRGB, select Edit>Convert to Profile. Set the Destination space to sRGB. Allow the image to be flattened. Click OK to convert. Likely, your image will appear unchanged. This is a good thing!

If your image is using 16 bits/channel, Photoshop will automatically convert it to 8 bits when you save as JPEG. You may do this manually by choosing Image>Mode>8 Bits/Channel.

Bicubic Sharper Interpolation

Photoshop provides options for interpolating/resampling. The Bicubic Sharper option is especially good for web images, as most images are *downsampled* for use on the web. This option applies that gentle amount of sharpening which downsampled images usually require.

Choose Image>Image Size. Check the Resample Image box, then choose Bicubic Sharper from the menu at the bottom of the dialog box. It's easy to forget to do this, as this is usually not the default method. However, the CS6 default is Bicubic Automatic, which *should* use Bicubic Sharper when you downsample. If you create web images regularly, you may consider making Sharper the default (via Photoshop's General Preferences).

Specify the required Pixel Dimensions at the top of the Image Size dialog box.

Save As JPEG

Choose File>Save As, then choose JPEG as the file format. In the dialog box, you can preview your image as you choose a Quality setting. For a moment, choose 0 to see the kinds of artifacts that JPEG compression might introduce if allowed. Increase the Quality, toggling the Preview periodically to gauge the fidelity of the resulting JPEG.

Sometimes a web designer may specify a maximum file size which you can monitor in this dialog as well. Most often, we aim for the lowest Quality setting that renders an acceptable version of our image. To squeeze out a slightly lower file size, you can try to use the Baseline Optimized or Progressive Format Options, but these are less compatible with some older browsers and email programs.

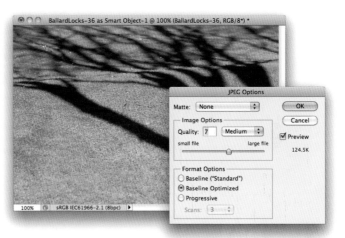

Web files need to be small and still render a high quality image. The JPEG file format provides an excellent compromise between size and quality. Use JPEG files for your web images, and be willing to use the moderate quality settings that allow your files to be very small.

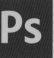

Save for Web

Save for Web is superior to the process outlined in the previous section. In principle, you would open your full-size ProphotoRGB image, then use File>Save for Web. This will work well if the image is no more than seven or eight megapixels. A warning message appears if it is larger, but I recommend that you try Save for Web nonetheless—your computer may handle it quite well.

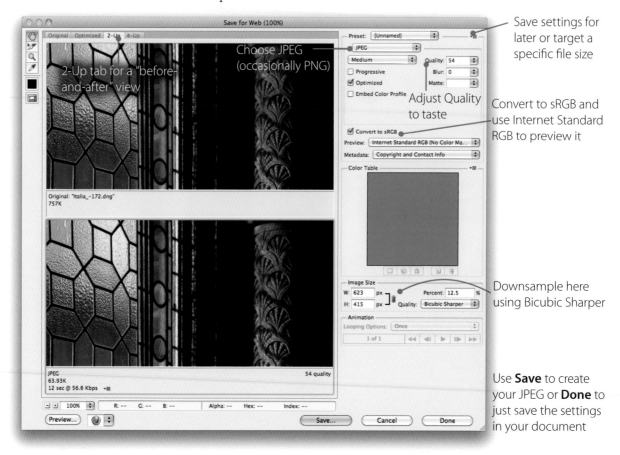

Note that there is a "fly-out" menu in the upper-right corner of the dialog box where you can choose to save your settings. Use it! Once you work to dial in what you use, give it a name.

In the dialog, you will choose JPEG as the format and choose a Quality setting. Although the scale runs from 0 to 100 rather than 0 to 12, as in the Save As dialog, the values really do represent the same range. There is a provision to resample in the lower right that allows you to specify the desired pixel dimensions and resampling method. I use this for most images.

Use the Convert to sRGB setting. If you choose Internet Standard (No Color Management) as a Preview, the preview will accurately predict what a typical browser will show. Of course, you may also use the Preview button in the lower left to see the image in a real browser.

Building a Web Gallery

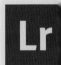

1. **Collect Your Images**—Use a methodology similar to that outlined for printing: use collections to organize and recall settings.

2. **Choose a Template in the Web Module**—This may be only a starting point that will be refined. Essentially, the big decision is whether this is an HTML, Flash, standard, or third-party template.

3. **Fine-Tune Layout and Output Settings**—What text should accompany your images? What colors should decorate the gallery's pages? How big should your thumbnail and large images be? These are the questions you get to answer in these panels.

4. **Configure Upload Settings**—Use this if you're building a site (or part of one) that is to be uploaded. When you're done, you might also choose to Export the web gallery so it can be viewed on a CD, for example. Your Upload Settings include FTP (or SFTP) username and passwords, the URL to which you're uploading, and the exact directory/folder to which your web gallery files should go.

5. **Preview in Browser**—Although the Preview area acts like a browser and does a good job, there is no better test for a website than a real web browser.

6. **Upload or Export**—Uploading will prompt you for your FTP password (as supplied by your web hosting service provider). Export will prompt you for a location for your export.

1. Collect the Images

Create or choose a Collection, or create a web Gallery Collection. Target a Collection, then select images and tap the B key, or click on the circle in a thumbnail's upper right corner when you hover over it.

When you're ready, select the Collection—it will "remember" the settings you choose in this and the other output modules.

2. Choose a Template and/or Engine

Flash or HTML?

The left side of the Lightroom window is dedicated to the Template Browser and its Preview. I've picked Earthy. It happens to be a more traditional HTML-based gallery. The other choice is Flash, which has nicer transitions but will not be functional on iOS devices like Apple's iPad. However, the HTML templates are pleasant, and I'm comfortable editing Lightroom's HTML code if I wish to customize it later.

Note: The work area (the central window) responds to the choices you make as you build your website, and it does so as a browser would. If you make your window larger, the work areas re-center your content like a web browser does. Better still, it navigates like the web does! If you click on a thumbnail, it brings you to the larger version; click on the larger image, and you're back to the thumbnails.

3. Fine-Tune Layout & Output Settings

There are many choices you can make to have a lovely web gallery.

Site Info Customize your site's text. You may even use a little light HTML if you know it. If you enable your Identity Plate, you can also designate that it become a link when the site is generated. Usually, this links to the main page of the site, so the default is "index.html", which is the name of the main page on many sites. Determine whether the thumbnails should have numbers or not.

Note: The link you specify under Web or Mail Link is the web address to which a person is whisked if they click on the text you entered under Contact Info.

Color Palette I started with the Earthy template, but thought I'd lighten a few things. This panel is where you do that. However, to see all the elements that are affected, use the main window as you would the web browser: click on a thumbnail to see the larger image. Note the text on that page is also available for colorization.

Appearance Just click in the grid to create a thumbnail array with as few as nine to as many as 40 images. You will need to go from the Grid pages to the Image pages to evaluate your decisions.

Image Info You may have text above and below the large versions of your images, whether the Filename or any of the other choices we saw in the Print Module's image info. You can also include Custom Text.

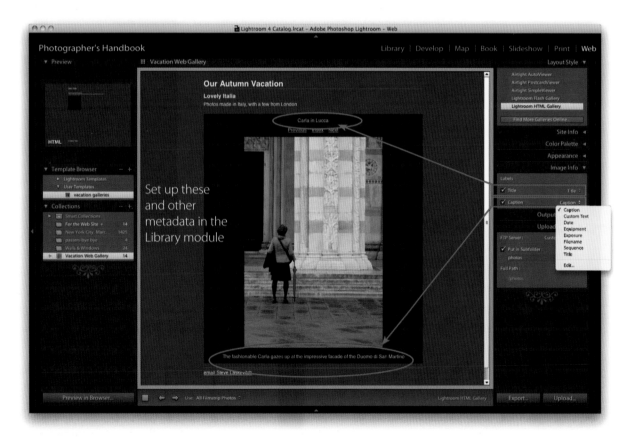

Output Settings This allows you to set the size of the large JPEG versions of the images. You can choose widths of 300 to over 2000 pixels. Of course, such size differences greatly affect the look and feel of the page and may

restrict who can use the site (bigger images favor owners of bigger monitors). You also must choose the JPEGs' Quality. Here, I've used 70. Since the image will be resampled, apply some sharpening, too. Standard works well. Finally, choose which metadata gets included in the image and whether a copyright watermark will appear on it.

4. Configure Upload Settings

This last, small panel is where you configure upload (FTP) settings. If you already have a website, you may simply add another directory/folder containing the site you just built here in Lightroom.

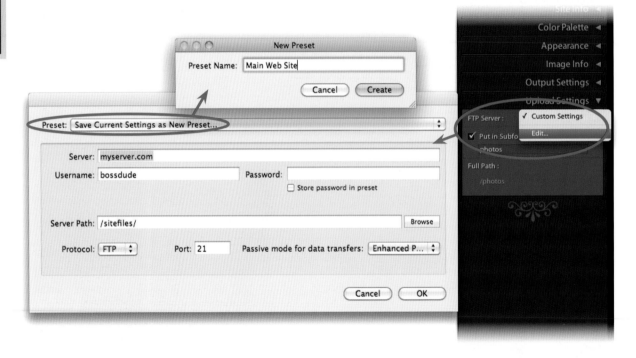

5. Preview in Browser

To see your work in a real web browser before you're ready to commit to uploading it where the world can see, use the Preview in Browser button below the work area window.

6. Upload or Export

To upload to a site, use the Upload button at the lower right. It will use the settings from the Upload Settings panel.

Sometimes you might want to make a functioning website to burn onto a CD-ROM to permit a client a private look with a pleasant interface. In this case, you would use the **Export...** button. Give the containing folder a name, then the site gets saved to your specified location.

It's rarely so easy.

Slideshows

Lightroom

Building a Slideshow

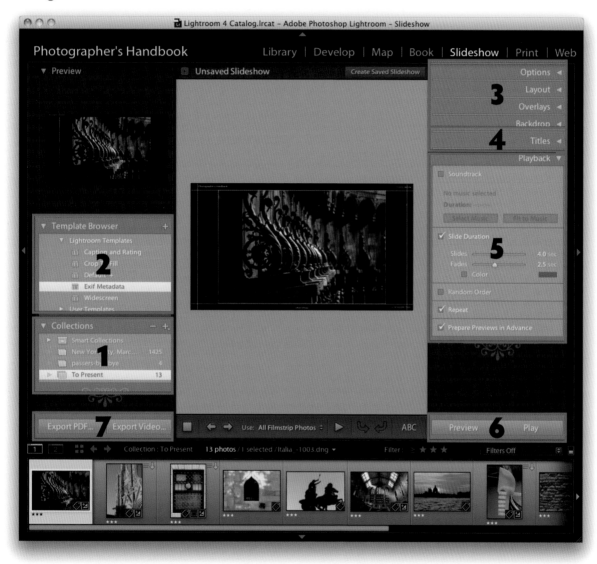

1. **Create or Choose a Collection**—Sound familiar yet?

2. **Choose a Template in the Slideshow Module**—This may be only a start-
 ing point that will be refined. Essentially, the big decisions are what, if
 any, metadata is shown with the images and what music will go with
 the images.

3. **Fine-Tune Layout and Appearance Settings**—What text should accompany your images? What colors should decorate each slide? How large should the images be and what margins should accompany them? These are some of the questions you get to answer in these panels.

4. **Edit Titles (Intro and Ending Screens)**—You get to create and/or edit identity plates to use on otherwise blank slides that begin and end your slideshow.

5. **Configure Playback Options**—You must determine how long each slide remains on screen, how long the transition is between them, and what music is to be playing, if any. You can choose any MP3 file for your accompanying music.

6. **Preview and Play**—Always preview your show before presenting!

7. **Export Slideshow as PDF or Video**—Sometimes you need to make a presentation on a computer that doesn't have Lightroom installed. In that case, you might use the free Adobe Reader to show a PDF (there will be no music), or create a video (complete with music) that can be viewed with the Adobe Media Player, Apple Quicktime, or Windows Media Player.

Create a Collection

Use either a Standard Collection or create a Slideshow Collection when you choose this module.

In the Filmstrip, you can rearrange the images, changing the order of the slideshow. All that remains for you to do is to choose the appearance and behavior of your Slideshow.

Slide Layout

Start with a Template. It's much easier to adjust something already made, unless you have a very clear idea of what your slides should look like.

Most likely, you will not simply work your way down the list of panels on the right. Rather, you'll find yourself going among them, balancing, for example, the margins in the Layout panel with room needed for your identity plate, or judging the effectiveness of a background image (in Backdrop) with your particular images. You'll experiment with the slide duration, trying to let each image have a chance to be appreciated but not bore your viewers. That is, you'll try some settings, then either use the Preview button or the Play button on the lower right. Either way, you'll notice a delay before the music begins the first time.

To edit your Identity Plate, open the Overlays panel, then click on the small version (with a dark checkerboard). A menu appears where you can choose Edit. The dialog box that appears is where you can edit the text of your Identity Plate, including font and size, or you can insert a small graphic you've built.

If you want a generic text overlay, perhaps a title for the slideshow or explanatory text, click on the ABC below the main Image window. A field appears for you to enter your custom text, or you may choose metadata. Once you've committed your text overlay (for custom text, by pressing Enter), a scalable box appears anchored to the lower left corner of the slide area. You can drag the box and/or its anchor, resize it, anchor it to the frame or part of the image, or use the Custom Text field to change it. Use the Text Overlays section of the Overlays panel to edit the opacity, color, and font for the selected text overlay.

Playback

If you choose an MP3 file, you can then have Lightroom figure out the duration of each slide so the show ends gracefully with the music.

Exporting Slideshows

When you've dialed in your slideshow, you'll want to show it, of course! You may either show it directly from Lightroom, in which you get all the bells and whistles, or you can export it as an Acrobat PDF. PDFs don't support music, and the transitions won't be so elegant, but neither you nor anyone else will need Lightroom to play the PDF version of your slideshow. All that is needed is the free Adobe Reader software.

You may also create a video with music that can be viewed using Adobe Media Player, Apple Quicktime, or Windows Media Player.

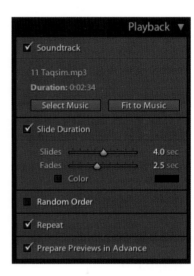

Bridge

In a hurry? Has your client, boss, or instructor just walked into the room expecting not a messy Bridge window but a presentation of your work? Just select the first image of those you want to present, then tap the spacebar. Suddenly, you're in Full Screen Preview. Tap the arrow keys to advance and the esc key to exit Full Screen.

If you have just a little more time, configure a proper slideshow with View>Slideshow Options…. You may specify any of several transitions and their duration, as well as the scaling of the images to the screen, and whether and how the filename and ratings appear. A Full Caption displays the file data in the lower central portion of the image in large type, whereas Compact discretely places a smaller version in the lower left corner. You might also choose just page numbers or no data at all. Trigger the show with ⌘+L / Ctrl+L.

Have Fun!

No matter what you photograph, or to what medium you output, make the process an enjoyable one. Experiment, allow happy accidents, and if they're unhappy, call them learning opportunities!

Thanks for reading. Now go outside (or to the studio) and get shooting.

Index

Get in the Picture!

c't Digital Photography gives you exclusive access to the techniques of the pros.

Keep on top of the latest trends and get your own regular dose of inside knowledge from our specialist authors. Every issue includes tips and tricks from experienced pro photographers as well as independent hardware and software tests. There are also regular high-end image processing and image management workshops to help you create your own perfect portfolio.

Each issue includes a free DVD with full and c't special version software, practical photo tools, eBooks, and comprehensive video tutorials.

Don't miss out – place your order now!